MW00580377

*the cinema of* CHRISTOPHER NOLAN

**DIRECTORS' CUTS**

*the cinema of*
# CHRISTOPHER NOLAN

*imagining the impossible*

# Edited by Jacqueline Furby & Stuart Joy

 **WALLFLOWER PRESS** LONDON & NEW YORK

A Wallflower Press Book
Published by
Columbia University Press
Publishers Since 1893
New York • Chichester, West Sussex
cup.columbia.edu

Copyright © Columbia University Press 2015
All rights reserved
Wallflower Press® is a registered trademark of Columbia University Press

A complete CIP record is available from the Library of Congress

ISBN 978–0–231-17396-4 (cloth : alk. paper)
ISBN 978–0–231-17397-1 (pbk. : alk. paper)
ISBN 978–0–231-85076-6 (e-book)

Series design by Rob Bowden Design

Cover image of Christopher Nolan courtesy of the Kobal Collection

Columbia University Press books are printed on permanent
and durable acid-free paper.
This book is printed on paper with recycled content.
Printed in the United States of America

# CONTENTS

ACKNOWLEDGEMENTS

The editors wish to thank all of the authors for their contributions and for their participation in the preparation of the manuscript. We also wish to thank students, friends and colleagues at Southampton Solent University and Yoram Allon, Commissioning Editor at Wallflower Press, for their enthusiasm and sustained support throughout this project.

JF – I'd firstly like to thank Stuart Joy for his exemplary specialist knowledge about and enthusiasm for all things Nolan. My thanks are due to colleagues at Southampton Solent University and elsewhere for support, inspiration and friendship: Karen Randell, David Lusted, Mark Aldridge, Darren Kerr and Donna Peberdy. Thank you to my students past and present for always being ready to chat about Nolan's films with the kind of infectious zeal that only film undergraduates can generate. In particular thank you to Liam Hunter Nicholson, for being a willing test audience one stressful afternoon of indecision. Thank you to my family for their support and forbearance during the many times when I've had to neglect them in favour of 'doing the book'. And finally, special thanks are due to Claire Hines for always having impeccable judgement, giving sensible advice, offering generous help and patient support, not to mention all the tea, wine and, especially, chocolate.

SJ – To begin with, I would like to thank my co-editor and collaborator, Jacqueline Furby, without whom this book would not exist. Secondly, I want to thank my parents for their continued love, encouragement and support throughout all my endeavours. I would not be where I am today were it not for you. I would also like to express my gratitude to my brother, Philip Joy, and my good friend Kierren Darke, who both offered invaluable insights on early drafts of my own work and continue, in their own ways, to make me smile. Thanks also go to Claire Hines, Terence McSweeney, Donna Peberdy, Darren Kerr, Mark Aldridge and Karen Randell for taking the time to listen to my thoughts on Nolan throughout the years as well as for offering a few of their own. And finally, special thanks to Sophie for her patience, understanding and for her unfailing confidence in me. You continue to inspire me every day, and I can't thank you enough.

Thanks to *Kaleidoscope* for permission to publish a revised version of the essay that appeared as 'Revisiting the Scene of the Crime: Insomnia and the Return of the Repressed', *Kaleidoscope*, 5, 2, (2013).

# NOTES ON CONTRIBUTORS

**Warren Buckland** is Reader in Film Studies at Oxford Brookes University. He is the author of numerous publications, including *The Cognitive Semiotics of Film* (2000) and *Film Theory: Rational Reconstructions* (2012), the editor of *Puzzle Films: Complex Story-telling in Contemporary Cinema* (2009) and *Hollywood Puzzle Films* (2014), and the co-editor (with Thomas Elsaesser) of *Studying Contemporary American Film: A Guide to Movie Analysis* (2002) and (with Edward Branigan) of *The Routledge Encyclopedia of Film Theory* (2015).

**Peter Deakin** is Visiting Tutor in Film Studies at the University of Salford. He has published on *American Psycho* and the work of Fred Zinnemann.

**Felix Engel** is Research Assistant at the Institute of Philosophy at Bremen University. He is a professional filmmaker and is currently completing a PhD concerning film theory and semantics.

**Jacqueline Furby** is Senior Lecturer in Film at Southampton Solent University. She is the co-editor (with Karen Randell) of *Screen Methods: Comparative Readings in Film Studies* (2006), co-author (with Claire Hines) of *Fantasy* (2011) and currently completing a monograph entitled *The Shape of Film Time*.

**Erin Hill-Parks** is an independent scholar with a PhD from Newcastle University. She is the author of *The Formation of Ideologies in Narrative Film: Understanding War Through Three Kings and Black Hawk Down* (2004), as well as articles on identity construction in cinema.

**Stuart Joy** is Associate Lecturer in Film and Television at Southampton Solent University. He has published on the *Paranormal Activity* franchise, the politics of national identity in *Line of Duty* and Nolan's *The Prestige*.

**Andrew Kania** is Associate Professor of Philosophy at Trinity University in San Antonio. He is the editor of *Memento* (2009) and co-editor (with Theodore Gracyk) of *The Routledge Companion to Philosophy and Music* (2011).

**Erin Kealey** is Adjunct Assistant Professor of Philosophy at Shenandoah University. She is the author of numerous publications, including articles on *Zombie Apocalypse* and Terrence Malick's *The Tree of Life*.

**Todd McGowan** teaches theory and film at the University of Vermont. He is the author of *The Fictional Christopher Nolan* (2012) and *Enjoying What We Don't Have: The Political Project of Psychoanalysis* (2013), amongst other works.

**Sorcha Ní Fhlainn** is Lecturer in Film Studies and American Literature at Manchester Metropolitan University. She is the editor of *Our Monstrous (S)kin: Blurring the Boundaries between Monsters and Humanity* (2010) and *The Worlds of Back to the Future: Critical Essays on the Films* (2010), and is currently completing a monograph entitled *Clive Barker: Dark Imaginer and Postmodern Vampires: Film, Fiction, and Popular Culture*.

**Jonathan Olson** is Honorary Fellow in the Department of English at the University of Liverpool. He is the co-editor (with Angelica Duran and Islam Issa) of the forthcoming volume, *Milton in Translation*.

**Lisa K. Perdigao** is Professor of English at the Florida Institute of Technology. She is the author of *From Modernist Entombment to Postmodernist Exhumation: Dead Bodies in Twentieth-Century American Fiction* (2010) and is co-editor (with Mark Pizzato) of *Death in American Texts and Performances: Corpses, Ghosts, and the Reanimated Dead* (2010).

**Fran Pheasant-Kelly** is Reader in Film and Television Studies at the University of Wolverhampton. She is the author of *Abject Spaces in American Cinema: Institutions, Identity and Psychoanalysis in Film* (2013) and *Fantasy Film Post 9/11* (2013) amongst other works, and the co-editor (with Stella Hockenhull and Eleanor Andrews) of *Spaces of the Cinematic Home: Behind the Screen Door* (2015).

**Tosha Taylor** is a PhD candidate at Loughborough University. She has published on the figure of the Joker.

**Kwasu David Tembo** is a PhD candidate at the University of Edinburgh. He has published on the cyborg in cinema.

**Margaret A. Toth** is Associate Professor of English and the Director of the Film Studies minor at Manhattan College. She has written several essays on modern American literature and visual media.

**Allison Whitney** is Associate Professor of Film and Media Studies at Texas Tech University. She has published on female subjectivity, spectatorship, and sex, race, and colonial fantasy in *Star Trek*.

**Janina Wildfeuer** is Research Fellow at the Faculty of Linguistics and Literary Science at Bremen University. She is the author of *Film Discourse Interpretation: Towards a New Paradigm for Multimodal Film Analysis* (2014), the editor of *Building Bridges for Multimodal Research* (2015) and co-editor (with John Bateman) of the forthcoming volume, *Film Text Analysis*.

# *Are You Watching Closely?*

## Will Brooker

A single Christopher Nolan film is a puzzle. What, then, can we make of ten? From *Doodlebug* (1997) to *Interstellar* (2014) – from a three-minute, thousand-dollar movie set in a cramped apartment and shot in grimy black and white, to a three-hour epic with a $165m budget, which starts in widescreen cornfields, then soars into space – what do we see, and what can we hope to solve, when we examine the collected cinema of Christopher Nolan?

There are remarkable differences, of course, in the individual films that map the path of Nolan's own soaring career acceleration: from his student film through independent features like *Memento* (2000), to blockbusters like *Batman Begins* (2005), and finally to *Interstellar*. But more remarkable are the similarities, the consistencies, the shared themes and motifs. *Doodlebug*, at the end of its three minutes, shows us – through ingenious, shoestring special effects – that its claustrophobic space is in fact a room-within-a-room, one level in a multidimensional network of duplicate apartments, each smaller than the last. *Interstellar*, in turn, takes us through a wormhole to the grandest, galactic level, only to return to a bedroom, or rather a series of bedrooms across fifth-dimensional geography and chronology. We could imagine Cooper (Matthew McConaughy), looking down at his daughter Murph (Mackenzie Foy/Jessica Chastain) from beyond a black hole, stepping sideways and glimpsing, through those bookshelves, the grimy apartment of Nolan's first short film: both films, despite their differences, end with a similar twist in space and dimension.

There is a gulf between them in terms of budget, special effects and Nolan's authorial reputation; but in the less-than-twenty years between *Doodlebug* and *Interstellar*, what may strike us most is not how far Christopher Nolan has come, but how close he remains to his early visions, or how consistently he returns to them. In the broadest terms, Nolan's brand, or author-function, has long carried an association with intellectual rigour, narrative sleight of hand and a sternly uncompromising approach, a commitment to serious play. These films present themselves as puzzles, as boxes-within-boxes, rooms-within-rooms – more than one essay in this collection employs the term *matryoshka*, referring to Russian nesting dolls – without easy or obvious answers

and escape routes. The central enigma is, rather than a narrative hook, often the whole point: the restless ambiguity that stays with us after the film becomes the central meaning. Even if a viewer claims to have guessed the twist early on, or sees it coming the second time around, there remains another layer of meta-questioning; we might see through the narrative tricks in *The Prestige* (2006), but we are still engaged in the illusion of Nolan's story and become caught up in its ruses. We might have an answer to the puzzle of Cobb's (Leonardo DiCaprio) spinning top in *Inception* (2010), but as viewers we have also been drawn into a dream, with each of the main characters corresponding to a role in a film crew: the Forger is the actor, the Architect the screenwriter, and the Extractor – Nolan's near-double, DiCaprio – the director. (We might recall that the Soviet inventor of the 'cinema eye' in the 1920s, Denis Kaufman, gave himself the codename 'Dziga Vertov', or 'spinning top': we might wonder if Nolan knows it, too). As one of the essays in this volume points out, the answer to *Inception*'s key question, 'whose subconscious are we going through, exactly?'– or simply put, *whose mind is it anyway?* – is always, Nolan himself. His real trick is that we cared about the trick at all.

Doubles, of course, haunt Nolan's movies, and resonate across his work as a whole. Cobb himself has a predecessor in the similarly-suited, identically-named Cobb (Alex Haw) from *Following* (1998). *The Prestige* is built around a structure of twins and clones, friends turned rivals and antagonists. Batman's (Christian Bale) arch-enemy, the Joker (Heath Ledger), insists 'you complete me'. Will Dormer (Al Pacino), in *Insomnia* (2002), passes sleeplessly from the role of hero cop to bad guy, recalling the ambiguity surrounding detective-turned-killer-turned-detective Leonard Shelby (Guy Pearce) in *Memento* and, in turn, pre-empting a later line from Harvey 'Two-Face' Dent (Aaron Eckhart) in *The Dark Knight* (2008): 'You either die a hero, or live long enough to see yourself become the villain.'

A study of Nolan's oeuvre complicates and duplicates the already-multiple layers of his individual movies, revealing further clues and raising further questions. We know his filmmaking is to an extent a family business, with younger brother Jonathan Nolan providing the source for *Memento* and co-writing several other scripts, while his wife Emma Thomas consistently produces or co-produces. We might be tempted to ask, then, what symbolic function Michael Caine plays – returning as the mentor in *The Prestige, Inception, Interstellar* and the *Dark Knight* trilogy – for a director who first encountered film through his father's Super-8 camera; and we might also wonder whether a man so concerned with ego and identity deliberately directed three films beginning with the same resonant vowel (*Insomnia, Inception* and *Interstellar*). These are questions for auteur theory to investigate, and this book confirms that while it had split into various strands even by the 1970s, this approach to cinematic creation, through the figure of the director, is far from redundant in the IMAX era.

Many of these questions are taken up in the essays that follow – these questions, and many others. The contributors here explore the part that trauma plays for Nolan's troubled protagonists; they consider the relationship between Nolan, *noir* and 9/11. They examine the importance of Nolan's hands-on technical choices, his insistence on

control and his preference for celluloid over digital; they weigh up the artistic input of Nolan's cinematographers and composers, and they remind us how women are often left on the margins in Nolan's stories of male doubles.

Rather than solving the puzzle, they present diverse angles of approach to the prism of Christopher Nolan's oeuvre to date; they offer focused insights on a complex body of work, and in doing so, illuminate it. It is surely the point of this collection that its chapters send the reader back to the films with further questions, rather than providing final answers. Far from ruining the trick, these analyses add to and deepen our enjoyment of Christopher Nolan's particular, peculiar cinematic conjuring.

# *Dreaming a Little Bigger, Darling*

## Stuart Joy

'I've done really well so far in my career by trusting the audience to be as dissatisfied with convention as I am.'

<div align="right">Christopher Nolan (2010: 18)</div>

When asked 'What is the job of the director?' as part of the *Hollywood Reporter*'s annual Roundtable, Christopher Nolan initially replied, 'Filmmaking, just putting images together' (2014).[1] To his fellow directors who were sat with him at the time, the simplicity of Nolan's response may have seemed somewhat contrived given that he is renowned for his innovative approach to storytelling as well as his methodically structured narratives. But Nolan's statement is largely in keeping with the ambiguous nature of his films which, even after numerous repeated viewings, often remain as mysterious to audiences as the man himself.

Since 2000, Nolan has emerged from the margins of British independent cinema to become one of the most critically and commercially successful directors in Hollywood.[2] His eight films since his first, *Following* (1998), have together generated more than $4.2 billion in revenue worldwide, and yet his films manage to be both mainstream blockbusters and the objects of cult appeal. From *Memento* (2000) to *Interstellar* (2014), the sheer inventiveness of Nolan's work, combined with his ability to court the mass audience, has rendered the traditional divisions between mainstream and independent cinema arbitrary as the boundaries between the two have become increasingly blurred.[3] Indeed, such dualistic thinking is wholly inadequate when it comes to an analysis of Nolan's cinema; the use of binary oppositions such as popular and personal, or art and commerce, can only offer a limited insight into his work. Rather than operating within a popular conception of American cinema as either Hollywood or not-Hollywood, Nolan's work seemingly transcends the inherent limitations of these categories, offering instead a unifying approach that has enabled him to earn a reputa-

tion as a director able to work within the apparent confines of Hollywood while at the same time exercising sufficient creative control to retain a measure of independence and convey his own personal vision.

This thin line between popular cinema and the notion of a singular creative voice in filmmaking; the auteur – one that complicates and questions the nature of authorship – is something that is invariably addressed by studies focused on a director working within Hollywood.[4] These studies, many of which are included in the Wallflower Press *Directors' Cuts* series, often tend to emphasise a director's personal vision and formal choices as the basis for an analysis of wider socio-political issues, as well as larger stylistic and thematic consistencies within their body of work. The following collection of essays continues this trend with a view to introducing the reader to the films of writer, director and producer Christopher Nolan. Through the contextualisation and close readings of each of Nolan's films, this book brings together work from a range of disciplines and international scholars to examine his central themes and preoccupations – memory, time, trauma, gender identity and *noir* – while also offering analyses of otherwise marginalised aspects of his work, such as the role of music, video games and the impact of IMAX and other new technologies.

Born in London in 1970, Nolan began making films from an early age with his father's Super 8mm camera and an assortment of action figures. The son of American and British parents, Nolan spent the majority of his childhood moving back and forth between the United Kingdom and the United States. However, upon returning to the UK, Nolan pursued an interest in filmmaking while he studied for his degree in English Literature at University College London. While Nolan's personal life is not automatically, necessarily or with any certainty related to his creative output, it is interesting to note how integral his nationality and literary background are to the construction of his filmmaking persona. Beyond the combination of critical praise and high box-office returns, Nolan's position within American cinema as a British émigré working within the Hollywood system seemingly distinguishes him from his contemporaries, and instead positions him as a natural successor to the likes of British director Ridley Scott whose *Blade Runner* (1982) has been frequently cited by Nolan as one of his major influences (see Feinberg 2015).

Beyond Scott, Nolan has frequently drawn comparisons with Stanley Kubrick: 'When movie aficionados look for a context in which to set the British filmmaker Christopher Nolan, the name that is mentioned most often is that of another director noted for his meticulous planning, fierce intelligence and ambitious reach: Stanley Kubrick' (Naughton 2014). Like Kubrick, who also studied literature at university, Nolan possesses a marked interest in the complex interaction of narrative and characterisation. Literary theorists have long studied narrative form and their insights have provided scholars with a wealth of knowledge with regards to its sophistication and complexity. It is perhaps unsurprising then that when questioned about his unusual approach to narrative following the release of *Insomnia* (2002), Nolan's thoughts immediately returned to his time at university: 'I wasn't a very good student, but one thing I did get from it … was that I started thinking about the narrative freedoms that authors had enjoyed for centuries' (Andrew 2002). This awareness of the apparent

restrictions of classical film narration in contrast to the relative freedoms afforded to writers and novelists emerges in Nolan's feature-length directorial debut, *Following*. Shot over the course of a year on a budget of only $6,000, the film's fractured time-line and characters introduce Nolan's key interests in exploring narrative structure, a dominant theme that has remained throughout the rest of his films. In particular, his follow-up, the critically acclaimed *Memento* and later, *The Prestige* (2006) and *Inception* (2010) all seek to explore and extend the limits of film structure and technique, as well as furthering the audience's film experience.

Among his other connections to Kubrick, Nolan has also chosen a life away from the public eye and yet, as with Kubrick, his seeming inaccessibility has only furthered his mythic status. Throughout his career Nolan has often opted to give the minimum contractual amount of promotional interviews and very little is known about his personal life which he guards with great secrecy (see Naughton 2014). He rarely talks about the complexities of his work, preferring instead to maintain a level of mystery that emphasises the central ambiguities of his films. In a recent interview for the *Hollywood Reporter* he discussed his desire to disentangle his work from what he perceives to be the limiting effects of his biography: 'I don't want people to know anything about me. I mean, I'm not being facetious. The more you know about some-body who makes the films, the less you can just watch the movies – that's my feeling … I mean, you have to do a certain amount of promotion for the film, you have to put yourself out there, but I actually don't want people to have me in mind at all when they're watching the films' (Feinberg 2015). Clearly Nolan feels that too much information about the filmmaker detracts from the audience's experience and that any such biographical information is therefore unnecessary. However, his reluctance to embrace his own personal narrative is a choice that in an unexpected way actually emphasises control, or rather a desire for control, as one of the central themes of his work.[5]

Mastery and obsession with control runs as a continuous theme through Nolan's films. At one point in *The Prestige*, a film that focuses on the rivalry between two magicians in Victorian-era London, Alfred Borden (Christian Bale) warns a young boy about the danger of revealing the secret to his trick: 'They'll beg you and they'll flatter you for the secret, but as soon as you give it up, you'll be nothing to them. You understand? Nothing. The secret impresses no-one, the trick you use it for is everything.' This excerpt can be read as a more general reflection of Nolan's attitude towards his own audience who are often left without definitive answers to his most complex narrative puzzles. For example, while the director's DVD commentary on *Memento* provides a conventional insight into the film's production history, Nolan offers multiple different recorded conclusions to the final scene but insists that he has a full, definitive interpretation of the film that he keeps to himself. Similarly, the ques-tion implicit in the final moments of *Inception* – does the top keep spinning? – is one that has confounded critics and audiences alike resulting in numerous blog posts, arti-cles and the publication of two edited volumes (both called *Inception and Philosophy*), all of which have provided multiple theories concerning whether or not Cobb (Leon-ardo DiCaprio) remains in a dream or in reality. Once again, in this instance Nolan

has refused to provide audiences with a definitive conclusion to the film preferring instead to allow the ambiguity of the ending to encourage them to create their own meaning. However, at the same time, he positions himself as the singular authoritative voice behind the film by retaining a complete understanding of how the film ends. In an interview for the *New York Times* he emphasises his belief that in order to render the ambiguity of his films satisfying from an audience perspective he must maintain an objective position of authority:

> The only way to be productively ambiguous, is that you have to know the answer for you – but also know why, objectively speaking. If you do something unknowable, there's no answer for the audience, because you didn't have an answer. It becomes about ambiguity for ambiguity's sake. There has to be a sense of reality in the film. If you don't have rules, then what I'm doing would be formless. I feel better with consistent rules. (Lewis-Kraus 2014)

All of Nolan's films are to an extent organised according to a consistent set of thematic or formal rules. In *Following*, the unemployed writer (credited as 'The Young Man', played by Jeremy Theobold) who shadows strangers to gather material for a new book abandons his own strict rules that dictate who he must follow, ultimately leading to his downfall. In *Memento*, Nolan abolishes conventional narrative principles as he attempts to align the audience with Leonard Shelby (Guy Pearce), a man with no short-term memory who seeks vengeance for the apparent rape and murder of his wife. In *Insomnia*, Nolan's debut studio film, a corrupt detective (Al Pacino) defaults to bending the rules in order to obtain a conviction and later conceal his own mistakes. Following the critical and commercial success of *Insomnia*, Nolan was presented with an opportunity to reimagine one of DC comic's most treasured icons, Batman. The resulting film, *Batman Begins* (2005) successfully grounded the story of the Caped Crusader in a convincing reality and in doing so defied traditional genre conventions. The ensuing sequels, *The Dark Knight* (2008) and *The Dark Knight Rises* (2012), continued to mine Nolan's fascination with rules and systems through an examination of a host of post-9/11 anxieties such as terrorism, mass surveillance, torture, the global recession and class warfare. In between making the *Dark Knight* trilogy, Nolan directed *The Prestige* (the film is an adaptation of a Christopher Priest novel; Nolan co-authored the screenplay with his brother) and later *Inception*. Whereas the former replicates in its structure the three stages of a magic trick and in doing so promotes a connection between the magician and the film director, in the latter, a heist film set in the mind of a business heir, Nolan exposes the rules, techniques and modes of representation from both narrative cinema and video games.

Nolan's most recent film at the time of writing, *Interstellar*, continues his fascination with rules and control on perhaps the grandest scale by focusing on the laws of physics. In the film, a team of astronauts must travel across space and time to discover a new planet that will replace a dying Earth. The film has unsurprisingly drawn comparisons to Kubrick's genre-defining *2001: A Space Odyssey* (1968), a connection that Nolan doesn't shy away from: 'I put it like this: you can't make a science-fiction film

pretending that *2001* doesn't exist … but I think *2001*'s relationship with humanity is more philosophical, more abstract. I wanted to embrace the metaphysics, but relate it to something more obviously human, like love' (Collin 2014). To hear Nolan emphasise the emotional dimension of the film is arguably at odds with one of the more common criticisms directed at him – that he is primarily a technical filmmaker whose understanding of form frequently overshadows the performances of his actors (see Lawrence 2010; Jones 2012; Bevan 2012). But another way of approaching Nolan's work is to suggest that, while the scale of his films have increased exponentially since *Following*, very few other directors have sought to pursue such a complex combination of form and characterisation while also maintaining a high level of engagement with a set of repeated themes across an entire filmography. Reflecting on *Interstellar*, film critic Mark Kermode encapsulates this view:

> While the end result may not represent the pinnacle of Nolan's extraordinary career, it nevertheless reaffirms him as cinema's leading blockbuster auteur, a director who can stamp his singular vision on to every frame of a gargantuan team effort in the manner of Spielberg, Cameron and Kubrick. 'Whose subconscious are we in?' asked Ellen Page in *Inception*. The answer here, as always, is unmistakably Nolan's. (2014)

In many ways *Interstellar* reflects on the passing of an ambitious space age. But perhaps more than this, the film also laments the passing of an age in cinema, marked by the increasing move towards digital technologies at the expense of film. While many of his contemporaries have already shifted to digital forms of film production, Nolan is one of the few remaining vocal advocates for the continued use of 35mm film stock while also choosing to shoot parts of *The Dark Knight* and *The Dark Knight Rises* in IMAX 70mm, a practice that he continued with *Interstellar*. Shot using a combination of 35mm anamorphic film and 70mm IMAX film, *Interstellar* reinforces Nolan's enduring commitment to celluloid, and increasingly to IMAX, demonstrating his desire to provide the audience with an enhanced experience of film-as-film to offer, as he says, 'something special, something extraordinary' (Feinberg 2015). This traditional approach to filmmaking also extends to a reluctance to use computer-generated imagery (CGI) and a resistance to 3D technology.[6] In contrast, Nolan has taken an active role in the development of other film-related forms of media by being the first director to deliver a live and interactive commentary on *The Dark Knight* Blu-ray through the BD-Live feature.[7] More recently, he has been involved in a multi-platform partnership between Paramount and Google to promote *Interstellar* through a range of immersive experiences and exclusive content delivered across an array of platforms including Google for Education, Google+, Google Play and YouTube (Sneider 2014). In this way, Nolan displays an acute awareness of the advancements in technology for the dissemination of his films as well as for offering new and interactive opportunities to engage with his audience. At the same time, he strives to advance the traditional art and craft of filmmaking by emphasising the aesthetic virtues of celluloid while spearheading a discourse surrounding film formats that posits film-as-film as a form

of authentic cinema.[8] It is for these reasons that Nolan can be seen as not only the writer, director and producer of his films, but also as a complete filmmaker – one who oversees all aspects of production while also managing cultural and industrial factors outside of the text.

Nolan's reluctance to employ a second-unit, preferring instead to shoot the entire film himself, is further testament to his desire for full control of his artistic vision. Referring to his work on the *Dark Knight* trilogy he remarks:

> Let me put it this way: If I don't need to be directing the shots that go in the movie, why do I need to be there at all? The screen is the same size for every shot. The little shot of, say, a watch on someone's wrist, will occupy the same screen size as the shot of a thousand people running down the street. Everything is equally weighted and needs to be considered with equal care, I really do believe that. I don't understand the criteria for parceling [sic] things off... Having said that, there are fantastic filmmakers who use second and third units successfully. So it all comes back to the question of defining what a director does. Each of us works in different ways. It's really helped me keep more of my personality in these big films. There's a danger with big-action fare that the presence of the filmmaker is watered down; it can become very neutral, so I've tried to keep my point of view in every aspect of these films. (Ressner 2012)

The attention to detail, the clarity of vision, and the level of personal accountability demonstrated in Nolan's response emphasises his position as the primary creator – the auteur. However, elsewhere he also portrays himself as someone appreciative of the collaborative nature of commercial filmmaking. As part of the *Hollywood Report*'s annual Roundtable referred to earlier, he remarked: 'The thing is, you go on a set and I don't shoot the film, I don't record the sound ... You sit there in the middle of it all trying to be a conductor or something, I don't know, trying to be helpful, trying to be a lens for everybody else's input.' As such, if one considers Nolan to be an auteur, it is not necessarily just Nolan who contributes to that construct, but also his collaborators both in front of and behind the camera. For example, Nolan has chosen to repeatedly work with a number of actors such as Michael Caine and Christian Bale as well Cillian Murphy, Ken Watanabe, Marion Cotillard and Anne Hathaway, among others. Beginning with *Memento*, he often shares a writing credit with his brother Jonathan while cinematographer Wally Pfister, editor Lee Smith, production designer Nathan Crowley, visual effects supervisor Paul Franklin, composers Hans Zimmer and David Julyan, and perhaps most importantly, his longest standing collaborator, his wife and producer Emma Thomas, have all been involved in a large number of Nolan's films.

Beyond the cast and crew, Nolan's affiliation with Warner Bros. has proven to be both hugely productive and mutually beneficial.[9] Where Warner Bros. have profited greatly from the financial successes of his films, Nolan has been the primary beneficiary of the willingness of the studio to support his development as a filmmaker (see Feinberg 2015). In particular, by entrusting him with increasingly larger budgets and one of their most lucrative franchises, Warner Bros. demonstrated a firm commitment

to the cultivation of Nolan's brand identity. In return, some observers have suggested that for every 'personal' or original film that Nolan has directed with an indeterminate commercial outcome such as *The Prestige* or *Inception*, he has subsequently returned to direct another instalment of what would become the *Dark Knight* trilogy, a series more overtly aimed at a mass audience and high grosses.[10] However, this pattern of alternating between mainstream and more personal productions is not one that Nolan consciously subscribes to, preferring instead to maintain his creative freedom *within* the studio system: 'There are filmmakers who pride themselves on "one for the studio, one for me", and I just don't see it that way... I have an opportunity that very few film-makers get, to do something on a huge scale that I can control completely and make as personal as I want' (Collin 2014).

Even in his commercial blockbusters for Warner Bros. it is not difficult to locate Nolan's personal themes. His interest in psychological dramas, his repeated experiments with narrative form and his ongoing exploration of time, memory and identity have now become established traits. But beyond his thematic interests and stylistic innovations, Nolan's cinema is primarily driven by the complex intersection between the artist and the industry. It seems fitting then to begin this collection with a consideration of Nolan's films within the wider industrial frameworks of film criticism, audience reception and recent technological developments affecting both film production and exhibition. Erin Hill-Parks' essay begins to explore these broadly defined issues with a detailed analysis of the critical reaction to Nolan's first three feature films: *Following*, *Memento* and *Insomnia*. Drawing attention to the importance of professional film critics and reviews, she argues that Nolan's early career blossomed in large part due to critics developing a persona around him; a persona that continually positioned him as the sole cinematic author of his films. She suggests that the language of these reviews creates a perpetuating, though constantly evolving, vision of Nolan as the central creative force in the filmmaking process, one that has possibly influenced how audiences understand him as a director.

In keeping with a discussion of how audiences have engaged with Nolan's films, Allison Whitney's essay 'Cinephilia Writ Large: IMAX in Christopher Nolan's *The Dark Knight* and *The Dark Knight Rises*', highlights how recent shifts in the American film industry from analogue to digital technologies have contributed to the rise of a new generation of cineastes, for whom Nolan has become an iconic figure. With a methodology that combines industrial context, textual analysis and audience reception, Whitney argues that Nolan's resistance to adopting digital filmmaking tools aligns him with a particular brand of cinephilia, one that emphasises the aesthetic virtues of celluloid as a form of authentic cinema. Echoing a similar notion, Jonathan R. Olson's essay suggests that Nolan's commitment to film, and particularly to IMAX, is a direct consequence of his desire to provide the most immersive audience experience possible. Beyond Nolan's preoccupation with celluloid, Olson also maintains that his films support the audience's immersion in the narrative while frequently contesting aspects of narrative cinema which would otherwise disrupt their suspension of disbelief. Focusing on *The Prestige* and *Inception* Olson foregrounds Nolan's use of stage magic and shared dreams which, while acting as allegories of cinema and of Nolan's

personal practice of filmmaking, circumvent the danger of dismantling the audience's immersion in the illusion of film.

In the same way that a number of foreign-born directors such as Billy Wilder, Otto Preminger and Fritz Lang made important contributions to *film noir*, a grouping of films established during the classical period of Hollywood, one of the most important features of Nolan's work is his similar engagement with *film noir*. Of course such a statement assumes that *film noir* can be considered a stable point of reference and yet, from its most primitive incarnations, one of the principal challenges of defining *film noir* is that almost as soon as it became an established formal category, it began to mutate. As a result, there is now a relatively long history of discussion regarding what can be considered to be the defining qualities of *film noir*.[11] However, the debate as to what does or does not constitute *film noir* is perhaps redundant given the prevalence of numerous conflicting theories surrounding the topic. Instead, it is more useful to consider Nolan's conception of *noir*, how *he* views it and how *he* seeks to implement it in his films. Whether it is through his unconventional narrative structures or the psychological shortcomings that characterise so many of his protagonists, beginning with *Following* and *Memento*, almost all of his films are saturated with *noir* sensibilities. Scholar Jason A. Ney remarks:

> While it's true that Nolan hasn't made a 'true' or 'pure' *noir* since his first two films, what Nolan sees as the essence of *film noir* – everyday fears placed into tightly compressed situations – still casts a long shadow over the themes and characters of his later films. (2013: 65)

In addition to Ney's discussion of how *noir* is integrated through the themes and characterisations present within Nolan's filmography is an acknowledgement of gender, which has been of central importance to those studying *noir* as early as E. Ann Kaplan's edited collection, *Women in Film Noir* (1978). And yet, considering that Nolan has frequently been criticised for his portrayal of female characters, whose roles have often been restricted to the original *noir* archetypes of the *femme fatale*, the victim or the 'doe-eyed ingenue', there is a limited amount of critical engagement with his treatment of women within the *noir* framework (see Bevan 2012). This collection seeks to address this imbalance with three essays examining Nolan's ongoing engagement with *noir* in relation to discourses of gender.

Beginning with Tosha Taylor's essay, 'Saints, Sinners, and Terrorists: The Women of Christopher Nolan's Gotham', the issues of gender identity in the *Dark Knight* trilogy are examined with a particular emphasis on how Nolan's narrative and visual choices inform his portrayal of the principle female characters in the series. Drawing on feminist theory and writings from Laura Mulvey (1975), Judith Butler (1990) and Yvonne Tasker (1998), Taylor considers how the female characters of the *Dark Knight* trilogy conform to, contest and rework the prescribed set of feminine roles within the superhero film through the lens of a *noir* aesthetic. In '*Memento*'s Postmodern *Noir* Fantasy: Place, Domesticity and Gender Identity', Margaret Toth considers how *Memento*, alongside its source story, Jonathan Nolan's 'Memento Mori', reimagines

both the gender politics and the physical spaces of classical *film noir*. Referring to the work of Mary Anne Doanne (1985; 1991), Vivian Sobchack (1998) and Andrew Spicer (2002; 2007), she problematises the film's construction of masculinity by suggesting that Nolan offers a revision of classical *noir* archetypes like the weak male protagonist, the *femme fatale* and the homemaker. Working along similar lines, Peter Deakin suggests that Nolan's films are seemingly tinged with a *noir*ish fear of empowered femininity and a masculine loss of control. Against a theoretical backdrop informed by the writings of R. W. Connell (1995), Susan Faludi (1999) and Slavoj Žižek (2011), in 'Men in Crisis: Christopher Nolan, Un-truths and Fictionalising Masculinity', Deakin considers Nolan's films in relation to gender-based anxieties surrounding male identity and what he considers to be Nolan's particular vision of masculinity in a state of crisis.

When speaking about the appeal of *noir* Nolan has said that he found himself drawn to 'working within a genre that lets you take our everyday neurosis – our everyday sort of fears and hopes for ourselves – and translate them into this very heightened realm... That way, they become more accessible to other people. They become universal. They're recognisable fears; they're things that worry us in real life'.[12] The plots and central characters of Nolan's films regularly display symptoms of neurosis, often stemming from guilt, trauma or some overarching sense of loss. From the amnesiac protagonist of *Memento* to the dissociative identity disorder of Bruce Wayne (Christian Bale) in the *Dark Knight* trilogy, each of Nolan's leading characters are frequently debilitated by inner conflict and the after effects of traumatic events. The character of Cooper (Matthew McConaughey) in *Interstellar* continues to underscore Nolan's preoccupation with the themes of memory and trauma as the character struggles to cope with the absence of his children. While the psychological states of the main characters in Nolan's films are such a dominant aspect of his work, there is a marked lack of writing on the various representations of trauma within existing scholarship. Taking into consideration the limited focus on this area to date, my own essay alongside contributions from Fran Pheasant-Kelly and Lisa K. Perdigao will aim to fill a major gap in the critical research.

To begin with, Pheasant-Kelly seeks to contextually locate films such as *Memento*, *Inception* and the *Dark Knight* trilogy within post-millennial studies of trauma including those of Susannah Radstone (2001), E. Ann Kaplan (2005) and Roger Luckhurst (2008; 2010). Combining textual analysis with a historicist perspective, Pheasant-Kelly suggests that Nolan's cinema, replete with a number of physically and emotionally traumatised male characters, is perhaps best understood in the post-9/11 contexts of disenchanted masculinity and questionable American moral identity. Perdigao's essay also engages with traumatic memories, albeit with a particular focus on the processes of mourning and melancholia. By principally referring to the work of Sigmund Freud (1957; 1961; 1989), Perdigao offers a psychoanalytical interpretation of *Memento* and *Inception*, one that draws attention to Nolan's ongoing desire to return to the themes of guilt, loss and regret. Continuing with this theme, my own essay similarly embraces a psychoanalytic consideration of Nolan's cinema placing a particular emphasis on *Insomnia*. Drawing on Freudian theory and the analysis of two

key scenes, my essay suggests that the narrative, though basically linear, is guided by the structural principles underlying the mechanisms of repression and, as such, can be considered one of Nolan's key films to engage with the experience of time and the effects of traumatic memories.

According to Steven Soderbergh, '*Insomnia* is a terrific companion piece to *Memento* because they're both very subjective films that take you inside the central character's experience' (quoted in Bowles 2002). This 'experience' is one that is intimately bound to an understanding of the fictions we tell ourselves to protect us from a truth we so often cannot accept. For instance, in *Insomnia*, Will Dormer's decision to plant false evidence to convict a child murderer is based on his belief that the end justifies the means. In *Memento*, Leonard deliberately sets in motion a chain of events that will falsely implicate Teddy (Joe Pantoliano), a man who used him for his own interests, in the apparent murder of Leonard's wife (Jorja Fox).[13] The ways in which these characters rationalise the lies they tell themselves is characteristic of Nolan's entire film catalogue, which often hinges upon various forms of deceit (see McGowan (2012)). Where *Following*, *Memento* and *The Prestige* are based on misdirection and lies; the plot of *Inception* is rooted in the art of deceiving as the characters seek to implant an idea in the mind of a business heir without his knowledge and consent. Elsewhere, in the *Dark Knight* trilogy, deceit manifests not through Nolan's favoured experimentation with film form but rather through the lies embedded in the institutional framework of society. Given the central thematic and narrative focus on deceit in Nolan's work, essays from Sorcha Ni Fhlainn and Todd McGowan draw attention to the challenges of integrating the *Dark Knight* trilogy within Nolan's filmmaking project; Ní Fhlainn through an analysis of William J. Palmer's (2009) concept of 'spin' as well as the puzzle box film form, and McGowan through an analysis of the ideological function of the superhero.

In her essay, Ni Fhlainn suggests that Nolan's particular brand of cinema is frequently based upon contested subjectivities rooted in the complexities of perceived memory and the puzzle box film form. As such, she argues that where Nolan's more personal films are grounded in a fear of doubting our own memories, the *Dark Knight* trilogy exists on the periphery of Nolan's work as it rejects the intricately structured narratives of deceit evident in his other films in favour of a more conservative approach. Echoing these sentiments, McGowan discusses Nolan's career trajectory so far focusing particularly on his turn to the superhero genre. In his essay, McGowan suggests that there exists a fundamental conservatism in the figure of the superhero, one that even Nolan's emphasis on deception cannot overcome. Whereas the false hero, a figure who ends up betraying the spectator's confidence, is at the centre of what McGowan considers to be an authentic Nolan film, Batman cannot function as the false hero in the same way that Nolan's other protagonists can. The superhero cannot deceive the spectator and still remain a superhero. As a result, for McGowan, Nolan's three-part tale of the Batman legend is one that transforms and ultimately undermines the uniqueness of Nolan's cinema.

Like Ní Flhainn and McGowan, Andrew Kania also positions the *Dark Knight* trilogy at the margins of Nolan's filmography. However, he also argues that *Inception* is a significantly less accomplished film when compared to his more personal work,

which he believes manages to effectively balance both form and content. In '*Inception*'s Singular Lack of Unity among Christopher Nolan's Puzzle Films', Kania suggests that where the complex narrative structures of Nolan's earlier puzzle films are related to their thematic concerns, *Inception* fails to provide a convincing link between the puzzle-solving aspects of the narrative and the emotional core of the film. Continuing with an analysis of *Inception*, Warren Buckland notes that while several reviewers have remarked in passing on the overlap between the film and video games, to date there has been a limited amount of academic attention given to the videogame logic elements in the film.[14] With this in mind, Buckland discusses the intersection of videogames and *Inception* by identifying what videogame structures are manifest in the film and what role videogame rules play in structuring the film's narrative logic.

The remaining essays in the book focus specifically on what are perhaps Nolan's most enduring themes: time and identity. Characters in Nolan's films frequently struggle to define themselves beyond the narratives they communicate to others. For instance, both the Young Man in *Following* and Leonard in *Memento* are confused about who they are. Similarly in *Insomnia* and the *Dark Knight* trilogy, doubling is a main narrative feature that calls into question the possibility of a singular and coherent identity. More recently in *Inception*, the indistinguishable boundary between dream and reality means that the notion of a fixed identity remains elusive in a diegetic world where characters can function as mere projections of their remembered identities. Nolan's concern with the formation and flexibility of identity extends to *Interstellar* where his focus expands to explore a number of philosophical concerns about the nature of the human condition. However, more than any other film, *The Prestige* is perhaps the single most visible expression of Nolan's fascination with time and identity. In its complex narrative of two competing magicians, the central characters not only act as doubles of each other, but ultimately have their own physical doubles giving rise to a series of complex questions about identity and selfhood.

The final section of the book begins with Kwasu David Tembo who examines Nolan's use of the double in *The Prestige* to explore the concepts of selfhood, subjectivity and the performative nature of both. Referring to Walter Benjamin's seminal essay, 'The Work of Art in the Age of Mechanical Reproduction' (1936), Tembo offers a philosophical interpretation of the role that twins and doubles perform in the film as a particular manifestation of the search for the self. He suggests that the theme of shared identities points implicitly towards an existential crisis experienced by the main characters who struggle to define their self-identities against the tedium of everyday existence in Victorian London. Continuing with a philosophical perspective, in 'No End in Sight: The Existential Temporality of *Following*', Erin Kealey approaches the complexity of Martin Heidegger's philosophy in relation to similar notions of what constitutes an authentic self. Through an analysis of the film's innovative spatio-temporal disruptions she argues that *Following*'s fractured narrative, which unfolds across three distinct plot lines, challenges how time is related to the construction of identity. She suggests that film's structural organisation and the Young Man at the heart of it function as a conduit for the film's most sustained analysis of an inauthentic existence, defined here as everyday being.

Turning to an examination of Nolan's aural landscape, Felix Engel and Janina Wild-feuer discuss the use of music in *Inception* and explore the way in which the soundtrack functions as a guiding path through the film. In particular, they focus their attention on the instrumental's basis on, and interplay with, Édith Piaf's 'Non, je ne regrette rien' as a means to orientate the audience both spatio-temporally as well as emotion-ally. Finally, in 'About Time Too: From *Interstellar* to *Following*, Christopher Nolan's Continuing Preoccupation with Time-Travel', Jacqueline Furby provides a retrospec-tive analysis of Nolan's experimentations with narrative time to suggest that, while *Interstellar* is the first of his films to overtly engage with time-travel in the story, all of his films play with temporality and conventional structures of narrative organisation. By exploring the different kinds of time(s) and modes of time (travel) that operate in Nolan's films, she considers why it was inevitable that Nolan would eventually tell a science fiction-based story about time travel.

## Notes

1   Aside from Nolan those directors present included Angelina Jolie, Bennett Miller, Mike Leigh, Morten Tyldum and Richard Linklater.

2   As measure of Nolan's current popularity, consider for a moment the IMDb's Top 250 list, a populist register of films aggregated by viewer votes, where his work is a consistent fixture ranked among the highest entries.

3   Information courtesy of Box Office Mojo. Used with permission. Online. Avail-able at: http://www.boxofficemojo.com/people/chart/?view=Director&id=christo phernolan.htm (accessed 20 February 2015).

4   The 'auteur theory' was a specific articulation of an idea put forward by the French film critic and director Alexandre Astruc in his 1948 article 'The Birth of a New Avant-garde: La Caméra-stylo'. Astruc argued that cinema was potentially a means of artistic expression as complex as written language, highlighting what he believed to be the corresponding patterns between the pen of the writer and the camera of the filmmaker. Influenced by Astruc, it was François Truffaut in his seminal 1954 article, 'Une certaine tendance du cinéma français',who was the first to make the distinction between *metteurs-en-scene* and *auteurs* (the former being directors who comprehended the language of cinema as opposed to auteurs who had a developed a clear and distinctive style). For more information on the auteur theory see Erin Hill-Parks' essay in this collection.

5   Nolan's obsessive level of control is perhaps best illustrated in this quote taken from Jeremy Kagan's *Directors Close Up 2: Interviews with Directors Nominated for Best Film by The Directors Guild of America* (2013). He says: 'If you lose control of yourself, you certainly lose control of the people around you, because they're only doing what you've asked. If they're not actually contributing to what the film's going to be and they're not giving their best, for me the attempt is to not get angry and not lose control of yourself. Go home and punch the fridge' (2013: 152).

6   Although some of his more recent films involve some form of CGI, Nolan has said in interviews that he prefers instead to use models, mattes and in-camera effects whenever possible (Ressner 2012).

7   For a more detailed discussion of the BD Live commentary for *The Dark Knight* see Chapter 3 in Erin Hill-Parks' doctoral thesis 'Discourses of Cinematic Culture and the Hollywood Director: The Development of Christopher Nolan's Auteur Persona' (Newcastle University 2010).

8   On 30 July 2014, Nolan's vocal commitment to the future of film-as-film was rewarded when Kodak, the last remaining manufacturer of 35mm stock, reached an agreement with studios to continue production (Giardina 2014).

9   In a move that is testament to their shared loyalty to one another, Nolan requested the involvement of Warner Bros. when he signed up to direct *Interstellar*, a project initiated by Paramount (see Shone 2014).

10  Nolan's longstanding commitment to Warner Bros. was extended in 2010 when he signed on to be a producer for Zack Synder's *Man of Steel* (2013) and an executive producer on the sequel, *Batman v Superman: Dawn of Justice* (slated for 2016). Despite lacking a diegetic connection to the *Dark Knight* trilogy, Nolan's presence within the promotion material of *Man of Steel* is an important marketing tool used by the studio to create links to his filmography.

11  For a rewarding discussion of the complex and sometimes contradictory definitions of *film noir* see Andrew Spicer and Helen Hanson's edited collection, *A Companion to Film Noir* (2013).

12  This remark was made in a DVD extra called 'The Influence of Noir with Christopher Nolan' taken from *Columbia Pictures Film Noir Classics I* (2009). Special thanks to Jason A. Ney for pointing me in the direction of where to find it.

13  Towards the end of *Memento*, Leonard kills the drug dealer Jimmy Grantz (Larry Holden) having been led to believe that he is the John G. who apparently raped and murdered his wife. However, fearing that he has killed the wrong man, Leonard confronts Teddy who reveals that he helped Leonard avenge his wife's assault a year earlier and sought to use Leonard to profit from Jimmy's death. Among others, this revelation causes Leonard to create false evidence which will lead to Teddy's death. As he destroys the evidence of Jimmy's murder we hear Leonard say to himself: 'I'm not a killer. I'm just someone who wanted to make things right. Can I just let myself forget what you've told me? Can I just let myself forget what you've made me do? You think I want another puzzle to solve, another John G. to look for? You're a John G. So you can be my John G. Do I lie to myself to be happy? In your case, Teddy, yes I will.'

14  See, for example, James Verini's retrospective on Christopher Nolan featured in *The New Yorker* (2012).

*Bibliography*

Andrew, Geoff (2002) 'Insomnia', *Time Out*, no date. Online. Available: http://www.timeout.com/film/reviews/76055/insomnia.html (accessed 21 April 2009).

Astruc, Alexandre (1948), 'The Birth of a New Avant-Garde: La Caméra Stylo', *L'ecran français* 141; reprinted in (1968) P. Graham (ed.) *The New Wave*. Garden City, NJ: Doubleday, 17–22.

Benjamin, Walter (1936) 'The Work of Art in the Age of Mechanical Reproduction', in Hannah Arendt (ed.) *Walter Benjamin, Illuminations*, trans. Harry Zohn. Glasgow: Fontana/Collins, 219–53.

Bevan, Joseph (2012) 'Christopher Nolan: Escape artist', *Sight & Sound*, 8 July. Online. Available at http://www.bfi.org.uk/news-opinion/sight-sound-magazine/features/christopher-nolan-escape-artist (accessed 22 November 2014).

Botz-Bornstein, Thorsten (ed.) (2011) *Inception and Philosophy: Ideas to Die for*. Chicago: Open Court.

Bowles, Scott (2002) 'Movies to keep you awake at night', *USA Today*, 24 May. Online. Available at: http://usatoday30.usatoday.com/life/movies/2002/2002-05-24-nolan.htm (accessed 21 February 2015).

Butler, Judith (1990) *Gender Trouble: Feminism and the Subversion of Identity*. London: Routledge.

Collin, Robbie (2014) 'Christopher Nolan interview: 'I'm completely invested in every project I do', *The Telegraph*, 31 December. Online. Available at: http://www.telegraph.co.uk/culture/film/11317410/Christopher-Nolan-interview-Im-completely-invested-in-every-project-I-do.html (accessed 15 January 2015).

Connell, R. W. (1995) *Masculinities*. Cambridge: Polity Press.

Doane, Mary Ann (1985) 'The Clinical Eye: Medical Discourses in the 'Woman's Film' of the 1940s', *Poetics Today*, 6, 205–27.

_____ (1991) *Femmes Fatales: Feminism, Film Theory, Psychoanalysis*. New York: Routledge.

Faludi, Susan (1999) *Stiffed: The Betrayal of the Modern Man*. New York: William Morrow.

Feinberg, Scott (2015) 'Christopher Nolan on *Interstellar* Critics, Making Original Films and Shunning Cellphones and Email', *The Hollywood Reporter*, 3 January. Online. Available at: http://www.hollywoodreporter.com/race/christopher-nolan-interstellar-critics-making-760897 (accessed 25 January 2015).

Freud, Sigmund ([1917] 1957) 'Mourning and Melancholia', trans. and ed. James Strachey. *The Standard Edition of the Complete Psychological Works of Sigmund Freud, vol. 14*. London: Hogarth, 239–58.

_____ ([1923] 1961) 'The Ego and The Id', trans. and ed. James Strachey. *The Standard Edition of the Complete Psychological Works of Sigmund Freud, vol. 19*. London: Hogarth, 1–66.

_____ ([1920] 1989) 'Beyond the Pleasure Principle', in Peter Gay (ed.) *The Freud Reader*. New York: Norton, 594–627.

Galloway, Steven (2014) *Angelina Jolie, Christopher Nolan and Director A-List on Their Toughest Decisions, 'Dreadful' First Cuts and Mike Nichols*. Online. Available at: http://bcove.me/0jn04qbz (accessed 27 January 2015).

Giardina, Carolyn (2014) 'Christopher Nolan, J.J. Abrams Win Studio Bailout Plan to Save Kodak Film', *The Hollywood Reporter*, 30 July. Online. Available at: http://

www.hollywoodreporter.com/behind-screen/christopher-nolan-jj-abrams-win-722363 (accessed 27 January 2015).

Hill-Parks, Erin (2010) 'Discourses of Cinematic Culture and the Hollywood Director: The Development of Christopher Nolan's Auteur Persona'. Ph.D. thesis, Newcastle University.

Johnson, David Kyle (ed.) (2011) Inception *and Philosophy: Because it's Never Just a Dream.* Malden, MA: Blackwell.

Jones, Jack (2012) 'Christopher Nolan – Traditional Taste', *Little White Lies,* 19 July. Online. Available at: http://www.littlewhitelies.co.uk/features/articles/christopher-nolan-traditional-taste-21121 (accessed 24 January 2015).

Kagan, Jeremy (2013) *Directors Close Up 2: Interviews with Directors Nominated for Best Film by The Directors Guild of America.* Lanham, Md: Scarecrow Press Inc.

Kaplan, E. Ann (1978) *Women in Film Noir.* London: British Film Institute.

_____ (2005) *Trauma Culture: The Politics of Terror and Loss in Media and Literature.* New Brunswick, NJ: Rutgers University Press.

Kermode, Mark (2014) '*Interstellar* review – if it's spectacle you want, this delivers', *The Guardian,* 9 November. Online. Available at: http://www.theguardian.com/film/2014/nov/09/interstellar-review-sci-fi-spectacle-delivers (accessed 18 February 2015).

Lawrence, Will (2010) 'Christopher Nolan interview for *Inception*', *The Telegraph,* 19 July. Online. Available at: http://www.telegraph.co.uk/culture/film/filmmakers onfilm/7894376/Christopher-Nolan-interview-for-Inception.html (accessed 29 December 2014).

Lewis-Kraus, Gideon (2014) 'The Exacting, Expansive Mind of Christopher Nolan', *The New York Times,* 30 October. Online. Available at: http://www.nytimes.com/2014/11/02/magazine/the-exacting-expansive-mind-of-christopher-nolan.html (accessed 12 December 2014).

Luckhurst, Roger (2008) *The Trauma Question.* London and New York: Routledge.

_____ (2010) 'Beyond Trauma: Torturous Times', *European Journal of English Studies,* 14, 1, 11–21.

McGowan, Todd (2012) *The Fictional Christopher Nolan.* Austin, TX: University of Texas Press.

Mulvey, Laura (1975) 'Visual Pleasure and Narrative Cinema', *Screen,* 16, 3, 6–18.

Naughton, John (2014) 'Christopher Nolan: the enigma behind *Interstellar*', *The Telegraph,* 8 November. Online. Available at: http://www.telegraph.co.uk/culture/film/film-news/11198035/Christopher-Nolan-the-enigma-behind-Interstellar.html (accessed 4 January 2015).

Ney, Jason A. (2013) 'Dark Roots: Christopher Nolan and *Noir*', *Film Noir Foundation.* Online. Available at: http://www.filmnoirfoundation.com/noircitymag/Dark-Roots.pdf (accessed 7 February 2015).

Nolan, Christopher (2010) *Inception: Shooting Script.* San Rafael, CA: Insight Editions.

Palmer, William J. (2009) *The Films of the Nineties: The Decade of Spin.* Basingstoke: Palgrave.

Radstone, Susannah (2003) 'The War of the Fathers: Trauma, Fantasy and September 11', in Judith Greenberg (ed.) *Trauma at Home after 9/11*. Lincoln, NE: University of Nebraska Press, 117–23.

Ressner, Jeffrey (2012) 'The Traditionalist', *Director's Guild of America Quarterly*. Online. Available at: http://www.dga.org/Craft/DGAQ/All-Articles/1202-Spring-2012/DGA-Interview-Christopher-Nolan.aspx (accessed 8 July 2014).

Shone, Tom (2014) 'Christopher Nolan: the man who rebooted the blockbuster', *The Guardian*, 4 November. Online. Available at: http://www.theguardian.com/film/2014/nov/04/-sp-christopher-nolan-interstellar-rebooted-blockbuster (accessed 17 December 2014).

Sneider, Jeff (2014) 'Christopher Nolan's *Interstellar* at Center of Unique Google Deal', *The Wrap*, 3 October. Online. Available at: http://www.thewrap.com/christopher-nolans-interstellar-at-center-of-unique-google-deal/ (accessed 4 January 2015).

Sobchack, Vivian (1998) 'Lounge Time: Postwar Crises and the Chronotope of *Film Noir*', in Nick Browne (ed.) *Refiguring American Film Genres: History and Theory*, Berkeley: University of California Press, 129–70.

Spicer, Andrew (2002) *Film Noir*. Harlow: Longman.

_____ (2007) 'Problems of Memory and Identity in Neo-*Noir*'s Existentialist Anti-Hero', in Mark T. Conard (ed.) *The Philosophy of Neo-Noir*. Lexington, KY: University Press of Kentucky, 47–63.

Spicer, Andrew, and Helen Hanson (eds) (2013) *A Companion to Film Noir*. Malden, MA: Blackwell.

Tasker, Yvonne (1998) *Working Girls: Gender and Sexuality in Popular Cinema*. London: Routledge.

Truffaut, François (1954) 'Une certaine tendance du cinéma français', *Cahiers du cinéma*, 31.

Verini, James (2012) 'Christopher Nolan's Games', *The New Yorker*, 17 July. Online. Available at: http://www.newyorker.com/culture/culture-desk/christopher-nolans-games (accessed 04 February 2015).

Žižek, Slavoj (2011) *Living in the End Times*. London: Verso.

CHAPTER ONE

# Developing an Auteur Through Reviews: The Critical Surround of Christopher Nolan

## Erin Hill-Parks

The auteur concept is one that has had longevity in popular and scholarly film culture partially due to its myriad of definitions and frequent use. Despite the rise of other, potentially contradictory, methods of enquiry in cinema such as reception studies, feminist film studies and star studies, the auteur concept continues to manifest in filmic discourse (see, for example, Gerstner and Staiger 2003; Wexman 2003; Friedman 2006; Naremore 2007; Grant 2008; Mayer 2009). The word 'auteur' and, more commonly, auteur language – using terms traditionally associated with auteur writings such as associating the director with the artistry and power behind a film – can be used in film reviews to help differentiate directors, help create meaning and unity in their set of films, and anoint certain directors as artists while others remain functionaries. This essay argues that critics' reviews in the general media promote a language, as described above, that helps enhance a specific auteur persona for Christopher Nolan, which can then be disseminated throughout film culture.

The reviews of Nolan's films position him as an independent director working within the Hollywood system, bringing artistic, intellectual sensibilities to what could be basic genre films. The language and attitude used in the reviews of his early films helps to create an aura around Nolan of a blockbuster auteur which can be seen in audience and official (interviews, promotional materials) discussion (see Flanagan 2004: 19–35). This essay will first discuss the rise of auteur ideology in Western film criticism, especially in the United States and United Kingdom, before then examining how reviews developed an auteur persona around Nolan in his first three films: *Following* (1998), *Memento* (2000) and *Insomnia* (2002). Although there are many ways the reviews emphasised Nolan as an auteur, this essay will look at two primary factors: i) the use of Nolan's name in the review; and ii) the identification of positive traits from the film with Nolan's personality and ability (for example intelligence, unusual film form). Ultimately the reviews are one factor in the discussion of Nolan as director, and they contribute to a wider consideration of Nolan as the primary meaning-maker and artist in a set of films.[1]

The development of what is now known as auteur theory is commonly credited to the French film critics of *Cahiers du cinéma* who first popularised the idea of the auteur in the early 1950s (see Astruc 1968: 17–23; Truffaut 1976: 224–37; Hillier 1985; 1986). Drawing from 'Jean Epstein's 1921 coinage of the designation *auteur* to refer to a film director' (Wexman 2003: 2), these critics did not initially propose a theory, but rather a *politique* which used the notion of an auteur as a way to critically analyse the popular medium of film. The auteur, although never having a complete and codified definition, was a director, often working within the restrictive Hollywood system, who rose above the subject matter or conditions of production to create a work of art, thereby imprinting his, or rarely her, viewpoint and style in the film. The auteur-director was supposedly a rare director and was differentiated from a *metteur-en-scène*, or a more formulaic and technical director. The auteur was a director 'consistently expressing his own unique obsessions, the other [was] a competent, even highly competent, filmmaker, but lacking the consistency which betrayed the profound involvement of a personality' (Caughie 1981: 10). Therefore, the traditional notion of an auteur is a director who consistently displays an artistic signature in the films he or she directs, making the director the primary source for artistry and unity in not just an individual film, but in a set of films.[2]

The initial idea of the auteur spread outside of France to British and American film circles as more critics began to think analytically about film as art.[3] It was in these countries, and especially with American film critic Andrew Sarris and his article in *Film Culture*, 'Notes on the Auteur Theory', originally published in 1962 (see also Sarris 1968; 1981), that the term 'auteur theory' was popularised and the original auteur concept developed by the French critics was transformed.[4] Sarris's classification of certain directors led to so-called 'aesthetic cults of personality' rising around certain directors, where every aspect of their lives were seen as relevant to the meaning of their films and 'minor directors were acclaimed before they had, in any real sense, been identified and defined' (Wollen 1998: 53). Auteur writing's detractors argued that claims for authorship could be made for anyone who had an influence on the finished film, including writers, composers (see Sergi 2003), producers (see Staiger 1995) or stars (see Dyer 1998). American critic Pauline Kael argued that 'traditionally, in any art, the personalities of all those involved in a production have been a factor in judgment, but that the *distinguishability* of personality should itself be a criterion of value completely confuses *normal* judgment. The smell of a skunk is more distinguishable than the perfume of a rose; does that make it better?' (1994: 297; emphasis in original). Most of the critics of auteurism were dismayed at the seemingly narrow and superficial scope used in this kind of criticism. Despite the detractors, auteur-influenced criticism permeated film writing. One of the breakthroughs of auteur criticism was that it helped open the field of writing about film to serious critical appraisals, starting to blend the divisions between high art and mass culture, which could account for its lasting popularity and use.

The 1970s solidified the auteur concept in popular and academic film writings with the rise of directors and critics schooled in early auteur writings and teachings.

Directors such as Steven Spielberg, Francis Ford Coppola and George Lucas were hailed as auteurs despite working within the Hollywood system, rather than fighting against its constraints. This called for a shift in how the auteur was conceptualised. Timothy Corrigan suggests the idea of a commercial, not just artistic, auteur; framed in a discussion of post-Vietnam War American films, he proposes that the auteur, rather than being considered a Romantic, solo, artistic individual who fought against production constraints, could instead be viewed as 'a *commercial* strategy for organizing audience reception' (1991: 103; emphasis in original). For Corrigan the auteur was not something present only in the films, but also outside of the film in the discursive surround and, moreover, had been commodified to the point where he or she was not truly present within the text, but instead interacted more directly with the audience outside of the text. Several directors have always had a certain level of involvement in the extra-textual features of their films, such as Frank Capra (see Buscombe 1981) or Alfred Hitchcock (see Truffaut 1986); however, Corrigan's suggestion of the commercial auteur moved beyond a separate discussion of promotion and films to a fusing of the two, to the radical point where, perhaps, the films were not always the central text in the construction of an auteur. Instead, Corrigan saw the auteur as being constructed outside of the text and perpetuated primarily through interviews. In the current film culture climate, where auteur concepts and language have become entrenched in discussion, this idea can be expanded so that an 'auteur' is developed not just in the films and interviews (and other official literature from the director/studio), but also through audience and critical discussion.

To examine how, and if, reviews do develop and transmit an auteur persona, which can then perpetuate and influence future readings of the films and future output from the director, this essay will briefly examine a selection of professional film reviews for Nolan's early films. Within the analysis of the critical reaction several factors will be focused on including overall critical reaction, how critics establish 'Christopher Nolan' through use of his name and creating association among his films, and the specific qualities attributed to Nolan directly or through implication. The critical surround develops specific name and thematic recognition in Nolan's auteur persona and constructs a language for discussing films which situates Nolan as an auteur within specific cultural and industrial contexts. Therefore, the development of Nolan's auteur persona in film reviews helps create a lasting auteur persona which may not be achieved through films alone and which directly relates to how a wider cinematic audience understands Nolan as auteur.

*Method*

While the critical reviews can be analysed through a variety of lenses, the following discussion will be based on textual analysis. However, cultural studies theories, such as encoding/decoding, inform the discussion to ensure robust and meaningful analysis (Hall 1980; Morley 1980). As Stuart Hall notes, 'there is no intelligible discourse without the operation of a code' (1980: 131), which in the case of critical reviews means the establishment of a specific way of writing about film. In examining the three factors

mentioned above – characteristics, name and film history, and genre – a type of code will be uncovered. This is not necessarily as strict a code as is traditionally associated with the encoding/decoding model because there are many sources of production in critical reviews. However, the critical discourse is a part of an art world, and so tends to reflect similar values and understandings, even if individual opinion varies.

A selection of reviews from newspapers and journals was chosen from the United States and the United Kingdom providing a comprehensive range of sources in terms of geography, cultural and political standing, and type of readership (table 1). The sources have been chosen with regard to their geographical and social breadth as well as their cultural influence.[5]

To determine how the author function of 'Christopher Nolan' is created within the reviews, the first factor analysed is how frequently Nolan's name is used and where in the review it appears. A higher frequency and more prominent use of Nolan's name helps recognition of Nolan as an auteur in the public sphere. In his examination of the evolution of film reviews, Shyon Baumann found that by the 1980s it was standard practice to include a director's name in reviews, suggesting that the inclusion of the director's name was an important marker of films being accepted as art rather than just entertainment because 'serious art forms require recognition of the artists by name' (2007: 124). Although Baumann found evidence to support this claim within the

Table 1: Publications used organised by type

| Type | Title | Country | Frequency |
|---|---|---|---|
| Industry/Targeted | Empire | UK | Weekly |
| Industry/Targeted | Entertainment Weekly | USA | Weekly |
| Industry/Targeted | Rolling Stone | USA | Bi-Monthly |
| Industry/Targeted | Sight & Sound | UK | Monthly |
| Industry/Targeted | Time Out | UK | Weekly |
| Industry/Targeted | Variety | USA | Daily |
| Regional | Austin Chronicle | USA | Weekly |
| Regional | Boston Globe | USA | Daily |
| Regional | Chicago Sun-Times | USA | Daily |
| Regional | Los Angeles Times | USA | Daily |
| Regional | San Francisco Chronicle | USA | Daily |
| Regional | Seattle Post-Intelligencer | USA | Daily |
| Regional | Village Voice | USA | Weekly |
| Regional | Washington Post | USA | Daily |
| National | Christian Science Monitor | USA | Weekly |
| National | Daily Mail | UK | Daily |
| National | Guardian | UK | Daily |
| National | Independent | UK | Daily |
| National | New York Times | USA | Daily |
| National | Telegraph | UK | Daily |
| National | The New Yorker | USA | Weekly |
| National | Times | UK | Daily |
| National | Time | USA | Weekly |
| National | USA Today | USA | Daily |

reviews he found, the initial impetus for looking at the director's name stemmed from Pierre Bourdieu's ideas on cultural capital. Bourdieu noted that 'knowledge of directors is much more closely linked to cultural capital than is mere cinema-going' (1984: 27) and one of the ways this is emphasised and learned is through critical reinforcement. The inclusion of the director's name becomes part of the cultural code. However, as Baumann found, mentioning a director's name is practically ubiquitous in critical reviews, so it is important to examine *how* the name is used in terms of the context, frequency and placement within the review. Furthermore, how the reviews refer to Nolan's films and which films they choose to refer to helps shape what the general audience knows of Nolan. A greater emphasis on Nolan as primary meaning-maker and the decision to highlight certain films stresses specific qualities and knowledge. This method provides an overview of how Nolan's auteur persona is developed and sustained through the successive films.

*Analysis of the Reviews*

*Following* (1998)

Nolan's first feature-length film was the very low-budget *Following*, which was shot at weekends using friends as cast and crew. Mostly shown at festivals with a limited cinema release, the critical reviews for *Following* construct an auteur persona for Nolan based on the themes and techniques used within the film and the genre and category in which the film is placed. *Following*, and to an extent *Memento* – discussed below – form the initial basis for the auteur persona in critical discourse. In the twelve reviews examined for *Following*, 83 per cent (10/12) of the reviews are primarily positive and stress Nolan's involvement with the film, highlighting him as the filmmaker, with a focus on his multiple contributions to the film, rather than only his role as a director. They also mention Nolan's personal narrative in relation to the quality of the film and positioning the film within specific genre terms (*film noir* or crime) and industry terms (independent).

As discussed above, one way critical discourse helps build an auteur is by creating associations between a director's other films and his name. Since this was Nolan's first film, there could not be any film history established, but his name was used multiple times to suggest authority and authorship. Prominent use of a director's name in the review, through placement and number of mentions, can help develop an auteur persona by implying that the director's name is worth remembering and that he or she has authority over the film. In the case of *Following*, Nolan's name is mentioned in six of the twelve reviews in the first few sentences, giving him the privilege of authorship. All of the reviews, as expected, mentioned Nolan at least once, with an average use of his name of just over four times (4.25; 51/12). The frequent use of Nolan's name throughout the reviews, despite the fact that he was a first-time director, reflects that the reviews generally assign full credit for the film on Nolan's abilities, even if it is a negative reflection (see Atkinson 1999).

Despite the lack of film history, the critical discourse places Nolan within a specific industrial and genre history while at the same time providing him with distinct quali-

ties, such as intelligence in regards to film form, creativity and British-ness, which distinguish him from other filmmakers. These aspects begin to establish an auteur persona for Nolan which continues and develops in critical discourse through his subsequent films. Mirroring statements by the majority of critics (75 per cent; 9/12), as the review in the *Independent* notes, 'judging from his debut, Chris Nolan's career is going to be one to, ahem, follow', placing Nolan as director for the reader to pay attention to as a talented filmmaker (Darke 1999: 14).

The critical discourse formed an initial association between Nolan and a specific genre and industry, but an auteur persona can rarely be based on only one film. Instead, an auteur persona must be consistently developed through a director's career. The critical discourse plays a role in the evolution of the auteur persona by connecting new developments of his or her films with the director's history. Therefore, while the foundation for Nolan's auteur persona was introduced in the critical reception for *Following*, a full auteur persona could not develop until more than one film had been released, as will be discussed below.

### Memento (2000)

Critical reviews for *Memento* further develop the auteur persona of a creative, film-intelligent and independent filmmaker laid out in the reviews for *Following*. However, due to the wider release and perceived quality of *Memento*, Nolan's auteur persona was amplified and transposed onto a different cultural sphere, treating him as a more established director rather than one with something to prove.

*Memento* reviews are positive overall, and this quality is explicitly attributed to Nolan's work on the film; for example, the *Empire* review credits the film's 'stroke of genius' to Nolan as the writer and director (Errigo 2000).[6] The *Los Angeles Times* calls *Memento* 'writer-director Christopher Nolan's exceptional new film' (Turan 2001) while the *Independent* states 'Nolan retains unwavering control of his material, and the results are that rare thing – an intellectual roller coaster' (Billson 2000). Though not unique to name the director as the author or creator of a film, the repeated close link between Nolan and the techniques and themes of the film demonstrate a high level of respect for his role in all aspects of the film. For example, the *Guardian* review asks 'how is Christopher Nolan going to construct a thriller without the continuous thread of time and memory to slot its constituent scenes together? That he is able to do so, daringly abolishing normal narrative rules, is proof of a precocious imagination and technical facility' (Bradshaw 2000). The reviews call attention to Nolan's distinct film features and explicitly link creativeness and a high competence in film tropes and genre to Nolan, positioning him as a complete filmmaker, rather than an aspiring one as in the *Following* reviews. Several of the critics linked the film's overt themes to a more discursive investigation of cinematic form, suggesting to the reader that Nolan is someone who is more than just a director, but a filmmaker building a distinct career (for example, see Baumgarten 2001; Guthmann 2001; Scott 2001; Sterritt 2001).

While it is common to refer to a director's earlier works in a discussion of the current film, the positioning of this earlier work can present different meanings. In the case of *Memento*, 62 per cent (13/21) of the reviews refer to *Following*, and more

tellingly, they incorporate the themes of *Following* into a discussion of *Memento*. For example, the *Variety* review notes near the beginning that 'British-born scripter-helmer Christopher Nolan avoids the sophomore slump with flying colors while deepening some of the themes so craftily explored in his debut effort, *Following*' (Nesselson 2000) while the *Village Voice* comments:

> Adding several extra dimensions and considerable confidence to the 29-year-old Nolan's tricksy first feature, *Following* (1999), *Memento* may be a stunt, but it's a remarkably philosophical one. The movie is a tour de force of frustration, a perverse tribute to the tyranny of cinema's inexorable one-way flow, and in effect, an ad for a home DVD player. It's also an epistemological thriller that's almost serious in posing the question: How is it that we know ourselves? (Hoberman 2001).

By linking the films together, not just by their connection with Nolan but their underlying thematic (mutability of identity) and technical (non-traditional narrative structure) similarities, these reviews imply that Nolan is developing new ways of using cinema to explore issues of identity and truth. While the reviews for *Following*, on some levels, seemed to regard the narrative disruption as a trick to get noticed, the reviews for *Memento* develop Nolan's auteur persona by heralding the narrative as a revised way to experience the cinema. They also imply the relationship between audience and auteur, discussing the ways Nolan seems to reach out to the audience, trusting them to follow the film and asking them to create their own understanding of the film within the structure provided.

As with *Following*, the reviews use Nolan's name to help highlight his authority within meaning-making. Nolan's name appears in the first two sentences of the review in approximately 62 per cent (13/21) of the reviews studied, further emphasising that reviewers consider Nolan the primary force behind the film. He is mentioned on average approximately three times (2.95) in each review, with Jonathan Nolan, who wrote the short story on which the film was based, mentioned in only 38 per cent (8/21) of the reviews. When Jonathan *is* mentioned, it is always as Nolan's brother, placing him almost as a continuation of Nolan, rather than as an independent member of the team. Jonathan becomes part of Christopher's vision, rather than a separate entity. This is present starting with *Memento*, but is seen again in their future collaborations where the two are sometimes referred to as 'the Nolans' instead of individually, further incorporating Jonathan's contributions as an extension of Nolan's auteur persona. Although other crew members are mentioned in some reviews, no one is mentioned as close to as many times as Christopher Nolan. As the *Guardian* claims, '*Memento* is a film high on thrills and high on IQ – an impressive new step in the career of this heavyweight director' (Bradshaw 2000). The reviews of *Memento* clearly position Nolan as a talented independent filmmaker who creates intellectual films which address themes at the centre of filmmaking and identity. However, as discussed previously, the auteur persona must continually be developed to sustain, and so implicit in these reviews is also a looking forward to Nolan's next film.

*Insomnia* (2002)

Despite the move from an independent to a studio production, the *Insomnia* reviews contribute to his auteur persona by continuing to associate Nolan with intelligence and having a keen sense of the cinematic form, but also credit him with successfully negotiating his independent sensibility to a summer Hollywood film, establishing the idea that Nolan is a blockbuster auteur. For example, *Entertainment Weekly* praised 'the directorial confidence of Christopher Nolan. Neither repeating nor losing touch with the keen trickiness of *Memento* or his feature debut, *Following*, he uses his first big Hollywood picture – a good, basic cop flick – to demonstrate that he's the real deal. This is a filmmaker in full control of mood, tone, and pacing' (Schwarzbaum 2002). Nolan is still given independent stature, by virtue of his independent features being incorporated with the description of *Insomnia*, and suggesting that he should be making films in Hollywood by claiming he is 'the real deal' and not *just* a small-picture director. The opinion that a Hollywood film was a positive step for Nolan is frequently expressed, with comments such as he 'smoothly vaults into the studio leagues' (Lim 2002) and that he has 'a gift of creating intelligent, engrossing popular entertainment' (Turan 2002). Supporting Martin Flanagan's (2004) argument that the first years of the 2000s saw the development of auteur blockbusters, the *Austin Chronicle* claims that *Insomnia* 'sure makes a strong case for the value of smart, daring filmmakers in Hollywood' (Baumgarten 2002). Nolan's auteur persona is developed within this discourse by being positioned not just as an intelligent filmmaker, but one who can effectively balance entertainment and artistic concerns within the relative restrictions of a studio-financed film with well-known actors.

The reviews for *Insomnia* were mainly positive, reaching the same critical approval as for *Memento*, with 91 per cent (21/23) of the reviews praising the film. As with his previous films, though, even the two negative reviews still favourably praise Nolan's skill. For example, the *Washington Post* review notes that 'both in his first film, the little-seen *Following*, and in his breakout hit *Memento*, Nolan showed an edgy creativity and willingness to bend the rules' (Hunter 2002) and the *New Yorker* review comments 'the director, Christopher Nolan, showed his hand to dazzling effect in *Memento*... The trouble is that his skills are now applied to a tale that can scarcely bear the pressure of his sophistication' (Lane 2002). Within these reviews Nolan is positioned as a skillful director working with material that does not fully suit his talents. While this was the minority opinion, these two examples show that even at an early stage in his career, Nolan's auteur persona is already so well-established that reviewers can call upon his 'known' skill and quality to demonstrate to readers he is better than this film, which the reviewer did not like. The reviews use Nolan's previous films to emphasise his skills, which helps to foster association between Nolan's films.

The reviews of *Insomnia* also connect Nolan's auteur persona to the themes and techniques in the films. Every review refers to *Memento* at least once, while 35 per cent (8/23) of the reviews also reference *Following*. This mention was almost always used to incorporate praise for Nolan such as 'Nolan matches his *Memento* achievement with another triumph of style and substance' (Travers 2002); 'Nolan, who made the ingenious backward-tracking thriller *Memento*' (Quinn 2002) and that the film is 'very

recognisably the work of the sharp, probing intelligence that gave us *Following* and *Memento*' (Andrew 2002). While describing the films, these quotes are also explicitly tying Nolan to both the films and the properties within those films. These then translate, mostly, to praise for the current film. Further, these reviews, as with the reviews of *Memento*, incorporate many of the main themes of the film, often in reference to Nolan himself. For example, the *New York Times* review begins 'the intensely sharp-witted remake of the *noir* thriller *Insomnia* – a cat-and-mouse game in which the mouse feels its pursuer's breath on its fur and the cat is burdened with shame – matches the director Christopher Nolan's particular interests' (Mitchell 2002). *USA Today* continues this idea, claiming *Insomnia* is 'a perfect fit between filmmaker (*Memento*'s Christopher Nolan) and material (Norway's same-name psycho-chiller from 1997)' (Clark 2002), and the *Boston Globe* states 'Nolan, who's British, has an unrelenting obsession with desperate men debilitated by the psychosomatic' (Morris 2002). There is a connection clearly made between the director's personality, which incorporates his nationality, and his choice in film themes.

Nolan was continually positioned as the central creative force through the use of his name as well as through the adjectives used about him. Despite transferring from a film where he ostensibly had more artistic freedom (as an independent film and in the dual roles of writer and director) to one where he had less (as a studio picture and solely director), Nolan's name was still mentioned in the first two sentences in 57 per cent of the reviews (13/23), as opposed to the 62 per cent (13/21) for *Memento*. The similarity in prominence could be seen as a continued amount of critical praise for his artistic abilities. Furthermore, Nolan was explicitly referred to an average of four times (4.13), once more than for *Memento*. This is surprising given that Nolan was the writer and director of *Memento* while acting only as the director on *Insomnia*. The writer, Hillary Seitz, is mentioned in only 61 per cent of reviews (14/23), suggesting that Nolan is still the primary filmmaker despite not scripting the film.

Along with the artistic credence placed on Nolan in the reviews, they as with *Following* and *Memento* look forward to his next film, claiming that '*Insomnia* bodes well for Nolan's future... This is one director who's not asleep at the wheel' (Baumgarten 2001), again tying Nolan to the themes of his film (insomnia). Further reviews suggest that Nolan's 'detailed, ornate style and thematic preoccupations are a cry for auteur status' (Morris 2002) and 'credibility is something that Christopher Nolan ... has in spades' (Sandhu 2002) positioning Nolan as among the best directors working, rather than just a functionary, whose future films are worthy of study by association with the director, rather than simply on their own merits. Furthermore, in claiming that Nolan's films are crying for auteur status, Morris suggests that Nolan is aware of the discourse surrounding his films and is actively seeking to become an auteur.

The implied statement in these reviews, though, is that Nolan needs to move beyond working on a re-make in just a directorial role, with *Sight & Sound* noting that 'Nolan's real promise is as a writer-director, rather than a director for hire. And in that case, getting a solid mainstream success like this under his belt is a shrewd move, buying him the freedom to do his own thing in the future' (Wrathall 2002). With *Insomnia* Nolan managed in critical discourse to maintain the identity of a creative and

intelligent filmmaker – more than just a director, despite only acting as director – and also to establish that he could bring this creativity in genres (remake, cop-buddy) that may not usually have this level of intelligence. The critical discourse positions Nolan as an auteur by linking him to the thematic and industrial contexts within which he works, but by also differentiating him from those contexts by referencing his independent film past and stressing the play with genre tropes. The continued emphasis in the *Insomnia* critical discourse on similar qualities as in the reviews of *Following* and *Memento* shows that a stable set of conditions have been formed for Nolan's auteur persona, including an attention to the film form and genre traditions. However, these stable qualities are transposed, mainly, to praise for Nolan as a Hollywood director, something not present in earlier discourse. Nolan's auteur persona as developed by critical surround functions to pacify discrepancies between Hollywood industry and the individual films, beginning to establish Nolan as part of a new type of Hollywood director – the blockbuster auteur.

*Conclusion*

The reviews for Nolan's first three films set the stage for Nolan to be considered an auteur by emphasising his name with prominent use throughout the reviews. This is seen through linking the three films together through Nolan to create a unified body of work and associating positive traits within each film to Nolan. More specifically, the language developed about Nolan could be read to suggest that he was a *blockbuster* auteur, and that his future films would bear this out. Nolan's next film was the Hollywood vehicle *Batman Begins* (2005), and helped to cement his status as a blockbuster auteur, despite receiving mixed reviews. In the reviews for *Batman Begins*, Nolan's name was used approximately five (5.30) times per review, positioning him firmly as the primary meaning-maker and driving force of the film. However, his name was used in the first two sentences in only 35 per cent (8/23) of the reviews. The position of the film within the Batman franchise, instead, was the focus of most of the reviews and led the articles. In Nolan's next film, the star-filled *The Prestige* (2006), his name was used less frequently overall, approximately 3.59 times in each review, but was mentioned in the first two sentences 64 per cent (14/22) of the time, more than for any of his earlier films. The pattern of referring to Nolan in auteur terms, and using his name as the main referent for the films, is present in all of his earlier films, and contributes to the perception of Nolan as an artistic, auteur director in wider film culture. This can be seen in the lead-up to and reviews of his later films, such as *The Dark Knight* (2008), *Inception* (2010) and *The Dark Knight Rises* (2012) and his role as a 'godfather' on other films such as DC Comics'/Warner Bros.' *Man of Steel* (2013).

The goal of the analysis performed in this essay was to determine how critical discourse contributes to the development of an auteur persona around Nolan, and in doing this highlight the utility and continued use of auteur concepts in the critical surround and wider film culture. This case study shows how the critical surround can propagate a language of auteur around certain directors as a way to understand meanings in individual films as well as a specific set of films. The critical surround develops

the concept of Nolan as auteur by bestowing authority on Nolan, transmitting auteur language about Nolan in the reviews and using Nolan's name as a unifying referent to link his films to him and each other. The establishment of the name as referent assigns meaning to the films and helps to create a culture of auteurism. Reviews can specifically voice the auteur ideology, which is perhaps only underscored in the films, by giving prominence to the auteur's name and his or her qualities. The critical surround is reliant upon the original film, but separate in its function and design, which adds to the development of a particular director being considered an auteur.

Critical reviews establish Nolan as the centre of meaning within his texts and uses Nolan's auteur persona to help create meaning around the similarities and differences within his films. Within reviews, generally Nolan's independent status is stressed, through choices within the films and his outsider status, as well as his creativity and intellectual nature. These features and qualities are used to differentiate Nolan from other contemporary Hollywood directors, increasing the validity and dissemination of a distinct auteur persona.

*Notes*

1  For an in-depth discussion of the different factors developing an auteur persona, see Erin Hill-Parks, *Discourses of Cinematic Culture and the Hollywood Director: The Development of Christopher Nolan's Auteur Persona* (Newcastle University: Newcastle-upon-Tyne, unpublished Ph.D. thesis, 2010). Accessed at https://theses.ncl. ac.uk/dspace/bitstream/10443/961/1/Hill-Parks10.pdf (04 June 2014).
2  See Hillier (1985) for information on the early growth of auteur ideology.
3  During this period, film studies was also beginning to be established as an academic discipline, so many critics were also theorists. The two can, and do, overlap, but here the term 'critics' refers to film writers who review films for a wider audience.
4  See Caughie (1981) for a thorough overview of the transformation and adoption of auteur ideology, especially in Britain and the United States.
5  For in-depth information about the selection of sources and details on the reviews in each see Hill-Parks 2010, which also contains a more detailed and exhaustive analysis, upon which this essay is based. A minimum word count (over 200 words) was imposed to ensure that each review was more than a capsule and thus had a critical element. Not every publication had reviews of each film: ultimately, there were 12 *Following*, 21 *Memento*, and 23 *Insomnia*.
6  Four reviews were mixed, rather than fully positive: the *New York Times*, the *New Yorker*, the *Austin Chronicle* and the *Chicago Sun-Times*. However, these reviews still recommended the film and had positive things to say about parts of the film and about Nolan.

*Bibliography*

Andrew, Geoff (2002) 'Insomnia', *Time Out*, no date. Online. Available: http://www.timeout.com/film/reviews/76055/insomnia.html (accessed 21 April 2009).

Astruc, Alexandre (1968 [1948]) 'The Birth of a New Avant-Garde: La Caméra Stylo', in Peter Graham (ed.) *The New Wave*. New York: Doubleday, 17–23.

Atkinson, Michael (1999) 'Shadow of a Doubt', *Village Voice*, 30 March. Online. Available: http://www.villagevoice.com/1999–03–30/film/shadow-of-a-doubt/ (accessed 22 April 2009).

Baumann, Shyon (2007) *Hollywood Highbrow: From Entertainment to Art*. Princeton, NJ: Princeton University Press.

Baumgarten, Marjorie (2001) 'Memento', *Austin Chronicle*, 30 March. Available at http://www.austinchronicle.com/gyrobase/CalendarFilm?Film=oidpercent3A141 059 (accessed 22 April 2009).

_____ (2002) 'Insomnia', *Austin Chronicle*, 24 May. Online. Available: http://www.austinchronicle.com/gyrobase/Calendar/Film?Film=oidpercent3A142114 (accessed 22 April 2009).

Billson, Anne (2000) 'Memento', *Independent*, 22 October.

Bourdieu, Pierre (1984) *Distinction: A Social Critique of the Judgement of Taste*, trans. Richard Nice. Cambridge, MA: Harvard University Press.

Bradshaw, Peter (2000) 'Memento', *Guardian*, 20 October. Online. Available: http://www.guardian.co.uk/film/2000/oct/20/1 (accessed 22 April 2009).

Buscombe, Edward (1981) 'Ideas of Authorship', in John Caughie (ed.) *Theories of Authorship: A Reader*. London: Routledge, 22–34.

Caughie, John (ed.) (1981) *Theories of Authorship: A Reader*. London: Routledge.

Clark, Mike (2002) '*Insomnia* Awakens Psychological-Thriller Genre', *USA Today*, 24 May. Online. Available: http://www.usatoday.com/life/movies/2002/2002–05–24-insomnia-review.htm (accessed 20 March 2009).

Corrigan, Timothy (1991) *A Cinema Without Walls: Movies and Culture After Vietnam*. New Brunswick, NJ: Rutgers University Press.

Darke, Chris (1999) 'Saturday Night Fever on a Budget', *Independent*, 29 October, 13–14.

Dyer, Richard (1998) *Stars*, second edition. London: British Film Institute.

Errigo, Angie (2000) 'Memento', *Empire*, no date. Online. Available: http://www.empireonline.com/reviews/ReviewComplete.asp?FID=6255 (accessed 22 April 2009).

Flanagan, Martin (2004) '"The Hulk, An Ang Lee Film": Notes on the Blockbuster Auteur', *New Review of Film and Television Studies*, 2, 1, 19–35.

Friedman, Lester D. (2006) *Citizen Spielberg*. Urbana, IL: University of Illinois Press.

Gerstner, David A. and Janet Staiger (eds) (2003) *Authorship and Film*. London: Routledge.

Grant, Barry Keith (ed.) (2008) *Auteurs and Authorship: A Film Reader*. Oxford: Blackwell.

Guthmann, Edward (2001) 'A Man Whose Memory Doesn't Serve: Nolan's *Memento* is a Challenging Thriller', *San Francisco Chronicle*, 30 March. Online. Available: http:// http://www.sfgate.com/movies/article/A-Man-Whose-Memory-Doesn-t-Serve-Nolan-s-2936860.php (accessed 22 April 2009).

Hall, Stuart (1980) 'Encoding/Decoding', in Stuart Hall, Dorothy Hobson, Andrew Lowe, and Paul Willis (eds) *Culture, Media, Language: Working Papers in Cultural Studies, 1972–79*. London: Routledge, 128–38.

Hill-Parks, Erin (2010) *Discourses of Cinematic Culture and the Hollywood Director: The Development of Christopher Nolan's Auteur Persona*. Newcastle University, Newcastle-upon-Tyne, unpublished Ph.D. thesis. https://theses.ncl.ac.uk/dspace/bitstream/10443/961/1/Hill-Parks10.pdf (accessed 4 June 2014).

Hillier, Jim (ed.) (1985) *Cahiers du Cinema: Volume 1: The 1950s: Neo-Realism, Hollywood, New Wave*. Cambridge, MA: Harvard University Press.

_____ (ed.) (1986) *Cahiers du Cinema: Volume 2: 1960–1968: New Wave, New Cinema, Re-evaluating Hollywood*. Cambridge, MA: Harvard University Press.

Hoberman, J. (2001) 'Persistence of Memory', *Village Voice*, 13 March. Online. Available: http://www.villagevoice.com/2001–03–13/film/persistence-of-memory/ (accessed 22 April 2009).

Hunter, Stephen (2002) 'Numb, Alaska: *Insomnia* Suffers From Uneven Acting', *Washington Post*, 24 May. Online. Available: http://www.washingtonpost.com/wp-dyn/content/article/2002/05/24.html (accessed 21 April 2009).

Kael, Pauline (1994) *I Lost It at the Movies: Film Writings 1954–1965*. London: Marion Boyars.

Lane, Anthony (2002) 'Odd Couples', *New Yorker*, 27 May. Online. Available: http://www.newyorker.com/archive/2002/05/27/020527crci_cinema (accessed 22 April 2009).

Lim, Dennis (2002) 'Waking Life', *Village Voice*, 28 May. Online. Available: http://www.villagevoice.com/2002–05–28/film/waking-life (accessed 20 March 2009).

Mayer, Sophie (2009) *The Cinema of Sally Potter: A Politics of Love*. London and New York: Wallflower Press.

Mitchell, Elvis (2002) 'A Cop Runs But Can't Hide', *New York Times*, 24 May. Online. Available: http://movies.nytimes.com/movie/review?res=9C05E3DE1F38F937A15756C0A9649C8B63 (accessed 10 November 2008).

Morley, David (1980) *The 'Nationwide' Audience: Structure and Decoding*. London: British Film Institute.

Morris, Wesley (2002) 'Intense Pacino, cool Williams awake the inner-nail-biter in their psychological duel', *Boston Globe*, 24 May. Online. Available: http://www.boston.com/movies/display?display=movie&id=1380 (accessed 22 April 2009).

Naremore, James (2007) *On Kubrick*. London: British Film Institute.

Nesselson, Lisa (2000) 'Memento', *Variety*, 14 September. Online. Available: http://www.variety.com/review/VE1117788079.html?categoryid=31&cs=1 (accessed 21 April 2009).

Quinn, Anthony (2002) 'Edge of Darkness', *Independent*, 30 August. Online. Available: http://www.independent.co.uk/arts-entertainment/films/reviews/insomnia-15–641368.html (22 April 2009).

Sandhu, Sukhdev (2002) 'Sleepless Policeman', *Telegraph*, 30 August. Online. Available http://www.telegraph.co.uk/culture/film/3582083/Sleepless-policeman.html (accessed 22 April 2009).

Sarris, Andrew (1968) *The American Cinema: Directors and Directions 1929–1968*. New York: E. P. Dutton.

____ (1981) 'Notes on the *auteur* theory in 1962', in Jim Caughie (ed.) *Theories of Authorship: A Reader*. London: Routledge.

Schwarzbaum, Lisa (2002) 'Insomnia', *Entertainment Weekly*, 22 May. Online. Available: http://www.ew.com/ew/article/0,,241650-1-0-insomnia,00.html (accessed 20 March 2009).

Scott, A. O. (2001) 'Backward Reel the Grisly Memories', *New York Times*, 16 March. Available at http://movies.nytimes.com/movie/review?res=9E06E5DC173DF93 5A25750C0A9679C8B63 (accessed 10 November 2008).

Sergi, Gianluca (2003) 'Blockbusting Sound: The Case of *The Fugitive*', in Julian Stringer (ed.) *Movie Blockbusters*. London: Routledge, 141–52.

Staiger, Janet (1995) 'Introduction', in Janet Staiger (ed.) *The Studio System*. New Brunswick, NJ: Rutgers University Press, 1–14.

Sterritt, David (2001) '*Memento* Proves Memorable', *Christian Science Monitor*, 16 March. Online. Available: http://www.csmonitor.com/2001/0316/p15s2.html (accessed 22 April 2009).

Travers, Peter (2002) 'Insomnia', *Rolling Stone*, 6 June. Online. Available: http://www. rollingstone.com/reviews/movie/5947689/review/5947690/insomnia (accessed 20 March 2009).

Truffaut, François (1976 [1954]) 'A Certain Tendency of the French Cinema', in Bill Nichols (ed.) *Movies and Methods: Volume 1: An Anthology*. Berkeley and Los Angeles, CA: University of California Press, 224–37.

____ with Helen G. Scott (1986) *Hitchcock*, revised edition. London: Paladin.

Turan, Kenneth (2001) 'Backward Unreels the Thriller', *Los Angeles Times*, 16 March. Online. Available: http://articles.latimes.com/2001/mar/16/entertainment/ca-38285 (22 April 2009).

____ (2002) 'Caught Up in *Insomnia's* Deft Waking Nightmare', 24 May. Online. Available: http://articles.latimes.com/2002/may/24/entertainment/et-turan24 (accessed 22 April 2009).

Wexman, Virginia Wright (ed.) (2003) *Film and Authorship*. New Brunswick, NJ: Rutgers University Press.

Wollen, Peter (1998) *Signs and Meaning in the Cinema*, expanded fourth edition. London: British Film Institute.

Wrathall, John (2002) 'Insomnia', *Sight & Sound*, 12, 9, 62–4.

CHAPTER TWO

# Cinephilia Writ Large: IMAX in Christopher Nolan's The Dark Knight and The Dark Knight Rises

## Allison Whitney

In a period when the global film industry is undergoing major shifts from analogue to digital systems, including camera, post-production and exhibition technologies, Christopher Nolan has made a point of extolling the aesthetic virtues of celluloid, and participating in a discourse surrounding film formats that posits them as a form of authentic cinema, both by virtue of their photochemical properties and their high-definition mode of realism. Nolan has been consistently vocal about using 35mm film stock, while also choosing to shoot parts of *Inception* (2010) with Panavision Super 70 and VistaVision, but his most emphatic endorsement of film-as-film mani-fests in his shooting portions of *The Dark Knight* (2008) and *The Dark Knight Rises* (2012) in IMAX 70mm, a practice he continued with *Interstellar* (2014). In this essay I will discuss how Nolan's allegiance to film, and particularly IMAX, aligns him with a particular brand of cinephilia, one that is highly invested in technological specificity. This love of cinema, here defined as not only an appreciation of film's aesthetic quali-ties, but also a resistance to the industrial shift toward digital systems, is in turn echoed in much of the reception discourse on the films, with critics, industry professionals and fan communities debating the merits of IMAX presentation as an avenue to a more 'authentic' experience of Nolan's films and of the cinema in general.

In the final credits for *The Dark Knight Rises*, the list of companies providing the cameras, lenses, prints, colour processes and other technical services concludes with this statement: 'This motion picture was shot and finished on film.' Nolan is by no means the only contemporary filmmaker who insists on using film – consider the limited 70mm release of Paul Thomas Anderson's *The Master* (2012) – but this concluding statement is at once factual and polemical. In the documentary *Side by Side* (Christopher Kenneally, 2012), which explores the implications of digital film-making, Nolan states in an interview: 'I am constantly asked to justify why I want to shoot a film on film, but I don't hear anyone being asked to justify why they want to

shoot a film digitally.' Indeed, in virtually every published interview with Nolan or members of the film crew concerning the *Dark Knight* films, there is at least some mention of not only his love of film, but of IMAX as a medium that surpasses digital technologies, and these comments usually present Nolan as 'proudly and defiantly old-school' (McCarthy 2012) in his insistence on using film. For example, Nolan's regular cinematographer and longtime collaborator Wally Pfister explains that Nolan thought of IMAX as not only a high-quality medium in which to execute his vision, but also as an explicit rejection of digital filmmaking, even more emphatic than his continued use of 35mm film.[1] Meanwhile, Jody Duncan's *Cinefex* essay on *The Dark Knight* quotes Visual Effects Supervisor Nick Davis:

> I think that shooting IMAX was Chris's kick-back against the entire world going digital... In his book, we're losing a lot of the mystique and the glamour of film. In contrast to digital is this fantastic, beautiful IMAX format; and I think Chris just wanted to have a chance to show the public and the industry what we might be losing. (2008: 64)

This rhetoric of loss, glamour and mystique is consistent with a brand of medium-specific cinephilia that mourns the loss of traditional film technologies, but it also recalls a longer discourse of mourning and nostalgia in cinephilia. Indeed, as Thomas Elsaesser explains in 'Cinephilia, Or the Uses of Disenchantment', cinephilia 'has always been a gesture towards cinema framed by nostalgia and other retroactive temporalities' (2005: 27).

Cinephilia – the love of cinema – is a discourse with a long history in film culture, criticism and scholarship, and in each historical moment it has taken on a different manifestation: from the European cine-clubs and film magazines of the 1950s and 1960s, to the advent of home video in the 1980s and a new culture of film collecting, to contemporary online communities of enthusiasts for particular cinemas, technologies and formats.[2] While cinephilia is a complex and contested term, it connotes a delight in the cinema's material, social and artistic properties – the pleasure of watching vibrations in the emulsion, the scratches on a print testifying to its checkered past, the smell of popcorn, the emotional multiplier of communal viewing, the psychic impact of a striking image or sound, or the passion of compiling, preserving and sharing one's own film collection. In the late twentieth and early twenty-first centuries, cinephiles have turned to debating the implications of digitisation and its dramatic effects on the capture, processing, restoration, storage, distribution and projection of moving pictures.[3] These discourses vary from debating the relative merits of Blu-ray transfers to, in many instances, concern that industrial shifts away from celluloid, both in production and exhibition, will hasten the death of cinema.[4] Nolan is a vocal part of this discourse, and his effort to continually remind audiences of his relationship to film functions as a form of product differentiation. Not only does he seek to distinguish his productions from trends in digital cinema, but he does so in a way that associates the film medium with notions of quality, artistic integrity, work ethic and a nostalgic connection to older traditions of filmmaking and film-going – traditions that

in turn testify to the refinement of cinephile audiences who seek out his productions in their 'truest' celluloid form. Consider, for example, the rhetoric in Nolan's interview in *Empire* magazine, where he not only describes using film as a way of ensuring aesthetic quality, but he also ascribes a work ethic to eschewing digital intermediate and other new technologies, saying 'we should be doing it the hard way, if it's the best way' (Jolin 2010: 100).[5] In the case of the *Dark Knight* films, the presence of IMAX footage supports Nolan's enlistment of cinephilia by rendering these versions of the film emphatically cinematic, aesthetically differentiated from digital productions and employing the rhetoric of enhanced experience and sensory engagement associated with IMAX.

For Nolan, IMAX is both artistically and ideologically useful both for its technical properties and also for the set of associations that have crystallised around the medium since its invention in 1970. While a number of camera and exhibition systems bear the IMAX Corporation's brand name, for our purposes 'IMAX' refers to a 70mm format, sometimes called 15/70, as each frame has fifteen sprocket holes (by comparison, traditional 70mm has five sprocket holes). An IMAX frame is roughly ten times the size of standard 35mm, and in a traditional IMAX facility, the film is projected on screens that are at least six stories in height. When I say a 'traditional' facility, this is to differentiate from the corporation's recent move toward smaller projection facilities, as well as digital projection, both of which involve large screens, but lack the same magnitude as traditional IMAX GT (Grand Theatre), which fills all or most of the audience's field of view, including the upper and lower extremes of peripheral vision.[6]

One of the reasons that there is some confusion about the meaning of IMAX is that since 2003, the corporation has been re-formatting films produced in 35mm for exhibition in IMAX theatres. In this process, called DMR (digital re-mastering), 35mm prints are scanned, whereupon proprietary software analyses and extrapolates from the grain, adding a level of data to the image that allows it to be blown up to IMAX proportions without a jarring loss of resolution. On the level of corporate strategy, DMR was introduced to remove key impediments to the expansion of the IMAX theatre network. For the first thirty years of IMAX history, the majority of their cinemas were in science centres, museums or other institutional settings, and these theatres needed content that conformed to their educational mandates.[7] Therefore, the bulk of the IMAX filmography consisted of documentaries, travelogues and other nonfiction genres such as concert films. The institutional interests in IMAX made it difficult for filmmakers to produce fictional narrative films in the format, as they would rarely have sufficient exhibition opportunities to secure financial backing. Meanwhile, the lack of fictional narrative films made exhibitors reluctant to embrace IMAX technology for more commercial ends. The IMAX Corporation sought to solve this problem and expand the market for its equipment by introducing the DMR process, and encouraging Hollywood to see IMAX as an ancillary release option for their products (see McDonald 2010: 50).

Many blockbuster films underwent the DMR process to have IMAX releases, with early examples including *Star Wars: Episode II – Attack of the Clones* (George Lucas, 2002) and *The Matrix Reloaded* (Andy and Lana Wachowski, 2003), but they were

met with mixed reviews from both filmmakers and audiences, who appreciated some of the properties of the screenings, while also noting the incompatibility of the IMAX infrastructure with films designed for a smaller screen. For example, films shot in a widescreen ratio occupy only the middle of the IMAX screen, missing the opportunity to employ the upper and lower portions of viewers' peripheral vision, which accounts for much of the unique sensory impact of IMAX exhibition.[8] *The Dark Knight* was the first Hollywood production to combine DMR with footage shot with IMAX cameras and intended to be exhibited on traditional IMAX screens. The finished film included 37 minutes of IMAX footage, while its sequel, *The Dark Knight Rises*, included 72 minutes worth. When these films are viewed in an IMAX facility, the image changes shape quite dramatically between the 35mm anamorphic material, which has a more conventional widescreen ratio of 2.40, and the IMAX shots, which are considerably taller at a ratio of 1.43. The films' continual shifting between ratios presents a number of challenges both to the filmmakers who must decide when and how to employ their different camera systems, and to audiences who try to discern the significance of the image's continually changing shape.

In David Bordwell and Kristin Thompson's book *Christopher Nolan: A Labyrinth of Linkages*, they reiterate the critique that Nolan's filmmaking lacks a certain formal rigour: 'Nolan's recent films often display the same tendency toward loose, roughly-centered framings. His avoidance of tight shot design may be encouraged further when he shoots in both the 1.43 of IMAX ratio and the 2.40 anamorphic one. It's hard to create complex compositions respecting both ratios at the same time' (2013: 14). Further, since the film would be exhibited in both IMAX and conventional cinemas, each version of the film required different framing strategies. For example, *The Dark Knight Rises* editor Lee Smith explains that for the 35mm release version of the film, they would mask the IMAX footage to make a 2.40 ratio, and in that process, 'do a re-position on the IMAX frame to make it fit' (Blair 2012). Such adjustments inevitably alter the film's compositional logic, but the fact that the film would be exhibited in both IMAX and conventional cinemas, with the latter being a re-framed version of the former, was often used to argue that the IMAX versions were more 'authentic', truer to the filmmakers' vision, and offered a level of privileged engagement with the text.

In the *Dark Knight* films, Nolan uses IMAX cameras in the expected contexts of aerial photography, landscape scenes and action sequences, but he also employs them in more intimate contexts. Admittedly, the films are not entirely consistent in their use of image size, in part because of technical restrictions on the production. IMAX cameras are large, noisy and heavy, with the lightest ones weighing 65 pounds, and while Nolan's cinematographers used IMAX with Steadicam rigs to allow for unprece-dented camera mobility, there were still instances where 35mm was the more prac-tical choice. And yet Nolan does use the shifts in scale between 35mm and IMAX to achieve a variety of expressive ends: to denote moments of character revelation or other cognitive shifts; to instill feelings of vertigo by using IMAX in montage sequences with comparatively claustrophobic 35mm; to facilitate moments of contemplation; and to emphasise the photographic 'realness' of images that might otherwise be construed as digital effects.

There are several moments, particularly in *The Dark Knight Rises*, where a 35mm sequence switches to IMAX at the moment a character undergoes some kind of cognitive shift, whether solving a mystery, discovering a new balance of power or reaching an emotional epiphany. For example, when Selina Kyle/Catwoman (Anne Hathaway) meets with a client who hired her to steal Bruce Wayne's (Christian Bale) fingerprints, it initially appears that he has the upper hand. The opening shots of this sequence, which take place in a dark and generally unremarkable bar, are filmed in 35mm, and this aspect ratio seems appropriate to a scene that consists primarily of dialogue among seated characters. However, once the client discovers that Selina has tricked him, and that the police will soon converge on the bar, it cuts to IMAX and remains in that ratio for the rest of the sequence. Later in the film, when she leads an unwitting Batman/Bruce Wayne to be ambushed in Bane's (Tom Hardy) underground lair, the shift from 35mm to IMAX occurs at the moment that he realises her betrayal. In this instance, the shift appears to take place within a single shot, i.e. rather than cutting from 35mm to IMAX, the image appears to 'open up' to fill the IMAX screen just as he is trapped.

While one could argue that in each of these instances, the shift has more to do with using IMAX to photograph the ensuing fight scenes than with representing character psychology, there are several moments where this pattern has a less stereotypical connection to IMAX as spectacle. For example, at the end of the fundraising gala/masked ball sequence, which plays out in 35mm, Bruce approaches the valet to retrieve his car, but is informed that his 'wife' has taken it. As Bruce is unmarried, this gives him pause, but he quickly realises that Selina has tricked the valet into handing over his Lamborghini. And indeed, the next two shots, in IMAX, show the car speeding away with Selina at the wheel. The scene returns to 35mm for the shot of Alfred (Michael Caine) picking Bruce up in a Bentley. If we consider the conventional reasoning for using IMAX in a dramatic film, it might seem wasteful to use it to show the interior of a car, while at the same time we might appreciate an IMAX shot of the Bentley's exterior, but in these instances, the sensory jolt of cutting from small to large, and from regular to high resolution, correlates to a shift in characters' power relations. Similar shifts occur later in the film when Blake (Joseph Gordon-Levitt) comes to realise that Gotham's ubiquitous cement trucks are full of explosive materials, and that much of the city's infrastructure is now rigged for detonation. The format shifts to IMAX immediately after he discovers the conspiracy, and it remains so for the duration of the sequence, with one exception. When the mayor (Nestor Carbonell) assures journalists that the urgent behavior of the police is merely a training exercise, his announcement is depicted in 35mm in what is otherwise an IMAX sequence. It would seem that in this case, once a shift to IMAX scale is encoded as marking moments of enlightenment, the reversion to 35mm might then signal ignorance or denial.

In other instances, IMAX frames can instill feelings of vertigo, while contributing to claustrophobia in comparatively cramped 35mm. Indeed, most aerial shots, or shots from high vantage points, use IMAX cameras, but they sometimes use 35mm as a kind of spatial and sensory counterpoint. For example, in *The Dark Knight Rises*, when Bruce crawls out of a window at the hospital to secretly visit Commissioner Gordon

(Gary Oldman), the image opens up to IMAX scale just as he exits the window, providing a vertiginous thrill while also conveying the sensory transition from safe interior to precarious exterior. In *The Dark Knight*, when Batman and the Joker (Heath Ledger) have their final showdown in a half-built skyscraper, the film exploits the power of shifting aspect ratios in order to generate anxiety. In this scene, the Joker has rigged two ships with explosives and provided the passengers of each with a trigger, instructing them that they can save themselves by blowing up the other ship. As the countdown to the explosion draws near, Batman and the Joker are fighting on the edge of the building, and their encounter is filmed in IMAX, while the shots on board the ship are in 35mm. Even though the shots of Batman and the Joker are primarily medium shots and close-ups, which are not traditionally regarded as suitable to IMAX presentation, they do allow for an interesting dynamic as the scene cuts back and forth from their argument to the ships. The spaces in the ships, presented in the widescreen ratio, appear all the more claustrophobic when compared with the vertical magnitude of IMAX, even though the IMAX frames do not necessarily represent objects of great height. Thus, the dynamic effect of shifting between aspect ratios creates a montage of spatially-provoked anxieties, with a sense of claustrophobia on the one hand, and vertigo on the other.

While IMAX can generate a variety of sensory and visceral thrills, Nolan will sometimes use it for more calming purposes, to slow the pace of the film, particularly after moments of kineticism and psychological intensity. For example, in *The Dark Knight* the sequence where Batman is forced to choose between saving Harvey Dent (Aaron Eckhart) or Rachel Dawes (Maggie Gyllenhaal) is particularly shocking in its depiction of physical and emotional suffering. The sequence begins with Batman's brutal interrogation of the Joker, then continues as the Joker describes the sadistic pleasures he takes in mutilation and murder. While Batman and the police race to rescue Harvey and Rachel, the Joker realises his grotesque plan to blow up the police station with explosives planted within a prisoner's body. Meanwhile, Rachel professes her love to Harvey over the telephone as she comes to terms with her impending death, a death represented through dramatic explosions, concluding with the horrifying visual effects of Harvey's burning face. Nolan shoots the sequence primarily in 35mm, with occasional IMAX shots of Batman riding to the rescue, but once the suspense is over and Rachel has died, there follows a montage of IMAX images, narrated with Rachel's posthumous voice-over. The montage begins immediately after Gordon realises that this entire scenario had been the Joker's plan, and the first IMAX shot is of the Joker hanging out of the window of a police car, weaving through the streets in a kind of reverie. The diegetic sound fades away, and we are left with only extra-diegetic music and Rachel's narration, where she tells Bruce that she intends to marry Harvey. The ensuing shots are of the firefighters in the destroyed building, Batman standing in the rubble, shots of Alfred reading Rachel's note, Harvey undergoing emergency surgery and of Batman returning Harvey's two-faced coin, now charred by the explosion. While we do briefly hear Batman's voice, apologising to Harvey, this montage is comparatively quiet, and a significant departure from the fast pace of the previous sequence. While these formal properties are consistent with the pathos of the scenario,

much of their emotional impact stems from the scale of the images, and their remarkable clarity, which has the effect of encouraging the viewer to scan them closely for detail. In these cases, the engulfing scale of the IMAX image creates a temporal and spatial pause where the viewer might contemplate both the beauty of the medium and also the film's troubling moral economy.

Of course, many of the IMAX sequences are more predictable in their content, such as action, landscape, cityscape and crowd scenes, but even in these cases, their purpose is bound up with a valorisation of IMAX as a film medium, primarily because of the image's high resolution, and the resulting difficulty in concealing the tricks of filmmaking. For example, in an interview with Jeffrey Ressner for *The Director's Guild of America Quarterly*, fittingly titled 'The Traditionalist', Nolan explains: 'For *The Dark Knight Rises* we were on Wall Street with a thousand extras, and you can see everybody's face in the frame. In some ways, I feel it takes me back almost to the silent film era, when they had those huge cameras. Trying to do things in more of a tableau fashion' (2012). This comment also reminds the reader that rather than employing CGI to depict huge crowds, Nolan uses a literal cast of thousands.[9] Similarly, production accounts of IMAX scenes, such as the opening sequences of both films, emphasise the use of IMAX as a means of announcing that the audience is witnessing something 'real', such as real stunt performers zip-lining between buildings in the opening of *The Dark Knight*, or real airplane parts falling from the sky in *The Dark Knight Rises*. Not only do these accounts evoke admiration for the filmmakers who create spectacles 'the hard way' using practical effects, but they also seek to enhance feelings of suspense and excitement by highlighting the danger and intricacy of blowing up real buildings, flipping real trucks and using real stunt performers rather than their digital doubles.[10]

The rhetoric of 'realness' surrounding IMAX has a practical foundation in that its high-resolution properties make many of the illusions of conventional filmmaking harder to pull off. While production designers of a 35mm film might be able to gloss over, say, using anachronistic fabrics in period costume design, IMAX will not allow polyester to pass for silk. Meanwhile, the height of the IMAX image means that it is much more difficult to use conventional movie sets, since the ceiling is always visible in the shot. Therefore, most of the IMAX footage in the *Dark Knight* films was shot on location, which in turn contributes to the impression of 'realness' in the films. For example, one of the things that contributes to this perceived authenticity is that many location shots contain recognisable landmarks: Chicago's elevated train tracks and iconic skyscrapers appear in *The Dark Knight*, while in *The Dark Knight Rises*, where the geography of Gotham is modeled on New York City, the stock exchange sequence was indeed shot on Wall Street.

Of course, part of the difficulty with the notion that IMAX film testifies to the realness of its subject is that many of the IMAX sequences in fact rely on CGI. In both films, the filmmakers used digital processes to, for example, remove stunt performers' wires or repair damage to the negative, while some sequences relied almost entirely on digital animation. For example, in the underground car chase sequence in *The Dark Knight*, the Batmobile is damaged beyond recovery, so Batman deploys the 'Batpod', a motorcycle constituted of Batmobile parts. While there is a 'real' Batpod operated by

a stunt driver in several shots, the images of the Batpod emerging from the Batmobile are entirely CGI, and yet they are presented in IMAX format (Duncan 2008: 80). In Jody Duncan's essay in *Cinefex*, she explains that in order to give it an 'authentic' look that was distinct from the 'digital origami' one expects from digital animation, the filmmakers made a point of having the car appear clunky, heavy and metallic (2008: 81). While of course all effects artists strive for a consistent aesthetic, there is an effort here to make the digital effects conform to the visual standards of IMAX, an emphatically analogue film technology.

Again, the relationships between 35mm and IMAX footage are not entirely consistent throughout the films, and one might read this inconsistency as a counterargument to their expressive potential. However, it is fair to say that the frame variations encourage a form of cinephiliac spectatorship, encouraging the viewer to wonder why a given moment is or is not shown in IMAX. This interpretive speculation not only suggests that seeing the film in IMAX will provide an additional level of engagement with the text, but it also continually reminds the viewer of both the production and exhibition technologies and their unique properties and powers. Not only does the shift in image size announce the profilmic presence of an IMAX film camera, but its presentation in an IMAX facility is also necessarily cinematic, as its physical dimensions are so extreme that they cannot be replicated in any of the other spaces or technologies available to twenty-first-century audiences. This is an important distinction in the era of multiple viewing platforms for, as Christian Keathley explains in *Cinephila and History, or The Wind in the Trees*, home video technologies signaled an end 'of the experiencing of a film as an event' (2006: 21). Once the cinema itself was not the exclusive venue for exhibition and a film could be seen, albeit in a different format, at a later date, the special-event status of film-going diminished in value. The geometry of an IMAX theatre, however, has the potential to resurrect the cinephiliac ritual of film-going as an exclusive and specialised activity, differentiated from the computers, smartphones and other systems now routinely used to consume film content.[11] The emotional, visceral and narrative impact of IMAX is part of an enhanced or privileged access to the text – and this kind of access is heavily coded as a product of celluloid.

The exclusive properties of IMAX formed a significant part of the promotional campaigns for the *Dark Knight* films. For example, the IMAX opening sequence of *The Dark Knight Rises* was exhibited as a special preview before IMAX screenings of *Mission Impossible: Ghost Protocol* (Brad Bird, 2011). Meanwhile, the technological specificity of the experience was highlighted in several publications, such as in a *New York Times* article which states: 'In 2008 the director Christopher Nolan's "Dark Knight", the second in his trilogy of Batman movies, introduced some audiences to a character not before seen in the franchise, or any studio narrative feature until that time. But that character wasn't on the screen. It was the screen' (Murphy 2012). This article goes on to describe many of the technical properties of IMAX cameras and theatres, priming viewers to see the IMAX version of the film as technologically distinct, to the point where the apparatus is an active 'character' in the experience.

Mainstream critical responses to *The Dark Knight* and *The Dark Knight Rises* often address the use of IMAX, emphasising how IMAX exhibition exercises visceral power

over its audience. For example, in Peter Travers' *Rolling Stone* review of *The Dark Knight Rises*, he claims of the IMAX sequences: 'From the opening skyjacking to the blowing up of a football field and a nerve shattering prison break, the film shakes you hard and often' (2012). Meanwhile, other critics mention IMAX only in a cursory manner, if at all. For example, Scott Foundas's review of *The Dark Knight* in the *Village Voice* offers only an oblique reference in a discussion of Heath Ledger's acting performance: 'But even then, Ledger seems to make the film grow larger whenever he's onscreen (no matter if you happen to already be watching it in the giant-screen IMAX format)' (2008). More interesting, however, are the debates among networks of fans, be they of large-format cinema, Nolan's filmography or Batman, whose commentary in online forums offers its own discourse of cinephilia, one that both resonates with Nolan's and extends it into new territory.[12]

For example, users of several online forums discuss the merits of seeing these films in IMAX facilities, and listing the attributes of IMAX-brand theatres – i.e. whether they are digital, MPX or IMAX GT, or in some cases, projected in IMAX Dome.[13] Some users asked for advice about ideal screening conditions, or whether it was worth the additional expense or travel time to see the IMAX version of the film. For example, a user on one Yahoo message board asks: 'Do you think it's worth driving an hour and a half to see it [*The Dark Knight*] because that's how far away the nearest IMAX screen is from my house? I've already seen it on the regular screen but I want to know if the IMAX version is good enough to warrant a trip.'[14] The responses to these enquiries vary, with some denying a substantial difference, but even these dismissals would often yield further questions exploring the distinctions among screening facilities, or what constituted an 'ideal' experience of the film. Others offered encouragement to users who were considering making substantial sacrifices of time and money by noting the lengths they would go in order to see the film in IMAX: 'I would say yes. We went to a midnight showing here at a local drive in. But, we are thinking about going to Dallas to see it at the IMAX theatre there, nearly a 5-hour drive. I think it would be worth it.'[15] Meanwhile, on nolanfans.com, a web forum dedicated to Christopher Nolan, one participant responded to a question about whether it was worth seeing *The Dark Knight Rises* in IMAX, saying: 'And to answer your question, this film should not be viewed in any other way except IMAX or else you are not even really experiencing the film the way it was meant to be.'[16] Another user on the same forum offered this story:

> TDKR was also my first IMAX experience. I loved it and thought the two-hour drive was completely worth it, but it wasn't until I saw the movie again at my local theater that I truly appreciated just how much better IMAX was. Not just the improved visuals and sound, but the midnight experience made it something to remember. There was clapping, cheering, laughing, etc., at just about every moment you'd expect. Much to the contrary, the atmosphere back home was quite boring. Of course the movie itself was just as great, but the experience was a letdown. With midnight showings, you get people who are genuinely interested in the movie. Seeing it again on Friday night, that's when the people come out of the woodwork who just consider going to the movies a

social event (quite literally, people were talking the entire time, with very little to no reactions toward the movie) and have no true appreciation for the film they're watching it seems. So, in short, this only enhanced my thoughts of that first IMAX experience.[18]

This narrative, with its mention of a lengthy journey, the enthusiastic behaviour one might expect at a midnight screening, and the negative comparisons with both aesthetic and social experiences in a conventional theatre, all add the additional layer of cinephilia – that of taking pleasure in the exhibition context and its social nature – to the larger discourse around these films. In many respects, the brand of cinephilia cultivated in the *Dark Knight* films recalls what Thomas Elsaesser calls 'cinephilia take one', which 'valued the film almost as much for the effort it took to catch it on its first release or its single showing at a retrospective, as for the spiritual revelation, the sheer aesthetic pleasure or somatic engagement it promised at such a screening' (2005: 38). Elsaesser is referring to forms of cinephilia that emerged from the culture of art house and festival cinemas, but this experience also resonates with the contemporary viewer who conducts research on the technological amenities of specialised theatres and travels great distances to attend them. Not only do these cinephiles relish the attributes of the text and its psychological and sensory impact, but, in a contemporary twist on the cinephiliac ritual, compare this exclusive experience with other iterations of the text, from conventional screenings to the subsequent DVD, Blu-ray and other digital incarnations. Of course, not all viewers share this impression, as some testify to not noticing a difference between IMAX and conventional footage, but it is significant that the IMAX-specificity of *The Dark Knight* and *The Dark Knight Rises* aroused this particular kind of debate.[18]

Cinephilia is as changing as the branching and mutating medium it holds as its object of desire. Nolan cultivates a discourse of cinephilia around his work by using film technologies that are necessarily theatrical, and whose visual and geometric distinctions from conventional formats not only remind audiences of the apparatus as a 'character' in the drama of film-going. Further, this attention to the apparatus invites the viewer to make interpretive speculations, wondering how and why the film presents a given object, action or event using a specific technology. Nolan and cinephile communities alike enlist notions of nostalgia, of technological specificity and of spectatorship as social and cultural ritual to invest the IMAX versions of the *Dark Knight* films with special status, both by connecting these films to larger histories of film production and reception, and suggesting novel ways of using IMAX in dramatic narrative.

*Notes*

1    Wally Pfister, Audio Commentary, *The Dark Knight – Special Features*, directed by Christopher Nolan (Warner Bros., 2008), Blu-ray.
2    For a succinct discussion of the historical shifts within cinephilia as a discourse, see James Morrison (2012) 'After the Revolution: On the Fate of Cinephilia', in Scott Balcerzak and Jason Sperb (eds) *Cinephilia in the Age of Digital Reproduc-*

*tion: Film, Pleasure and Digital Culture, Vol. 2.* London and New York: Wallflower Press, 11–27. Also useful is Jenna Ng (2010) 'The Myth of Total Cinephilia', *Cinema Journal*, 49, 2, 146–51.

3 Examples of online cinephilia culture include blogs such as 'Davekehr.com: Reports from the Lost Continent of Cinephilia' at http://www.davekehr.com, and 'Project: New Cinephilia', which is affiliated with the Edinburgh International Film Festival, at http://projectcinephilia.mubi.com. There are also innumerable blogs, web forums and other online discourses organised about particular film-makers, historical periods, issues in film collecting, projection technologies and other topics related to cinephilia.

4 A seminal text in the discourse on the cinema's impending 'death' is Susan Sontag (1996), 'The Decay of Cinema', *New York Times Magazine*, February 25, 60–1. While this essay was written before the widespread transition to digital filmmaking and exhibition systems, it does note how the proliferation of screens in everyday life de-centres the cinema as the space of spectatorship, and mourns the loss of a variety of cinephilia that depended on the exclusivity of the cinema as a space of communal viewing.

5 Thanks to Bryan Munson for sharing his insights on Nolan's practice of avoiding digital intermediate.

6 In February 2003, IMAX Corporation announced the development of MPX, a modified version of their projection system that is small enough to fit into a traditional 35mm booth. MPX made it feasible for exhibitors to convert pre-existing cinemas into IMAX facilities, usually by combining two or more multiplex auditoria. MPX theatres, which bear the same brand identification as traditional IMAX theatres have more conventional screen shapes and less intricate sound systems. Audience reaction to this process has been, in some cases, negative and vocal. Indeed, audience members who are unimpressed with this 'mini' version of IMAX have gone so far as to establish websites differentiating 'real' IMAX from MPX, and now digital facilities.

7 For example, the Smithsonian Institution's National Air and Space Museum in Washington D.C. has actively participated in the production of films about aviation and space exploration, while the Canadian Museum of Civilization has had a similar role in producing documentaries about world civilisations. Alison Griffiths (2008) offers a detailed discussion of IMAX and museums, particularly Smithsonian facilities, in her book *Shivers Down Your Spine: Cinema, Museums, and the Immersive View.* New York: Columbia University Press.

8 Indeed, much of the sensory impact of traditional IMAX cinematography comes from the way the image engages peripheral vision, for while the audience might not get a clear impression of the material at the top and bottom of the image, its presence has a powerful effect on one's feeling of orientation in space, which allows IMAX films to create strong illusions of movement, feelings of vertigo and other physiological responses.

9 There are, however, instances in both films where they used CGI to enhance crowd scenes.

10 Extensive discussion of special effects and visual effects processes can be found in the Blu-ray special features for both *The Dark Knight* and *The Dark Knight Rises*.

11 Warner Bros. also issued a mobile app for *The Dark Knight*, allowing the user to view the film on their mobile device, while also promising an enhanced experience of the film, including production narratives and trivia games, among other features. For an analysis of the app, see Caetlin Benson-Allott (2011).

12 For discussions of cinephilia in online communities, see Melis Behil (2005) and Girish Shambu, Zach Campbell *et al.* (2009).

13 IMAX Dome, also known as OMNIMAX, uses IMAX film projected into a Dome screen. These facilities are almost exclusively housed in museums and science centres, and while relatively few of them are used for exhibition of DMR films, it does happen on occasion.

14 kfw9257, 'For those of you who saw The Dark Knight on an Imax screen?' July 2008, *Yahoo answers*, http://answers.yahoo.com/question/index?qid=200807242 15746AAVP59I.

15 SunnyD, comment on 'For those of you who saw The Dark Knight on an Imax screen?' July 2008, *Yahoo answers*, http://answers.yahoo.com/question/index?qid= 20080724215746AAVP59I.

16 BatMan528491, comment on *nolanfans.com*, July 26, 2012 (2:40 am), http://www.nolanfans.com/forums/viewtopic.php?f=33&t=11220.

17 Hustler, comment on *nolanfans.com*, July 26, 2012 (3:06 am), http://www.nolan-fans.com/forums/viewtopic.php?f=33&t=11220.

18 I should note that while I am taking people's accounts of whether they do or do not notice a distinction in exhibition formats at face value, I am mindful of the fallacy that if an audience member does not consciously notice some formal element of a film, then it somehow does not matter, or that it fails to have an impact on their experience.

*Bibliography*

Behil, Melis (2005) 'Ravenous Cinephiles: Cinephilia, Internet, and Online Film Communities', in Marijke de Valck and Malte Hagener (eds) *Cinephilia: Movies, Love and Memory*. Amsterdam: Amsterdam University Press, 111–23.

Benson-Allott, Caetlin (2011) 'Cinema's New Appendages', *Film Quarterly*, 64, 4, 10–11.

Blair, Iain (2012) 'IMAX Made *Dark Knight*'s Smith Think Big', *Variety*, 5 December. Online. Available: http://variety.com/2012/digital/news/imax-proved-big-challenge-for-dark-knight-1118063033/ (accessed 21 February 2015).

Bordwell, David with Kristin Thompson (2013) *Christopher Nolan: A Labyrinth of Linkages*. Madison, WS: Irvington Way Institute Press.

Duncan, Jody (2008) 'Batman Grounded,' *Cinefex*, 115, 63–88.

Elsaesser, Thomas (2005) 'Cinephilia, Or the Uses of Disenchantment', in Marijke de Valck and Malte Hagener (eds) *Cinephilia: Movies, Love and Memory*. Amsterdam: Amsterdam University Press, 27–43.

Foundas, Scott (2008) 'Heath Ledger Peers Into The Abyss in The Dark Knight', *Village Voice*, 16 July. Online. Available: http://www.villagevoice.com/2008-07-16/film/heath-ledger-dark-knight/ (accessed 21 February 2015).

Griffiths, Alison (2008) *Shivers Down Your Spine: Cinema, Museums, and the Immersive View*. New York: Columbia University Press.

Jolin, Dan (2010) 'We Should Be Doing it the Hard Way', *Empire*, July, 98–101.

Keathley, Christian (2006) *Cinephilia and History, or The Wind in the Trees*. Bloomington, IN: Indiana University Press.

McCarthy, Todd (2012) 'The Dark Knight Rises', *Hollywood Reporter*, no date. Online. Available: http://www.hollywoodreporter.com/movie/dark-knight-rises-0/review/349354 (accessed 21 February 2015).

McDonald, Paul (2010) 'IMAX: The Hollywood Experience', in John Belton, Sheldon Hall and Steve Neale (eds) *Widescreen Worldwide*. New Barnet: John Libbey Publishing, 41–57.

Morrison, James (2012) 'After the Revolution: On the Fate of Cinephilia', in Scott Balcerzak and Jason Sperb (eds) *Cinephilia in the Age of Digital Reproduction: Film, Pleasure and Digital Culture Vol. 2*. London: Wallflower, 11-27.

Murphy, Mekado (2012) 'The Imax Difference, Blockbuster Size', *New York Times*, 13 July. Online. Available: http://www.nytimes.com/2012/07/15/movies/how-the-dark-knight-rises-makes-use-of-imax.html (accessed 21 February 2015).

Ng, Jenna (2010) 'The Myth of Total Cinephilia', *Cinema Journal*, 49, 2, 146–51.

Ressner, Jeffrey (2012) 'The Traditionalist', *Director's Guild of America Quarterly*. Online. Available: http://www.dga.org/Craft/DGAQ/All-Articles/1202-Spring-2012/DGA-Interview-Christopher-Nolan.aspx (accessed 8 July 2014).

Shambu, Girish, Zach Campbell *et al.* (2009) 'The Digital Cine-Club: Letters on Blogging, Cinephilia and the Internet', in Scott Balcerzak and Jason Sperb (eds) *Cinephilia in the Age of Digital Reproduction: Film, Pleasure and Digital Culture, Vol. 1*. London and New York: Wallflower Press, 54–67.

Sontag, Susan (1996) 'The Decay of Cinema', *The New York Times Magazine*, 25 February, 60-61.

Travers, Peter (2012) 'Film Review: *The Dark Knight Rises*', *Rolling Stone*, 16 July. Online. Available: http://www.rollingstone.com/movies/reviews/the-dark-knight-rises-20120716 (accessed 21 February 2015).

# Nolan's Immersive Allegories of Filmmaking in Inception and The Prestige

## Jonathan R. Olson

'When film is not a document, it is dream. [...] Méliès was always there without having to think about it. He was a magician by profession.'

Ingmar Bergman (1994: 73)

'These dreams can be run through a projector, thrown onto a screen.'

Christopher Nolan (2013)

Christopher Nolan's frequently expressed aspiration to provide the most immersive experience for audiences of his films drives three hallmarks of his filmmaking practice: his commitment to film and resistance to digital photography and exhibition; his dedication to filming practical effects in-camera; and his increasing use of the IMAX format in opposition to 3D technologies. Even Nolan's famous uses of non-chronological narrative structures are designed to enhance the audience's experience of a character's point of view. In both their material format and methods of storytelling, Nolan's films support the audience's immersion in narrative rather than disrupt suspension of disbelief. To this end, Nolan is scrupulous in his films to avoid explicit references to cinema, lest such metacinematic images draw the audience's attention to the experience of viewing the present film and compromise the sense of immersion. When his films explore and comment on aspects of narrative cinema, therefore, they do so not directly but through metaphor, conceit and allegory. Nolan's most deliberate examinations of narrative cinema, *The Prestige* (2006) and *Inception* (2010), revisit many of the elements of his earliest films and remodel them into extended conceits – mechanical illusions, confidence schemes and shared dreams – bordering on allegories of cinema in general and of Nolan's personal practice of filmmaking in particular.

Throughout his career Nolan has championed film as superior to digital technologies in both photography and exhibition. For many years Nolan's support for film

consisted of defending the format in interviews and resisting studio pressure to switch to digital photography on his own productions (see Ressner 2012).[1] In the first weeks of 2014, Nolan was in post-production on *Interstellar* (2014) for Paramount when the studio quietly informed exhibitors that it would no longer distribute motion pictures on film, and Nolan entered a new phase of advocacy whose full extent would not become public for months (see Verrier 2014). His July opinion-editorial in the *Wall Street Journal*, arguing that theatrical exhibitors of film would innovate in the face of digital content delivery, was a harbinger of new heights of influence that Nolan would exert in Hollywood in the rest of the year. By the end of the month, trade news outlets reported that Nolan and other directors had successfully lobbied five major studios to commit to purchasing film stock from Kodak, thus preventing the expected closure of the last production plant of Hollywood's only remaining supplier of motion picture film (see Fritz 2014; Giardina 2014; Swart and Giardina 2014). The pinnacle of Nolan's ability to leverage the clout accrued by his last three films earning $2.9 billion became public in October when Paramount and Warner Bros., the domestic and international distributors of his new picture, announced they would release *Interstellar* on film prints two days early in US and Canadian cinemas able to exhibit 35mm or 70mm film (see McClintock 2014a; Yamato 2014). Therefore Nolan had compelled Paramount to give precedence to a format they had disavowed and punish the exhibitors who had accepted the studios' promotion of digital distribution, had converted to digital-only projection, and were now financially unable to accommodate exceptions (McClintock 2014b). Despite small cinema chains' complaints of mixed messages from studios, Nolan's campaign to revive film projection was effective not only in rewarding cinemas that had not discarded the older technology, but also in motivating others to reinstall film projectors, however temporarily, and hire technicians with the skill to operate them: ultimately film prints of *Interstellar* were struck for exhibition on 240 screens (see Lussier 2014; McNary and Lang 2014).

For Nolan, the virtue of film is its ability to give audiences an immersive experience. Unlike nostalgic defences of the medium offered by enthusiasts such as Quentin Tarantino, who not only professes a subjective attachment to film but has also derived an aesthetic from the physical damage sustained by used film prints, Nolan's arguments for film consistently focus on its technical capacity for superior quality in comparison to digital: 'I am not committed to film out of nostalgia. I am in favor of any kind of technical innovation but it needs to exceed what has gone before and so far nothing has exceeded anything that's come before' (Hammond 2014).[2] Since 2007 Nolan has also become notorious for his counter-intuitive but well observed objections to 3D exhibition formats as less immersive than conventional projection, and his championing of IMAX film as the most immersive of any format.[3] Indeed, 'immersive' is a favourite term of Nolan's that has run through his interviews and those of his long-time cinematographer, Wally Pfister, for many years.[4] Nolan's rationale for shooting all of his movies on film and much of *The Dark Knight* (2008), *The Dark Knight Rises* (2012) and *Interstellar* with IMAX cameras is that film still offers a higher resolution image than digital formats, that IMAX has the highest resolution of any format and that IMAX exhibition provides the most immersive audience experience. In support

of *Interstellar*'s release in multiple formats, its website sought to educate cinemagoers on the relative quality of each form of exhibition; it even provided a hierarchy of formats arranged vertically, descending from 'IMAX 70mm Film', '70mm Film' and '35mm Film', to 'IMAX [Digital]', '4K Digital' and lastly '[2K] Digital' (Anon. 2014). Nolan collaborated with the studio on phrasing the individual format descriptions, which laud the 'clear, high resolution images' of 35mm without disparaging the film's digital presentations, while calling IMAX 'the world's most immersive movie experience' (Anon. 2014; see also McNary and Lang 2014).

Given Nolan's preoccupation with film, his oeuvre is conspicuous insofar as it contains no depictions of particular films or cinematic culture in general. Indeed, Nolan's pursuit of an immersive audience experience precludes metacinematic images; he has been careful not to include in his films direct references to or images of the cinema, lest they threaten the audience's immersion by making them self-conscious of their experience. In *Batman Begins* (2005), Nolan and David S. Goyer even changed a longstanding element of the character's origin story in order to avoid depicting a film within their film: they had the Wayne family attend an opera instead of *The Mark of Zorro*. Describing how the film would have become a metacinematic image if depicted in *Batman Begins*, Nolan explains: 'We didn't have young Bruce going to see *Zorro* because a character in a movie watching a movie is very different than a character in a comic book watching a movie. [...] It creates a deconstructionist thing that we were trying to avoid' (Boucher 2008). Nolan's dedication to immersion and consequent eschewal of explicitly metacinematic images therefore necessitate that his films comment on cinema indirectly, through references to other forms of narrative. Writing looms large in five of Nolan's films: in *Following* (1998), the Young Man (Jeremy Theobold) claims to be an aspiring writer but fails to realise that the boxes Cobb (Alex Haw) shows him are fictions devised to entice him; in *Memento* (2000), Leonard Shelby (Guy Pearce) asks his wife (Jorja Fox) why she's re-reading a novel, remarking that 'I always thought the pleasure in a book is not knowing what happens next', and he writes notes for himself on paper and his own body; in *Insomnia* (2002), the victim's killer is identified through his novels and, anticipating his police interview, he says 'I can write that easily'; in *The Prestige*, Alfred Borden (Christian Bale) and Robert Angier (Hugh Jackman) read each others' journals, only to discover they are not private records but narratives written for the other's eyes. Nolan's films feature other forms of storytelling: still photography (*Memento*), opera (*Batman Begins*), stage magic (*The Prestige*) and several forms of video. Tellingly, every depiction of video within Nolan's films is of a non-fiction genre that reinforces immersion: television advertisements (*Memento*), terrorist execution videos (*The Dark Knight*), an array of screens that convert 'wiretapped' sonar to live video (*The Dark Knight*), news programmes (*The Dark Knight* and *The Dark Knight Rises*), documentary interviews and personal video messages (*Interstellar*). None of the videos in Nolan's films are cinematic or even fictional forms; even the television advertisement used in *Memento* is not a dramatic sketch or vignette, but the famous Southern California car salesman Cal Worthington personally delivering his sales pitch and 'Go See Cal' jingle to the TV viewer. Amidst *Memento*'s reverse chronology, Leonard's comment about 'not knowing what happens

next' is Nolan's most self-conscious joke; since then his films have avoided winking at the audience so overtly and found more covert ways to comment on film.

The 'tesseract' sequence in *Interstellar* is the latest of a series of metaphorical images of cinema that Nolan has offered in his films. Sometime after Amelia Brand (Anne Hathaway) speculates that fifth-dimensional beings might access the past and future as easily as descending a valley or climbing a mountain, Cooper (Matthew McConaughey) finds himself in a construct comprised of an endless series of three-dimensional snapshots of his daughter's bedroom at every moment in time. By floating up or down, left or right, Cooper can traverse time at will like a fifth-dimensional being. This Borgesian library of four dimensions represented in three corresponds closely to Nolan's description of how a reel of film physically represents time: 'Film's relationship with dimensionality has always fascinated me: two-dimensional representations of three dimensions printed onto a strip whose length adds the dimension of time. Time is strikingly represented by the rapidly unspooling rolls of celluloid on a projector' (Nolan 2014b).[5] Before the tesseract, Nolan utilised other metaphors for film in *Inception* and *The Prestige*. The former explores film editing, the importance of audience immersion and Nolan's particular narratological strategies in more depth than any of his other films. But to do so without compromising the audience's own immersion in the film, it adopts two famed analogues of cinema: the confidence scheme and dreams.

## Con-Artist as Filmmaker, Filmmaker as Con-Artist

Of all Nolan's films, *Inception* contains the most obvious analogies to filmmaking. It adopts the standard theatrical analogies of the con-artist film and embellishes them into an allegory of a film production crew. It also uses the premise of shared dreaming to reveal similarities between the subjective experiences of dreams and of narrative cinema. The film's conceit of multiple dream levels then enables a diegetic replication of Nolan's signature narrative devices, especially as deployed in *The Prestige*. By exploring the nature of narrative cinema indirectly through con-artists who operate in dreams, *Inception* is able to support the audience's immersion in the narrative and not disrupt their suspension of disbelief.

Critics have almost uniformly identified *Inception* with the heist genre, and Nolan himself has repeatedly stated that he based the screenplay on the structure of heist pictures. Consistent with the genre, the marketing of *Inception* announced the film as a story about the theft of ideas from dreams: the teaser and both trailers used the tagline 'the mind is the scene of the crime' and the first trailer featured a voiceover of Leonardo DiCaprio – not from the film but written for the trailer – introducing the premise that an idea is 'the most resilient parasite' and concluding with the declaration, 'that's why I have to steal it'. The second trailer rearranged dialogue from the film to mislead the audience about the meaning of the film's title: a shot of Ariadne (Ellen Page) saying 'then you break in and steal it' and Cobb (Leonardo DiCaprio) shrugging, 'well, it's not, strictly speaking, legal', is followed by a voiceover of DiCaprio declaring that 'it's called inception'. Initially, the film itself seems to confirm its participation in the heist

genre: the opening thirteen-minute sequence, though set within a dream, nonetheless depicts an attempted theft gone wrong, a conventional way for a heist film to introduce the expertise of its characters and set up the expectation of a successful theft by story's end. Twenty minutes into the film, however, Saito (Ken Watanabe) reveals that 'inception' means planting an idea instead of stealing one – the opposite of a heist. The film here exposes that the marketing campaign and the opening sequence itself were misdirections designed to preserve the surprise of the title's meaning and the premise of the rest of the film. This revelation of deception is the means by which the film announces that its subject is a special practice of deception.

Rather than a heist or other form of theft, the concept of inception is a form of confidence scheme – one so comprehensive and permanent in effect that, if the scheme is successful, its victims never discover they have been conned. With the film's focus on its characters' fabrication of fictional scenarios into which they draw their victim, *Inception* hews much closer to the tradition of con-artist films than heist films. In the twenty-first century, Hollywood has frequently synthesised the two genres: in the latter half of 2001, Frank Oz's *The Score*, David Mamet's *Heist* and, most influentially, Steven Soderbergh's *Ocean's Eleven* each incorporated elements of confidence schemes into their heists – making their heist's success dependent on misdirection, deception and acting – and standardised the fusion of these otherwise relatively distinct genres.[6] As we have seen, Nolan's consistent comparison of *Inception* to heist movies was an aspect of the misinformation campaign before the film's release – but on a few occasions Nolan has described *Inception* in terms of the con-artist film. Each time, Nolan's description has reflected the twenty-first-century synthesis of the heist and con-artist genres: 'as soon as you want to present the subtle art of conning somebody, of fooling somebody, then you enter the world of the heist movie' (2010: 10). Nolan implies that the two genres share a common narrative structure when he states that 'I wanted to use the heist-film or the con-film structure' (Taubin 2010: 32). In the twentieth century, con-artist films remained more distinct from heist films, which lacked the metatheatrical elements of the former. By virtue of their emphasis on characters' performances, whether in a small-time hustle or as a fictional persona in a 'long con', all con-artist films necessarily comment on their theatricality. Rian Johnson explores this facet of the genre explicitly in *The Brothers Bloom* (2008), whose con-artists treat their schemes as a form of storytelling; indeed, the primary motivation for one of them to 'write' cons is to give his brother dramatic characters to play.

A perennial convention of con-artist films is the possibility of actors playing characters who are acting. Diegetic characters may be performing 'hypodiegetic' characters at any point in the con-scheme, or indeed the film. These second-degree performances are not necessarily signaled to the viewer; the third act of con-artist films conventionally withhold certain details of the scheme in order for the audience to share the credulous victim's experience of being conned. Part of the scheme that *The Sting* (George Roy Hill, 1973) withholds until the final scene is that one of the characters is hypodiegetic: FBI Agent Polk (Dana Elcar) is 'played' by a con-artist character otherwise unknown to the audience; when the protagonist seems to betray his partner to Polk, a first viewer is disadvantaged to a similar degree as their mark Snyder (Charles Durning) and led

to believe along with him that it is a genuine betrayal. This metatheatrical quality of con-artist films is most acute in a subgenre that Yannis Tzioumakis labels the 'con game' film, which adopts the perspective of the mark rather than the con-artists (2009: 108–11). Nolan's first feature, *Following*, belongs decisively to this subgenre, joining Brian De Palma's *Obsession* (1976), David Mamet's *House of Games* (1987) and *The Spanish Prisoner* (1997), and David Fincher's *The Game* (1997). Later con-game films, such as Fabian Bielinksky's *Nine Queens* (2000), Gregory Jacob's remake *Criminal* (2004) and Ridley Scott's *Matchstick Men* (2003) use experienced con-artists as their protagonists to divert suspicion from them being the victims of con-schemes.

*House of Games*, *The Spanish Prisoner* and *The Game* offer multiple clues that signal to the audience that the protagonists are being conned, while *Nine Queens*, *Matchstick Men* and *Criminal* feature con-schemes so extensive that the performances of the con-artist characters collapse into the performances of the actors, effecting a virtual correlation between the film and the con. At the end of *Matchstick Men*, the audience discovers along with Roy Waller (Nicolas Cage) that his previously unknown-to-him fourteen-year-old daughter, with whom he has been developing a relationship, is a twenty-year-old hustler. The film hides the 'fact' that the character is in her twenties by exploiting the audience's bargain with the film to suspend their disbelief in the 23-year-old actor Alison Lohman playing a much younger character. Applying a similar strategy to all but one of their characters, *Nine Queens* and *Criminal* would hardly be acted, shot or edited differently if their narratives were 'real' and their protagonists not being conned. In the final scene of *Nine Queens*, every major and minor character seen in the film appears together, revealed to have been part of a day-long con-scheme that began in the first shot of the film. Its remake, *Criminal*, reserves this *dénouement* for the final credits, and as a paratextual scene its narrative status is uncertain. The characters' celebration appears indistinguishable from what documentary footage of the cast's wrap party would be, and raises the question of whether the shot belongs to the same non-fictional genre as the outtakes that sometimes appear during credits scrolls. By revealing in their conclusions that every character but one was 'acting', these films betray the pretense of narrative cinema that characters are not actors, and suggest that all fiction films are confidence schemes designed to draw the audience into a plausible world, and everyone in them is actually performing.

With the actors' performances aligning so closely with their characters' performances, con-game films clarify the metatheatrical nature of all con-artist films. Though Tzioumakis does not cite it, the progenitor of the con-game film is *Vertigo* (1958), which relates its con-scheme from the perspective of the victim. Hitchcock's film is notorious for its metacinematic commentary on directing: Elster's (Tom Helmore) implied direction of Judy's (Kim Novak) role as Madeleine to seduce Scottie (James Stewart) is so effective that it is usurped by Scottie's obsessive direction of Judy to reprise the Madeleine role in his remake of the original scenario. With its adherence to the point of view of the conspiracy's victim, *Vertigo* also established the participation of nearly all con-game films in the *film noir* mode. Of Nolan's films, *Following* is the most influenced by *Vertigo*: the Young Man (Jeremy Theobald) believes the contents of the boxes he finds when he breaks into homes with Cobb (Alex Haw) are genuine

expressions of the residents' private selves, without realising Cobb has arranged them solely for Bill's own spectatorship in order to frame him. In his next film, *Memento*, Nolan combined the functions of con-artist and victim into a single character, but used the device of converging reverse- and forward-chronologies to align the audience's perspective solely with Leonard's role as the unwitting mark. Nolan returned to the genre in *Inception* but shifted perspective from the victim's to the con-artists' points of view as they plan and execute their scheme. The role of Cobb in *Inception* parallels that of Cobb in *Following* not because they are thieves – *Following*'s Cobb only pretends to be a burglar in order to seduce the Young Man – but because both create fictions into which they invite their subjects to participate.

Despite its narration from the con-artists' points of view, Nolan confirms *Inception*'s ancestry with a direct allusion to *Vertigo*: in the second dream level, Ellen Page's Ariadne wears a grey suit and hairstyle in the manner of Kim Novak's Madeleine.[7] Like Hitchcock, Nolan comments on filmmaking without explicit references to cinema: *Inception* adopts *Vertigo*'s analogy of the relationship between director and actor then goes further, establishing correspondences between all of its con-artist characters and the different roles or departments involved in filmmaking. In an interview published at the time of the film's release, Nolan told Amy Taubin:

> I think there are a lot of connections between what Leo is engaged in – what his character is capable of doing and how he puts the team of people together to do it – and the process of making a large-scale Hollywood film. There are a lot of striking similarities. When for instance the team is out on the street they've created, surveying it, that's really identical to what we do on tech scouts before we shoot. [...] In writing about a process that interested me, it naturally became analogous to my process. (2010: 33–4)

Echoing this thought, Nolan told *Entertainment Weekly* that 'in trying to write a team-based creative process, I wrote the one I know [...] It's rare that you can identify yourself so clearly in a film' (Jensen and Vary 2010). Accordingly, Leonard DiCaprio said he based his interpretation of Cobb on Nolan; even the actor's hairstyle and goatee mimicked the director's. The interviewers paraphrase Nolan's self-consciousness about the filmmaking analogy during the writing process: 'As he finished the *Inception* script in 2009, Nolan realized his fantastical notions about "shared dreaming" ... were also forming an elaborate metaphor ... for moviemaking and moviegoing, and for Nolan's own artistic life' (ibid.). They assign the following metaphorical roles to the characters: 'DiCaprio's squad of dream thieves is analogous to a filmmaking operation, complete with director (DiCaprio), producer (Gordon-Levitt), production designer (Page), actor (Hardy), and financier (Watanabe)' (ibid.). Some of these correspondences have been easier to identify than others, and those that have been interpreted inconsistently reveal much about Nolan's view of cinema.

While impersonating other people might be thought to be something anyone could do in a dream, in *Inception* only Tom Hardy's Eames has the expertise to do so; in the most theatrical allusion of the film, Eames even sits in front of an actor's vanity mirror

as he prepares to impersonate Browning (Tom Beringer), though there is no need for him to apply make-up in the dream. Along with Eames' function as an actor, Cobb's, Saito's and Arthur's (Joseph Gordon-Levitt) roles of director, financier and producer – not to mention Fischer's (Cillian Murphy) correspondence to the audience – are rarely mistaken by professional and amateur critics. However, recognition of the filmmaking counterparts of the Architect, Ariadne and the Chemist, Yusuf (Dileep Rao), has been more elusive. Despite many associations of Ariadne with production design, such as building scale models of the dreamworlds, some have identified her with the screenwriter (see Faraci 2010; Johnson 2012). It is understandable why the screenwriter could be regarded as the 'architect' of a film, but it does not accord with the initiative that Cobb and Eames take in choosing the three complementary ideas to plant in the three dream levels, a series that tells a story like the three acts of a magic trick or a screenplay. In *Inception*, screenwriting is collaborative and the discussions between Eames and Cobb reflect the widely reported influence of DiCaprio on shaping his character in conversation with Nolan, on the basis of which Nolan revised the screenplay. David Kyle Johnson identifies Yusuf as 'the special effects expert', a common but misleading interpretation of the character who designs the compound that puts the team to sleep (2012: 351). The best clue to Yusuf's counterpart in the production process of a film is his moniker as the Chemist, whose trade was exposited indirectly by Nolan himself years later. At the AMPAS's Scientific and Technical Awards show on 15 February 2014, Nolan presented a special Academy Award of Merit 'to all those who built and operated laboratories, for over a century of service to the motion picture industry'. Nolan's speech began:

> There are alchemists who for over a hundred years in various windowless rooms, basements, what have you, all across the world, have practiced a very special form of alchemy, that is, turning silver and plastic into dreams. And not just any kind of dreams, but the kind of dream that you can unspool from a reel, and hold in your hand, hold up to the light, and see, frozen, magically. And these dreams can be run through a projector, thrown onto a screen, where they will spark the imagination and emotion of audiences as they have all across the world for so long, for so many generations of filmmakers. (Nolan 2013)

For Nolan, the most important 'special effect' in a film is the cinematographic illusion itself, effected by the combination of filmstrip with a projector. The Chemist's counterpart is a film lab technician whose 'alchemy' makes it possible for an audience to share a collective dream. Nolan's description of filmstrip as a dream that can be shared encapsulates the premise of *Inception*.

*Film as Dream*

Following a long tradition in filmmaking and film theory of drawing analogies between dreams and cinema (see Rascaroli 2002), many of Nolan's films have associated memories with both dreams and cinema. In his films, flashbacks are virtually never unmo-

tivated. Whether brief glimpses of past events or lengthy sequences, Nolan uniformly depicts them subjectively as memories in the mind of a particular character. Nolan adopted this approach from Terrence Malick after seeing *The Thin Red Line* (1998), deployed it in *Memento*, and has never strayed from the style since (see Mottram 2002: 121–2). Like Leonard in *Memento* and Bruce Wayne (Christian Bale) in *Batman Begins*, Cobb deals with his past by retelling his memories to another person, which manifest visually in the film as flashbacks. These flashbacks become more extensive as he relates them to Ariadne until he seems to have told the whole truth. But Cobb's memories are not depicted only as conventional flashbacks illustrating a history he relates verbally to another character; Cobb also relives his own memories as dreams. Nolan had most directly conflated memories with dreams and cinema in the second scene of *Batman Begins*, when the adult Bruce Wayne is startled awake by a childhood memory he has been experiencing as a dream. Bruce's dream of a memory has been experienced by the audience as the first scene of the film, until this moment of contextualisation reinterprets the narrative's beginning as a cinematic flashback device. This triple association of memory with dream, and of both with cinema, is a hallmark of Nolan's filmmaking. Improving on *Following*'s device of crosscutting between three main periods of time, *The Prestige* uses characters reading journals to enact their entrance into the memories of the writer – effecting a shared memory – and these memories are revealed finally to be fictions. Once the relationship between the three time periods is clear, and we can return from the earliest time period to the middle period by Angier closing Borden's journal (18:04), and within ten seconds return from the middle time period to the later period by Borden looking away from Angier's journal (18:14), Nolan can now crosscut at will, bypassing Angier's journal and returning directly to the earliest time period through Borden's own memory (18:24). The Fischer con-scheme in *Inception* replicates the nested structure of *The Prestige* with metaleptic 'sends' and 'kicks' functioning comparably to Borden and Angier opening and closing each other's journals. The conceit of nested dreams thus enables *Inception* to foreground within a chronological narrative the methods of non-chronological storytelling Nolan employed in *Following* and *The Prestige*. One of the innovations of *Inception*'s dreams-within-dreams structure, unlike *The Prestige*'s memories-within-memories, is that it permits metaleptic transgression of characters across narrative levels, yet accomplishes this without metaficion's typical disruption of the suspension of disbelief.[8]

One of the most direct comparisons *Inception* draws between dreams and films is its treatment of immersion and the suspension of disbelief. In her training dream, immediately after Ariadne rearranges Paris to be much less realistic, three passersby look directly into the advancing camera, seeming to break the fourth wall. As the camera pivots like a turning head, we hear Ariadne ask in voiceover, 'Why are they all looking at me?' thus clarifying the shot as her point of view. Cobb explains: 'Because my subconscious feels that someone else is creating this world.' Breaking the fourth wall is a classic metacinematic device virtually synonymous with drawing the audience's attention to the artifice of the film, and in both this scene and the hotel bar scene during the Fischer job, Nolan accordingly portrays threats to immersion in the dream with shots of 'extras' looking directly into the camera. But Nolan preserves

the audience's suspension of disbelief by disguising these fiction-puncturing gazes as point-of-view shots.

In the same training dream, Cobb asks Ariadne, 'You never really remember the beginning of a dream, do you? You always wind up right in the middle of what's going on.' This experience is best exemplified in *Memento*, by Leonard's thought process expressed in voiceover at the beginning of a scene: 'Okay, so what am I doing? Oh, I'm chasing this guy. No, he's chasing me.' Comparably, several of the dreams in *Inception* begin with point-of-view shots of mundane objects – the pavement, a face, elevator buttons – glimpsed in the middle of what's going on. Every scene in any film begins in the middle of what's going on, but cinemagoers are conditioned by the conventions of narrative filmmaking to orientate themselves within the scene and not worry about the gap between the preceding scene and the present one. Indeed, narrative cinema depends on illusions of continuity on multiple levels. During any film, viewers mentally bridge the gaps between frames, between shots and between scenes. Within a shot, the optical illusion of motion is achieved by the projection of still images at 24 frames per second. Between shots, the appearance of continuous action is achieved by matching shots of the same subject taken from different angles, even at different times. Continuity of narrative is achieved across a scene by the Kuleshov Effect of ordering shots of different subjects, and across a film by ordering scenes depicting different times or locations, into a narrative sequence. The optical illusion depends on the mind not registering the gaps between each frame, while the illusion of continuous action across camera angles depends on viewers' familiarity with and acceptance of the conventional grammar of narrative cinema. But a film's continuity of narrative depends on the audience's voluntary suspension of disbelief, their willingness not to question changes of time and location from scene to scene. As in a dream, a film's change of scene does not prompt viewers to doubt the integrity of the narrative; rather, film viewers mentally bridge the gap in the narrative by, for example, assuming the character's transportation to the new location. The necessity of bridging the gaps between discontinuous frames, shots and scenes is represented in *The Prestige* by Borden's red ball and Angier's silk hat, which the magicians use in their 'Transported Man' illusions to imply continuity between the Borden twins and between Angier and his double.

Apparent gaps in continuity have become the basis of many interpretations of the status of *Inception*'s 'real world' on close readings of particular scenes, for example: Did Eames visibly pick Fischer's pocket on the plane? Did Eames produce poker chips from thin air? Why don't we see Cobb enter his father-in-law's lecture theatre? By similar standards, virtually all movies would fail a 'reality test' due to the discontinuities that inevitably arise in a narrative film that is assembled from more than one shot or tells a story in more than one location. The conclusion to be drawn from these discontinuities is not that the world presented as real in *Inception* is a dream, but that all films contain dreamlike discontinuities. The evidences often cited that *Inception*'s real world is a dream are conventions of cinema and genre. The tight space that Cobb squeezes through is a motif of the cinema not only of dreams. Saito coming to Cobb's rescue seemingly out of nowhere, another commonly cited evidence that the film's

real world is a dream, would be regarded as conventional in any other Hollywood action film. It would hardly draw notice in *Inception* if it did not occur immediately after the dreamlike shot of Cobb struggling through the alley. Saito's last-minute rescue is not so much evidence that the scene is a dream but evidence that it is a movie and therefore a shared dream. In the guise of Cobb calling Ariadne's attention to inconsistencies in dreams, Nolan invites the audience to register the kinds of discontinuities in his film that are routinely passed over by any audience that suspends disbelief in cinematic narrative. The story depicted in *Inception* is a dream because it is a film; all films, not just *Inception*, are dreams. Nolan insisted that the cut to black be imposed 'from the outside of the film' as 'the appropriate kick' (Jensen 2010). Even if Cobb is not in someone else's dream at the end of the film and the top will fall over 'after' the cut, from the audience's perspective the scene must cut to black while the top is still spinning because the audience is experiencing someone else's dream, a dream shared by the filmmaker.

*Film as the Prestige*

*The Prestige* shares *Inception*'s interest in the willing suspension of disbelief but instead of utilising the conceit of a con-scheme or dream, it emphasises the ability of a mechanically-based illusion to affect an audience emotionally. A close reading of the opening and closing sequence of the film will illuminate one of the several tricks that are the subject of *The Prestige*. Fading in behind the white-on-black title card, the first shot dollies past dozens of silk hats strewn across fallen branches in a glade, accompanied by a question asked in voiceover, 'Are you watching closely?' The film will later reveal that the anonymous voice belongs to the magician Alfred Borden and the phrase is a quotation of a later scene but now, removed from its diegetic context, this voice seems to address the audience directly. The question challenges us, or misdirects us, to pay attention to the shot and the film, as if we are about to witness a sleight of hand. It warns us to expect a trick and challenges us to solve it as it begins. Due to their conventional use as a prop in the hat trick, silk hats are synecdochical icons of both stage magic and the magicians who wear them – thus with this first image the film announces its subject of stage magic and alludes to the objects of the film's 'Transported Man' tricks, not rabbits but magicians. The multiplicity of these particular hats and their apparently remote location are both answers to a specific mystery presented in the second act. In the parlance of the film, these hats are 'the prestige' of an experimental magic trick – and here they are explicitly labeled as such. The title card originates as white text fading in on a black screen; a moment later the shot of hats fades in from black while the title remains across the fade, superimposed over the hats and becoming a label for them. Indeed, this appearance of the title at the start of a film is now uncharacteristic of Nolan; title cards appear at the beginning of his first three features, but Nolan's fourth film, *Batman Begins*, established a new practice of not showing the title or any other production or acting credits until the final credits. Before *The Dark Knight*, *Inception* and *The Dark Knight Rises* entrenched this practice, however, Nolan reverted to using an opening title in *The Prestige* as a clue to the cinematic magic trick set up in

the film's first shot. The title card therefore doubles as a name for the film and for the items in the shot.

The film's identification of itself as a magic trick occurs more explicitly in the second shot of the film. An unidentified character (played by Michael Caine) opens a cage in an aviary containing many canaries – like the silk hats, their multiplicity is a clue. A second disembodied voice, known to belong to the character on screen only because the audience's prior familiarity with the actor enables them to connect the face to the voice, states that 'Every magic trick consists of three parts, or acts'. This interpretation of the parts of a trick as three 'acts' aligns 'every magic trick' with the conventional three-act structure of Hollywood screenplays. Caine's subsequent description of these acts, which he terms 'the pledge', 'the turn' and 'the prestige', implies that *The Prestige* shares the structure of a magic trick. While Nolan's change of the novel's term, 'stages', to 'acts' draws a connection between the magic trick and Hollywood storytelling, his further replacement of the novel's 'set up' and 'performance' with 'pledge' and 'turn' distance the film's terms from theatrical connotations (see Priest 2004: 64). Cutter presents a canary to a girl while his voiceover explains the pledge: 'The magician shows you something ordinary: a deck of cards, a bird.' But when the voice adds 'or a man', the film cuts to a man sitting in an audience (Borden), then cuts to a magician (Angier) on stage, arms raised in a cruciform pose, presenting himself as if a sacrificial offering to the audience. The film then cuts to a wide shot of the curtain rising behind the magician to reveal an electrical apparatus, and the magician's gesture cues the audience's applause. The film thus identifies four parallel objects as a pledge: the bird, Borden, Angier and the apparatus. When Cutter says 'he shows you this object', we see him showing the canary to the girl, and when he adds 'perhaps he asks you to inspect it, to see it is indeed real', we see Angier inviting members of the audience on stage, his assistant choosing Borden among others, and Borden inspecting the apparatus. When Cutter says, 'but of course, it probably isn't', the film immediately cuts to Borden backstage, accosted by a stagehand who removes Borden's disguise, thus realigning the 'object' with Borden himself. When Cutter's voice announces that 'the second act is called the turn', we see Angier turn his back to the audience, returning him to the focus of the sequence as he enters the apparatus and draws arcs of electricity from it. The focus on Angier is reinforced when Cutter declares that 'the third act' is 'the part we call the prestige', and the film cuts to a close up of Angier drowning in a water tank. Angier's death in the tank is the behind-the-scenes reality of the turn of the bird trick. Cutter does not show the crushed bird to the girl, and we do not see the deadly basis of the bird trick until later, first when a crying boy claims the bird's brother is dead, then when we see Borden disposing of it behind the scenes. Comparably, the prestige of the bird trick is the behind-the-scene reality of Angier's death, to be revealed in the third act of the film. The parallel between the bird and another pledge of this sequence, Borden, appears to comprise the film's primary mystery. One of Nolan's major revisions of Christopher Priest's novel is the attempt to keep Borden's twin a secret until the final sequence. Despite several clues that function simultaneously as misdirections – most effectively in the form of Cutter insisting that Borden must have a double to perform his trick, which seems intended merely to lend credibility to Angier's conviction that such an explanation is too simple – the appearance of Borden's twin after his

hanging is treated as a revelation. The fourth pledge of the opening sequence, the apparatus that the magician 'asks you to inspect', appears to recede as a trick in the film. The audience's progression of understanding of the mechanism coincides with Tesla's (David Bowie)and Angier's own discovery of its unexpected method of operation.

Cutter's explanation of the magic trick is followed immediately by a scene shift to a courtroom trial. The prosecutor repeats the last words of Cutter's speech and the scene appears to follow continuously from it, contextualising the occasion of Cutter's explanation: his testimony as a witness in Borden's murder trial. The most conventional use of voiceover is as retrospective commentary on or narration of the images being shown, with the voiceover from a later if not the latest period in a film's chronology. The courtroom context of Cutter's voiceover seems to fulfill this expectation and appears to identify a diegetic audience for Cutter's explanation that otherwise might have existed only for the benefit of the film's audience. But the film's final sequence reveals that Cutter's bird trick occurs not before but much later than the trial, and is in fact the latest period in the chronology. In the opening montage, therefore, Nolan seems to have inverted the usual temporal relationship of the image occurring earlier than the voiceover. However, the vocal tone of the rest of Cutter's court testimony – speaking loudly and combatively from a raised witness box – does not match the hushed, confidential tone of the preceding voiceover. In fact, the occasion of this speech is never clarified in the rest of the film, leaving its audience unspecified after all.

The reprise of Cutter's explanation of the magic trick in the final sequence casts further doubt on the origin and purpose of that very explanation. Cutter's voice repeats the same speech as began the film: 'Every magic trick consists of three parts, or acts. The first part is called the pledge; the magician shows you something ordinary.' But this truncated version omits the rest of the description of the pledge and skips right to the next part of the speech: 'The second act is called the turn; the magician takes the ordinary something, and makes it into something extraordinary.' This is the first hint that we are not hearing precisely the same thing we heard at the beginning of the film – there, one word was different: 'and makes it *do* something extraordinary.' Now the two speeches diverge in structure. In the first, Cutter had claimed:

> Now you're looking for the secret. But you won't find it. Because, of course, you're not really looking. You don't really want to know. You want to be fooled. But you wouldn't clap yet. Because making something disappear isn't enough. You have to bring it back. That's why every magic trick has a third act – the hardest part – the part we call the prestige.

But at the end of the film, Cutter follows the description of the turn immediately with a sufficient summary of the prestige: 'But you wouldn't clap yet. Because making something disappear isn't enough. You have to bring it back.' At these words the second Borden twin arrives at the aviary and reunites with his daughter who has been entertained by Cutter's bird trick. But here, after the prestige of the fifth shot of the film that had pledged Borden as 'a man' in a trick, Cutter's speech picks up with the passage that formerly preceded his description of the prestige. It is not merely a reor-

dering of the parts of the speech; though the words are the same, it is a different vocal performance altogether. Cutter even places stress on different words than the original sequence (original stresses italicised; closing stresses underlined): 'Now *you're* looking for the secret. But you won't *find* it. Because, of course, you're *not really* looking.' Then the speeches diverge in phrase, with 'you don't really want to know' replaced by 'you don't really want to work it out'. The last words of the film, finally, are 'you want to be fooled'. Whereas at the film's outset, Cutter warns us we will half-heartedly claim to look for the secret but really want to be fooled in anticipation of the prestige, Cutter now asserts that even after the trick is complete we still want to be fooled. The last line's accompanying image of one of the Angier corpses floating in a water tank is not a revelation; the method of 'The Real Transported Man' has been clear for all of the third act and was confirmed by the appearance of Lord Caldlow. So what does Cutter mean by saying, in direct address to the film's audience, that even after seeing the three-act magic trick, the film, we continue to want to be fooled?

By now the Tesla apparatus has fallen from view as one of the objects pledged at the beginning of the film. With the white flash that accompanies its duplication of anything presented before it, it is essentially a photographic machine. The first time Angier tests the machine, he kills the duplicate that it produces; but thereafter, in each of his performances, Angier allows himself – 'the man who goes into the box' – to drown, so his life continues only in the new image of himself. Every audience that views a performance requires yet another duplication of his image. Even the show's limited run of a hundred performances requires the extraordinary act of Angier duplicating an image of the previous image of himself a hundred times. Comparably, the exhibition of *The Prestige* to multiple audiences is dependent on the repeated duplication of an image several generations removed from the original performance. Apart from a few show prints struck directly from the original camera negative, the release prints exhibited in cinemas are positive image copies of the 'duplicate negative', which are copies of the interpositive, which are the first-generation copies of the original camera negative, which are the photographic image of the performance. The Tesla apparatus is a camera and the prestige is *The Prestige*. The duplicating technology of photography also makes possible the duplication of Christian Bale as twins and of Hugh Jackman as Angier and Root, but images of both characters in the same shot are merely single-frame metaphors for any film image of any actor. We 'want to be fooled' insofar as we willingly suspend disbelief in the mechanical illusion of cinema. In both *The Prestige* and *Inception*, Nolan claims that the most significant illusions in films are not the deceptions practiced by the characters within the narrative, but by the cinematic illusion itself. In order to maintain that very illusion, Nolan can only make this claim through other kinds of illusionists: magicians, con-artists and dreamers.

*Notes*

1    Nolan claimed: 'For the last ten years, I've felt increasing pressure to stop shooting film and start shooting video, but I've never understood why. It's cheaper to work on film, it's far better looking... . I think, truthfully, it boils down to the

economic interest of manufacturers and [a production] industry that makes more money through change rather than through maintaining the status quo' (Ressner 2012).

2   In their respective contributions to the double-feature *Grindhouse* (2007), Tarantino and Robert Rodriquez artificially replicated various forms of damage to film prints including 'the splice-cut … the film-burn … the missing reel' that Rodriguez says 'help accent the film dramatically', comparing them to traditional editing techniques like 'the fade, the cross-fade, or jump-cut' (Rea 2007). For defences of film's technical superiority to digital, see Wally Pfister's comments in Heuring (2008, 2010) and (Anon. 2012), and Nolan's and Pfister's comments in Stasukevich (2012).

3   Nolan argues that 3D 'shrinks' the size of the screen and favours an 'individual perspective' (Ressner 2012), and that the dimness of 3D projection at 13 instead of 16 foot-lamberts is 'extremely alienating' (Boucher 2010).

4   On a featurette titled 'Gotham Uncovered: Creation of a Scene' contained on the Blu-ray edition of *The Dark Knight*, Nolan says that IMAX 'creates an extraordinarily immersive image [that] throws the audience right into the action in a way no other film format could'. Elsewhere he recollects: 'I've always been fascinated by large-format photography's immersive quality … and I'd never seen a fiction film or a Hollywood movie that employed that degree of immersion on the visual side' (Heuring 2008); echoing Nolan, Pfister says that 'IMAX is our version of immersive cinema' (Anon. 2012) and 'we strongly believe IMAX is the most immersive format' (Stasukevich 2012); more recently, Nolan told cinema owners, 'Really what we are attempting is to give audiences a better experience, an immersive experience' (Hammond 2014).

5   Nolan paraphrases the same thought elsewhere in his guest-edited issue of *Wired*: 'A photograph represents three dimensions in two. And then a strip of film adds time. That's how you take time and you represent it physically: a reel of film running through a projector' (Nolan 2014a).

6   Brian De Palma's *Mission: Impossible* (1996) and its sequels feature heist sequences among their set pieces, but the IMF team and their schemes still have more in common with con-artists.

7   This alignment if not identification of Ariadne with *Vertigo*'s Madeleine may be one of the strongest suggestions that Cobb himself is the subject of inception in the film.

8   In articles over several years Norman Holland has discussed the tendency of meta-film to disrupt the suspension of disbelief (see 2003, 2007 and 2008). Miklós Kiss observes that *Inception* '"diegetises" the narrative idea of permeable embedded narrative levels' (2012: 37).

*Bibliography*

Anon. (2012) '*The Dark Knight Rises* in Immersive IMAX', *InCamera*, 6 August. Online. Available: http://motion.kodak.com/motion/Publications/InCamera/

Sections/Large_Format/The_Dark_Knight_Rises_in_Immersive_IMAX.htm (accessed 18 February 2015).

____ (2014) 'Ways to See *Interstellar*', Online. Available: https://interstellar.withgoogle.com/ways-to-see (accessed 10 January 2015).

Bergman, Ingmar (1994) *The Magic Lantern: An Autobiography*, trans. Joan Tate. New York: Penguin.

Boucher, Geoffrey (2008) 'Christopher Nolan says his Batman Doesn't Play Well With Others', *Hero Complex*, 29 October 2008. Online. Available: http://herocomplex.latimes.com/uncategorized/christopher-n-2/ (accessed 10 January 2015).

____ (2010) 'Christopher Nolan's Dim View of a Hollywood Craze: "I'm not a huge fan of 3-D"', *Hero Complex*, 13 June. Online. Available: http://herocomplex.latimes.com/uncategorized/christopher-nolan-inception-3d-dark-knight-hollywood/ (accessed 18 February 2015).

Faraci, Devin (2010) 'Never Wake Up: The Meaning and Secret of *Inception*', *CHUD*, 19 July. Online. Available: http://www.chud.com/24477/never-wake-up-the-meaning-and-secret-of-inception/ (accessed 10 January 2015).

Fritz, Ben (2014) 'Movie Film, at Death's Door, Gets a Reprieve', *Wall Street Journal*, 29 July. Online. Available: http://www.wsj.com/articles/kodak-movie-film-at-deaths-door-gets-a-reprieve-1406674752 (accessed 18 February 2015).

Giardina, Carolyn (2014) 'Christopher Nolan, J. J. Abrams Win Studio Bailout Plan to Save Kodak Film', *The Hollywood Reporter*, 30 July. Online. Available: http://www.hollywoodreporter.com/behind-screen/christopher-nolan-jj-abrams-win-722363 (accessed 18 February 2015).

Hammond, Pete (2014) 'CinemaCon: Christopher Nolan Warns Theatre Owners: How "Interstellar" Is Presented Will Be More Important Than Any Film He's Done Before', *AwardsLine*, 26 March. Online. Available: http://deadline.com/2014/03/cinemacon-christopher-nolan-warns-theatre-owners-how-interstellar-is-presented-will-be-more-important-than-any-film-hes-done-before-704897/ (accessed 18 February 2015).

Heuring, David (2008) 'Batman Looms Larger', *American Cinematographer*, July. Online. Available: http://www.theasc.com/ac_magazine/July2008/TheDarkKnight/page1.php (accessed 10 January 2015).

____ (2010) 'Dream Thieves', *American Cinematographer*, July. Online. Available: http://www.theasc.com/ac_magazine/July2010/Inception/page1.php (accessed 10 January 2015).

Holland, Norman N. (2003) 'The Willing Suspension of Disbelief: A Neuro-Psychoanalytic View', *PSYART*, 7. Online. Available: http://www.psyartjournal.com/article/show/n_holland-the_willing_suspension_of_disbelief_a_ne (accessed 10 January 2015).

____ (2007) 'The Neuroscience of Metafilm', *Projections*, 1, 1, 59–74.

____ (2008) 'Spider-Man? Sure! The Neuroscience of Suspending Disbelief', *Interdisciplinary Science Review*, 33, 4, 312–20.

Jensen, Jeff (2010) 'Christopher Nolan on His "Last" Batman Movie, an "Inception" Video Game, and That Spinning Top', *Entertainment Weekly*, 30 November.

Online. Available: http://www.ew.com/article/2010/11/30/christopher-nolan-batman-inception (accessed 10 January 2015).

Jensen, Jeff and Adam B. Vary (2010) '"Inception": Dream a Little Dream', *Entertainment Weekly*, 23 July. Online. Available: http://www.ew.com/ew/article/0,,20404183_2,00.html (accessed 10 January 2015).

Johnson, David Kyle (2012) (ed.) *Inception and Philosophy: Because it's Never Just a Dream*. Malden, MA: Blackwell.

Kiss, Miklós (2012) 'Narrative Metalepsis as Diegetic Concept in Christopher Nolan's *Inception* [2010]', *Acta Univ. Sapientiae, Film and Media Studies*, 5, 35–54.

Lussier, Germain (2014) 'Exclusive: TCL Chinese Theater IMAX to Install 70mm Projector For Christopher Nolan's "Interstellar"', *Slashfilm*, 25 September. Online. Available: http://www.slashfilm.com/tcl-chinese-interstellar-imax-70mm/ (accessed 10 January 2015).

McNary, Dave and Brent Lang (2014) 'Christopher Nolan's "Interstellar" Launching Early in Imax', *Variety*, 1 October. Online. Available: http://variety.com/2014/film/news/christopher-nolans-interstellar-imax-nov-5-1201318411/ (accessed 10 January 2015).

McClintock, Pamela (2014a) 'How Christopher Nolan's Crusade to Save Film Is Working', *The Hollywood Reporter*, 1 October. Online. Available: http://www.hollywoodreporter.com/news/how-christopher-nolans-crusade-save-737191 (accessed 10 January 2015).

_____ (2014b) 'Why Theater Owners Aren't Happy About Christopher Nolan's "Interstellar" Film Initiative', *The Hollywood Reporter*, 2 October. Online. Available: http://www.hollywoodreporter.com/news/why-theater-owners-arent-happy-737661 (accessed 10 January 2015).

Mottram, James (2002) *The Making of Memento*. London: Faber and Faber.

Nolan, Christopher (2010) *Inception: The Shooting Script*. San Rafael, CA: Insight Editions, 2010), pp. 7–19 (p. 10);

_____ (2013) 'Sci-Tech Awards: Christopher Nolan', *The YouTube Page of The Academy of Motion Pictures Arts and Sciences*, 18 February. Online. Available: https://www.youtube.com/watch?v=gTuPudlCc7M (accessed 10 January 2015).

_____ (2014a) 'Space. Time. Dimension.', *Wired*, 17 November. Online. Available: http://www.wired.com/2014/11/christopher-nolan-wired-editor/ (accessed 10 January 2015).

_____ (2014b) 'The Metaphysics of Interstellar: A Conversation with Kip Thorne and Christopher Nolan', *Wired*, 17 November. Online. Available: http://www.wired.com/2014/11/metaphysics-of-interstellar/ (accessed 10 January 2015).

Priest, Christopher (2004) *The Prestige*, third edition. London: Gollancz.

Rascaroli, Laura (2002) 'Like a Dream: A Critical History of the Oneiric Metaphor in Film Theory', *Kinema*. Online. Available: http://www.kinema.uwaterloo.ca/article.php?id=141 (accessed 10 January 2015).

Rea, Steven (2007) '"Grindhouse:" "Amped-up and crazed"', *The Inquirer*, 1 April. Online. Available: http://articles.philly.com/2007–04–01/entertainment/24993287_1_grindhouse-projection-booth-exploitation (accessed 10 January 2015).

Ressner, Jeffrey (2012) 'The Traditionalist'. Online. Available at: http://www.dga.org/Craft/DGAQ/All-Articles/1202-Spring-2012/DGA-Interview-Christopher-Nolan.aspx (accessed 10 January 2015).

Stasukevich, Iain (2012) 'Batman to the Max', *American Cinematographer*. Online. Available: http://www.theasc.com/ac_magazine/August2012/DarkKnightRises/page1.php (accessed 10 January 2015).

Swart, Sharon and Carolyn Giardina (2014) 'Film Fighters, All in One Frame: J. J. Abrams, Judd Apatow, Bennett Miller, Christopher Nolan and Edgar Wright', *The Hollywood Reporter*, 17 December. Online. Available: http://www.hollywoodreporter.com/news/film-fighters-all-one-frame-758431 (accessed 10 January 2015).

Taubin, Amy (2010) 'DreamWork', *Film Comment*, 46, 4, 30–5.

Tzioumakis, Yannis (2009) *The Spanish Prisoner*. Edinburgh: Edinburgh University Press.

Verrier, Richard (2014) 'End of Film: Paramount First Studio to Stop Distributing Film Prints', *Los Angeles Times*, 17 January. Online. Available: http://articles.latimes.com/2014/jan/17/entertainment/la-et-ct-paramount-digital-20140117 (accessed 10 January 2015).

Yamato, Jen (2014) 'Christopher Nolan's 'Interstellar' To Open Two Days Early In 35mm, 70mm', *Deadline Hollywood*, 1 October. Online. Available: http://deadline.com/2014/10/interstellar-open-early-film-projection-35mm-70mm-844162/ (accessed 10 January 2015).

CHAPTER FOUR

# Saints, Sinners and Terrorists: The Women of Christopher Nolan's Gotham

## Tosha Taylor

Christopher Nolan's choice to work within the genre of the superhero film seems, perhaps, a strange one. The action-packed genre is a far cry from his previous well-known films, the narratively challenging *Memento* (2000) and the psychologically atmospheric *Insomnia* (2002). Indeed, with the genre's typical focus on action rather than characterisation or narrative style, the superhero film may seem well out of Nolan's scope. In a 2012 interview with Scott Foundas in *Film Comment*, Nolan explains his desire to tackle one of American pop culture's most mythic figures: 'I got excited about the idea of filling in this interesting gap – no one had ever told the origin story of Batman.' His take on the superhero film has been popularly described as *hyperrealistic*, grounding characters and plots in natural, rather than supernatural, phenomena: 'tonally', he tells Foundas, 'I was looking for an interpretation of that character that presented an extraordinary figure in an ordinary world' (2012). With the *Dark Knight* trilogy, Nolan integrates pre-existing material from the comics into his own directorial and writing style, combining urban gothic panoramas and brutal action with the character-driven story not of Batman but of Bruce Wayne (Christian Bale).

While Nolan has received praise for his interpretation of the trilogy's many male characters, little has been said of its women. It is arguably through his women that Nolan demonstrates some of his most innovative techniques in adapting a pop culture legend and imbuing it with his own distinct directorial voice. This essay will, therefore, explore Nolan's presentation of women with a particular concern for how it may both conform to and subvert the prescribed feminine role within the superhero film. Attention will be paid to psychoanalytical and both foundational and contemporary feminist film criticism regarding conventional depictions of women in genre film. I will also draw from arguments put forth by Laura Mulvey's seminal essay, 'Visual Pleasure and Narrative Cinema' (1975). Though it is now met with some criticism for its perceived generalisations and assumed male spectatorship, the essay's core analysis should not be overlooked by contemporary feminist film studies. Pam Cook argues for the continued

acknowledgement of the feminist film theory of the 1970s for its 'undeniable legacy' (1993: xi) to contemporary feminist analysis. Moreover, since Mulvey's essay is primarily concerned with genres of Hollywood film which are, despite twenty-first-century changing demographics, still primarily targeted at male audiences, it remains useful for discussions of the superhero film. This essay will ultimately take into account Nolan's roles as story creator, co-screenwriter and director of the trilogy, examining his narrative and visual choices in his presentation of female characters.

The *Dark Knight* trilogy features three principle women. The first of these, Rachel Dawes – portrayed by Katie Holmes in *Batman Begins* (2005) and Maggie Gyllenhaal in *The Dark Knight* (2008) – is Bruce's first love, a childhood friend who shares his commitment to establishing justice in Gotham City but not his methods, working as an assistant district attorney rather than a caped crusader. *The Dark Knight Rises* (2012) introduces Selina Kyle (Anne Hathaway) – the anti-heroine Catwoman (though the film does not use her comics moniker) – and Miranda Tate (Marion Cotillard), who is revealed in the film's final act to be Talia al Ghul, daughter of villain Ra's al Ghul (Liam Neeson). While all three serve as love interests for Bruce, they occupy entirely different places on a spectrum of traditional representations of women in Hollywood – the saint, the sinner and the psychopath.

### The Saint

Rachel is the trilogy's embodiment of feminine virtue, an incorruptible figure in Gotham's frighteningly corrupt criminal justice system. Interestingly, she is the only major character in the trilogy who is not based the source material. As such, she is an ambivalent figure. She exists, but only in Nolan's version of the DC Comics universe; unlike Selina and Miranda/Talia, she occupies a brief pop cultural space limited to a single auteur. She is a clear inspiration for Batman's actions, but Bruce ultimately wishes to cease those actions in order to forge a romantic relationship with her. She fights on the side of justice, but disapproves of Batman's methods. She accepts her death bravely, deviating from traditional images of the woman who cowers in terror, but her death appears to serve little purpose other than to spur on Bruce and, respectively, Harvey Dent (Aaron Eckhart) in their opposing paths. Despite her ambivalence, she remains what Yvonne Tasker defines as the '"good" woman', who, in stark contrast to Selina and Miranda/Talia , 'possesses nurturing qualities [which] are evident in her behaviour towards the hero' (1998: 121). Her motives in her sometimes-platonic relationship with Bruce never appear dubious. Her admonishments against his vigilantism are heartfelt but gentle; she becomes a stand-in for the Good Mother he lost in Martha Wayne.

Yet in a surprising departure from convention, Rachel does *not* choose Bruce as her romantic partner prior to her death. Her final spoken words of comfort are meant for Harvey, not Bruce, and she has previously composed a letter informing Bruce of her decision to remain with Harvey. Her letter marks Nolan's narrative and visual subversion of the typical tropes of the superhero film. Mulvey notes the encouraged identification between the spectator and the male hero. Citing Alfred Hitchcock as a prominent example, she finds that the 'male hero does see what the audience sees'

(1975: 13). Here, however, the audience sees far more than the hero can. Alfred's (Michael Caine) initiative in burning the letter allows Bruce to continue in his illusion of a lost but faithful lover. The audience is privileged with knowledge that the hero does *not* have: as Bruce languishes for Rachel, the spectator knows that Rachel has chosen Bruce's romantic rival over him.

Judith Butler notes an unequivocal but dialectical exchange of *meaning* between the male figure and his female partner, in which the 'process of meaning-constitution requires that women reflect that masculine power and everywhere reassure that power of the reality of its illusory autonomy' (1990: 57–8). For Bruce, Rachel continues to reflect his beliefs about his own power even after her death; her photograph, placed alongside that of his parents in the abandoned wing of Wayne Manor, preserves her as an unchanging ideal. She can provide no further comment on Bruce's actions, can neither condemn nor alleviate his psychological decline, can question him no further. The romantic relationship he believed was guaranteed can never be ended. His *idea* of Rachel, his concept of the woman he loves as she exists in his memory, will never be contradicted by her reality. For Bruce, Rachel remains a static guarantor of masculine power. In his aim to present Bruce as an outsider, however, Nolan empowers the spectator in a way that is atypical of the genre. Through Rachel's (feminine) voice and Alfred's (masculine) actions, we know that Bruce is wrong.

Rachel's death in *The Dark Knight* introduces a common trope of concern for contemporary feminist critics – violence, often fatal, against women for the purpose of inspiring the male lead's actions.[1] With Rachel's emphasised virtue within a corrupt system and her clear affection for Bruce, it perhaps seems inevitable that she will die; after all, good people do not last long in Gotham, as Harvey Dent's transformation emphasises. The death of a woman, however, often fulfils a separate narrative function than the death of a man, and Nolan's depiction of it does not appear to stray very far from convention. What is notable about it is the narrative's implicit indictment of Batman's androcentric chivalry. The Joker (Heath Ledger), having seen that Batman is willing to risk the safety of all the guests at Bruce Wayne's fundraiser in favour of saving Rachel and thus confirming their romantic connection, provides Batman with faulty information regarding his captives' whereabouts. Batman rushes to the damsel in distress only to find Harvey; the police arrive too late to save Rachel. The Joker thus makes a mockery of Batman's more paternalistic impulses.

That Rachel is objectified through passive use twice by the Joker – in other words, made into bait for the male hero and rendered incapable of defending herself without his aid – recalls early feminist concerns about representations of women in film. To explicate the typical role of women in the Hollywood film, Mulvey cites a passage from Budd Boetticher that remains useful for current film analysis: 'What counts is what the heroine provokes, or rather what she represents. She is the one, or rather the love or fear she inspires in the hero, or else the concern he feels for her, who makes him act the way he does. In herself the woman has not the slightest importance' (1975: 11). Rachel's death would seem to emphasise her function not as an active agent in the narrative but a generic female figure designed only to affect Bruce and thus creates a contradiction. Both films in which she appears see her acting in her own role in

the justice system; the first half of *The Dark Knight* even places her, not Harvey, at Lau's (Chin Han) interrogation. But unlike Commissioner Loeb (Colin McFarlane) and Harvey, Rachel receives no honours for her work. In her death and the events leading up to it, she is relegated to the role Boetticher describes. Rachel continues this passive non-existence into the first half of the trilogy's final film, serving as Bruce's inspiration when he once again takes up the bat mantle until Alfred reveals the truth of her letter. Miranda uncovers Rachel's picture and reminds Bruce of her loss just before she seduces him, manipulating this vulnerable spot in his psyche to ensure her upcoming betrayal carries the full emotional impact. Rachel passes from living woman to haunting spectre.

Is Nolan, then, following Hollywood convention to a fault? Or do the Joker's and Miranda's respective uses of her actually undermine the convention, drawing attention to its falsehood? The possibility of ambiguity becomes more apparent through the trilogy's other women, who serve as Rachel's opposites.

*Femmes Fatales: The Sinner and the Psychopath*

Batman stories have traditionally mixed the flamboyance of the American superhero with elements of *film noir*, featuring urban gothic landscapes, crime-ridden back streets and gritty, anti-heroic detectives. Not coincidentally, then, Bruce Wayne – in both his public persona and masked alter ego – often finds himself working alongside or against the quintessential female figure of *noir*, the beautiful yet dangerous *femme fatale*. In the comics universe, Bruce is perpetually surrounded by *femmes fatales*; they are as much a part of his immediate world as classic villains like the Joker. However, Nolan does not introduce this archetypal figure until the third instalment of the trilogy, which features two such women, Selina Kyle and Miranda Tate.

Mary Ann Doane defines the *femme fatale* as a 'figure of a certain discursive unease, a potential epistemological trauma [whose] most striking characteristic, perhaps, is the fact that she never really is what she seems to be; [she] transform[s] the threat of the woman into a secret, something which must be aggressively revealed, unmasked, discovered' (1991: 1). Selina's role as *femme fatale* is evident from the film's beginning, when she, disguised as a timid maid, reveals herself to be a cat burglar who steals both Martha Wayne's pearl necklace (an iconic object) and Bruce's fingerprints. Miranda, however, is presented far more innocuously as a clean energy advocate who has financially backed Wayne Enterprises' abandoned nuclear project and in whose stewardship Bruce leaves the company. It is only in the film's final act that her true identity becomes known: stabbing Batman in one of his suit's vulnerable spots, she identifies herself as Talia, the daughter of Ra's al Ghul and the legendary 'child of the pit' Batman believes to be his nemesis.

The *femme fatale* must also serve as a potential romantic partner for the male hero. Both women of *The Dark Knight Rises* become Bruce's love interests. His initial confrontations with Selina are fraught with the promise of romantic tension even as she criticises his capitalistic ignorance of Gotham's oppressed class. Sex with Miranda occurs, with little prelude, halfway through the film. The film's conclusion establishes

that after faking his own death, Bruce has absconded to Europe with Selina. The spectator does not see the development of either relationship; the narrative does not seek to answer any questions regarding the women's experiences of Bruce. Rather, the evolution of both relationships from disdain to sexual interest seems a natural end. No character questions it, nor is the spectator encouraged to do so.

Perhaps we should not, however, look for too much motivation within the *femme fatale*. Richard Dyer describes the woman of *noir* as 'above all else unknowable' (1978: 92). Unknowability certainly characterises the two principle women of *The Dark Knight Rises*. Selina's public persona changes to match her situation: she presents herself as a shy servant to gain access to Wayne Manor, then later as a terrified witness to flee a crime scene. Bruce, believing he knows her motivation, follows her to Bane's (Tom Hardy) lair, only to find that she is participating in a planned trap. Later, when he returns to Gotham, he entrusts Selina with opening a tunnel through which people may escape, but cannot be certain she will fulfil his request. Miranda/Talia becomes equally unknowable and unpredictable once her true identity is revealed, for not only has Bruce not known her motives, he has not known the person. Even his knowledge of the child of the pit does not equip him with an understanding of Talia. Her identity reveals an entirely new history: no longer is the legendary child a boy amongst violent men but a young woman who has seen her mother raped and killed and is protected from the same fate by Bane, whose help she rewards with rescue and leadership of the League of Shadows. Any power that Bruce may have had in his role as the male hero vanishes, and he realises he is at the mercy of a woman he has never known.

It is nonetheless Bruce's belief in a predictable knowledge of women that endangers him. Both Selina and Miranda tease Bruce about his lack of trust in them shortly before betraying him. 'If you want to save the world, you have to start trusting it,' Miranda advises as she encourages Bruce to give his company to her, thus granting her full power over all financial assets and Wayne Tower itself. Selina chides, 'Don't you trust me?' as she leads Batman through the sewers to Bane's trap. The women's betrayal may simply correspond to the inherent treachery of the *femme fatale*, but it may also point to Bruce's own assumptions about the opposite sex. Unerring belief in the virtuous woman, initially inspired by his own mother, causes Bruce to believe the *femmes fatales* mean him no harm. Similarly, Commissioner Gordon (Gary Oldman) misses his chance to apprehend the person controlling the bomb as the film's script makes an implication that becomes significant later. Gordon warns Foley, 'There's only one man with his finger on the trigger – Bane.' Seconds later, having overheard their conversation, Miranda volunteers for Gordon's search party: 'I hear you're looking for men, Commissioner. How about me instead?' Though Gordon cannot possibly know the true meaning of Miranda's suggestion, she does offer him the answer he seeks, secure in the knowledge that her role as a seemingly innocent woman places her above suspicion.

Nolan extends the unknowability of the *femme fatale* to the idea of privileged seeing that occurs in *Batman Begins*. With this film, the spectator is given information the male hero is not, and that information frequently pertains to the *femmes fatales*. Limited only to news coverage on a small television in the prison, Bruce is unable

to see the full destruction of Gotham, while a change in perspective relates it to the spectator in great detail. Selina continues to develop as an active character, but Bruce is incapable of witnessing or participating in this development. In Miranda's case, the viewer shares Bruce's lack of knowledge until the very end of the film, indeed, to such an extent that her reveal as the film's true villain risks losing some of its dramatic impact. Nonetheless, the viewer is permitted a glimpse of Miranda that suggests she is not what she seems. As Batman returns to rescue her, a brief shot reveals Miranda in City Hall waiting calmly rather than fearfully, already wearing the costume that marks her transformation into Talia. In this moment, as in the case of Rachel's letter, the astute observer is privileged with information Bruce does not have that might have altered his course of action. A wide shot of City Hall's interior as he enters it provides confirmation of Miranda's transformation. The spectator sees her new costume in its entirety, while Bruce, single-mindedly focused on his only perceived enemy, verbally acknowledges her presence but overlooks her revealed identity. When she stabs him minutes later, he is rendered powerless by both pain and shock, while the spectator's trust in her has already been compromised.

Nolan artfully suggests an inability to truly know the *femme fatale* through the use of masks. Masks are frequently a vital element to superhero stories. But where male characters in Nolan's trilogy use masks – and in the Joker's case, make-up – to signify their identities, women deploy masks as a means of subversion. The female mask of Nolan's trilogy constitutes a component of glamour. Glamour is uniquely feminine in film, creating, according to Annette Kuhn, 'a sense of deceptive fascination, of groomed beauty, of charm enhanced by means of illusion' (1985: 12). Onscreen, the glamorous woman wields power over the viewer through appealing to spectatorial desire.

With both Selina and Miranda/Talia relying on disguises to achieve their disruptive goals, it is no coincidence that Bruce is confronted by both at a masquerade gala. As Gotham's wealthiest citizens feast and dance at the party, Selina and, respectively, Miranda present themselves to Bruce wearing masks. Glamour hides their truth: they are imposters, Selina a burglar and implied prostitute (as she has sometimes been in the comics), Miranda a product of abject poverty and violent cultish ideology. Their masks grant them power that their true social positions do not. We may here consider glamour in both definitions, that which connotes beauty and that which constitutes artifice. On the physical level, corresponding to glamour in the first sense, the masks heighten the aesthetic appeal of the women's gala costumes. These masks do not actually conceal their identities as Selina Kyle and Miranda Tate/Talia al Ghul, but they *do* create a metatextual suggestion of secrecy, even deception. The masked woman poses a threat to the male hero: as Joan Riviere writes, 'the trouble with masquerade is man's trouble', with the mask serving as the object 'behind which man suspects some hidden danger' (1929: 313). Expounding upon Riviere's text, Stephen Heath describes Nietzsche's anxiety over the feminine in terms that are well-suited to the male hero when confronted with the masked woman: '[He] is fascinated and threatened, seduced and mocked: woman is the vanishing point for which he lacks any true perspective, since the perspective *he* has guarantees he cannot know *her*, while the impossibility of knowing her is itself *his* perspective' (1986: 51). In separate conversations, Selina

and Miranda confront Bruce with his lack of perspective, suggested, in psychoanalytic terms, by the masks they wear. Both women make criticisms of Bruce's wealthy life-style, Selina speaking as one of Gotham's poor, Miranda as a terrorist pretending to be a charitable socialite. That he insults the party's host, without realising it is Miranda, gains new significance later, when he also fails to realise her role in the League of Shadows until it is too late.

Miranda Tate's ascension to the heights of the corporate world is, on one hand, accomplished through deception and manipulation.[2] It is only when she removes her glamour that Miranda reveals her power. In her study of cross-dressing in film, Kuhn finds that dress is 'an outward mark of difference, of a fundamental attribute of the wearer's identity… Far from being a fixed signifier of a fixed gender identity, clothing has the potential to disguise, to alter, even to reconstruct the wearer's self' (1985: 53). A simple change of wardrobe reveals an entirely new identity. Gone are the shapely red dress and the fashionable boardroom attire – now she dons the coarse, androgynous, robelike coat of her father and pulls her previously full hair back into an austere braid. Dressed simply and with minimal makeup, she leaves Gotham's City Hall as her army's final commander; even Bane must pause to witness her departure.

Nonetheless, despite her inherent unknowability, the *femme fatale* is consigned to a prescriptive fate. All the power she has wielded must be lost, whether through a surrender for the sake of the hero's love or, if she will not repent, through humiliation and defeat, confinement, or even death. Selina transitions, just as she has in the comics, from villain to anti-heroine. Her moral opposition to Bruce's capitalist hedonism – a begrudging hedonism, but hedonism all the same – appears to fade when she learns that he is Batman. Following his return to Gotham, she becomes a reluctant ally, foregoing her own safety to aid his war against the League of Shadows. Their alliance establishes what Tasker calls 'hetero-bonding' (1998: 74), the teaming up of the action hero and the female lead. It is she, not Batman, who kills Bane, ultimately deposing him, but rather than attempting to flee the city, she remains to help Batman fight against Talia. Doane writes that the 'textual eradication' of the *femme fatale* through the loss of her power 'involves a desperate reassertion of control on the part of the threatened male subject' (1991: 2). Throughout much of their interactions, Selina has questioned and even challenged Bruce's socioeconomic privilege, actively reminding him that his heroic persona has not, in fact, become the intended saviour of Gotham. The implication of her romance with him during the film's final scene would seem to erase the ideological conflict between them without removing its cause, for they are both fashionably dressed and in apparent good health, dining in an Italian café.

Talia, conversely, has aligned herself firmly against Bruce and thus must die. A controversial element in Nolan's interpretation of Batman, Bruce is directly respon-sible for Talia's death, just as he is for Ra's al Ghul's death in *Batman Begins*, despite his traditional aversion to killing.[3] Notably, Talia dies in the same manner as her father: in the trilogy's first film, Ra's dies when Batman, having tasked Gordon with blowing up a section of the raised overground railway, leaves him in the train as it plunges over the edge. Here, Batman's frontal assault on Talia's truck causes her not to see the upcoming fork in the road, thus preventing her from swerving in time to avoid the edge of an

overpass.[4] She dies believing that she has succeeded in her mission to destroy Gotham, but is posthumously thwarted when Batman is able to carry the bomb away from the city.

Nolan's engagement with the *femme fatale* may not be particularly unique. Certainly, both Selina and Talia continue to correspond to a paradigmatic treatment of this female archetype, just as Rachel Dawes may arguably be said to inhabit a servile space in the trilogy's narrative. What sets Nolan's treatment of the *femme fatale* apart from many more conventional films, however, is the gendered reversal of power that occurs when they are present. Mulvey, with regard to the spectator's identification with the male protagonist, notes his power to 'make things happen and control events' (1975: 12). The ability to enact change and maintain control certainly remains a prominent characteristic of superhero texts. Nolan's trilogy, however, departs somewhat from the classic narrative. Both *Batman Begins* and *The Dark Knight* state Bruce's need for accomplices, with Jim Gordon and Rachel Dawes drafted into his quest to rid Gotham of corruption. It is to Rachel that he confesses his desire to give up the cape and cowl as soon as he feels the city can be trusted to govern itself. *The Dark Knight* makes clear that not only is he waiting for a replacement, he believes he has found one in Harvey Dent. *The Dark Knight Rises* goes further by removing Batman from much of the principal action; indeed, he spends a significant part of the film outside Gotham. The two *femmes fatales*, however, remain within the confines of the city, Selina deploying her street savvy to stay alive, Miranda secretly ruling it alongside Bane. Here it is Selina, not Batman, who rescues a child, while Bruce remains out of commission, imprisoned abroad. Likewise, when Bane is killed prior to the film's climax, it is Talia who nearly succeeds in destroying Gotham and who appears responsible for Batman's death. All three women are thus placed into a rare privileged role in the superhero/action film, acting as confessor, steward and final nemesis.

Space, too, is governed by the final film's women in a reversal of generic tradition. In the conventional Hollywood film, according to Mulvey, 'the male protagonist is free to command the stage, a stage of spatial illusion in which he articulates the look and creates the action' (1975: 13). As previously discussed, Bruce is prevented from *looking* or *doing* in his captivity; the space he previously commanded is now denied him. The method of torture Bane chooses for him is rooted in a sense of space: as Bane himself explains to Bruce, the shape of the pit itself offers hope where this is none. It is only by re-enacting Talia's childhood feat, not his own strength, that he is finally able to negotiate the space of his prison. But in stark contrast to Bruce's lack of power over space, Selina uses space and Talia manipulates it. Selina controls space on a micro scale, coming and going through windows and doors, moving catlike through private interiors nominally forbidden to her. Protected storage spaces, such as safes, do not deter her. Talia wields control over space at the macro level. Disguising herself as a helpless citizen, she secretly rules all of Gotham, using Bane as her emissary and military commander. Though Bane has immediate power over the League's troops and public discourse, Talia may overrule him at any moment, for she carries the bomb's detonator. In a perverse mockery of Gordon's resistance, she joins the Commissioner's search party for the bomb she herself controls. The 'unsung hero' of Bane's stadium

speech, it is ultimately she who determines Gotham's fate for the five months of Bruce's absence. She effectively switches spatial roles with Bruce: once confined to the pit, she now rules a metropolis.

For the trilogy's most dramatic reversal of gendered power expectations, more attention must be given to Miranda Tate. While arguably few and minor changes are made to Selina Kyle, Nolan's script completely reinvents Talia al Ghul. Thus, it is arguably in her character that Nolan's role as *auteur* becomes clearest. The remainder of this essay will focus on the narrative and cinematic means by which this character, despite her death, subverts the generic prescriptions of women in the superhero film.

Debuting in the comics in 1971, Talia has traditionally been a wealthy woman of Arabic and East Asian descent and Batman's on-again/off-again lover. The casting of a white French woman in the role is not without its problems, though it is possible that Nolan wanted to circumvent the racial implications of the trilogy's only major woman of colour being a terrorist. Despite Marion Cotillard's ethnicity, online fan discussions shortly after the announcement of her casting speculated that she would play Talia, and even the release of Miranda Tate's name did not dissuade such speculation, perhaps due to her similar role as *femme fatale* in Nolan's then-most-recent film, *Inception* (2010). Until the film's climax, Miranda Tate has little in common with Talia. She is born and raised in poverty, not wealth, and spends the first several years of her life in constant danger.[5] By removing Talia's traditional socioeconomic privilege, Nolan positions her as a stark contrast to Bruce, thus enabling her and her army to engage in the same critique of Western capitalism that appears throughout the trilogy.

The endangered woman of the action film has previously been discussed, but it is a notion that warrants special consideration in Talia's case. Of particular note in Nolan's dramatic revisioning of Talia al Ghul is the removal of her rape. The character does have a past connection to Bane in the comics, initially romantic but becoming violent when she rejects Bane's advances. Once she has been physically and emotionally subdued, Bane wields the threat of rape over her, and the art of two comics (*Batman: Bane of the Demon* #4 and *Detective* #700) suggests that he may actually have fulfilled his threat. In Nolan's film, however, Talia-as-Miranda and Bane lead the League of Shadows together. Bane poses merely the illusion of a threat to her when he orders his men to separate her from the other prisoners. Miranda's reveal as Talia re-contextualises this scene, for the spectator now understands that the two are partners, not attacker and victim.

If *The Dark Knight* hovers between conventional treatment of women and indictment of Bruce's need to rescue the damsel in distress, its sequel moves entirely into the latter category. Both the Joker and Bane explicitly manipulate the significance of the woman to the male hero – the former when he places Rachel Dawes and Harvey Dent in separate, explosives-rigged locations, the latter when he uses Miranda Tate as a human trap for the returning Batman. Miranda's complicity in the plot does not change its intentions, for it is Batman's belief in Miranda's innocence that will draw him back to City Hall. The ruse's success becomes more significant in light of Boetticher's assertion that 'in herself the woman has not the slightest importance' (quoted

in Mulvey 1975: 11). Miranda Tate is a fictional construct, a cover for Talia; through both the film's cursory treatment of her and Bruce's lack of personal knowledge of her, Miranda exists merely as an object to be rescued, deliberately created to fulfil Bruce's own fantasy of the woman.

Even apart from Bruce's knowledge, the film's narrative does little to elucidate Talia as an actual character. Two possibilities emerge: the neglect of Miranda's characterisation may indicate a perceived lack of importance, or it may point toward a subversion of Bruce's patriarchal chivalry. He has no need nor even desire to know anything about Miranda past their cursory business – and later sexual – relationship. He comes to her rescue in fulfilment of a gendered script, by which he has already inscribed his claim on her. More importantly, Bane and Talia *know* he will follow this script, and use it to entrap him. Batman's heroism is cruelly subverted when the trilogy's final damsel in distress is revealed not to be such at all, but rather the leader of the terrorist organisation holding Gotham hostage and daughter of Ra's al Ghul.

While her unexpected power is revealed narratively through her name, the cinematic revelation occurs through the look. Mulvey posits that the filmic gaze is 'obsessively subordinated to the neurotic needs of the male ego' (1975: 18). Though, as has already been discussed, the trilogy does move away from Bruce's gaze for significant periods, it is during the confrontation with Talia that the traditional gaze is visually subverted. For Miranda's reveal as Talia, Nolan departs from sweeping, IMAX-friendly shots to intimate close-ups which focus on her face and hands. A facial close-up is particularly significant. Doane explicates the power of such a shot:

> The face, more than any other bodily part, is *for* the other. It is the most articulate sector of the body, but it is mute without the other's reading. In the cinema, this is evidenced in the pause, the meaningful moment of the close-up, *for the spectator*, the scale of the close-up corresponding less than other shots to the dictates of perspectival realism. And this being-for-the-gaze-of-the-other is, of course, most adequate as a description of the female subject, locked within the mirror of narcissism. (1991: 47; emphasis in original)

Here, however, Talia becomes the performer of the gaze and both Bruce and Bane its objects. Nolan's use of the close-up does not emphasise her beauty, but rather her power. The camera invites the viewer to share Talia's perspective, thereby establishing a female gaze that reverses the male one. She effectively shatters the androcentric 'mirror of narcissism', removing herself as the other who is objectified by the gaze. She subjugates Batman not only with her knife but with her eyes. As Judith Butler writes, the male hero is threatened by the 'sudden intrusion' of the female subject of the gaze, for this reversal marks an 'unanticipated agency'; once an object, she now 'inexplicably returns the glance, reverses the gaze, and contests the place and authority of the masculine position' (1990: xxvii–xxviii). Bruce loses his place of power under her gaze, finding himself objectified by the very woman he has assumed to be a passive object. His lover becomes his enemy; her face dominates the spectator's field of vision, commanding rather than inviting a new reading.

In spite of Nolan's clear status as an auteur, his trilogy cannot depart entirely from Hollywood archetypes. However, this does not prevent the films from venturing into unexpected territory. Kuhn reminds us that, in the Hollywood film, 'hegemony is never without contradiction' (1985: 7). Nolan does not forego stereotypical Hollywood treatments of women in the androcentric superhero film altogether, but he does augment their roles with metatextual subversions. The virtuous woman remains virtuous, but she ultimately rejects the male hero. The *femmes fatales* do not deviate from archetypal progressions, but the challenges they pose to the hero are not easily overcome with brute strength or heteronormative masculine sexuality. They question the hero and invite the spectator to do the same, suggesting a moral uncertainty in the films' moral centre. In these women, the male hero's authority is compromised. The viewer may disagree with their actions, particularly in Talia's case, but all three women pose valid criticisms against Bruce's quest. Moreover, they question the role and expectations of women in the superhero film, offering a surprising interpretation of the cinematic woman that simultaneously upholds and defies convention.

*Notes*

1    In the context of her medium, comics writer Gail Simone has famously dubbed this trope 'Women in Refrigerators'.
2    Talia is also an accomplished businesswoman in the comics, but does not require the same level of deception in this area of her career. In one *Superman* storyline, she is hired as steward of Lex Luthor's company specifically because of her identity.
3    As Ra's al Ghul is immortal in the comics, Batman has sometimes fatally wounded him in the past. Nolan's film nonetheless faced criticism for depicting Batman's willingness to do so.
4    The manner of Talia's death seems significant in the context of the comics, though Nolan's version of the character is quite different from the comics incarnation. She is traditionally torn between her duty to her father and her romantic love for Bruce, and her inability to choose between them is a frequent source of internal conflict. In this way, Nolan's choices for her death seem to acknowledge her traditional characterisation.
5    Due to her poverty and androgynous appearance as a child, Miranda Tate bears a greater initial resemblance to Talia's half-sister in the comics, Nyssa Raatko. To date, however, Nolan has not spoken of this character, and thus the resemblance may be coincidental.

*Bibliography*

Butler, Judith (1990) *Gender Trouble: Feminism and the Subversion of Identity*. London: Routledge.
Cook, Pam (1993) 'Border Crossings: Women and Film in Context', in Pam Cook and Philip Dodd (eds) *Women and Film: A Sight & Sound Reader*. Philadelphia: Temple University Press, ix–xxiii.

Doane, Mary Ann (1991) *Femmes Fatales: Feminism, Film Theory, and Psychoanalysis.* London: Routledge.

Dyer, Richard (1978) 'Resistance Through Charisma: Rita Hayworth and *Gilda*', in E. Ann Kaplan (ed.) *Women in Film Noir.* London: British Film Institute, 91–9.

Foundas, Scott (2012) 'Cinematic Faith', *Film Comment*, November/December. Online. Available: http://filmcomment.com/article/cinematic-faith-christopher-nolan-scott-foundas (accessed 25 February 15).

Heath, Stephen (1986) 'Joan Riviere and the Masquerade', in Victor Burgin, James Donald and Cora Kaplan (eds) *Formations of Fantasy.* London: Metheun, 45–61.

Kuhn, Annette (1985) *The Power of the Image: Essays on Representation and Sexuality.* London: Routledge and Kegan Paul.

Mulvey, Laura (1975) 'Visual Pleasure and Narrative Cinema', *Screen*, 16, 3, 6–18.

Riviere, Joan (1929) 'Womanliness as Masquerade', *International Journal of Psychoanalysis*, 10, 303–13.

Simone, Gail (1999) 'Women in Refrigerators', *LBY3*, March. Online. Available: http://www.lby3.com/wir/ (accessed 25 February 15).

Tasker, Yvonne (1998) *Working Girls: Gender and Sexuality in Popular Cinema.* London: Routledge.

CHAPTER FIVE

# Memento's Postmodern Noir Fantasy: Place, Domesticity and Gender Identity

Margaret A. Toth

Jacques Tourneur's classical *noir Out of the Past* (1947) begins with a credits montage that underscores place, specifically Northern Californian geography. The opening shot of a small lake surrounded by a range of craggy peaks and foliage dissolves into another perspective of the mountain, which dissolves into yet another frame featuring the natural landscape. With Roy Webb's romantic orchestral score supporting the majestic quality of the scenery, this editing pattern continues until one image, rather than cutting to the next, lingers on a picturesque open range before panning to a milepost on the side of a country road. This montage, and the milepost in particular – which informs us precisely where we are (one mile from Bridgeport, California and 349 miles from the archetypal *noir* city, Los Angeles) – firmly anchors the viewer in the film's idyllic setting. This California countryside soon becomes synonymous with another space conceived within the film as idyllic: home. In the scene that introduces the film's haunted protagonist, Jeff Baily (Robert Mitchum), he describes to his sweetheart, Ann Miller (Virginia Huston), his dreams of building a house for them on the very terrain the opening credits glorified. But this is a fantasy that remains unrealised, a point that Tourneur foreshadows early in the film when Jeff picks up Ann for a date. As he is about to open the gate to the Millers' yard, Jeff hears Ann's mother, who is inside the house, stridently criticising him; Jeff falters, and Tourneur registers in medium close-up Jeff's defeated expression and hesitant body language. Although Mrs. Miller complains that 'the man won't even come to the door', Tourneur implies that Jeff's 'choice' in this moment is profoundly foreclosed. Too many barriers – physical, social and personal – bar him from accessing the Miller house and all the cherished ideas it represents: family, home and a sense of secure rootedness.

R. Barton Palmer claims that Jeff's is a fundamental dilemma for the classical *film noir* male: 'singularity of place and continuity of time do not define the *noir* protagonist'; rather, he is 'trapp[ed] ... "between times" and in a multiplicity of

irreconcilable spaces' (2004: 60, 63). Jeff's specific predicament, however, is unusual, insofar as most classical *noir* characters, particularly the hardboiled figures adapted from the novels of authors like Raymond Chandler and Dashiell Hammett, actively court these spatial and temporal interstices by explicitly rejecting the idea of home. The narrative trajectories of countless *noir* protagonists – from Walter Neff of *Double Indemnity* (Billy Wilder, 1944) and Chris Cross of *Scarlet Street* (Fritz Lang, 1945) to Frank Bigelow of *D.O.A.* (Rudolph Maté, 1950) and Mike Hammer of *Kiss Me Deadly* (Robert Aldrich, 1955) – are organised around a deliberate transgression of this space and all its social trappings. As Megan Abbott puts it, 'the tough guy's discomfort with traditional roles or bourgeois values of home, family, and friends is fundamental to his self-concept' (2005: 3). Even the stories of *noir* protagonists whom we wouldn't label hardboiled, such as Richard Wanley, the conventional family man of Fritz Lang's *The Woman in the Window* (1944), are principally motivated by the fantasy of transcending the binds of domestic life, usually in order to pursue a *femme fatale*. Film *noir*'s treatment of home, then, is highly fraught, as the protagonist either repudiates domesticity or, in Jeff's atypical case, aspires to but cannot attain it. As Vivian Sobchack declares in 'Lounge Time', her seminal essay on the physical spaces of classical *noir*, the home unfailingly functions as a tangible absence in these films from the 1940s and 1950s: 'the house is almost never a home. Indeed, the loss of home becomes a structuring absence in *film noir*' (1998: 144).

Jeff's quest to replace that absence with a material home life renders him unique among his classical *noir* cohort. However, his cinematic descendants, the male protagonists of the neo-*noir* movement, share his goals.[1] But where Jeff's narrative path is forward-moving – he seeks to outrun his past and build a home in the future – these characters' stories are driven by nostalgic, backward-moving impulses. Indeed, the desire to reconstitute or return to a domestic space, one lost but enshrined (however inaccurately) in the protagonist's memory, motivates a surprisingly high number and diverse range of neo-*noirs*, from modernist classics like *Point Blank* (John Boorman, 1967) to postmodern art-house films such as *Blue Velvet* (David Lynch, 1986), *Suture* (Scott McGehee and David Siegel, 1993) and *Lost Highway* (David Lynch, 1997) and more recent blockbusters like *Shutter Island* (Martin Scorsese, 2010). In this essay, I discuss how Christopher Nolan's postmodern neo-*noir Memento* (2000) – loosely based on Jonathan Nolan's short story 'Memento Mori'[2] – explores these ideas through its intimate character study of the protagonist, Leonard Shelby (Guy Pearce), a man who suffers from anterograde amnesia and seeks to avenge the apparent rape and murder of his wife (Jorja Fox). Critics who have acknowledged *Memento*'s indebtedness to *noir* focus on the film's excessively complex structure, identifying it as an extension of the tamer non-linear patterns of early *noirs* like *Double Indemnity, Laura* (Otto Preminger, 1944) and *Murder, My Sweet* (Edward Dmytryk, 1944).[3] By contrast, I explore the film's understanding of home – and other physical spaces that get invested with psychological meanings – in order to identify how Nolan both draws upon and revises the cinematic legacy of *noir*.

In the first part of the essay, I argue that Nolan's treatment of place, particularly Leonard's fixation on domesticity, is deeply bound up with the film's notion of both

fantasy and identity. If in the standard classical *noir* fantasy the male protagonist's desire for the *femme fatale* entails a rejection of domesticity – a choice that ultimately leads to his ego unraveling – here the fantasy is organised around Leonard's desire to reclaim the home, his dead wife and, by extension, his former self. In the second section of the essay, I suggest that this shift in fantasy both derives from and shapes the film's gender constructions. Specifically, Nolan reworks, sometimes radically, classical *noir* archetypes like the weak male protagonist, *femme fatale* and home-builder. I contend that when we interrogate these ruptures in gender categories, the disturbing underpinnings of Leonard's fantasy – elements repressed by Leonard and perhaps even the film itself – become patent.

*Domestic Desires*

In his comprehensive study of 1940s cinema, Dana Polan argues that 'to a large degree, forties narrative is nothing so much as a vast meditation on place and space, on the field in which action and meaning are constituted' (1986: 252). But if classical *noir* films overtly exclude the home, the most common setting in, for example, 1940s melodrama, what physical places *do* they emphasise? The dominant environment is the urban macrocosm, with various seedy microcosms within the city – 'the cocktail lounge, the nightclub, the bar, the hotel room, the boardinghouse, the diner, the dance hall, the roadside café, the bus and train station, and the wayside motel' (Sobchack 1998: 130) – figuring prominently. Polan suggests that these physical sites, outside of legitimate power structures and 'reduced to dead ends, backwaters, marginalia to the system', function through 'the iconography of a kind of nonspace' (1986: 268). I suggest that neo-*noir* texts, particularly postmodern prose fiction and films, remobilise this concept of 'nonspace', sometimes to explore power systems but more often to interrogate personal identity. For example, throughout 'Memento Mori', Jonathan Nolan carefully delineates the various institutional, sterile and uncanny rooms that his protagonist (named Earl in the story) occupies in order to convey the character's psychological condition and help the reader co-experience it. The first time Earl 'wakes up' in the story, the reader shares his disorientation:

> Earl rises and takes a look around. The room is large for a hospital – empty lino-leum stretches out from the bed in three directions. Two doors and a window. The view isn't very helpful, either – a close of trees in the centre of a carefully manicured piece of turf that terminates in a sliver of two-lane blacktop. The trees, except for the evergreens, are bare – early spring or late fall, one or the other. (2002: 184)

As this passage indicates, the 'nonspaces' Earl regularly finds himself in provide little to no evidence not only of where he is but also of *when* – it could be 'early spring or late fall' – or *who* he is. Although 'every inch of the desk is covered with Post-it notes, legal pads, neatly printed lists, psychological textbooks [and] framed pictures' (ibid.), they fail to ground Earl and provide him with a fixed or enduring sense of identity.

Nolan also deploys this strategy, metaphorising the unstable, blank memory of his protagonist, Leonard, through the generic motel rooms he inhabits. After the opening credits, which literally run in reverse and thereby announce how the colour scenes in the film are organised, Nolan introduces the first black and white segment of the film. Leonard sits in a motel room and describes the experience of 'waking up': 'So where are you? You're in some motel room. You just ... you just wake up and you're in some motel room. There's the key. It feels like maybe it's just the first time you've been here, but perhaps you've been there for a week, three months, it's kinda hard to say. I ... I don't know. It's just an anonymous room.' This dialogue, delivered in a halting manner, plays in voiceover while the audience sees various shots of Leonard and the motel room he explicitly describes as 'anonymous'. Like Earl's hospital room, nothing serves to anchor Leonard or the viewer in this scene, as the objects populating the *mise-en-scène* – a room key in a plastic ashtray, a bare wooden dresser, an empty closet full of unused hangers and bedside tables with cheap lamps – withhold clues about where, when or who he is.[4] The shot concluding the short scene, a high angle on Leonard as he sits on the bed and looks around him with a puzzled expression, could have been lifted right out of a classical *noir* film: the oblique angle announces his vulnerability and powerlessness, while the rich black, white and silver tints and chiaroscuro lighting suggest the stark gravity of his dilemma.

Even when Nolan dispenses with such self-conscious *noir* aesthetics – shifting, for instance, to colour stock, natural lighting and eye-level perspectives – he maintains a focus on the 'nonspaces' of *noir*. Leonard briefly stays at Natalie's (Carrie-Anne Moss) house, a place that we might label semi-domestic or, following Palmer, 'proto-domestic' (2004: 62), but he spends the bulk of the film's running time in a series of temporary, interstitial spaces: motel rooms and lobbies, diners and restaurants, a shabby bar, a public bathroom, an abandoned construction site, a defunct oil refinery, a tattoo parlour, his car and a parking lot for mobile (rather than stationary) homes. While these individual spaces all have a generic quality to them, the urban macrocosm, Los Angeles, also feels curiously nonspecific, an effect the production designer, Patti Podesta, explicitly sought out when scouting locations: 'we wanted something anonymous. We were looking for locations that were exchangeable with each other. ... We were looking for a place you could not place. A no-place' (quoted in Mottram 2002: 154). Christopher Nolan himself has discussed the 'relationship between the setting and the predicament of the character', suggesting that the 'no-place' or 'nonspace' functions as an exteriorisation of Leonard's identity crisis. 'There's something about the landscape', he says, 'It's not specifically LA. ... There's really nothing in the film that you could recognize as LA. That seemed very important to the story, to be getting lost in this landscape' (quoted in Mottram 2002: 167).

Adrift not only in various nonspaces but also in disjointed temporal registers, Leonard appears to be a neo-*noir* character somehow transported back to and trapped in a classical *noir* chronotope, the time-space that Sobchack labels 'lounge time':

> The spatiotemporal structures and smaller chronotopic units (or motifs) like the cocktail lounge or the hotel room that constitute lounge time merge in

their historical coherence as threats to the traditional function, continuity, contiguity, and security of domestic space and time. They substitute for and fragment into 'broken' status the nurturant functions of another and more felicitous chronotope discussed earlier: the home. (1998: 156–7)

At first glance, nearly every aspect of Leonard's present existence seems subject to and dictated by this chronotope, which 'substitute[s] impersonal, incoherent, discontinuous, and rented space for personal, intelligible, unified, and generated space' (1998: 158). However, even as Nolan pays homage to this classical *noir* trope, Leonard obviously doesn't live in the post-war late-1940s, the definitive era of lounge time; he navigates an overtly twenty-first-century Los Angeles. Instead, in postmodern fashion, Nolan refracts this earlier chronotope. On the one hand, he reproduces features of it in a clever pastiche that governs not just visual but also basic narrative choices. For instance, prior to his accident, Leonard is an insurance claims investigator, invoking Barton Keyes of *Double Indemnity* and Jim Reardon of Robert Siodmak's *The Killers* (1946). On the other, Nolan introduces new elements, particularly the space that arguably is the film's centre of gravity: Leonard's home.

Indeed, Leonard's present is repeatedly, if fleetingly, punctuated by glimpses of his lost home, what I would describe not as a chronotope but as a mnemotope, or memory-place.[5] Even though *Memento* offers a complex meditation on time, and granting that memory and time are obviously linked, I submit that the mnemotope is a more useful construction for understanding Leonard's predicament. Perhaps counter-intuitively, this mnemotope, the memory-place of Leonard's former home, resists temporal grounding; rather than being anchored firmly in Leonard's past, as one might expect, it gets invested, by Leonard himself, with meanings that attach equally to his present and future.

Early in the film when Leonard and Natalie meet at a diner, Natalie encourages Leonard to close his eyes and remember his wife. As Leonard tells Natalie about the 'bits and pieces you never bother to put into words', the audience sees a number of fragmented images of Leonard's past life, all of which feature the place absent from classical *noir*: the home. In the space of a mere forty seconds, we get thirteen shots of this mnemotope, as well as three that return to Leonard in the diner and thereby remind us that the images of the past we are glimpsing are subjective, contingent upon and filtered through Leonard's present. The editing is highly disjunctive, with several shots held for less than a full second, but we nevertheless know we are in the realm of the domestic. We see, for instance, the back of Leonard's wife as she walks through their home to their backyard; a close-up of her hands under the kitchen sink's tap; a reflection of her pulling her hair back in a glass cupboard; a close-up of her hands playing with a plastic fork; and a shot of her back as she sits at their dining room table. The brevity of the shots, along with the fact that access to the wife's face is either withheld or mediated via shadow or glass in nearly every image, underscores the nostalgic quality of this flashback. That is, the editing and cinematography work in tandem to position the past as irretrievable – one can return to it only in memory, which, as the flashback demonstrates, is elusive and partial.

Yet this mnemotope motivates Leonard's actions by promising, however illogically, return and restoration. As Todd McGowan points out, the structure of fantasy turns on the possibility of reclaiming the past: 'Though fantasy sometimes envisions an expected future, more often it delves into the past. And even the futures it imagines are not purely futural but recycled and transformed remnants from the past' (2012: 53). McGowan's observation is borne out in another image that Nolan places toward the end of the film, one that demonstrates how Leonard's forward-moving revenge quest is collapsed into and inseparable from a backward-moving desire to return to his home life. Having just set up Teddy (Joe Pantoliano), his next John G. victim, Leonard rationalises his actions while speeding down the streets of Los Angeles. As in the diner scene, he closes his eyes and seemingly remembers his wife and home. But instead of a flashback to the memory-place we witnessed earlier, we see an *impossible* mnemotope: he lays in bed with his wife, who caresses his bare chest, which displays a tattoo we know Leonard doesn't have: 'I've done it.' This shot lays bare the extent to which Leonard's supposed mission for revenge is inextricable from his desire to return home. Put differently, the film's fundamental fantasy revolves less around a future vengeance and more around a homecoming.

The home, then, is a crucial site – both physical and psychological – in *Memento*. Where the home is the structuring absence of classical *film noir*, in this postmodern *noir* it functions in a similar, though slightly different, manner: as a structuring *loss*. The lost home maintains a palpable presence in the film. Moreover, it is fetishised, as in the scene where Leonard hires a prostitute to place his dead wife's belongings around his hotel room in an effort to recreate the last moments they shared together. As such, the home determines the film's fantasy structure, as the promise of return – and more specifically the restoration of Leonard's former, coherent identity – propels the film, and Leonard himself, forward into the future.

### Gender Subversions

Leonard's fantasy of homecoming is overtly gendered, as it is governed by a desire to regain his stereotypically masculine roles of husband and breadwinner. Throughout the film, his masculinity is compromised not just because of his anterograde amnesia – he is an easy target, and we see multiple people take advantage of his illness – but also because of his ever-present memory of failing to protect his wife. Consequently, his character evokes the classical *noir* tradition, which features innumerable emasculated, impotent males. However, *Memento* abandons, even as it summons up, the predictable gender paradigms of classical *film noir*. Instead, Nolan figuratively shuffles the deck of classical *noir* character types – including the weak male protagonist, the *femme fatale* and the home-builder – with nearly all of the main characters resisting neat categorisation and instead becoming peculiar hybrids.

This subversion is evident in the development of the two female characters, whose roles in the original story are either minimal or non-existent: Leonard's wife, who doesn't physically appear in 'Memento Mori' but who nevertheless haunts its pages, and Natalie, a character that Nolan created for the film. Significantly, the film's visual

and narrative composition fetishises not a *femme fatale* but a home-builder character, Leonard's wife. However, Nolan refashions and complicates that type. For one, the costume design emphasises her embodiment in conflicting ways. In the flashback segments, she wears clothing that reveals her bare skin, which occasionally gets registered through intimate close-ups. But the simple, even child-like items she wears – a red cotton sundress in one scene, basic white underwear in another – render that flesh, even as it is sensuous, somehow innocent. Moreover, as with classic *femmes fatales* like *Double Indemnity*'s Phyllis Dietrichson or more recent figures like Mattie Walker of *Body Heat* (Lawrence Kasdan, 1981), Leonard's wife serves as the source of the protagonist's fixation and the driving force of the film's plot. Therefore, unlike the straightforward home-builder of classical *noir*, the 'almost asexual' woman 'placed on the narrative margins' (Spicer 2002: 91, 92), Leonard's wife – while only appearing briefly – holds a complex position in the film.

Although many critics read her as a paradigmatic *femme fatale*, Natalie's character is equally complex.[6] Nolan does draw upon the iconography of classical *femmes fatales* in his presentation of Natalie. Her dark hair, cut in a loose, shoulder-length bob, and clothing – she wears revealing and sheer fabrics dominated by 'cold and steely charcoals and gun-metal grays' (Mottram 2002: 150) – align her with seductresses like Kitty Collins of *The Killers*. Natalie also performs the role of female victim in order to manipulate, and sleep with, Leonard, a common *femme fatale* ploy. However, despite Natalie's certainty that he will remember their one-night stand, Leonard later forgets about and rejects her so that he can pursue his domestic-driven fantasy; she cannot maintain the mysterious power of the *femme fatale*. Moreover, Natalie is an unstable type, as she takes on qualities of both the home-builder, by inviting Leonard into her home, and the 'good-bad girl', by aiding him in his revenge quest (see Spicer 2002: 92–3). Perhaps most important, unlike the *femme fatale*, an unreadable figure who induces epistemological uncertainty in the viewer, Natalie's motives and desires are fully transparent. Instead, and here Nolan's reworking of gender is at its most radical, Leonard occupies the narratological position of the classical *femme fatale*. Mary Ann Doane argues that 'the *femme fatale* is the figure of a certain discursive unease, a potential epistemological trauma. For her most striking characteristic, perhaps, is the fact that she never really is what she seems to be. She harbors a threat which is not entirely legible, predictable, or manageable' (1991: 1). This is the precise role that Leonard performs. Indeed, even as Leonard resembles the classical weak and disadvantaged male protagonist attempting to solve a crime in which he is implicated, he also remains the most enigmatic and inscrutable figure of the film. 'Leonard is not, after all, the detective figure in *Memento*', Knight and McKnight claim, 'but rather the film's central mystery' (2009: 160).

Moreover, Leonard shares a bizarre affinity with another cinematic female type: the 'medicalised' heroine of 1930s and 1940s 'women's films', including Irving Rapper's paradigmatic *Now, Voyager* (1942) and hybrid melodrama-mysteries such as John Brahm's *The Locket* (1946) and Curtis Bernhardt's *Possessed* (1947) (see Doane 1985: 206). This type, typically a lead character that suffers from one or more physical or psychological disorders, features in a sub-genre of Hollywood melodrama

that, according to Mary Ann Doane, 'situate[s] the woman as the object of a medical discourse' (ibid.). Leonard, whose medical condition and misguided revenge quest render him a cold-blooded murderer, evokes this 'medicalised' heroine, a hysterical and pathological figure whose 'symptom' threatens those with whom she comes into contact. This gender play gets interwoven into the film's discourse of fantasy. As with the melodramas Doane describes, whose 'medicalised' characters are 'cured' when they conform to stereotypically-defined feminine expectations (1985: 208), *Memento* associates, in Leonard's fantasy, the restoration of psychic integrity with a realignment of traditional gender roles.

However, this gendered fantasy possesses a dark underside. Upon one interpretation of *Memento*, Leonard is a wife-killer. If the viewer believes the lecture Teddy gives Leonard at the end of the film, then Leonard accidentally killed his wife, who survived the attack, by injecting her with an overdose of insulin; he then, defying the logic of his disorder, reconditioned himself to displace this traumatic act onto another figure, Sammy Jankis (Stephen Tobolowsky). If this is true, then the mnemotope of *Memento* is at best unreliable and at worst an outrageous deception: Leonard horrifically revises history, disavowing his own violence against his wife and killing various innocent people to avenge the crime he actually committed. However, even if we don't adopt this interpretation, one myself and others find most consistent, Nolan subtly suggests that the mnemotope of neo-*noir*, like his 'medicalised' protagonist, is nonetheless polluted.[7]

In 'Memento Mori', the domestic space is entirely absent, but Earl's musings gesture towards how the home functions in the film. In a scathing note he writes to his future self, Earl declares: '*you'd probably prefer to sit in your little room and cry. Live in your finite collection of memories, carefully polishing each one. Half a life set behind glass and pinned to cardboard like a collection of exotic insects. You'd like to live behind that glass, wouldn't you? Preserved in aspic*' (2002: 187; emphasis in original). Jonathan Nolan, commenting on this moment in the story and, more broadly, on how the figure of the absent wife functions, says, 'having her taken away is much easier; now she's preserved in aspic, as it says in the short story. Locked away in a filing cabinet, she becomes a memory, not a person' (quoted in Mottram 2002: 39). *Memento* also 'preserves' the wife in the 'aspic' of the protagonist's memory, but the film goes a step further to demonstrate how that memory is falsely shaped according to Leonard's desires. In other words, even if we don't subscribe to the belief that Leonard erased and wrote over the memory of killing his wife, we see him revising his past in other ways, ones that position the mnemotope as speciously idyllic.

When Natalie prompts Leonard to remember his wife in the diner scene described above, Leonard initially says, 'She was beautiful. To me she was perfect.' Natalie stops him, saying, 'No. Don't just recite the words. Close your eyes and *remember* her.' Natalie's words carry a warning to the viewer to be wary of the stories Leonard robotically rehearses about his wife. Even in the flashback described above, one that primarily functions to cast the lost home in a nostalgic light, the reality of Leonard's marriage seeps into the images. In one brief shot, we see his wife gesticulating in frustration, engaged in what appears to be a heated argument. Similarly, in the only flashback

that contains dialogue, Leonard and his wife have a quarrel about the fact that she is rereading a book that he says she has read 'like a thousand times'. 'Don't be a prick', she says. 'I'm not reading it to annoy you. I enjoy it.' On one level, this flashback contains a sly self-referential joke about the film's backward-moving structure, as Leonard claims: 'I always thought the pleasure of a book was in wanting to know what happens next.' But on another level, this scene, privileged in the film as the only continuous action set in the mnemotope, reveals that Leonard didn't think his wife was 'perfect'. William G. Little makes a similar observation, noting that even though 'throughout the film Leonard does his best to mask any trace of marital discord', this scene is 'not quite one of domestic bliss' (2005: 75). Leonard's conviction that 'memories can be distorted. They are just an interpretation' must be applied to his own constructed memories of home: his domestic fantasy is retroactive.

## Conclusion

The enigmatic, 'medicalised' male character nurturing fantasies of a lost mnemotope appears repeatedly not just in Nolan's filmography – we might consider both Robert Angier (Hugh Jackman) of *The Prestige* (2006) and Dom Cobb (Leonardo DiCaprio) of *Inception* (2010) in this context – but also in the postmodern *noir* landscape more generally. The protagonists of the aforementioned *Suture*, *Lost Highway* and *Shutter Island*, as well as *Abre Los Ojos/Vanilla Sky* (Alejandro Amenábar, 1997/Cameron Crowe, 2001), *Fight Club* (David Fincher, 1999), *Secret Window* (David Koepp, 2004) and the Bourne franchise (Doug Liman, 2002; Paul Greengrass, 2004; Tony Gilroy, 2012) – to name just a few examples – suffer from a variety of psychological pathologies. And whether the condition is amnesia, brain damage, psychological trauma or schizophrenia, the characters' symptoms often hinge upon or are at least are connected to the loss of domestic stability and a desire to return home.

For instance, the narratives of *Lost Highway* and *Shutter Island*, also showcasing male characters haunted by memories of their dead wives and lost homes, are plotted according to fantasies of return that look remarkably similar to Leonard's. In both of these films, as in *Secret Window*, we ultimately learn that the protagonist himself is the agent of his wife's death, a fact that forces us to revisit the way in which the films construct the space of the home. In *Shutter Island*, for example, we initially experience Teddy Daniels' (Leonardo DiCaprio's) dreams and hallucinations about his wife Dolores (Michelle Williams) – surreal and haunting scenes that Scorsese shoots in stunning, hyper-saturated colour – as poignant tributes to her untimely death: Dolores was killed in a fire that also destroyed their family home. Upon second viewing, once the audience knows that the schizophrenic Teddy actually shot his wife and watched her slowly bleed to death, these fantasies become Teddy's perverse rewriting of his personal history. Of course *Shutter Island*, along with *Lost Highway* and *Secret Window*, make this point in dramatic fashion, while the degree to which *Memento* exemplifies it depends upon how one reads the ending of the film. Nevertheless, far from being a pure construct, the mnemotope of *Memento* – the memory-place of the lost home – is tinged with disease.

*Notes*

1   I divide the neo-*noir* movement into two periods: modernist *noir*, the boundaries of which Andrew Spicer delineates as roughly 1967–1976, and postmodernist *noir*, roughly 1981 forward (2002: 130).

2   It's not quite apt to call *Memento* an adaptation of 'Memento Mori'. While Jonathan Nolan originally developed the story concept of a man with anterograde amnesia seeking vengeance for the death of his wife, the two brothers wrote their individual works simultaneously, and *Memento* was released before the story was published. For more on the genesis of the story and film – and how the Nolans worked together – see Mottram (2002) and Shiloh (2010).

3   Deborah Knight and George McKnight (2009) offer the most pointed exploration of *Memento* as a *noir*. While they discuss place, they focus on how the film's narrative patterns distinguish it from the classical *noir* tradition. Even when classical *noirs* are non-linear, the viewer follows the investigator figure through a fairly straightforward plot-line, whereas *Memento*'s highly unstable chronology puts the viewer in a unique position: 'it becomes increasingly evident that it is the viewer who must finally serve as the detective' (2009: 159). For more on *Memento*'s use of *noir* tropes, see Mottram (2002), Spicer (2007), Shiloh (2010) and McGowan (2012).

4   In the next black and white segment, Leonard will insist that 'you know who you are and you know kind of all about yourself', but by the end of the film – when we see Leonard delude himself and set up Teddy – this statement is dramatically invalidated.

5   Christine Sprengler uses this term to describe nostalgia films, particularly those that feature characters who embark on actual or emotional 'pilgrimages' to sites of their childhood: 'Whether accessed physically by visiting the childhood home or mentally through flashbacks, these objects of nostalgic longing are often represented to the spectator as manifesting the presence of the past. This is accomplished by marking these sites with "memory traces" established as significant within the film' (2009: 74).

6   Spicer, for instance, refers to Natalie as a 'hard and ruthless *femme fatale*' (2007: 59).

7   For an informative discussion of the various, often conflicting, answers to this question, see Klein (2001).

*Bibliography*

Abbott, Megan (2005) *The Street Was Mine: White Masculinity in Hardboiled Fiction and Film Noir*. New York: Palgrave MacMillan.

Doane, Mary Ann (1985) 'The Clinical Eye: Medical Discourses in the "Woman's Film" of the 1940s', *Poetics Today*, 6, 205–27.

_____ (1991) *Femmes Fatales: Feminism, Film Theory, Psychoanalysis*. New York: Routledge.

Klein, Andy (2001) 'Everything You Wanted to Know about "Memento"', *Salon*, 28 June. Online. Available: http://www.salon.com/2001/06/28/memento_analysis/ (accessed 18 February 2015).

Knight, Deborah and George McKnight (2009) 'Reconfiguring the Past: *Memento* and Neo Noir', in Andrew Kania (ed.) *Memento*. New York: Routledge, 147–66.

Little, William G. (2005) 'Surviving Memento', *Narrative*, 13, 1, 67–83.

McGowan, Todd (2012) *The Fictional Christopher Nolan*. Austin, TX: University of Texas Press.

Mottram, James (2002) *The Making of Memento*. London: Faber and Faber.

Nolan, Jonathan (2002) 'Memento Mori', in James Mottram, *The Making of Memento*. London: Faber and Faber, 183–95.

Palmer, R. Barton (2004) '"Lounge Time" Reconsidered: Spatial Discontinuity and Temporal Contingency in *Out of the Past*', in Alain Silver and James Ursini (eds) *Film Noir Reader 4: The Crucial Films and Themes*. New York: Limelight Editions, 53–66.

Polan, Dana (1986) *Power and Paranoia: History, Narrative, and the American Cinema, 1940–1950*. New York: Columbia University Press.

Shiloh, Ilana (2010) *The Double, the Labyrinth and the Locked Room: Metaphors of Paradox in Crime Fiction and Film*. New York: Peter Lang.

Sobchack, Vivian (1998) 'Lounge Time: Postwar Crises and the Chronotope of Film Noir', in Nick Browne (ed.) *Refiguring American Film Genres: History and Theory*. Berkeley, CA: University of California Press, 129–70.

Spicer, Andrew (2002) *Film Noir*. Harlow: Longman.

_____ (2007) 'Problems of Memory and Identity in Neo-Noir's Existentialist Anti-Hero', in Mark T. Conard (ed.) *The Philosophy of Neo-Noir*. Lexington, KY: University Press of Kentucky, 47–63.

Sprengler, Christine (2009) *Screening Nostalgia: Populuxe Props and Technicolor Aesthetics in Contemporary American Film*. New York: Berghahn Books.

# Men in Crisis: Christopher Nolan, Un-truths and Fictionalising Masculinity

## Peter Deakin

Slavoj Žižek has suggested about *The Dark Knight* (2008), one of Christopher Nolan's most critically and commercially celebrated films, that the 'undesirability of truth' and within that space, the fragility of control, may appear as Nolan's most dominant theme (2011: 61). Indeed, the concealed identities of 'masked men', narratives that require the unravelling of perverse truths and lies, all aggravated by ruptures in chronology, are each pertinent components of Nolan's cinema. But also latent in Nolan's films is an implicit play with gender. His films are loaded with desperate men and the moments that drive them to extremes; visceral representations of fractured male heroes and anti-heroes, duel identities and male identity complexes. Seemingly tinged with a *noir*ish fear of female empowerment and a masculine loss of control, locked into Nolan's cinema is a continual engagement with masculinity in a critical state. So much so in fact that, as this essay will contend, Žižek's understanding of Nolan's continual engagement with the 'undesirability of truth' seems driven by and systemic to his concern with male identity neuroses, masculine anxieties and his vision of masculinity in a state of crisis.

Despite such collective thematic concerns there has surprisingly, prior to the present volume, been a limited amount of scholarly analysis of Nolan's body of work, and even less written on his vivid and seemingly collective courting with gender as a major thematic. Consequently, this essay seeks to address this critical void. It will aim to not only place Nolan's cinema in a gendered theoretical context, moving through an examination of his films sequentially, but will also attempt to give his body of work some cultural contextualisation. Further, this essay will also foreground how Nolan's cinema may be driven by a deep-seated desire to satisfy the so-called 'masculine malaise', in which it will be understood that he offers his male (anti-)heroes the fictional means and pathways to 'un-truths' to transcend the limitations of their 'fractured' male existence.

Nolan's first major success came in 1998 with the release of his feature debut, *Following*. The film 'follows' an unemployed writer, credited simply as the 'Young Man' (Jeremy Theobald), who, somewhat adrift in the crowded recesses of London, decides to follow disparate individuals on their everyday journeys in his resolute search for material for his new book.[1] His pseudo-anthropological scheme falters however, when he is confronted by Cobb (Alex Haw), a yuppie/thief who realises the Young Man's routine only to persuade him to turn his hand to burglary. A second encounter with a seemingly random beautiful 'Blonde' (Lucy Russell), whose flat he and Cobb had previously burgled, spirals the Young Man's journey further into criminality. After acknowledging the Young Man's advances, she convinces him to break into the safe of her dangerous ex, the mysterious 'Bald Guy' (Dick Bradsell), only to later, somewhat joyfully, confess that all has been an elaborate ploy in which, in partnership with *her* yuppie accomplice Cobb, the Young Man has been set up to take the fall for his burglaries and more vitally to deflect Cobb from suspicion for a murdered woman whose body was found during one of his jobs. However, and here's the final twist in Nolan's first feature puzzle film, Cobb goes on to further reveal that the Blonde has also been victim to a secondary double-cross and bludgeons her to death – leaving the Young Man once again to be implicated for the heinous act before Cobb vanishes into a crowd.

Upon presenting this rather difficult synopsis of the film, one that is rich with Nolan's now trademark twists and turns and disjointed approach to time's linearity, certain fragments of the film, in addition to the film's primary thematics, seem to illuminate a certain desire, or rather anxiety, in Nolan's cinema that will go on to extend the length of his filmography. To begin, the film presents two kinds of archetypal villain that become expressed in more dynamic ways throughout his later films. The first is the 'yuppie villain', or the capitalistic villain, through which the malefaction of greed also becomes accentuated. Although Cobb displays the materiality of this characterisation, it is also the Young Man's assimilation of this archetype that marks his impending ruination. Stealing a credit card, and with it, the identity of assumed 'co-yuppie' 'Daniel Lloyd' and absorbing the yuppie appendages of a fitted suit and tie, complete with a transitional short haircut, the Young Man also becomes increasingly driven by yuppie desires of status, avarice and commodity fetishism. It is greed in fact that drives his desires to perpetually reach beyond the safe point, until, consumed by it, he is snared, an effect that reverberates, as this essay will examine, in various forms later in Nolan's cinema.

Secondly, Nolan introduces his audience to his impending obsession with the *femme fatale*, who whilst also becoming a staple part of Nolan's utilisation of the *noir* genre and its aesthetic – its relayed anxious backdrops, its urban settings, men in suits and muted colours all becoming recognisable components of his subsequent cinema – also often comes to drive the hero to terrains of despair (see Schuker 2008). Thirdly, though articulated here in tacit form, Nolan places a dead female as a further driver of action for the active male. In itself a patriarchal narrative trope (see Gornick 1971), it is an effect, as we shall see, that is presented in all but one of his later films. Further, the idea of voluntary protocols and what happens when they are broken or fractured is also explored in *Following* as Nolan seemingly begins to question institutional, social and

cultural systems, boundaries and chaos. Themes of individuality and alienation seem to follow from this departure, in addition to those of mistrust and duality, and most importantly bridging all of these desires or anxieties are Nolan's concerns with identity; its transformation and re-invention and its fracture and disjunction.

Kobena Mercer asserts that the prevalence of identity issues is linked to post-modern concerns, noting: 'identity only becomes an issue when it is in crisis, when something assumed to be fixed, coherent and stable is displaced by the experience of doubt and uncertainty. From this angle, the eagerness to talk about identity is sympto-matic of the postmodern predicament' (1990: 64). Indeed in attempting to reconcile the desires, anxieties and thematics in Nolan's films we may wish to locate his cinema amongst the cultural context and seemingly 'postmodern predicament' in which they were conceived and produced.

A child of Generation X, Nolan was born into anxieties circumventing 'greed is good' yuppie idealisms, 'ornamental culture' (see Faludi 1999), the so-called feminisa-tion of labour (see Jensen *et al.* 1988) and, largely by inflection of the former, most importantly a period in which later fervent charges are made towards a certain 'crisis of masculinity' (see Bly 1991; Connell 1995; Fauldi 1999). It is within these critical spaces that Nolan (along with other Gen X directors, perhaps like David Fincher and Paul Thomas Anderson) seems to find the fertile ground for much of his thematic branches to blossom. Hoping to make sense of the dialectic and more importantly articulate a new, or rather old (or at least nostalgic), understanding of what it is to be a man in the post-modern age, *Following* seems to insist that neither women or capitalistic desires can be trusted, and with those femininity or 'soft masculinities' often in imbrication.[2] Alongside a radical proposition that one's identity can be adjusted and maladjusted to invoke a new sense of self, Nolan's cinema seems to begin to unravel its imminent messages.

It would take Nolan's second feature *Memento* (2000) to really articulate these desires and their complexities in a way that would see them become a staple part of his cinema. The story follows another young white male in crisis as former insurance claims adjuster Leonard Shelby (Guy Pearce), who suffers from anterograde amnesia that renders him unable to form or store new memories, attempts to find the apparent killer of his deceased wife (Jorja Fox); who whilst also being dead before the film begins and only recalled for a handful of (mostly muted) screen minutes in the private back-drop of Leonard's memory, is, like the deceased old lady in *Following*, another dead female who propels the action.

Bennett Kravitz compares *Memento* to David Fincher's *Fight Club* (1999): 'as true exemplars of popular culture, both films depict the individual's struggle with late capitalism in order to establish identity in a de-centered world' (2004: 29). Like the Narrator's job in *Fight Club* in which decisions are based solely upon the financial imperative – as an insurance re-call co-ordinator his principle job is evaluating whether it will be cheaper for his car company to recall faulty products or settle lawsuits in or out of court to those parties harmed or killed due to his company's fault – Leonard Shelby also worked for an insurance company with a dubious sense of social morality. And whilst the reality of his work remains somewhat ambiguous – for example, about whether there ever was a Sammy Jankis (Stephen Tobolowsky) case or whether this

was just a fantastic projection of Leonard himself – whatever plot line we follow, 'the late capitalist rationale', as Kravitz suggests 'is either the trigger or source of Leonard's condition' (2004: 35).

But whilst the Narrator has his alter-ego 'anti-consumerist provocateur' (Windrum 2004: 306) Tyler Durden (Brad Pitt) to take him through the pitfalls of capitalistic culture in *Fight Club*, Leonard, aside from the ambiguously unscrupulous Teddy/John G. (Joe Pantoliano) and another mysterious, caustic and seductive *femme fatale* Natalie (Carrie-Anne Moss), who, in a world full of backstabbers and betrayers reaches the apex of duplicity, is left completely alone with himself to make his own truth and master narrative, an effect which has implications for his representational masculinity.[3] Indeed, Leonard's quest may appear Sisyphean – it intrinsically presents delayed gratification and is endlessly stalled by deceit, a lack of place and so on – his deferred and perpetually wanton vengeance *also* gives him an immutable sense of masculine utility.[4]

Upon realising that Teddy may not be the actual John G. that he is looking for, Leonard asserts to him 'fine, then you can be *my* John G... Do I lie to myself to be happy? In your case, Teddy... yes, I will.' Though poised with a perverted sense of nihilism, Leonard takes *this* John G. (and we can assume he is not the first or last) to be his villain and exacts his retribution. In this space we find Nolan's underlining and soon-to-be oft-repeated 'escapist clause' – reinvention and truth- and self-fictionalisa-tion; an effect that expands the closing aperture of *Following* and marks the beginning of Nolan's more direct assertion of masculine identity, and with it so called 'truth', as malleable and performable.

The film closes with Leonard's haunting narration: 'I have to believe that my actions still have meaning, even if I can't remember them. I have to believe that when my eyes are closed, the world's still there.' Reflecting the plea of the postmodern subject, Leonard's 'condition' perhaps is a metaphor for the postmodern condition (see Kravitz 2004: 31, 42). To overcome a society that has rendered him useless, Leonard's anterograde amnesia allows him to seek utility, a sense of worthiness and an affirma-tion of meaning that can be grounded, even if not in the concreteness of reality. The 'truth' imagined, fictionalised then lived gives Leonard a sense of order and control in a perverse postmodern world. Indeed, overlapping Nolan's participation in these pledges one can also find an escapist cinema, built itself on the very foundations of fiction and metafiction. As Joseph Bevan has insisted, Nolan seems to suggest that it is man's ability to fictionalise himself – to practice a performative (and perhaps dream-like) self and morality, to make himself into whatever he needs to be – that can redeem him (2012). The undesirability of truth, to reposition this back with Žižek, where this essay began, is thus used as an assertion of freedom once it is mediated as a performed or intentional un-truth and a (re-)assertion of a new, 'better' 'fictional' self. Articulated in hyper-reality in *Memento*, from here on in Nolan extends this rationale throughout his entire proceeding cinema.

In Nolan's next film *Insomnia* (2002), where Los Angeles detectives Will Dormer (Al Pacino) and Hap Eckhart (Martin Donovan) are sent to a northern Alaskan town to investigate the murder of a local teenage girl (who yet again is dead before the film begins), this ability to fictionalise oneself, to dream another 'better' or more 'func-

tional' you, is denied, quite poetically, by the insomnia Dormer faces to which the film takes its title. Alongside the main narrative strand, an intense internal affairs investigation back in Los Angeles is about to put Dormer under the microscope for seemingly fabricating evidence to help convict a paedophile he is certain was guilty of murdering a child. Acknowledging the lie for the greater good, Dormer is fearful that the bureaucratic forces and their red tape will undermine the case and in doing so, will bring all of his previous convictions under the same kind of scrutiny with the added implication that many may be quashed if he is found guilty. Along with a proceeding cover-up for apparently accidentally killing his partner, and exacerbated by the piercing daylight of the Alaskan summer town of Nightmute, itself taking a provincial inquisitional spotlight role in the film, Dormer becomes plagued by insomnia. Yet another anti-hero is trapped by a bureaucratic job in which his masculine autonomy and agency has been stemmed, and 'feminised' by the debilitating constraints of others, Dormer fragments and is unable to silence his anxieties.[5]

However, although finally killing the counter-cast murderer (Robin Williams), unable to keep up the un-truths, and more importantly unable to (literally) dream and by implication fictionalise himself anew, Dormer is eventually fatally wounded. In this way he becomes the only one of Nolan's male heroes – with perhaps contentious exception to dubious (anti-)heroes Alfred Borden (Christian Bale) and Robert Angier (Hugh Jackman) at the climax of *The Prestige* (2006), see below – to die at the climax of a film, perhaps as telling a sign of Nolan's thematic exposition as any.

Nolan augmented his vision of his male character's ability to create or fictionalise another cathartic self with even more vigour when in early 2003 he approached Warner Bros. with his idea about a human Batman film (the ultimate self-fictionalised hero), grounded in a 'relatable' world more reminiscent of a classical drama than a comic-book fantasy (see Foundas 2012). Nolan seemingly wanted to tell the origins of the Batman legend and his emergence as a force for good in Gotham in a manner that was far more connected to the real world than the somewhat 'camp' and 'compulsive weirdness' of Tim Burton's (1989, 1992) and Joel Schumacher's (1995, 1997) previous respective cinematic takes (see Turan 2005). Indeed, when *Batman Begins* (2005) was released, the words 'realism' and 'realistic take' were perpetually bandied about in the film's promotional spaces and press junkets.[6] But 'while the uses of the term "realism" imply specific approaches to performance, editing, characterization and narrative' in Nolan's *Batman* films 'they also express a broader and more significant meaning of no-nonsense masculinity' asserts Will Brooker, as Nolan transposed the very notion of realism to imply a more violent, and crucially more hyper-masculine kind of heroism (2012: 93).

Heralding a trend towards a darker Batman franchise, from this departure Nolan also broadened the gap between Bruce Wayne (Christian Bale) and Batman more than any of his predecessors. Other than several clashes with mob boss Carmine Falcone (Tom Wilkinson), depraved psychiatrist Jonathan Crane/ Scarecrow (Cillian Murphy) and a final climatic struggle with Henri Ducard/Ra's al Ghul (Liam Neeson) *Batman Begins* seems more concerned with Wayne's conflict with himself and expressing the difference between him and his imminent assimilation to Batman than any superhero battle with nefarious villains. Expressing himself as a dichotomy in order to save the

city and to save himself from detection and a seemingly more self-destructive and nihilistic revenge, Wayne fictionalises himself into a dyad of near-binary proportions and predicates the success of his desires on his enduring *performance* of *hyper*-decadent Wayne on the one hand and *hyper*-masculine Batman on the other.

On one half of the dyad, Wayne performs a hammy rendition of his decadent, 'feminised' billionaire playboy self, who in keeping with Nolan's anti-capitalistic position becomes reminiscent of Christian Bale's own satirical performance of hyper-yuppie Patrick Bateman in Mary Harron's *American Psycho* (2000). Built around the underpinning logic of the feminisation of labour and burgeoning yuppie idealisms, projecting a somewhat vulgarised concern for parties, women and material decadence, Wayne is also incapable of sanctioning autonomy and levelling any kind of justice. Whilst providing the, albeit rare, light humour in the film, such as the scene in which Wayne, posing as a playboy, pulls up to his party in a gaudy convertible with two scantily-clad models, the audience is encouraged to perceive Wayne as an object of ridicule. Indeed his decadence and white-collared tailored suits serve to be just as much of a cloaking device as his alter-ego's mask and costume. Pitching Wayne as an apex of materialism means that no one will suspect him of being the hyper-masculine hero Batman, whose intrinsic desires reach beyond his own, as Nolan impresses the idea that ascetic and altruistic qualities mark the authentic masculine hero, an effect that, as this essay examines, heightens as the *Batman* series continues.

Wayne's alter-ego Batman eschews the white collar, and with it its threatening effeminacy, for an obtusely gravelly voice and black suit of armour symbolising muscularity, physicality and action. Further, the material effect of Batman's mask, like the very idea of Batman himself, poses as a kind of freedom. He is a loaded space of masculine potentiality. Anybody could be under that costume. Co-screenwriter David S. Goyer asserts: 'What distinguishes Batman from his counterparts is that he's a hero anyone can aspire to. You could never be Superman, you could never be the Incredible Hulk, but anybody could conceivably become Batman' (quoted in Brooker 2012: 90). The press notes emphasise the point, describing the protagonist as 'a superhero with no superpowers [whose] ambitious quest to forge his mind and body into a living, breathing weapon against injustice inspires both fear and admiration' (ibid.). Iterating Nolan's underlining assertion, that any man can become the man they want to be, and that one can become a 'fiction' of oneself as something more, it is an intrinsic effect of the characterisation that perhaps attracted Nolan to the project in the first instance.

Beyond countering Wayne, Batman is of course also antithetical to yuppie desires of greed and self-interest *de facto*, and after saving rather than avenging the death of yet another woman in distress, Batman eventually becomes the 'more than just a man' Nietzschean 'ideal' both Ducard and childhood sweetheart Rachel (Katie Holmes) impress upon him at the very moment of his conception. 'This is not me... I am more,' Wayne, caught in the performance of himself, insists to Rachel. It becomes the underlining critiquing tenet – materialistic and feminised Wayne is *less* than Batman will ever be – until he is given in to grand pronouncements of masculine agency: 'it's not who you are underneath, it's what you do that defines you' and 'why do we fall...' sentiments.

Before returning to the *Batman* franchise, Nolan's next film, mystery thriller *The Prestige*, an adaptation of a Christopher Priest novel about two rival nineteenth-century magicians, Robert Angier and Alfred Borden, continues in the path of *Batman Begins*, ushering in a similar codified message in its conclusion. Starting as assistants for veteran *ingénieur* to stage magician John Cutter (Michael Caine), Angier's wife Julia (Piper Perabo) is accidentally drowned during a water escape illusion. Blaming Borden for her death, Angier relinquishes their partnership and conspires to avenge her (so far, so Nolan) by becoming the best illusionist and ruining the career of his former associate.

Several years pass and the two men eventually become two of the top performers in their field. However, spurred on by what appears to be a toxic mix of ego and the need to prove who is the greater man of magic, Angier and Borden spend the next few years trying to 'one-up' and counter each other, whilst Angier, undoubtedly the most sadistic of the two, insists on trying to find out how he can imitate and better Borden's mysterious teleportation trick. However, both men are complicit in taking their craft more seriously than perhaps it is moral and healthy to. The rivalry progresses far beyond Angier's anger or mourning and becomes a decidedly masculine search for superiority. The journey results in severed fingers, prison sentences, murder raps, suicides and the devastation of many people's lives, most notably their own, as Nolan takes the competitive masculine spirit to the most dramatic of extensions.

Duality also recurs as a major plot-point and thematic alongside the hyper-personal cat and mouse game, driven once again by the divisional binary of masculine/feminine. Sharing the same obsession for magic and pulling off the best trick (at one point they even share the love of the same woman) as one attempts to outdo the other, no matter what the cost, they become separated by *how* they eventually cross the line, with Borden realised as the film's victor in the outcome. It becomes a matter once again of illusion over truth. Borden, represented as possessing all the tenets of 'traditional' masculinity – he is hard working, utilitarian, pragmatic and doesn't mind 'getting his hands dirty' – creates the teleportation trick using his identical twin as his double. More than this, however, is that in order to avoid detection he *performs* his illusion to such a standard that he quite literally 'lives his act'. Alternating between magician and identical twin, they take it in turns to 'perform' at being each other both on and off-stage. *The Prestige* goes on to further press the proposition that identity is a malleable, performable entity, and that one can fictionalise oneself into something more if, as in this case, you can work hard enough to realise it.

Angier rather seeks to make the illusion a reality and thereby goes against one of the material desires of Nolan's cinema. Opting to *purchase* the transportation illusion, he buys his way into a reality that he can no longer deal with and spawns innumerable clones of himself – each time fracturing his sense of self whilst offering only a temporary promise of glory regulated by a deferred climax (he has to kill each of his clones mid-performance) – in so doing becoming a metaphor for the postmodern/capitalist condition.[7]

Nolan's preoccupation with male rivalry also means that *The Prestige*'s women once again become relegated to the status of vectors of male egotism, rivalry and passion,

with heterosexual love playing second fiddle to the homosocial obsession. Nolan's underlying message, set against the backdrop of this Victorian intertext, seems to be that self-mastery may ultimately poison and constrain our interpersonal relationships, but because he never really invests any time or interest in developing the latter, masculine quintessence is given precedence and is projected as the ultimate pursuit in this film, a pursuit, which like Borden's self-sacrificing craft, feels as though it is not critiqued but rather is celebrated in the fiction.

Taking a further step towards expressing identity dualities and continuing with the idea of the un-desirability of truth, Nolan returned to the *Batman* franchise with the hotly-anticipated sequel *The Dark Knight* in 2008. Just as it begins to appear as if Batman, Lt. James Gordon (Gary Oldman) and District Attorney Harvey Dent (Aaron Eckhart) are making ground in their unremitting battle against Gotham's criminal element, the wisecracking Joker (Heath Ledger) plunges the city into complete chaos. Once played by Cesar Romero and Jack Nicholson, this time Ledger dons the facepaint, complete now with visible scars, as Nolan presents a viscerally darker adversary than that of his somewhat 'camp' predecessors.

With the demons inside himself seemingly conquered, the dichotomous battle is now given over to the face-painted fiend who comes to represent the nihilistic, greedy and chaotic antithesis to Batman's stalwart discipline and direction. Though the Joker gives the film a 'real' semblance of terror and dread, allowing Batman once again to test his strength of character, masculine virility, autonomy and physical prowess against a formidable other, the film also induces a more subtle ideological code to the Joker's sense of aversion. The Joker provides 'a scarred face to the invisible logic of capitalism … pure desire without an object, paradoxically making the impersonal and invisible visible' asserts Charles Reece (quoted in Taylor 2010: 165). With his larger-than-life appearance, laughter, use and disposal of the 'working man' and his cutthroat attitude to 'business', in which he also leaves a trail of anonymous masked Jokers behind, the Joker brings to the film the normally repressed and invisible elements of the capitalist system. As the embodiment of the 'senselessness of the capitalist social system in which death and destruction are tolerated as long as they can feasibly be understood as part of a plan' (Taylor 2010: 165), the Joker asserts: 'nobody panics if it's all part of the plan … I'm an agent of chaos … and you know the thing about chaos … it's fair', confronting the function of the capitalist system and its rule.

Batman, however, attempts to undermine the Joker and with him this capitalist exposition as the series turns to distance itself even further from the decadent world of Wayne towards a more humanist, ascetic and 'hands on' (dare I even say 'blue collar') 'will to act' masculine heroism and projection of masculine prowess. It is a force that comes to a climax in the final instalment, examined below, when Wayne is finally made destitute. This also becomes accentuated in another plotline. The lives of both Batman and District Attorney Dent are shattered when Rachel, the woman they both love, is killed at the hands of the maniacal Joker. Not only is this yet another example of woman-as-catalyst, with Maggie Gyllenhaal seemingly struggling in what Bevan (2012) has pitched as yet another 'underwritten part' for a woman in Nolan's cinema, but the different ways in which the two men deal with this loss continues to expose the thematic detail.

Searching for retribution 'Dent sacrifices morality and choice for the flip of a coin … a plunge into a completely meaningless existence of pure contingency and nihilism' (Kellner 2010: 11). This marks his transition to villainy and leads his alter ego 'Two Face' to synthesise the same somewhat symbolically capitalistic chaotic irrationality as the Joker who in actual fact convinces him to turn to this trajectory in the first instance.[8] Batman, however, exudes what Frank Krutnik (1991) may call 'redeemed' masculinity, and in the climax overcomes his desire to kill the murderous Joker and hands him over to the 'agents of patriarchal law on the police force' (Gabbard 2004: 53), his heroism, rationality and masculine resilience all intact.

The thematic schema is also expanded to the wider recesses of the film. In a key plotline, the Joker announces to the passengers and crew of two ferryboats that he has placed bombs on each vessel and given each boat the detonator to the other's bomb. Promising that he will blow *both* boats up at midnight if neither boat destroys the other, the Joker assumes that, like himself, 'when the chips are down … civilised people [will] eat each other' and chaos will ensue. However, interplaying with stereotypes, the film reveals and then revels in the fact that neither party has the capacity to commit such atrocities and therein both are marked with a heroic sense of humanity and compassion. Here lies the same dramatic redemptive clause for Nolan: we can all become better, even if, as Dent suggests, it is increasingly impossible to be 'decent men in an indecent time'. But if the Joker is representative of the 'truth' of the system in which Gotham's inhabitants live, he must, like the truth of Harvey Dent, be vanquished before Gotham can find redemption in Nolan's cinema.

Indeed, *The Dark Knight* further extends the possibilities of the un-truth if, as in Nolan's previous films, it is an un-truth that is required to perpetuate a flow in a 'better' direction. Proceeding Dent's rampage on Gotham and subsequent murder of those who compromised or aided in the murder of his beloved Rachel, Batman decides to take the blame for the crimes committed by Dent/Two Face. As Žižek puts it, there is a 'need to perpetuate a lie in order to sustain public morale' underscoring Nolan's underlining message – sometimes 'only a lie can redeem us' (2011: 59).

After *The Dark Knight*'s success Warner Bros. signed Nolan to direct *Inception* (2010) where a corporate espionage group led by Dom Cobb (Leonardo DiCaprio) penetrate people's dreams to steal secrets. Desperate to return 'home' to his children and back to 'reality' (itself a mired concept steeped in ambiguity even beyond the closure), as a suspect for the murder of his wife (Marion Cotillard) Cobb is forced to embark on one final mission in a desperate quest for an elusive clean slate. This time though Cobb isn't harvesting an idea, but sowing one. With a crack team of hyper-masculine specialists, including 'point man' Arthur (Joseph Gordon-Levitt) and *identity forger* Eames (Tom Hardy), Cobb seems to have everything planned to perfection with the dream state also offering the subject a chance to 'dream bigger' and 'possess' more.

Their mission is complicated, however, by the sudden appearance of a malevolent foe that seems to know exactly what they're up to, and precisely how to stop them. 'An idea is like a parasite,' asserts Cobb. In *Inception* this parasite of course, in keeping with Nolan's seeming myopic sense of female malignity is yet another *femme fatale*. In fact it's Cobb's dead wife (!); a 'projection' that stalks his memory, feeding on his

guilt for planting the idea that she is no longer living in a 'real' dimension. Literally making his dreams unstable, her irrationality and malevolence makes her yet another in a long-line of untrustworthy female/feminine antagonists in Nolan's cinema. The saboteur of his fantasies, she stems Cobb's ability to fulfil his (masculine) destiny and disturbs the autonomous flow of his team's mission which can only be realised once he has fully rejected her and let her go, marshalling in once again Nolan's enduring dramatic clause. Even after unleashing prodigious male power fantasies with its expert application of action-movie tropes, *Inception* eventually returns to its metaphor, that we can create our own reality; memories, money, nor materialist feminising attachments do not matter, an effect which becomes hauntingly echoed in the lyrics of Édith Piaf's 'Non, je ne regrette rien', the 'kick' motif on the soundtrack.[9]

In 2012 Nolan directed his third (and final) Batman film, *The Dark Knight Rises*. Set eight years after Batman vanished into the night, taking blame for the death of Gotham's loved DA-turned-villain Harvey Dent and all of his crimes, the truth fictionalised for the greater good seems to have worked as the ensuing Dent Act has almost completely eradicated organised crime. Everything changes, however, with the arrival of a sly, morally ambiguous, cat burglar, Selina Kyle (Anne Hathaway) and the far more dangerous Bane (Tom Hardy), a masked mercenary terrorist whose ruthless plans for Gotham drive Bruce out of his self-imposed exile.

However, it seems that the formidable Bane is having his strings pulled by a higher force. Talia al Ghul (Marion Cotillard), daughter of the League of Shadows leader Ra's al Ghul, has taken up his mantle and patiently sought Gotham City's destruction with Bane as her ally. Masquerading as a wealthy businesswoman and philanthropist, she manipulates Wayne into thinking her cause is a peaceful one. But raised in 'The Pit', a prison dubbed 'the worst hell on earth … forged from suffering, hardened by pain', Talia's ideals stem rather from her ascetic past and destructive, decidedly austere upbringing.

Indeed, furthering Nolan's last *Batman* entry, the film seems to cast an even darker cloud not just over Gotham, but also over the very ideal of capitalistic morality. In a city divided by the rich and the poor, Bane incites Gotham's everymen to violently eject the rich and powerful from their homes. His takeover 'is accompanied by a vast politico-ideological offensive' asserts Slavoj Žižek (2012). Publicly exposing the cover-up of Dent's death he releases the prisoners locked up under his Act and promises to restore the power of the people, calling on Gotham's citizens to 'take your city back'.

Born and raised in that same dimly-defined eastern dank prison known as the Pit, Bane is positioned as Batman's (or rather Bruce Wayne's, as Bane uncovers and understands him) dichotomous – rich/poor, decadent/afflicted – other. Indeed, while the film seeks a realistic portrayal of a hero without superpowers, we cannot ignore that Wayne/Batman is preternaturally wealthy. He fights crime with his fists but also with an array of his *own* million-dollar technology. Meanwhile Bane *only* threatens Gotham with his fists and a more obliterating destruction through a *stolen* nuclear device, 'acquired' in fact from Bruce's billion-dollar corporation itself. As a consequence of these two opposing positions where Batman appears antagonistic to Nolan's vision of masculine prowess, Nolan upsets the dichotomy and creates a permeable balance

in order to perpetuate his thematic desires. On their first encounter, in a desperate, no-holds-barred fight, Batman loses to the *superior man*/fighter, and Bane breaks his back and his spirit, after of course breaking his bank balance.

Indeed, for Batman to defeat Bane and seemingly for Nolan to end the franchise perhaps in the way he desired, he must completely absolve himself of the 'truth' of Wayne and all of his ancillary material possessions and commodities. Thrown into the *same* hell that Bane came from, the un-masked Wayne (not Batman) must rebuild himself with several months of *physical* therapy. In short the Batman/Wayne masculine/feminine divide collapses in on itself and following this dynamic of course it is only when Bruce has *lost* the *security* of the rope to break his fall, that he can escape his prison and pursue restoration. Batman/Wayne returns to Gotham, where problems once again are solved by violence. Now recharged and emerging as a truly ascetic hero, he engages Bane in more violence, and aided by Selina Kyle, he triumphs and goes on to do the same with Talia. This more austere Batman can also now save the city from the threat of nuclear annihilation by locating his own bomb and carrying it a safe distance away and with it the terror of (Wayne's) capitalism. The bomb explodes, apparently taking Batman with it. But this is another un-truth for the audience. Bruce has faked his own death, and that of his alter ego.

Just to cement the logic of ascetic heroism Bruce makes no move to heal the financial injuries he sustained or to recover the power with which he could do some structural good in a city that has spent six months under a terrorist siege. Though Wayne's parents were philanthropists, for Nolan the death of Batman provides people with enough of an example of heroic (masculine) sacrifice, albeit one that turns out to be every bit the lie that Harvey Dent's martyrdom was. Instead of doing structural good to heal his city (aside from giving his decadent home to Gotham's orphans), Batman fixes his back, hits more people and then takes off. But this is the point – money can't heal this broken city/world, just as his father's death has proved. Only un-truths, self-fictionalising and a little muscle can save the day.

In the more transparent recesses of gender play, yet again the driving philosophy on display in *The Dark Knight Rises* might be called 'masculine'. The film is about will, and power, and tropes traditionally associated with men. *The Dark Knight Rises* continues using women as symbols, not characters. Talia acts merely as an extension of her father. Selina Kyle, though seemingly remarkably self-assured, is eventually domesticated and serves, at the end of the film, to symbolise how Bruce Wayne can now get on with his life, to the joy of his surrogate patriarch, Alfred (Michael Caine).

Nolan's latest film *Interstellar* (2014) continues to feature his thematic exposition of dramatic un-truths and interplays with masculine quintessence, as yet another protagonist with a wife deceased before the story opens takes to the screen in a cinematic tale of stoic masculine heroism. Telling the tale of a not-so-distant humanity on the brink of starvation in a world increasingly inhabitable in the wake of overwhelming dust storms and blight, a series of 'ghost-like' apparitions eventually lead decidedly blue-collar NASA-trained pilot and engineer Cooper (Matthew McConaughey) to take off onboard the aptly-titled Endurance to find more habitable planets, leaving his farm, father-in-law Donald (John Lithgow), fifteen-year-old son Tom (Timothee

Chalamet), and ten-year-old daughter Murph (Mackenzie Foy) behind, in what seems to be a real celebration of the masculine (final) 'frontier' pioneer spirit.

Despite two solid performances from Jessica Chastain as the adult Murph and Anne Hathaway as Dr. Amelia Brand, *Interstellar* seems void, yet again, of the female perspective. Brand's mother, like Murph's, is also deceased before the story begins as the film truly denies any maternal perspective in the film. Both the heart and the instinctual (characteristics usually associated with the feminine ideal) are abandoned for scientific reason and so-called 'masculine rationality'. Indeed not only does Cooper reject Brand's plea to follow her heart and go to the planet where her lover Edmunds has settled – a decision that proves near fatal and catastrophically inept – Murph's instinctual reflexes and conjectures are also rejected as irrational, weak and childish in early stages of the film as the female perspective and position, once again, is under-represented and casually discarded in Nolan's cinema.

## Conclusion

As Joseph Bevan (2012) noticed, Nolan's anti-heroes only survive by learning to fictionalise themselves into something more than reality. *Memento*'s Leonard Shelby deliberately uses his amnesia to trick himself into forgetting the truth. Borden in *The Prestige* lives his life in its entirety as a kind of illusion. In *Inception*, Cobb plunges into the depths of dreamed realities and into dreamscapes of unimaginable possibilities. And *Batman*'s Bruce Wayne, the masquerade *par excellence*, dons the Batsuit to (re)-present a hardened, masculine exterior protecting and escaping the feminised and 'less than a man' vulnerability of the character beneath. The closing line of *The Dark Knight* perhaps spells out the underlining dialectic in Nolan's cinema: 'Sometimes the truth isn't good enough. Sometimes people deserve more,' as Nolan cinematically projects his anti-heroes as agents of the masculine crisis and the postmodern condition.

In fact, as this essay has examined, the only two heroes who perhaps deserve more but don't get it are to be found in Nolan's feature debut *Following* and his third offering *Insomnia*, where, unable to fictionalise themselves into 'something more', the Young Man and Detective Dormer respectively fall flat of Nolan's proposition and eventually become consumed by their 'condition'. Nolan's cinema then appears to be one of hope, even if it places that hope in hyperreal worlds and fictional dimensions on the edges of civilisation. Nolan suggests that even in these 'indecent times' one can become *more*: 'but if you make yourself more than just a man, if you devote yourself to an ideal, then you become something else entirely.' 'Which is?'

'A legend, Mr. Wayne.' (*Batman Begins*)

## Notes

1  For a film that circumvents the notion of consumer-era depersonalisation, reducing the protagonist and in fact all other characters in the film to a function of discourse or aesthetic trope – 'The Young Man', 'The Blonde', 'The Bald Guy', 'The Policeman' and so on – is a highly suggestive proposition.

2   *Following* itself was inspired by Nolan's real experience of having his flat broken into and disturbed (see Bevan 2012) and may therefore also be, at least in part, a reflection of a disturbance or disruption in Nolan's masculine volition.

3   From offering Leonard a beer with a considerable amount of her phlegm in it, to having him beat up the mysterious Dodd (Callum Keith Rennie), Natalie cynically takes advantage of Leonard's debilitating condition. She also takes delight in telling Leonard to his face that she will use and abuse him knowing that he will forget the encounter in the not so distant future.

4   Like Leonard, in Greek mythology Sisyphus of course was condemned forever to pursue a perpetually failing task; to roll a huge stone up a hill in Hades, only to watch it roll back down on nearing the top, and to repeat this action forever.

5   The insomnia trope is again curiously reminiscent of David Fincher's *Fight Club*, where Dormer's insomnia, like the Narrator's, is seen as a reflexive physiological outcome to a deadening 'feminising' anxiety. Also marking this conflict is female rookie officer Ellie Burr (Hilary Swank) who comes to investigate Dormer's role in the shooting of his partner, Eckhart. However, mesmerised by Dormer as 'the homicidal star from the big city' (French 2002), for the most part she rather poses as a projection, seeming to merely hold the mirror to Dormer's esteem.

6   See Andrew Pulver's (2005) 'He's not a god – he's human' interview with Christopher Nolan for some of the promotional ethics and concerns for *Batman Begins*, for example.

7   See McGowan (2007) for a more detailed proposition of *The Prestige*'s seeming congenital thematic relationship with capitalism.

8   Dare I even say it's a motion also marked in essentialist gender dogma. Masculinity and virility correlate to control, mastery, autonomy, rationality and morality, with 'femininity' understood as the relative absence of those things, asserts Gilmore (1990) and therefore he may be seen also seen as a more direct embodiment of feminine terror.

9   The key lyrics reading, *I don't care of the past anymore, I set my memories on fire, My agonies, and my pleasures, I don't need them anymore, Swept away in the agonies of love, Swept away forever, I'm restarting with nothing…* (translated from French). Nolan appears to utilise the lyrical content of Piaf's anthem to further pursue his message of reinvention and the promise of renewal.

*Bibliography*

Bevan, Joseph (2012) 'Christopher Nolan: Escape artist', *Sight & Sound*, 8 July. Online. Available: http://www.bfi.org.uk/news-opinion/sight-sound-magazine/features/christopher-nolan-escape-artist (accessed 29 September 2013).
Bly, Robert (1991) *Iron John*. Rockport, MA: Element.
Brooker, Will (2012) *Hunting the Dark Knight: Twenty-First Century Batman*. London: IB Tauris.
Connell, R. W. (1995) *Masculinities*. Cambridge: Polity Press.
Faludi, Susan (1999) *Stiffed: The Betrayal of the Modern Man*. New York: William Morrow.

Foundas, Scott (2012) 'Cinematic Faith', *Film Comment*. November/December. Online. Available: http://filmcomment.com/article/cinematic-faith-christopher-nolan-scott-foundas (accessed 20 August 2013).

French, Philip (2002) '*Insomnia*', *The Guardian*, 31 August. Online. Available: http://www.theguardian.com/film/2002/aug/31/philipfrench (accessed 10 November 2013).

Gabbard, Krin (2004) *Black Magic: White Hollywood and African American Culture* New Brunswick, NJ: Rutgers University Press.

Gilmore, David. D. (1990) *Manhood in the Making: Cultural Concepts of Masculinity*. New Haven, CT: Yale University Press.

Gornick, Vivian (1971) 'Woman as Outsider', in Vivian Gornick and Barbara K. Moran (eds) *Woman in Sexist Society*. New York: Basic Books, 137–44.

Jenson, Jane, E. Hagen and C. Reddy (eds) (1988) *Feminisation of the Labour Force: Paradoxes and Promises*. Cambridge: Polity Press.

Kellner, Douglas (2010) *Cinema Wars: Hollywood Film and Politics in the Bush-Cheney Era*. Oxford: Wiley-Blackwell.

Kravitz, Bennett (2004) 'The Culture of Disease and the Dis-ease of Culture: Re-membering the Body in *Fight Club* and *Memento*', *Studies in Popular Culture*, 26, 3, 29–48.

Krutnik, Frank (1991) *In a Lonely Street: Film Noir, Genre and Masculinity*. London: Routledge.

McGowan, Todd (2007) 'The Violence of Creation in *The Prestige*', *International Journal of Žižek Studies*, 5, 1, 3, 1–31. Online. Available: http://www.zizekstudies.org/index.php/ijzs/article/view/58/120 (accessed 4 July 2014).

Mercer, Kobena (1990) 'Welcome to the Jungle: Identity and Diversity in Postmodern Politics', in Jonathan Rutherford (ed.) *Identity: Community, Culture and Difference*. London: Lawrence and Wishart.

Pulver, Andrew (2005) 'He's not a god – he's human', *The Guardian*. 15 June. Online. Available: http://www.theguardian.com/film/2005/jun/15/features.features11 (accessed 21 January 2015).

Schuker, Lauren A. E. (2008) 'Warner Bets on Fewer, Bigger Movies', *The Wall Street Journal*, 21 March. Online. Available: http://online.wsj.com/news/articles/SB121936107614461929?mg=reno64-wsj&url=http%3A%2F%2Fonline.wsj.com%2Farticle%2FSB121936107614461929.html (accessed 28 October 2013).

Taylor, Paul A. (2010) *Žižek and the Media*. Cambridge: Polity Press.

Turan, Kenneth (2005) 'Wholly Rebound', *LA Times*. 14 June. Online. Available: http://articles.latimes.com/2005/jun/14/entertainment/et-batman14 (accessed 11 November 2013).

Windrum, Ken (2004) '*Fight Club* and the Political (Im)potence of Consumer Era Revolt', in Steven Jay Schneider (ed.) *New Hollywood Violence*. Manchester: Manchester University Press, 304–17.

Žižek, Slavoj (2011) *Living in the End Times*. London: Verso.

_____ (2012) 'The politics of Batman', *New Statesman*, 23 August. Online. Available: http://www.newstatesman.com/2012/08/people's-republic-gotham (accessed 17 September 2013).

# Representing Trauma: Grief, Amnesia and Traumatic Memory in Nolan's New Millennial Films

## Fran Pheasant-Kelly

### Introduction

A consistent preoccupation of Christopher Nolan's films is the psychological afflictions of their male protagonists, who variously experience flashbacks, hallucinations, amnesia or hyper-vigilance, and whose signs of emotional damage often stem from grief or guilt. However, mental trauma is not only a trait of Nolan's films but is discernible across a range of genres, with a noticeable surge of psychologically disordered male characters in films of the new millennium. Akin to their post-war *noir* predecessors, such representations of masculinity suggest that the unstable mental state of the twenty-first-century protagonist may relate to the effects of a post-9/11 milieu. What makes Nolan's oeuvre distinctive is that his new millennium films tend to be foregrounded by this feature, to the extent that mental aberration governs the narrative, thereby implying such characterisation as an authorial tendency. As Will Brooker notes, 'Nolan's authorial interest in psychological drama, his recurring themes of fear and memory and his characteristic experiments with narrative have now become established traits' (2012: 22).

Even when trauma is not an orchestrating aspect, it remains an underlying theme (for example, a significant focus of *The Prestige* (2006) is deceit, yet traumatic events punctuate its narrative). Indeed, unlike many other productions made since 9/11, it is not possible to attribute the presence of trauma in Nolan's new millennial productions solely to their post-9/11 contexts since *Memento* was released in 2000. If the presence of trauma is consistent within Nolan's canon, then arguably, it relates to the *noir*ish tendencies of his films, which frequently involve the death of the protagonist's wife, as in *Memento, The Prestige, Inception* (2010) and most recently *Interstellar* (2014). One might therefore propose that the emergence of the psychologically afflicted

male in Nolan's films contributes to an already established crisis in masculinity which happens to coincide with his predilection for narratives involving ambiguous identity and mental disorder. More specifically, this essay argues that Nolan's signification of trauma is connected to his concerns with uncertain identity, in the way that perpetrator guilt and victim trauma overlap. There are links between trauma and identity in that, as Roger Luckhurst states, 'trauma disrupts memory, and therefore identity' (2010: 1). The perpetrator/victim trauma binary and its associated blurring of good and evil also accommodates post-9/11 political issues, aspects that clearly emerge in *The Dark Knight* trilogy (2005, 2008, 2012) and which suggest a further influence on Nolan's inclination for traumatised characters. A particular repercussion of such characterisation is a proclivity for confusing, often multi-stranded narratives that variously unwind in reverse, in parallel, or otherwise repeatedly revisit the past through flashbacks. There is therefore growing scholarship on Nolan's films as 'mind game' narratives (see, for example, Elsaesser 2009; Brown 2014; Buckland 2014; King 2014; Panek 2014) as well as a focus on their philosophical and psychoanalytic aspects (see Fisher 2011; Johnson 2011; Russo 2014) and a second overarching theme, that of deceit (see McGowan 2012). Otherwise, scholarly attention has targeted, specifically, the groundbreaking narrative of *Memento* (see Kania 2009; Molloy 2010) heralded for its disorientating effects, the innovative spatio-temporal disruptions of *Inception* (see Cameron and Misek 2014) and the aesthetically rejuvenated Batman trilogy (see Pheasant-Kelly 2011; Brooker 2012). Whilst such studies often incidentally reflect on the aberrant mental states of the main characters, there is limited focus on the various representations of trauma, unusual since it is such a dominant aspect of Nolan's films. Engaging theoretically with trauma studies, including those of Luckhurst (2008, 2010), Richard McNally (2003) and Laurence Kirmayer *et al.* (2007), this essay therefore considers Nolan's films in respect of their traumatic preoccupations.

In this regard, *The Prestige* merits limited attention since it is less obviously concerned with the signification of trauma, although it too has an underpinning theme of ambiguous identity and has tragic undercurrents. Stuart Joy suggests that the film 'communicates trauma through a process of thematic, technical and visual repetition that is linked to the subject of the unconscious that Jacques Lacan (1977) defines being a "lack" or gap that emerges in the field of the Other' (2014). For Joy, repetition partly manifests in relation to the third part of a magician's trick, the eponymous prestige, which refers to the restoration of an object that has been made to disappear. Throughout the film this mostly involves the 'reappearance' of an individual, but on several occasions there is a failure for this to happen as a result of the individual's death. While the various characters do not especially display symptoms of traumatic disorder, the wives of the protagonists die, one as a result of suicide, the other during a magician's trick which goes awry. The distress of these events helps trigger the respective obsessions of the two protagonists, Robert Angier (Hugh Jackman) and Alfred Borden (Christian Bale) to out-compete each other, leading to their deaths too. The film further concerns itself with physical disability, with several close-ups of Borden's injured hand, and low-level shots of Angier's damaged leg. It therefore fits a general trajectory of cinema's doomed post-millennial masculinity,

which, in this case, is mediated through physical damage (another post-9/11 film trope) as well as psychological trauma.

Although acknowledging these traumatic preoccupations as potentially indicative of Nolan's status as auteur in relation to a common theme of confused identity, and as the latter end of an on-going crisis in masculinity which is readily discernible in past films more generally, such representations are therefore also located within discourses of masculinity, terrorism and grief, as relevant to the films' narratives and/or their post-9/11 zeitgeist.

*Masculinity in Crisis*

In contextualising the traumatised male protagonist of Nolan's post-millennial films, account needs to be taken of the aforementioned crisis in male identity that emerged several decades ago and became apparent in various forms of popular culture. For example, Sally Robinson notes that, 'post-sixties American culture produce[d] images of a physically wounded and emotionally traumatized white masculinity' (2000: 6) with her argument drawing on a range of literary and filmic texts. Harry Benshoff and Sean Griffin too identify representations of failing masculinity in several late 1960s' and 1970s' Hollywood films whose narratives signalled the decline of masculinity, arguably reflecting failures and losses in the Vietnam War; they also refer to a particular category of films that they define as 'dumb white guy comedies' (2009: 300) which include films such as *Dumb and Dumber* (Farrelly Brothers, 1994) and the *Pirates of the Caribbean* franchise (Gore Verbinski 2003, 2006, 2007; Rob Marshall, 2011). Benshoff and Griffin contend that these representations satirise masculine prowess and, at the same time, 'ask audiences to laugh at their nerdish characters' failed masculinity, a process that still upholds those same ideals as natural and desirable' (ibid.).

In respect of Nolan's films, Claire Molloy suggests that 'one reading that *Memento* makes possible is the suggestion that memory loss is a form of symbolic impotence which functions to offer a commentary on contemporary masculinity' (2010: 94). A number of canonical works have documented this visual trend of the male body in crisis, including those of Jonathan Rutherford (1992), Yvonne Tasker (1993) and Susan Jeffords (1994). Reflecting on the post-war generation, Rutherford suggests possible reasons for the source of this tendency: 'The narratives of masculinity which had belonged to their fathers' generation no longer seemed tenable in the years after 1968. Feminism, gay affirmation and a growing cultural diversity dislocated the cultural and inter-personal authority of masculinity and heterosexuality' (1992: 2–3). Overall, therefore, the presence of the psychologically troubled male in film not only reflects recent events but also comments on male identities previously threatened by a range of issues that were arguably triggered by losses in Vietnam. In the wake of the 9/11 attacks (the event itself often described as emasculating), this beleaguered masculinity has been beset still further; first, by revelations of detainee abuse at Guantánamo by US soldiers; second, by continuing terrorism and the associated 'war on terror'; and finally, by the current global economic recession.

Consequently, following the events of 9/11, an extensive range of genres have increasingly featured traumatised male protagonists. From *Shutter Island* (Martin Scorsese, 2010) through to the *Harry Potter* franchise (various directors, 2001–11) emotionally troubled characters abound. This focus on characters' unstable mental states and harrowing pasts arguably reflects a rising awareness of trauma following 9/11 and its subsequent expression in cinematic works. Such attention has prompted numerous post-millennial studies of trauma, including those of Janet Walker (2001), Judith Greenberg (2003), Richard McNally (2003), Susannah Radstone (2003), E. Ann Kaplan (2005), Nico Carpentier (2007), Roger Luckhurst (2008, 2010), Michael Roth (2012) and Meera Atkinson and Michael Richardson (2013). These have contributed to and built on trauma literature expressly instigated by earlier atrocities, including the two World Wars, the Vietnam War, the Rwandan genocide and the Holocaust, as well as increasing reports of child abuse since the 1970s; see, for example, Shoshana Felman and Dori Laub (1992), Cathy Caruth (1996), Judith Herman (2000) and Ruth Leys (2000). The more recent academic turn to trauma (and trauma cinema) is likely not only a result of the immediate experience of the September 11 attacks (and vicarious possibilities in their mediatisation), but also because of reports of the mental distress endured by army combatants returning from operations in Iraq and Afghanistan, with studies documenting that 20–40 per cent of returning US military personnel experienced mental health symptoms (Hoge *et al.* 2006). Moreover, according to Roger Luckhurst, cinema offers 'a key means for the temporalization of experience in the twentieth century and its specific stylistic devices (*mise-en-scène*, montage, conventions for marking point of view and temporal shifts in particular) have made it a cultural form closely attuned to representing the discordances of trauma' (2008: 177).

Even so, one of the difficulties in conveying trauma in visual culture is its generally acknowledged unrepresentability. In this respect, Slavoj Žižek (2002) adopts psychoanalytical terminology to discuss trauma as an example of the Real, which he compares to the Symbolic, the world that is understood through words and images rather than through lived experience. In relation to the latter, Žižek situates the Real as a less tangible concept because it entails an experience of something that cannot be visualised, including, for example, grief, hunger and trauma. One can therefore only imply trauma or suggest suffering – and film achieves this by means of a specific and often unique vocabulary. This language of trauma principally involves the flashback, a concept that was adopted from cinema by psychologists and has been examined at length by several film scholars, notably Maureen Turim (1989). Because the flashback involves a disturbance of narrative linearity, the spectator is taken back and forth in filmic time. As noted earlier, Nolan is particularly susceptible to conveying trauma by disrupting temporality, and complicating narrative structure – for example, *Memento* uniquely unfolds in a reverse spiralling form whilst *Inception*'s density arises from the fact that its three narrative strands unfold simultaneously, with each strand progressing at different rates. Additionally, Nolan depicts the psyche of Dom Cobb (Leonardo DiCaprio), *Inception*'s troubled male protagonist, as a multi-layered series of spaces.

Only when accessing the deepest level of his unconscious mind do we encounter the source of his traumatic memory. In other words, Nolan utilises the concept of regression as a novel narrative and visual device.

Nonetheless, as illustrated by the aforementioned examples, the most common means for cinema (and for Nolan) to represent an individual's trauma is through subjective flashbacks, thereby indicating one of trauma's most significant facets, namely, the unassimilated nature of the original event. As trauma theorist, Cathy Caruth explains, 'trauma is not locatable in the simple violent or original event in an individual's past, but rather in the way that its very unassimilated nature – the way it was precisely *not known* in the first instance – returns to haunt the survivor later on' (1996: 4; emphasis in original). The inability to integrate distressing events causes the traumatic memory to replay repeatedly as flashbacks and hallucinations, which are typically 'sudden, unbidden, emotionally intense sensory experiences (such as visual images or smells) that seemingly reinstate the sensory impressions that occurred during the trauma' (McNally 2003: 13). (Obviously, only the visual and aural aspects of flashbacks can be expressed cinematically.) The term 'flashback' itself was mentioned in *Variety* in 1916 (see Turim 1989: 3) so has a long lineage in film, and precedes its psychoanalytical application. Implicitly, flashbacks refer to memory but it is how these flashbacks are conveyed that gives information on their nature – in other words, whether they are presented as traumatic memories (chaotic and fragmented), flashbulb memories (clear recollections of what one was doing at the time of a significant event), normal recollections (coherent, undistorted and often depicted as monochrome or sepia-toned visuals) or as repressed memories (which are only made accessible through therapy). In most cases, aspects of the *mise-en-scène* or cinematography therefore give clues to their type. For instance, Nolan's *Dark Knight* trilogy typifies the use of flashback as traumatic memory, an aspect that is especially mobilised in *Batman Begins*. In the film's opening sequence, disturbing imagery of bats, concealed by darkness, and a rapidly edited montage of images clearly convey the events of the flashback as a traumatic experience to the child character, Bruce Wayne (Gus Lewis). Added to this, Nolan's depiction of the child figure activates a sense of trauma more fully to the viewer since the threatened or lost child is a particularly emotive trigger.

*Grief, Amnesia and Traumatic Memory*

Aside from eliciting sudden disturbing memories, trauma may otherwise result in a repression of the past to the extent that the sufferer may have no recollection of the original trauma, or there may be complete avoidance of thoughts concerning the event. In this case, the effects of trauma are even more difficult to portray, although Nolan successfully mimics the consequences of memory loss in *Memento* by disrupting the causal-logic of the narrative. In extreme cases of trauma, psychogenic amnesia may result, a condition characterised by 'sudden onset in response to stress, inability to remember precipitating events, loss of personal identity and extensive retrograde amnesia' (McNally 2003: 187). Alternatively, trauma may manifest as hyper-vigilance where the sufferer is in a constant state of alertness (see Luckhurst 2008: 1). This

collection of symptoms forms the basis for diagnosis of post-traumatic stress disorder (PTSD), a term formally adopted in 1980 by the American Psychological Association following the prevalence of such symptoms in Vietnam veterans. Even though the symptoms of PTSD are diverse, their common denominator is an extreme, unexpected stressor that is 'outside the range of normal human experience [including] war experience, natural and man-made disasters, rape and sexual abuse and other significantly stressful events' (Hunt 2010: 52). As Susannah Radstone explains, 'it is the unanticipated, unimagined quality of certain events that renders them so shocking. The mind has not prepared itself for an event that traumatizes' (2003: 119). To complicate the picture still further, symptoms may not only arise in the victim of trauma, but may also occur in the perpetrator, usually as a product of guilt. The effects of trauma on the perpetrator differ significantly from those suffered by the victim and will be explored more fully in relation to *Memento* and *Insomnia*.

*Perpetrator Guilt and Victim Trauma in Memento and Insomnia*

The precipitating traumatic event in Nolan's first post-millennial production, *Memento*, is the death of the protagonist's wife (Jorja Fox), who has been allegedly murdered and raped by an unknown assailant, thought to be known as 'John G.'. The film typifies the trauma-based, mind-game film because of the fractured memory of amnesiac protagonist Leonard Shelby (Guy Pearce), and its reversed narrative. Although learning that Shelby has suffered brain injury (during the simultaneous assault on his wife), which has since led to an inability to form new memories, by the film's end, the spectator realises that memories of events that occurred prior to his wife's death are also distorted, suggesting additional psychological causes for his memory loss. Richard McNally explains the differences between organic amnesia, arising from damage to the brain, and psychogenic amnesia caused by emotionally disturbing events (2003: 186–7). An inability to remember events before the causative incident is termed retrograde amnesia, and an inability to remember those after it is termed anterograde amnesia. As noted previously, classic psychogenic amnesia involves extensive retrograde amnesia and does not usually involve anterograde memory problems whereas organic amnesia may do (2003: 187).

Therefore, even though Shelby is clearly traumatised by his wife's death, his symptoms are not wholly psychogenic – he does not suffer identity loss (merely confusion), he can remember the precipitating event, and initially, he seems to recall everything prior to her murder. However, his inability to form short-term memories means that he does not remember that his wife survived the rape and, in fact, the film raises the possibility that it was he who inadvertently killed her with an overdose of insulin (because he could not recall administering the first dose and so repeated the dosage). Nonetheless, believing that someone else has murdered her, Shelby takes photographs of potential suspects and accomplices, and writes himself messages in order to accumulate evidence and locate the 'killer'. Because of its reversed narrative, the film begins at the end, with Shelby shooting the man he thinks has killed his wife, the bloody aftermath of this scene apparent before its precipitating circumstances then unwind. This

sequence entails a montage of forensic images including close-ups of blood-spattered spectacles, a used gun cartridge and a man's body, followed by the seemingly impossible reverse flight of a gun into Shelby's hand, which further establishes the film's reversal strategy. A close-up of a hand holding a Polaroid of the crime scene, which then slowly fades to white, also prefigures Shelby's amnesia (these photographs forming part of his 'evidence' and also 'standing in' for memory). Additionally, the film's process of rewinding indicates the backwards-spiralling narrative, which is retold through flash-backs. The flashbacks (which move forward linearly within their historical timeframe), dominate the narrative, and are in colour to differentiate them from short expositional sections that also move forwards temporally (but in real time) and are filmed in black and white. The first of these discloses Shelby in a hotel room, the use of long shot indicating his mental (and resultant social) isolation while the lack of context, together with Shelby's inability to explain his location, convey immediate confusion. The black and white sections include Shelby's voiceover to explain his system of writing everyday tasks on himself or on notes and photographs as a reminder of what he has already learnt. In rendering visible connections to the source of his grief, this *mise-en-scène* is thus an important aspect of signifying trauma. Particularly disturbing are the messages that Shelby has tattooed on his body, to the extent that he is covered in text – and a mirror reflection persistently returns to the words 'John G. raped and murdered my wife' inscribed across his chest. Shelby also constantly repeats himself because he cannot remember what he has already said – and so displays both repetitive behaviour and speech. As noted earlier, the structure of the film accentuates such repetition since each colour fragment partly overlaps and the spectator too therefore experiences a sense of *déjà vu*. For instance, although the opening credits feature the killing of his wife's supposed assailant, Teddy (Joe Pantoliano), the next segment of the film starts a little earlier and gives the contexts that lead up to Teddy's shooting. Because the causal logic is disrupted, the spectator, like Shelby, experiences sustained uncertainty throughout the film and it is not until the closing scenes that we learn of the possible cause of his wife's death (although this remains ambiguous).

Though the narrative assumes the guise of an investigation, the way in which Shelby attempts to reconstruct the sequence of events and come to terms with his experience of loss corresponds with interventions for the treatment of trauma, which generally rely on re-integrating the traumatic event through re-exposure and re-narrativisation (see Foa *et al.* 2009). This is due to the fact that even though episodes of acute trauma (such as torture, bereavement and rape) are usually remembered extremely vividly by survivors, trauma narratives are often fragmented. In other words, there are gaps in the chain of events, with memory becoming focused on the most trau-matic aspects. As McNally observes, 'the psychiatrist Bessel van der Kolk believes that the emotional intensity of trauma often makes it hard for survivors to piece together a coherent narrative of what happened' (2003: 135). Even though Shelby has clear recall of certain events that are coherent and fully articulated in flashback (rather than being incoherent traumatic memories), there are instances when the spectator experiences acutely fragmented flashes of the attack on his wife. These are presented as a montage of fleeting chaotic images, comprising first, a shadow passing under a

closed door, a close-up of her gasping mouth under a translucent shower curtain, and then the masked intruder. On occasion, this sequence forms one of Shelby's nightmares and seems to tally exactly with his recall of the murder. In this respect, the replication of trauma as nightmare corresponds with accounts of post-traumatic stress disorder (see McNally 2003: 108). McNally goes on to report one study (by Edna Foa) that defines narrative fragmentation as, 'repeated phrases, speech fillers, and unfinished thoughts that disrupted the smooth flow of the story' (2003: 135). Therapy usually aims to reconstruct a coherent narrative through treatments such as hypnotherapy and narrative exposure therapy. Here, the process of reassembling the notes, photographs and messages inscribed on Shelby's body into a logical story, with their accompanying revelations, also seeks to impose a coherency on the imagery and hence, on Shelby's traumatic memory. The notes and images are therefore more than merely a narrative device and are important in the signification of Shelby's trauma – first, recording the various events that have affected him functions as a form of testimony. As Laurence Kirmayer, Robert Lemelson and Mark Barad note, narratives told by the sufferer are important in dealing with trauma when they 'are witnessed and acknowledged by others' (2007: 15). Second, Shelby's constant reiteration of the facts is itself an attempt not only to understand what happened to his wife, but arguably indicates an attempt at mastery of the situation (traumatised individuals may display compulsive and repetitive behaviour). Finally, the nature of the narrative, with its fragmented flashes, reversals and unreal nature offers an insight into the experience of disassociation as a traumatic feature. According to Kirmayer *et al.*, 'in addition to symptoms related to fear and anxiety, the psychological consequences of trauma may include disturbances of memory, identity, and perception termed *dissociation*' (2007: 7; emphasis in original). McNally explains that dissociative symptoms include, '*derealization*, a strange, dreamlike sense that one's surroundings are unreal; *depersonalization*, a sense of being disconnected from one's own body; a sense that time is either slowing down or speeding up; and *amnesia*, an inability to recall important aspects of what happened' (2003: 172; emphasis in original). The spectator often gains an impression of a similar unreality in *Memento*, first because of the disjuncture between colour and black and white episodes, and second, because it is impossible to monitor time due to the reversing narrative. Indeed, Shelby comments specifically on his failure to grasp a sense of time, and its relationship with grief, stating, 'how can I heal if I can't feel time'. Thirdly, there is a sense of disconnectedness in the way that Shelby, other characters, and spectators alike repeatedly view his figure in reflection. Narratively, this strategy enables the viewer to read the messages tattooed in reverse on his body, and stylistically, accentuates tropes of *noir*, but cognitively, provides a disembodied view of him as an individual. In sum, the mediation of psychological trauma, which is compounded by cerebral injury, is achieved by the combination of sudden flashbacks and a reversed narrative told subjectively from a protagonist who is both victim and perpetrator. The repetition of scenes and dialogue, the colour/monochrome binary and fragmented montages of rapidly edited sequences give the impression of dissociative traumatic memory and its related confusion. In addition, slower-paced cinematography and framing, such

as the use of long shot, signify the protagonist's isolation whilst the unreliability of memory is made evident by the way that Shelby's apparently normal recollections are contradictory. For example, he idealises his wife and comments, 'to me she was perfect'. However, a series of ethereal images of her, during which there is no sound, contrasts with another remembered sequence during which she says to Shelby, 'don't be a prick' – shattering the illusion that Shelby's memories had previously created. Significantly, he is also unable to remember that his wife was a diabetic, and a flashback of him inserting a needle into her thigh is then replayed as if he is pinching her thigh, indicating the fallibility of his recall, though it is not made clear whether this is simply an error on his part or the wilful repression of memory arising from the possibility that he is the perpetrator.

As in *Memento* the protagonist of *Insomnia*, Will Dormer (Al Pacino), also has a guilt-ridden past. Like Shelby, Dormer, a police officer who arrives in Alaska with colleague Hap Eckhart (Martin Donovan) to help solve the case of a murdered school-girl, also displays signs of victim trauma. Dormer's guilt arises from two sources: first, the falsification of evidence in an earlier case that secured the conviction of a murder suspect whom he also believed to be a torturer and paedophile; second, the accidental shooting of his colleague, Eckhart, during the investigation of the Alaska murder case. The accident occurs during the chase of Walter Finch (Robin Williams), who is suspected of the schoolgirl's murder, a situation which initially leads the investigating officer, Ellie Burr (Hilary Swank), to believe that Finch also shot Eckhart. Unbeknownst to Dormer, Finch witnessed Eckhart's shooting and therefore blackmails Dormer. Principally because of guilt (but also affected by the light summer nights of arctic Alaska), Dormer is unable to sleep and becomes increasingly plagued by hallucinations, flashbacks and visual and aural disorientation. Effectively, though displaying symptoms of victim trauma, he suffers from perpetrator guilt, an aspect previously suppressed in trauma research but increasingly acknowledged (see LaCapra 2001; Morag 2013). Raya Morag explains that perpetrator trauma has been denied for various reasons, including 'the humanistic need to defend and treat the victim; processes of societal denial and projection; and the threat post-traumatic perpetra-tors pose to the privileged position of victims and their societal-cultural monopoly' (2013: 13). She goes on to identify several significant differences between the trauma suffered by the victim and that endured by the perpetrator, these differences involving the nature of guilt as well as that of trauma. Referring to Robert Lifton (1980: 120), Morag considers the terms 'static guilt', whereby the perpetrator 'constantly proclaims one's own evil in a self-enclosed fashion' (Lifton in Morag 2013: 15) and 'numbed guilt' (involving avoidance and vague feelings of uneasiness). Morag also examines the gap between guilt and guilt feelings, defining the former as 'motivated by empathy for the victims and characterized by assuming responsibility and looking "forward"' and the latter as 'characterized by evoking identification, melancholic narcissism, self-pity, and looking "backward"' (2013: 16). She proposes that a 'perpetrator complex' exists in between these two descriptions and that the 'core of perpetrator trauma lies in the profound moral contradictions challenging the perpetrators rather than in their psychological disintegration or disturbing and intrusive memories' (ibid.).

This is not exactly the case in *Insomnia*, however, since Dormer wants to keep information concerning the fabrication of evidence in earlier investigations suppressed. On the other hand, his colleague, Eckhart, has been offered an immunity deal by Internal Affairs to disclose the details of the fabricated cases, thereby unwittingly providing a motive for his later (albeit accidental) shooting by Dormer. Consequently, in order to avoid being accused of murder, Dormer conceals the truth concerning Eckhart's death, to the extent of again falsifying evidence. Even so, he appears to suffer the symptoms of victim trauma, with occasional recollections of the earlier case later becoming more persistent in his hallucinations. These recollections begin during the opening credits, which feature a close-up of white fabric slowly becoming saturated with blood, though the source and context of this image do not become apparent until the end of the film. The cloth is then viewed in extreme close-up as if to reinforce its significance, its sullying (as the back-story of the potential child murderer becomes known) possibly metaphoric for the destruction of innocence. Alongside this repeated 'flashback' of the blood-soaked fabric, the theme of contamination also manifests in overhead panoramic viewpoints as Dormer's aeroplane approaches Alaska – here, the white glaciers appear blackened on their ridges, the staining, like the blood-stained fabric, similarly signifying corruption.

The possibility of insomnia is hinted at by an early close-up of Dormer's tired-looking eyes and indeed, a significant aspect of suggesting trauma occurs through figure behaviour and the portrayal of physical exhaustion. Here, Dormer is viewing forensic photographs of the murdered schoolgirl that he has been called to Alaska to investigate (for an alternative reading, see Joy 2013). Thereafter, during forensic examination of the cadaver, Dormer studies contusions on the body, and a number of brief flashbacks interject – first, just as the pathologist explains to Dormer that the bruises on the victim's neck are 'superficial', a flashback immediately displays the victim's face being beaten. This strategy is repeated several times, with the assaults being viewed from the perspective of her (as yet unknown) assailant, the implication being that Dormer has a profound psychological understanding of the attacker's actions. This correspondence between the girl's murderer and Dormer becomes relevant as the narrative progresses since Dormer, too, kills someone. Insofar as Nolan's overall output is concerned, as discussed earlier, the proximity of good and evil is a theme that pervades all his films.

These flashbacks are also meaningful in that they prefigure Dormer's own hallucinations as he becomes progressively more disorientated. He initially looks fatigued because of lack of sleep (due to the light nights) but recurring flashbacks concerned with the earlier case involving falsified evidence become compounded when he accidentally shoots his colleague. The accident occurs because visibility is limited by fog, yet, just before he dies, Eckhart accuses Dormer of deliberately killing him. This accusation augments Dormer's guilt since he begins to doubt his motives and wonders if Eckhart's claim might be true. His anxiety manifests in physical vomiting and flashbacks almost immediately after the accidental shooting. Thereafter, he is haunted by traumatic memories and repeatedly imagines that he sees Eckhart in intrusive daytime recollections. In addition, his appearance deteriorates, and he looks increasingly dishevelled, with his hair astray and collar buttons left undone.

In one night sequence, his insomnia is signalled by an extreme close-up of a clock face (revealing the time to be 3:58), before the camera cuts to an apparently sunlit window. A sequence of images crosscut between Dormer, who is lying awake and restless, followed by a vision of Eckhart, then by the image of blood on white fabric seen in the opening sequence (which still remains unexplained). A sequential montage of disconnected images then discloses Dormer's random mental thoughts, thereby conveying his unstable mental state. Aside from a deteriorated physical appearance, his figure behaviour becomes increasingly bizarre, and he develops a slightly hunched posture and staggering gait. His mental instability is further signified by distortions and amplifications of everyday sounds (experienced by the spectator) – for example, the rattling of a pen and the whirring of a fan grow to be much louder than they would normally sound. Dormer also becomes even more obsessed about eliminating daylight from his hotel room, and tapes down the edges of the window blinds. A repeated montage of white fabric, blood, beams of sunlight almost burning through the window blind, an image of a dead dog (that Dormer came across earlier) and Eckhart structure his mental thoughts. During one of his sleepless nights, Finch, the schoolgirl's murderer, telephones Dormer telling him 'we're partners on this', suggesting parity between them (as was implied during the autopsy scene), and he later tells Dormer 'you didn't mean to kill him any more than I did'. In one of Dormer's increasingly frequent hallucinations, he imagines that he sees Eckhart much more clearly through the fog than he had done in reality – because he is exhausted, he becomes further confused about his motives, the clearer image suggesting that he now believes that he killed Eckhart deliberately. Dormer's visual disturbances become so intense that he is unable to focus clearly and he is completely irrational about excluding light from the window. That he has exaggerated the degree of sunlight entering the room is suggested when hotel owner Rachel Clement (Maura Tierney) contradicts him, saying, 'no, it's dark in here' and switches on the light (which is very bright), then switches it off again (when it becomes extremely dark).

Because the spectator experiences Dormer's hallucinations and perspective constantly, like the protagonist of *Memento*, we too gain a sense of traumatic experience and its accompanying uncertainties. Even though Dormer seems to suffer from victim trauma rather than perpetrator trauma, as detailed by Morag, the film nonetheless contains some parallels with perpetrator trauma. Morag explains that whereas 'victims experience the traumatic event as an experience in time ... it is the physical space in which the event took place that haunts the perpetrators' post-traumatic subjectivity' (2013: 17). This is precisely the case in *Insomnia* in that a noticeable aspect is Dormer's (and the narrative's) preoccupation with the site of Eckhart's shooting. He repeatedly returns to the physical space in his flashbacks as an expression of his guilt – while other characters also revisit it, narratively, to check evidence. Additionally, he 'confesses' to his actions in the closing scenes. As Morag explains, 'perpetrators "confess" their accounts [whereas] victim testimony is marked by the absence of the traumatic event' (2013: 19). She describes this as a 'successful' account in contrast to the failed narrativisation of victims' experiences. In sum, despite some correspondence with accounts of perpetrator trauma, there are deviations from the characteristics outlined by Morag

and, in the same vein as *Memento*, the film suggests that Dormer is a victim rather than an instigator of trauma.

## Regression and Memory in Inception

Similar to Shelby in *Memento*, the protagonist of *Inception*, Dom Cobb (Leonardo DiCaprio) too suffers flashbacks arising from the death of his wife (Marion Cotillard). Indeed, the concept of memory underpins the entire film, the plotline of which concerns the accessing of memories through dream states. Cobb is the architect of the scheme and, while he is able to infiltrate other characters' dreams and steal their ideas, the film's causality rests on a mission to *implant* ideas (inception) in executive Saito's (Ken Watanabe) business adversary, Robert Fischer (Cillian Murphy). In return, Saito arranges Cobb's return to the US, from where he is barred because of his wife's alleged murder (in fact, she committed suicide). The inception sequence occurs during an aeroplane flight, with Fischer and Cobb's team sedated in order to access multiple dream layers (dreams within dreams), enabling them to penetrate more deeply into Fischer's unconscious (necessary to implant the idea). The uppermost dream unfolds in a city centre, the second in a hotel, and the third in a snow-covered landscape, the visual distinctions between each serving to guide the viewer. There are also incursions to a deeper state of consciousness, termed 'limbo', each of these dream states requiring a synchronised 'kick' (usually a physical jolt) to return the dreamers to reality.

In its multiple dream layers, each of which supports separate narrative strands unfolding simultaneously, *Inception* typifies the mind-game film (see Elsaesser 2009: 17–18). Additionally, Cobb's experience of trauma, unmarked flashbacks and confusion about reality contributes to its complexity, with its *mise-en-scène* mostly deriving from his psychological imaginings. Even though Cobb enters these dream states with the narrative premise of stealing or incepting ideas, the process is clearly akin to hypnosis, not only in the reclining figure positioning of the protagonists, and the fact that they experience a changed mental awareness, but also because Cobb's repressed memories are uncovered. These repressed memories vary from the sudden intrusions observed in *Insomnia* and *Memento*. For instance, some of his dream sequences take the form of coherent narratives that resemble normal memory. In addition, the film's characters utilise the term 'projection' to describe various unanticipated events that thwart them within their dream states (such as the appearance of a freight train on a busy city street). The term refers to a hypnosis technique whereby patients are directed 'to project images, sensations and thoughts away from themselves, onto an imaginary screen ... to facilitate the process of separating memories from physically painful sensations' (Cardena *et al.* 2009: 437). This is not the exact use in *Inception* but highlights Nolan's preoccupation with psychological and psychotherapeutic processes. Moreover, Cobb's mental topography, a concept that was first articulated as a series of physical areas in the brain by Freud (2001: 24) (and defined as the id, ego and superego), assumes the form of a vertical sequence of scenarios accessed by elevator. According to Freud, the id is associated with primal desires and instinct, the ego with reason and self, and the superego with control over one's actions through conscience. The base-

ment level of Cobb's consciousness clearly corresponds with the id in its expression of raw emotion and desire, unrestrained by conscience. A final level of the unconscious mind, which is intermittently visualised, is termed 'limbo' and is described in the film as 'raw, infinite sub-conscious'.[1]

The film opens with an extreme close-up of Cobb washed up on a beach before a low-angle shot from his perspective looks up towards two children playing. In the classical linear narrative, the strategies of close-up and subjective camera would normally encourage identification with the protagonist and help orientate the spectator by revealing information known to the protagonist. Yet, as in *Memento*, the spectator is here denied any establishing contextual details and therefore experiences a similar confusion, especially as the children apparently disappear. Because the film persistently invokes Cobb's memories of his children and his deceased wife, Mal (Marion Cotillard), both through flashbacks in his waking reality and in his dream states, there is also constant uncertainty about whether he is experiencing a dream. When induced into a dream state (as distinct from his memories), he experiences further projections of Mal, in the form of flashbacks within the dream, these conveyed (as in the 'Paris' scene) in slow motion to differentiate them from the dream itself. Following the Paris dream, during which Mal attacks Ariadne (Ellen Page), the dream's architect, the latter comments that, 'Cobb has some serious problems that he's tried to bury down there [in his subconscious]'.

As the film progressively probes Cobb's unconscious through further 'regression' into dream states, we learn that these 'problems' stem from the fact that he was the trigger for his wife's suicide. Canted angles signify his increasing mental instability while his ongoing doubts concerning whether he is in a dream or not likewise lead the spectator to the same question. Indeed, the division between dream state and reality is a central motif of the film, with some characters appearing to become 'addicted' to the dream state to the extent that they can no longer differentiate the real world from their unconscious one. The use of a totem helps to establish this (both for the characters and for the spectator), with Cobb's spinning totem toppling over only in reality. When Cobb volunteers for an experimental drug to deepen his unconscious state (the intention is to descend through three levels of dream – in other words, a dream within a dream within a dream), he again visualises Mal, who tells him 'you know what you have to do to find me'. By this, she refers to the fact that if Cobb opts to descend into 'limbo', they can remain together permanently. However, on one occasion when he exits from such a dream state, Mal appears in an unmarked flashback and, unusually, the spectator witnesses her omnisciently rather than from Cobb's perspective, suggesting that she has become an autonomous entity. Indeed, Cobb is unable to control either Mal's appearance or actions within his dreams. In another scenario, Ariadne illicitly joins a sleeping Cobb during a voluntary dream session (a regular night-time activity) and finds herself descending in the darkened elevator as she enters Cobb's unconscious. At this point, she now realises (along with the spectator), that Cobb uses the dream equipment to access memories of his wife and children in order to be with them. The film therefore not only represents traumatic memory as integral to its narrative complexity, but also draws upon the concept of hypnosis and regression.

The hypnosis analogy is further suggested by an extreme close-up of a watch in the opening sequence, the second hand moving in slow motion and the sound of its ticking amplified and extended into later scenes – while this establishes tension in the film because of the temporal limitations of the dream spaces, it also simulates the sound of a metronome, used as an adjunct in hypnosis. Indeed, as Cobb and Ariadne awaken (from the Paris dream), Ariadne realises they have been asleep for only five minutes, Arthur revealing that five minutes in reality equates to one hour in a dream state. Narratively, he explains this temporal incongruity as resulting from acceleration in brain function during each dream state. Visually, extreme slow motion effects convey the discrepancies in time.

Spectator location is further destabilised when Ariadne and Cobb return to the Paris dream and she mentally distorts the physical architecture of the *mise-en-scène* so that the surrounding city streets seem to rise up and fold over them. The film therefore not only alters time, but also space itself. Moreover, a montage of discontinuous camera shots, which arise from varying omniscient perspectives, further accentuates viewer disorientation. As Ariadne and Cobb walk through the dream spaces of Paris, its structure continues to evolve, producing surreal effects and causing the spectator to experience a continual state of spatial and temporal indeterminacy. This too corresponds with hypnotic phenomena whereby hypnotised individuals may have 'various unusual experiences, including body image alterations, altered sense of time, and dissociative experiences, such as feeling detached from oneself or the environment'; additionally, there may be a 'tendency to blur the distinction between different states of consciousness' (Cardenza *et al.* 2009: 429), clearly a preoccupation of the film's narrative in the protagonists' use of totems. The authors explain that the aim of hypnotherapy is to enable the patient more control over their memories, while 'hypnosis may allow patients to separate themselves from memories of events' (2009: 436). This is exactly the case in *Inception* where Cobb revisits the 'basement level' of his unconscious in order to address traumatic memories. In the 'dream', Mal enquires about his feelings, to which Cobb replies, 'Guilt. I feel guilt, Mal – that the idea that caused you to question your reality came from me.' In other words, Cobb planted the idea in her mind that limbo was the real world, through the process of inception. Within this deep-seated memory, he tells Mal that 'I have to let you go', and so takes control of his memories. *Inception* therefore not only implies trauma through flashback, but constructs a mental topography within which traumatic memories are accessed. Moreover, like *Memento* and *Insomnia* it blurs the boundary between perpetrator guilt and victim trauma in that both exist with the protagonist. The progressive access to Cobb's deepest layers of his unconscious mind reflects the process of regression analysis, and he eventually confesses to Ariadne in the mode of perpetrator rather than victim.

*Traumatic Memory in the Dark Knight Trilogy*

In contrast to the previous films, the *Dark Knight* trilogy involves victim trauma rather than perpetrator trauma, yet still expounds the proximity between good and evil. *Batman Begins* tells the story of the origins of Bruce Wayne as Batman and opens with

Wayne as a child. As he plays with childhood friend Rachel Dawes (Emma Lockhart) in the grounds of his parents' mansion, he stumbles and accidentally falls into a well. An extreme-low-angle shot initially positions the spectator's viewpoint at the bottom of the well, and, as he falls, then assumes his perspective. In other words, the audience is made to experience the traumatic event simultaneously and to understand it as a source of distress. The sequence plays on childhood fears of the dark since, still assuming the child's point of view, the camera is directed towards an area of impenetrable blackness. The spectator is unable to discern anything in the recesses until a slow zoom into the darkness, which intercuts with images of a visibly terrified Wayne, then accedes to a montage of rapidly edited images as a swarm of bats fly out towards him. Screeching sound effects accompany their appearance and intensify a sense of threat. A cut back to the present sees an adult Bruce Wayne (Christian Bale) awakening, indicating that he has been having a nightmare about his childhood experiences and that the entire opening sequence was, in fact, a flashback.

The narrative trajectory of the film and the assumption of his Batman persona are channelled towards Wayne overcoming these fears (although the film deals with fear and its control more generally) and, thereafter, constantly flashes back to his childhood. He often suffers flashbacks of the bats or, otherwise, visual distortions stemming from his traumatic past, one such occasion occurring when he attends the opera with his parents. Here, a montage of images, viewed from his perspective, reveals the acrobats on stage appear to transform into bats, obviously a manifestation of his childhood experience of falling into the well. Looking troubled, he asks his parents if they can leave. However, this initial traumatic memory is then exacerbated by the fact that his parents are murdered as they exit the theatre. Camera framing, which pulls back to a long shot of the young Bruce Wayne adjacent to their bodies, conveys his sense of loneliness. These sequences of his childhood are extended and engender emotion in the spectator, partly because of his anguish, but also because of his feelings of guilt. 'It was my fault, Alfred' states the young Wayne, following his parents' murder. During the ensuing funeral sequence, a fixed camera frames the young Wayne and his butler, Alfred (Michael Caine), who stand motionless as others sweep past, again suggesting their isolation in grief whilst the *mise-en-scène* of a rain-soaked, sorrowful gathering, punctuated by black umbrellas, adds to the melancholic ambience.

Thereafter, the film repeatedly flashes back to the two moments – the bat swarm, and the murder of his parents – and references to them also crop up in the latter two films of the trilogy, depicted by verbal references to his parents and longing looks over dusty photographs of them. Personal artefacts such as his father's stethoscope trigger further memories for Wayne, which are also visualised as flashbacks. Other times, montages of the swarming bats and their screeching occur as traumatic memories when he is beset by fear. Indeed, when later detained in a Bhutanese prison for minor criminalities, and asked by League of Shadows mentor, Henri Ducard (Liam Neeson) about what he fears most, Wayne again experiences flashbacks of the well and opera scenarios. His training with the League aims to overcome this fear, which he only eventually conquers by returning to the well as an adult. After he descends into the shaft, the same slow zoom into the darkness that transpired at the film's outset is

repeated – however Wayne now walks into the darkness, and stands in the midst of the bats, and a static extended shot signals that he has overcome the trauma (as opposed to the rapidly edited montage that occurred earlier). The camera pulls out to an extreme long shot to emphasise both his physical envelopment by, and psychological resistance to the massing bats, and the film ends with Wayne sealing up the well, symbolically indicating that he has come to terms with his traumatic past. In selecting the bat as a symbol of his masked persona, Wayne states that he wants 'something elemental, something terrifying', the bat clearly summing up his innermost fears. When he returns to the burnt-out remains of his home, he also comes across the charred remnants of his father's stethoscope, which still provokes exactly the same vividly coherent flashback that it had done earlier, differentiating it from traumatic memory.

If *Batman Begins* focuses on the origins of the Batman story, it also reflects its post-millennial contexts in its mention of desert warfare, heavy arms manufacture, weaponised toxins and weapons of mass destruction, aspects that all have resonance during the ongoing 'war on terror'. The film's discussion of a prototype Bat suit, based, within the narrative, on the development of soldiers' protective gear, also entails a commentary about its cost and the fact that the military 'didn't think a soldier's life was worth $300,000'. Clearly, this refers to the real-world criticism of equipment supplied to the military during the Iraq War. So too, the use of a psychogenic hallucinogen by Batman's arch enemy, Scarecrow (Cillian Murphy), may derive from the anthrax attacks following 9/11, as well as the use of chemical warfare on Iraqi civilians by Saddam Hussein's regime. Scarecrow uses the hallucinogen to induce panic, because it causes its victims to visualise their worst fears and provokes trauma to such an extent that they become insane. The film uses horrific abject imagery to convey such fears – for example, Rachel Dawes (Katie Holmes) who is contaminated with the toxin, imagines maggots crawling on the face of Scarecrow with the use of close-up framing intensifying a sense of threat. In addition to thematic analogies with 9/11, there are also distinct visual allusions, first, in the blazing body of Batman seen jumping from a skyscraper, and second, in the way that the terrorists target a train to crash into Wayne Tower. These suggestions of 9/11 become more pronounced in *The Dark Knight* (2008) and *The Dark Knight Rises* (2012) where the theme of crashing various means of transport into buildings is revisited and images that include falling bodies, burning skyscrapers and terrorist figures abound. As noted elsewhere, 'Batman's coercive "interrogation" of the Joker (Heath Ledger) whilst in custody evokes scenes of Guantánamo and Abu Ghraib, perhaps condemning the methods used there, which amounted to torture' (Pheasant-Kelly 2011: 245). The concept of a weapon of mass destruction recurs in the final film of the trilogy, as well as the theme of torture. 'You can watch me torture an entire city,' arch-villain Bane (Tom Hardy) tells Wayne, returning to the torture aspects of *The Dark Knight* and its war on terror associations. These become even more overt with the destruction of large sections of Gotham that appears in panoramic shot to be very similar to New York, and news commentaries from the President who states 'we do not negotiate with terrorists'.[2] Bane also breaks into a prison and the film emphasises the release of orange-suited detainees, and the corruption of the police system, a process that obviously comments on the irregularities at detainee

camps at Guantánamo Bay, Abu Ghraib and Bagram. In addition, the subject of traumatised masculinity becomes even more noticeable – in the character of Harvey Dent (Aaron Eckhart) in *The Dark Knight*, and Bruce Wayne in *The Dark Knight Rises* – and imagery of the bats that originated in *Batman Begins* intermittently recurs through flashback in these films. Moreover, even though *The Dark Knight* presents profound visual and behavioural differences between the characters of Batman and the Joker, the film conspicuously explores the parallels between them and their respective ambiguous identities. The proximity between good and evil is also articulated through the character of Dent, who is initially described as 'Gotham's White Knight' but is later known as Harvey Two-Face on account of his degeneration into vigilantism. His turn to evil follows the murder of his girlfriend, Rachel Dawes (Maggie Gyllenhaal) and his own mutilation (both at the hands of the Joker), compromising his identity both physically and morally. A further scene during which convicted felons reject an opportunity to destroy innocent civilians marks similar ethical in-distinctions. In other words, the ambiguities of identity that Nolan expresses through trauma in the films discussed previously still persist here but reflect more closely their post-9/11 contexts.

In addition to signs of trauma, the physical incapacities that marked *The Prestige* and *Insomnia* become more pronounced in *The Dark Knight* and *The Dark Knight Rises*. In the former, Wayne suffers physical wounding (we see him stitching his own wound, in close-up for emphasis), whilst in the latter, he at first has a pronounced limp and depends on a walking stick. Later, following an assault by Bane, he endures a displaced vertebra, and is unable to move at all. As Wayne attempts to escape capture by ascending a shaft that distinctly resembles the well into which he fell in *Batman Begins* (the spectator is again positioned at its base, looking upward), and falls repeatedly, he experiences a flashback of his childhood when his father came down the well to rescue him. Eventually, he scales the shaft without a rope, and when he nears the surface, a swarm of bats fly out – though here they serve to inspire him rather than resurrect his childhood fears.

*Conclusion*

The prominence of trauma and psychotherapy in Nolan's post-millennial films initially suggests this as an authorial trait. He uses a variety of cinematographic and editing techniques to signal trauma, namely flashbacks, montage editing, acute canted angles and long shots. Additionally, the characters' figure behaviour, the accompanying *mise-en-scène* and complex narration contribute to the signification of traumatic symptoms, specifically dissociation and de-realisation. In particular, the use of close-ups reveals the apparent suffering of traumatised individuals, often with a focus on tired dark eyes and drawn features.

Yet the emergence of physically and emotionally traumatised male characters is a more ubiquitous peculiarity of post-9/11 cinema, with wounded and delusional male characters appearing across a wide range of genres and associated with a number of directors. Arguably, therefore, Nolan has tapped into a zeitgeist of threatened masculinity emergent from the war on terror and has provided a prototype of traumatised

masculinity in the characterisation of *Memento*'s Leonard Shelby. Nolan's focus on the proximity of good and evil invariably informs his portrayal of trauma, which, despite the preponderance of perpetrators, is mediated as that of the victim. As Sally Baxendale (2004) and Raya Morag (2013) note, cinema tends to focus on victim trauma, and, even when the perpetrator is clearly established as a murderer, as in *Insomnia*, he/she is depicted as a victim. This line of travel extends to the *Dark Knight* trilogy, where the ambiguity between good and evil is especially relevant to their 9/11 allusions and questions raised concerning the Bush Administration, notably the unethical aspects of the Iraq War. The 'war on terror' also resulted in the incarceration of thousands of suspected terrorists in detainee camps in Guantánamo Bay, Bagram and Abu Ghraib from 2002 onwards, before evidence of systematic abuse there that 'amounted to torture' (Simpson 2006: 217) was made public in 2004. Together with a lack of legal justification for the invasion of Iraq, the 'war on terror' that Bush had motivated was called into question.

The success of Nolan's films, signalled by the fact that the *Dark Knight* trilogy remain high in the top-grossing box office list of films, suggests that while audiences are reluctant to view factual or realistic genres concerning trauma – such as *The Hurt Locker* (Kathryn Bigelow, 2008), *Battle for Haditha* (Nick Broomfield, 2007) and *In the Valley of Elah* (Paul Haggis, 2007) which, while critically acclaimed, performed poorly at the box office – there is an affinity for watching fictionalised trauma narratives in complex, challenging films. The propensity to depict perpetrator guilt as victim trauma arguably reflects issues arising out of the 'war on terror' and the resultant equivocal position of the US, which, like many of Nolan's protagonists, became both victim and perpetrator. In sum, if Nolan focuses on trauma and psychotherapeutic processes, his narratives display more than a nod to their post-millennial contexts of thwarted masculinity and questionable American moral identity.[3]

## Notes

1   If the film's focus is on dream states, and surreal and futuristic settings, there are also subtle connections with 9/11 through the skyscraper scenes in 'limbo', where the outlines of the Twin Towers appear to be replicated infinitely.
2   The terrorists cause almost 3,000 men to be trapped in underground explosions, similar to the numbers killed on 9/11.
3   My thanks go to Nathanael Paul for his helpful comments on this essay.

## Bibliography

Atkinson, Meera and Michael Richardson (eds) (2013) *Traumatic Affect*. Newcastle: Cambridge Scholars Publishing.
Baxendale, Sally (2004) 'Memories aren't made of this: Amnesia at the movies', *BMJ* 329(7480), 1480–1483.
Benshoff, Harry and Sean Griffin (2009) *America on Film: Representing Race, Class, Gender and Sexuality*. Malden, MA: Wiley-Blackwell.

Brooker, Will (2012) *Hunting the Dark Knight: Twenty-First Century Batman*. London and New York: IB Tauris.

Brown, William (2014) 'Complexity and Simplicity in *Inception* and *Five Dedicated to Ozu*', in Warren Buckland (ed.) *Hollywood Puzzle Films*, London and New York: Routledge, 125–40.

Buckland, Warren (ed.) (2014) *Hollywood Puzzle Films*. London and New York: Routledge.

Cameron, Allan and Richard Misek (2014) 'Modular Spacetime in the "Intelligent" Blockbuster: *Inception* and *Source Code*', in Warren Buckland (ed.) *Hollywood Puzzle Films*. London and New York: Routledge, 109–124.

Cardena, Etzel, José Maldonado, Onno van der Hart and David Spiegel (2009) 'Hypnosis', in Edna Foa, Terence Keane, Matthew Friedman and Judith Cohen (eds) *Effective Treatments for PTSD: Practice Guidelines from the International Society for Traumatic Stress Studies*, London and New York: Guilford Press, 427–57.

Carpentier, Nico (ed.) (2007) *Culture, Trauma and Conflict: Cultural Studies Perspectives on War*. Newcastle: Cambridge Scholars Publishing.

Caruth, Cathy (1996) *Unclaimed Experience: Trauma, Narrative, and History*. Baltimore, MD: Johns Hopkins University Press.

Elsaesser, Thomas (2009) 'The Mind-Game Film', in Warren Buckland (ed.) *Puzzle Films: Complex Storytelling in Contemporary Cinema*. Malden and Oxford: Wiley-Blackwell, 13–41.

Felman, Shoshana and Dori Laub (1992) *Testimony: Crises of Witnessing in Literature, Psychoanalysis and History*. London and New York: Routledge.

Fisher, Mark (2011) 'The Lost Unconscious: Delusions and Dreams in *Inception*', *Film Quarterly*, 64, 3, 37–45.

Foa, Edna, Terence Keane, Matthew Friedman and Judith Cohen (eds) (2009) *Effective Treatments for PTSD: Practice Guidelines from the International Society for Traumatic Stress Studies*. London and New York: Guilford Press.

Freud, Sigmund ([1923] 2001) *The Ego and the Id and Other Works: The Standard Edition of the Complete Psychological Works of Sigmund Freud, Volume 19*, trans. James Strachey. London: Vintage.

Greenberg, Judith (ed.) (2003) *Trauma at Home after 9/11*. Lincoln, NE: University of Nebraska Press.

Herman, Judith (2000) *Father-Daughter Incest*. Cambridge, MA: Harvard University Press.

Hoge, Charles, Jennifer Auchterlonie and Charles Milliken (2006) 'Mental Health Problems, Use of Mental Health Services and Attrition from Military Service after Returning from Deployment to Iraq or Afghanistan', *Journal of the American Medical Association*, 295, 9, 1023–32.

Hunt, Nigel (2010) *Memory, War and Trauma*, Cambridge: Cambridge University Press.

Jeffords, Susan (1994) *Hard Bodies: Hollywood Masculinity in the Reagan Era*. New Brunswick, NJ: Rutgers University Press.

Johnson, David Kyle (ed.) (2012) *Inception and Philosophy*. Hoboken, NJ: John Wiley.

Joy, Stuart (2013) 'Revisiting the Scene of the Crime: *Insomnia* and the Return of the Repressed', *Kaleidoscope*, 5, 2, 61–78.

\_\_\_\_ (2014) 'Looking for the Secret: Death and Desire in *The Prestige*', *PsyArt: An Online Journal for the Psychological Study of the Arts*. Online. Available: http://www.psyartjournal.com/article/show/joy-looking_for_the_secret_death_and_desire_ (accessed 22 January 2015).

Kania, Andrew (ed.) (2009) *Memento*. London and New York: Routledge.

Kaplan, E. Ann (2005) *Trauma Culture: The Politics of Terror and Loss in Media and Literature*. New Brunswick, NJ: Rutgers University Press.

King, Geoff (2014) 'Unravelling the Puzzle of *Inception*', in Warren Buckland (ed.) *Hollywood Puzzle Films*. London and New York: Routledge, 57–71.

Kirmayer, Laurence, Robert Lemelson and Mark Barad (eds) (2007) *Understanding Trauma: Integrating Biological, Clinical and Cultural Perspectives*. Cambridge: Cambridge University Press.

LaCapra, Dominique (2001) *Writing History, Writing Trauma*. Baltimore, MD: Johns Hopkins University Press.

Leys, Ruth (2000) *Trauma: A Genealogy*. Chicago: University of Chicago Press.

Lifton, Robert (1980) 'The Concept of the Survivor', in Joel Dimsdale (ed.) *Survivors, Victims and Perpetrators: Essays on the Nazi Holocaust*. Washington, D.C.: Hemisphere, 113–26.

Luckhurst, Roger (2008) *The Trauma Question*. London and New York: Routledge.

\_\_\_\_ (2010) 'Beyond Trauma: Torturous Times', *European Journal of English Studies*, 14, 1, 11–21.

McGowan, Todd (2012) *The Fictional Christopher Nolan*. Austin, TX: University of Texas Press.

McNally, Richard (2003) *Remembering Trauma*. Cambridge, MA: Harvard University Press.

Molloy, Claire (2010) *Memento*. Edinburgh: Edinburgh University Press.

Morag, Raya (2013) *Waltzing with Bashir: Perpetrator Trauma and Cinema*. London and New York: IB Tauris.

Panek, Elliot (2014) '"Show, Don't Tell": Considering the Utility of Diagrams as a Tool for Understanding Complex Narratives', in Warren Buckland (ed.) *Hollywood Puzzle Films*. London and New York: Routledge, 72–88.

Pheasant-Kelly, Frances (2011) 'The Ecstasy of Chaos: Mediations of 9/11, Terrorism and Traumatic Memory in *The Dark Knight*', *Journal of War and Culture Studies*, 4, 2, 235–49.

Radstone, Susannah (2003) 'The War of the Fathers: Trauma, Fantasy and September 11', in Judith Greenberg (ed.) *Trauma at Home after 9/11*. Lincoln and London: University of Nebraska Press, 117–23.

Robinson, Sally (2000) *Marked Men: Masculinity in Crisis*. New York: Columbia University Press.

Roth, Michael (2012) *Memory, Trauma, and History: Essays on Living with the Past*. New York: Columbia University Press.

Russo, Paolo (2014) '"Pain is in the Mind": Dream Narrative in *Inception* and *Shutter Island*', in Warren Buckland (ed.) *Hollywood Puzzle Films*. London and New York: Routledge, 89–108.

Rutherford, Jonathan (1992) *Men's Silences: Predicaments in Masculinity*. London and New York: Routledge.

Simpson, David (2006) 'The Texts of Torture', in George Kassimeris (ed.) *The Barbarisation of Warfare*. London: Hurst, 207–19.

Tasker, Yvonne (1993) *Spectacular Bodies; Gender, Genre and the Action Cinema*. London and New York: Routledge.

Turim, Maureen (1989) *Flashbacks in Film*. London and New York: Routledge.

Walker, Janet (2001) 'Trauma Cinema: False Memories and True Experience', *Screen*, 42, 2, 211–16.

Žižek, Slavoj (2002) *Welcome to the Desert of the Real*. London: Verso.

# 'The dream has become their reality': Infinite Regression in Christopher Nolan's Memento and Inception

## Lisa K. Perdigao

Christopher Nolan's *Memento* (2000) reflects, at its source, 'never-ending grief'.[1] The title of Jonathan Nolan's short story, 'Memento Mori', from which the film is adapted, can be translated as 'Remember your mortality' or 'Remember you must die'. Trying to remember what he has lost – his wife and his identity – Leonard Shelby (Guy Pearce) attempts to recover his lost memories and reconstruct the story of his loss. The film's structure reflects how Leonard is caught in a seemingly infinite loop, with its ending returning to the beginning. While Nolan's work on *Batman Begins* (2005), *The Prestige* (2006), *The Dark Knight* (2008), *The Dark Knight Rises* (2012) and *Interstellar* (2014) keeps the screenwriter and director invested in the themes of memory, identity and grief, it is with the *Inception* (2010) that Nolan most clearly returns to the Möbius strip of his earlier design, suggesting that grief-work is never completed.

Where Leonard uses material objects (Polaroid photos, tattoos and notes) to create a puzzle that he cannot solve, *Inception*'s Dom Cobb (Leonardo DiCaprio) designs elaborate labyrinths in the subconscious layers of his mind as well as those of his targets and colleagues. The successful design and performance of the 'inception' on Robert Fischer (Cillian Murphy) provide him with an escape from his liminal state, the limbo of 'raw, infinite subconscious' where Cobb grieves over the loss of his wife and is kept away from his children and home. *Inception* internalises the drama of *Memento* yet yields a similar result. Tammy Clewell writes that Sigmund Freud's description of the work of mourning in 'Mourning and Melancholia' ([1917] 1957) 'entails a kind of hyperremembering, a process of obsessive recollection during which the survivor resuscitates the existence of the lost other in the space of the psyche, replacing an actual absence with an imaginary presence' (2004: 44). In Freud's model, 'mourning comes to a decisive and "spontaneous end"' once the mourner moves away from the lost object to accept consolation (ibid.). Both Leonard and Cobb are ultimately unable to achieve the 'spontaneous end' of grief that Freud describes. Instead, both insist upon the reality of objects that they can manipulate, surrogates for the 'lost objects' at the

centre of their lives and narratives. But rather than successfully complete the process of grieving, distinguishing memories from reality and accepting consolation, Leonard and Cobb indefinitely (and perhaps infinitely) become lost in a process of hyper-remembering, sustaining a hyperreality that they, and the viewers, cannot escape.

The story of loss permeates Nolan's filmography, and the similarities between *Memento* and *Inception* are, to borrow again from Freud, uncanny.[2] The two protagonists lose their wives in tragic circumstances, struggle with guilt over their roles in their wives' deaths (including their inability to 'save' them), and use 'projections' to remember their wives. In *Memento*, Leonard survives the violent home invasion that killed his wife (at least in one version of the story), but he loses his ability to make new memories. Suffering from anterograde amnesia, Leonard is ostensibly trapped within a dream-world of old memories, the world that he had inhabited with his wife. In *Inception*, Cobb also sustains the unreality of a dream-world where his wife is still alive. Cobb is an architect who is able to conjure dream-worlds to facilitate both the 'extraction' and 'inception' of an idea from/in the subject's subconscious. However, as Cobb reveals, the inception is especially problematic. The idea is persistent. Trying to bring his wife Mal (Marion Cotillard) back from the dream-world, Cobb plants the idea that 'she needed to wake up to come back to reality' in her subconscious. Unfortunately, the inception takes hold and follows her back to reality. In her desperate attempt to 'wake up' and escape the dream, she commits suicide in the real world. After Mal's death, Cobb remains in limbo, unable to let her go and creating projections of her in his dreams. The depictions of grief-work in the two films highlight the risk of entering – and remaining within – the dream-world. Clewell identifies how a 'magical restoration of the lost object' eventually leads to an 'objective determination that the lost object no longer exists' (ibid.); however, as she states, 'instead of reattaching the free libido to a new object, the melancholic refuses to break the attachment to the lost object when in reality it is gone' (2004: 59). Attempting to keep their memories – those projections – alive, Leonard and Cobb remain caught within a never-ending loop of grief, spinning like *Inception*'s top, poised between reality and illusion.

*Memento* and *Inception* can be staged within the ongoing critical debate about Freudian theory, particularly Freud's distinction between the processes of mourning and melancholia. Many critics cite the ambiguity of Freud's distinction between mourning and melancholia, with some suggesting that Freud further complicates the ideas in his later work. Clewell notes that Freud's *The Ego and The Id* (1923) recasts his earlier work, 'substantially revis[ing] our understanding of what it means to work through a loss' (2004: 61). She argues that 'working through depends on taking the lost other into the structure of one's own identity, a form of preserving the lost object in and as the self; in "Mourning and Melancholia" Freud thought that mourning came to a decisive end; however, in *The Ego and the Id* he suggests that the grief-work may well be an interminable labor' (2004: 61).[3] Jahan Ramazani comes to a similar conclusion about Freud's theories:

> Most clinical psychoanalysis has adopted 'normal,' 'healthy,' or 'successful' mourning as a therapeutic ideal, often hypostatizing mourning as a rigid step-

by-step program that leads from shock to recovery, and some literary applications of Freud's essay have transferred his abstract norm to texts, sifting them through predictable narratives in which artistic compensation redeems personal loss ... Yet Freud admitted in letters and other writings that mourners typically remain inconsolable, never filling the gaps of loss. (1994: 28–9)

Creating a space between mourning and melancholia, Ramazani proposes a theory of melancholic mourning at work in the modern elegy (1994: xi). His description of the modern elegist who 'tends not to achieve but to resist consolation, not to override but to sustain anger, not to heal but to reopen wounds of loss' (ibid.) is applicable to Leonard and Cobb. However, while Ramazani's elegist performs in the creative space of the text, Leonard and Cobb attempt to transform their realities into dream-worlds. According to R. Clifton Spargo, 'grief, even in its temporary expression, would oppose the necessity of death, causing the subject to adhere unrealistically to her attachment to the other and eventually to fall out of the time of the living' (2004: 19). In *Memento* and *Inception*, the prophetic directive 'Remember you must die' is ignored (or rejected) and 'the dream has become their reality'.

Leonard and Cobb struggle with death, a signifier with an 'incessantly receding, ungraspable signified, always pointing to other signifiers, other means of representing what is finally just absent' (Bronfen and Goodwin 1993: 4). For the characters, memories become the means to conjure what is absent – a re-presentation and recuperation of the lost body through images. According to Laura E. Tanner, 'The image of the absent body in memory expresses the mourner's desire without fulfilling it; the shape of memory constructs an outline that gestures toward the animating and embodied presence the image lacks' (2006: 90); memory recalls the absence rather than conjure presence.[4] That Leonard and Cobb obsess over memories *and* objects is important. As Tanner notes,

> Objects lend grief a form that exposes rather than compensates for bodily absence. [...] The press of objects resituates the survivor within a palpable dynamic of fleshly exchange that recalls an embodied experience it cannot recuperate; objects locate embodied grief by rendering loss in sensory form. The object's function, then, is not to substitute for embodied presence but to invoke its absence, acknowledging the irrecuperable dimension of grief that lurks beneath existing cultural discourses of compensation for loss. (2006: 178, 179)

William G. Little suggests that the souvenir 'bears a similarity to the reel played with by Freud's grandson in the famous *fort-da* game described in *Beyond the Pleasure Principle*', a game that 'marks the boy's attempts to compensate for the traumatizing disappearance of his mother' (2005: 70). Freud describes how the child derives pleasure from 'staging the disappearance and return of the objects within his reach' (1989: 600).

Mourning is composed of similar play, a 'compulsion to repeat ... supported by the wish (which is encouraged by "suggestion") to conjure up what has been forgotten

and repressed' (1989: 609). As Little notes, the play is a 'form of waking up, *in time*, to absence' (2005: 71; emphasis in original).[5] Yet Leonard's question, 'How am I supposed to heal if I can't feel time?', complicates this notion. He, like Cobb and Ramazani's elegist, cannot (or will not) heal but will instead continually 'reopen wounds of loss' (1994: xi). The risk that Spargo identifies is that the characters eventually 'fall out of the time of the living' (2004: 19). Suspended in a dream-world, Leonard and Cobb cannot wake up, in time, and complete the process of 'measuring reality against memory in order to let go' (Tanner 2006: 104). Leonard says to his lost wife: 'I can't remember to forget you.' Cobb's condition differs from Leonard's but is generated from the same source. He is able to create another world where he does not have to remember to forget his deceased wife. Arthur (Joseph Gordon-Levitt) tells Ariadne (Ellen Page): 'In a dream, you can cheat architecture into impossible shapes. That lets you create closed loops, like the Penrose steps.' After identifying the 'infinite staircase' as a 'paradox', Arthur says, 'so a closed loop like that will help you disguise the boundaries of the dream you create'. For Cobb, the line between his reality and dream-world becomes undefined, disguised. Tanner provides an apt metaphor for Cobb's predicament in her reading of Marilynne Robinson's *Housekeeping* (1980): 'In measuring memory against reality, the embodied subject is caught between lack and lack and finds itself spiraling into an experience of grief nameable under Freud's model only as melancholia' (2006: 104). Cobb and Leonard are both caught within that closed loop of grief, continually returning to the site of loss.

In *Memento* and *Inception*, Leonard and Cobb attempt to 'conjure up what has been forgotten and repressed' by 'staging the disappearance and return of the objects within [their] reach' (Freud 1989: 609, 600), manifesting the *fort-da* game within and between the two films. Identifying a thread that runs throughout Nolan's films (*Following, Insomnia, The Dark Knight, The Prestige, Memento* and *Inception*), Mark Fisher writes: 'Grief itself is a puzzle that can't be solved and there's a certain (psychic) economy in collapsing the antagonist into the grief object, since the work of grief isn't only about mourning for the lost object, it's also about struggling against the object's implacable refusal to let go' (2011: 42). The Mal projection violently intrudes in Cobb's reality, repeatedly calling out to him: 'You know how to find me. You know what you have to do.'[6] When Cobb leads Ariadne away from the projection, he assures Mal, 'I'll come back for you, I promise.' Continually replaying the *fort-da* game with Mal, Cobb is trapped within an endless loop of his own grief that persists until and through the film's conclusion. As Fisher suggests, '*Inception* leaves us with the possibility that Cobb's quest and apparent rediscovery of his children could be a version of the same kind of loop: a purgatory to *Memento*'s inferno' (2011: 29); the character is compelled to repeat the same plot.

The *fort-da* game takes form within *Memento* as Leonard is positioned between the memories of his wife when she was alive and the objects that remain in her absence. Little explains how *Memento* 'unsettles viewer expectations of temporal continuity and coherence' by offering competing and complementary narrative threads: a series of colour segments, 'while not exactly a reel running backward ... nevertheless moves the viewer backward through time' and the 'segments shot in black and white ... move the

viewer forward through time' (2005: 67).[7] Like in Freud's *fort-da* game, the reel (this time, the film) allows the viewer to wake up, '*in time*, to absence' (2005: 71). Leonard is unable to 'represent the loss of his wife' due to his 'inability to mark, or be awake to, the passage of time' (2005: 73); however, as Little remarks, 'One of the virtues of the repetition structuring the *fort-da* game is that it gives one a different kind of break; it creates time to *explore the missing*' (2005: 71; emphasis in original). Leonard is able to manipulate the reel, reordering and even reversing time.

While Cobb designs a dream-world that allows him to continue the process of mourning indefinitely, Leonard redesigns his reality to relive his experience of loss, mostly through the presentation and rearrangement of 'mementos'. Patrick O'Donnell highlights the historical significance of the memento, originating in the ecclesiastical traditions of Catholicism, 'where "memento" refers to two prayers in the Canon of the Mass that commemorate, respectively, the living and the dead', and leading to the 'memento mori', an 'image or icon popular in the late Middle Ages that caused one to reflect upon one's own mortality' (2009: 122). The memento or souvenir is, in Susan Stewart's reading, a symptom of a 'longing for a time of unity, plentitude, and wholeness' in the context of grief-work (quoted in Little 2005: 70). Yet without a sense of time, Leonard can never achieve closure. He can never awaken from his grief. Leonard says:

> I don't even know how long she's been gone. It's like I've woken up in bed and she's not here ... because she's gone to the bathroom or something. But somehow, I just know she's never gonna come back to bed. If I could just ... reach over and touch ... her side of the bed, I would know that it was cold, but I can't. I know I can't have her back ... but I don't want to wake up in the morning, thinking she's still here. I lie here not knowing ... how long I've been alone.

The images, icons and objects in *Memento* and *Inception* blur the boundaries between the living and the dead: as Leonard and Cobb attempt to remember their wives, they become suspended in limbo, unable to let go and move on. In one scene, Leonard hires a prostitute to casually place his wife's hairbrush, bra, teddy bear, book and clock around the motel room, pretending that they are her own. He intends to wake up to the presence of these objects and the idea that his wife is still alive. When Leonard awakens, he goes to the bathroom where his wife had struggled for her life. However, the performance does not work. Seeing the prostitute's drugs in the bathroom shatters Leonard's illusion of his wife's presence. Little writes:

> Leonard does repeatedly try to manipulate souvenir-like objects; however, the goal of this action is not to frame desire's play but rather to transcend it. ... Hence his intolerable disappointment when the re-creation does not work, leading him to take the souvenirs out to an abandoned refinery and burn them. Unable to entertain the missing, he wants either to make his wife reappear or to make his memory of her disappear. (2005: 73)

Although Leonard abandons the objects, as Freud proposes, along with his attachment to them, he continues the process, re-enacting his loss with photos, tattoos and notes. These mementos are better participants in the drama that he seeks to reenact. They allow him to continually restart the process of grieving. He is not able to bring his wife back to life, but he is able to remember the trauma that drives him to seek vengeance, and, at least superficially, closure. Leonard's manipulation of the facts – his tattoo reading 'Memory is treachery', his acts of burning a photo, crossing out a note and replacing it and removing twelve pages of case notes from the file – allows him to sustain the motivation behind his revenge plot. The tattoos he has written on his body are false leads, clues to a case that he has constructed to never end, the 'puzzle [he] could never solve'.

*Inception* similarly explores the labyrinthine structure of the mind and what unfolds in the film is an elaborate theory about the effects of planting an idea within it. While inception, that 'subtle art', requires imagination, it is predicated on the manipulation of material objects. Secrets to be extracted and ideas to be planted are contained within vaults and safes. Yet the dream-world of the inception is a world of ideas as well; as Cobb tells his father-in-law and mentor Miles (Michael Caine), the dream-world's architect has 'the chance to build cathedrals, entire cities, things that never existed, things that couldn't exist in the real world'. However, there are rules to follow, as his own experience shows: 'Building a dream from your memory is the easiest way to lose your grasp on what's real and what is a dream.' With an allusive name signifying her ability to navigate a complex labyrinth, the new architect Ariadne figures out the story of Cobb's traumatic past. After being confronted by the projection of Cobb's dead wife in her first design, Ariadne concludes that 'Cobb has some serious problems that he's tried to bury down there'. When Ariadne follows Cobb into his dream-world, she realises that 'these aren't just dreams. These are memories.' Playing the role of psychologist, Ariadne tells Cobb, 'You're trying to keep her alive. You can't let her go … Do you think you can just build a prison of memories to lock her in? Do you really think that's gonna contain her?'

Cobb's response to Ariadne's psychoanalysis indicates the tension between mourning and melancholia, consolation and closure versus an obsessive desire to re-create what is lost. Cobb tells Ariadne that he obsessively revisits these memories because 'these are moments I regret. They're memories that I have to change,' but later tells his team, 'We all yearn for reconciliation, for catharsis.' Cobb wants to recover what he has lost: his children *and* his wife. In Cobb's 'basement' is a memory of a time when Mal is 'already gone', the last time he saw his children James (Magnus Nolan/Jonathan Geare)and Phillipa (Claire Geare/Taylor Geare). It is a moment when he wanted to see their faces but couldn't wait; he had to leave the country because the authorities thought that he had killed Mal. Cobb says: 'I realise that I'm gonna regret this moment … that I need to see their faces one last time. But the moment's passed. And whatever I do, I can't change this moment.' Cobb's inception on Robert Fischer offers him the possibility of reuniting with his children yet it is underwritten with the inception that led to Mal's suicide. The dream-worlds are linked and grief is at the source. Fittingly, Fischer is also struggling with loss: the goal of the inception is to force Fischer to divide his

dead father's empire. The design is predicated on the complicated relationship between father and son, the need for reconciliation and catharsis that is always out of reach for Cobb. The controversial ending of the film highlights his predicament, as many argue, without providing resolution – does Cobb defeat the projection of his wife, getting rid of the ghost, and return home or is he forever suspended in a dream-world?

As Leonard and Cobb struggle with and against illusion and fantasy, objects play key roles in sustaining the illusion as well as breaking the spell. As Arthur and Cobb tell Ariadne, a 'totem' is essential to navigating the space between reality and the dream-world. Ariadne acknowledges that it is 'an elegant solution for keeping track of reality'. Arthur tells Ariadne that 'when you look at your totem, you know beyond a doubt that you're not in someone else's dream'. However, Cobb's totem is actually Mal's, as he admits: 'She would spin it in the dream and it would never topple. Just spin and spin.' Cobb's sense of reality is predicated on an object that is a reminder of Mal's absence. However, the totem's grounding in reality is always already tenuous, as Fisher notes: 'The top – that ostensible token of the empirical actual – first of all appears as a *virtual* object, secreted by Mal inside a doll's house in limbo' (2011: 42; emphasis in original). Cobb's top, like Leonard's mementos, complicates the relationship between reality and illusion, the living and the dead.

As Cobb tells Ariadne, a safe or a bank vault is a common object to conjure in the dream-world and the safe is a key feature in his two inception plots. The inception on Fischer is built on the loss of the father. Here is an obvious performance of Freud's Oedipal Complex, yet Fischer's predicament bears many similarities to Cobb's. Where Cobb had attempted (and failed) to extract secret documents from Saito (Ken Watanabe), in his inception on Fischer he is able to plant an important object in the senior Fischer's (Pete Postlethwaite) safe. It is fitting that that the object is a souvenir: a photo of the father and son. Fischer tells the shape-shifting Eames (Tom Hardy), who is masquerading as Robert's 'Uncle Peter' (Tom Berenger), that the image is not significant to his father; he was the one to put it beside the bed. However, Cobb recasts the object, imbuing it with new meaning: the pinwheel is his father's most valued possession. The presence of the object – albeit virtual – solidifies the idea that he was not a 'disappointment' to his father, leading Fischer to choose his own path and divide the company. This outcome is remarkably different from Cobb's earlier inception that failed due to the weight of the idea. While the totem allows the owner to distinguish reality from dream, Mal relegates her top to a safe in the dream-world. Cobb breaks into the safe and plants the idea that their dream-world isn't real. What he had not planned on, though, is that the inception is so insidious that even when Mal returns to reality, it persists. This is analogous to Cobb's predicament. He is similarly haunted by an idea – that he is responsible for Mal's death and that he can somehow bring her back to life.

Cobb proves that the inception is indeed resilient; it forces him to repeat and replay his trauma over and over again, rendering him unable to move into the future. The circuitous nature of his travels is indicative of this concept. Cobb's journey is non-linear, circling between Kyoto, Tokyo, Buenos Aires, Mombasa, Paris and the United States. Cobb longs to return home but instead exists in the liminal space between cities, those vague outlines. Michael J. Blouin states:

The *mise-en-scène* frequently shifts, taking the viewer through a kaleidoscope of worldly ports... Yet something begins to ring false in the film: the locales are too perfect, too much like what one might expect from classical Hollywood. It becomes very probable that everything is stemming from a particular imagination (likely Cobb's); the illusion of worldliness only further pushes viewers to question the veracity of the film's diegetic grounding. (2011: 328)

As Fisher notes: 'There's nothing alien, no *other place* here, only a mass-marketed "subconscious" recirculating deeply familiar images mined from an ersatz psychoanalysis' (2011: 45). Cobb says that he is heading to exotic destinations, yet he does not always arrive. He is repeatedly rerouted, reenacting his circling of the United States.

The film represents the liminality of Cobb's world from its beginning. The opening shots depict Cobb on the shore of his subconscious, in limbo, trying to find Saito. The extraction on Saito takes Cobb and the viewers between layers of his dream-world, from a cocktail party to streets filled with rioters, both ill-defined and ambiguous places. After experiencing the 'kick' that compels the characters from dream to reality, they awaken on a train. After separating, the characters are reunited on a helicopter pad. Cobb says that he is heading to Kyoto but is redirected to Paris to find a new architect.[8] His search for a chemist takes him to Mombasa. The inception on Fischer requires ten hours, time only provided by an operation or travel from Sydney to Los Angeles. The team chooses the latter, with Saito buying an airline to disguise the deception. With trains, helicopters and planes figuring so prominently within and as the foundation for the inception, they introduce paradox into the narrative. Cobb is a static character, unable to move forward in his life by letting Mal go and returning to his lost family.

The train, which is central to the plot of the first extraction on Saito, is an important recurring symbol within the film that is obsessively played out. In fact, in the initial moments of the inception on Fischer, a train crashes through the city landscape. While the train is believed to be a manifestation of Fischer's training, a subconscious security system that includes armored vehicles and soldiers, Ariadne, Cobb and the viewer can infer that the train is a projection of Cobb's memory. His earlier inception threatens the current one; the failure of this inception would prevent Cobb from returning home. The forward motion of the train runs counter to the past where the train figures prominently. When Ariadne first sees the projection of Mal, Mal presents her with a riddle. She says: 'You're waiting for a train. A train that will take you far away. You know where you hope this train will take you. But you don't know for sure. Yet it doesn't matter. How can it not matter to you where the train will take you?' The answer, Cobb supplies, is that it is because they are together. As Cobb later reveals, he and Mal awaken from their extended stay in the dream-world by lying on train tracks. One of the first shots in the film is a close-up of Mal's face as the train approaches.

The performance of that suicide is replayed, perhaps even confused, with the 'real' one, showing how deep the inception runs. Cobb's revelation of what happened in the hotel room on the night of Mal's suicide connects the images, the projections that the viewer sees throughout the film. And the staging of the suicide is yet another

repeated performance: Cobb and Mal return to the same hotel every year to celebrate their anniversary. That night, when Cobb walks into the room to find shattered glass and overturned furniture, he sees Mal sitting on the ledge outside another hotel room, facing him. This doubling reflects Mal's bifurcated view of her world. According to Mal, the two can – and should – jump so that they can return to their real lives and their real children. Obsessively repeating the story to himself and replaying it for Ariadne and the audience, Cobb illustrates how he is unable to move on from that moment. And Mal's real-world inception works. She had left a letter with her attorney fabricating her fear of Cobb and his abuse, keeping him trapped in a liminal state, unable to return to the United States and his children.

That the inception is so richly drawn with modes of transportation highlights the static nature of the characters as well as the dream-worlds themselves. As Cobb tells Ariadne: 'In a dream, your mind functions more quickly. Therefore, time seems to feel more slow.' This concept is depicted in the relationship between the three layers of the dream-world. Time is measured in factors of twenty: ten seconds in level one equals three minutes in level two and sixty minutes in level three. And yet these worlds, and their timing, are contingent; a 'kick' in one world ripples to the next. It is in limbo that time ceases to function; there, the character is suspended in the 'raw, infinite subconscious'.

The concepts of 'waking up, *in time*, to absence' (Little 2005: 71) and 'fall[ing] out of the time of the living' (Spargo 2004: 90) materialise in *Inception*'s navigation of its dream-worlds. Exiting the dream-world occurs in two ways: time runs out or the subject dies. Little's concept of 'waking up, in time' is made literal with the 'kick' that forces the subject to awaken to reality (or at least a higher level of consciousness). At the basic structure of the dream-world is the directive 'memento mori'. Yet this too causes confusion; death in the dream-world does not lead to a real death but rather an awakening. Blouin suggests that 'One must be killed to experience the kick, but it is a shallow death, always preceded by the guarantees of a metaphysical return' (2011: 333). However, if Saito – or any of the characters – dies in the three-layered dream-world, he will permanently fall out of time. Blouin writes: 'The "wake", designated as a liminal space in which the spectator moves from the remnants of life toward a sense of closure, is re-constituted through the layers of *Inception*' (2011: 332). Unable to complete the process of mourning, Cobb, like Leonard, is left in a state of permanent waking.

The films' endings prevent the spectator from moving toward a sense of closure, suspending him or her in a liminal space within and between *Memento* and *Inception*. *Inception* evidences a compulsion to repeat as it conjures up what has *almost* been forgotten and repressed in *Memento*. *Inception* not only returns to many of the themes presented in *Memento*; it recalls its very structure, a Möbius strip. The first sequence in *Memento* is played in reverse. The Polaroid photo of a dead man that Leonard holds in his hand un-develops, returns to the camera, and the camera's flash goes off. The camera focuses on the dead body and blood runs back into it before the body is reanimated. The next sequence introduces the man whom Leonard previously kills, in effect, resetting time until it leads to Teddy's (Joe Pantoliano) death.

The colour segments of the film play out in circuitous loops until Leonard's murder of Jimmy Grantz (Larry Holden) is depicted. It is as Leonard shakes the Polaroid photo of Jimmy's dead body that the black and white sequence turns to colour, joining the two narrative segments. As Andy Klein notes, 'the last sequence in the film, almost imperceptibly slips into color and, in an almost vertiginous intellectual loop, becomes … the first of the color scenes' (2001).

Leonard's development of the photo is the catalyst for a forward motion in time, but, conversely, it does not lead to Leonard's acceptance of consolation and closure. *Memento* is a never-ending loop: even as it moves forward in time, it leads to a conclusion that is itself played out in reverse. Toward the end of the film, Teddy reveals another photo, one taken after Leonard had murdered the first John G. It depicts a happy Leonard, in a departure from his melancholy. As Leonard burns the photo, he erases the memento of his 'spontaneous end' to mourning. As Leonard drives away from Teddy, his new John G., his final monologue indicates a kind of willful waking:

> I have to believe in a world outside my own mind. I have to believe that my actions still have meaning, even if I can't remember them. I have to believe that when my eyes are closed, the world's still there. Do I believe the world's still there? Is it still out there? … Yeah. We all need mirrors to remind ourselves who we are. I'm no different.

During this monologue, Nolan includes a sequence that appears like one of Leonard's memories: Leonard lies in bed with his wife, with a new tattoo reading 'I'VE DONE IT' prominently displayed on his chest, covering the once-empty space that Leonard tells Natalie (Carrie-Anne Moss) will remain until he finds his wife's murderer. For the tattoo to commemorate the success of the revenge plot, Leonard's wife had to have died. Yet, paradoxically, she lies beside him. The sequence exists out of time, suggesting a kind of waking dream, perhaps an inception for the 2010 film.

Maurice Blanchot writes: 'In the work of mourning, it is not grief that works: grief keeps watch. […] Grief, incising, dissecting, exposing a hurt which can no longer be endured, or even remembered' (quoted in Woodward 1992/93: 94). In *Inception*'s final sequences, Nolan continues his play at the *fort-da* game, again looping the film back to the beginning. Cobb returns to the shore of his subconscious to encourage Saito, an old man filled with regret and waiting to die alone, to 'take a leap of faith' and 'come back, so that [they] can be young men together again'. Nolan then circles back to Cobb's last moment of regret, allowing him to redress it. When Cobb sees his children again, the shots play out like those in *Memento*: the earlier sequence is completed. Although Cobb admits to Ariadne, 'The moment's passed. And whatever I do, I can't change this moment', one of the possibilities of the film's ending is that he is able to recover what was lost. However, as Fisher notes, 'this ending has more than a suggestion of wish-fulfillment fantasy about it' (2011: 38).[9] In its final sequence, Cobb turns away from the spinning top, taking a leap of faith. As the top continues to spin, the film resists closure, suggesting infinite play and possibility in the work of mourning, in the space between Freudian theory and contemporary grief-work.

1    Identifying how *Memento* is 'a tribute to grief', Andy Klein writes, 'Grief is an emotion largely based on memory, of course. It is one of *Memento*'s brilliant tangential themes that *relief* from grief is dependent on memory as well – and that is one of the chief hells our unfathomable hero is subjected to' (2001).

2    Mark Fisher notes that *Memento* and *Inception* share a 'coolly obsessive quality, in which a number of repeating elements – a traumatized hero and his antagonist; a dead woman; a plot involving manipulation and dissimulation – are reshuffled' (2011: 37). Fisher's terms are indicative of the obsessive repetitive feature of melancholia; this opens up a reading for how Nolan leaves the grief-work of his films open-ended, unresolved, not only within but also between his films.

3    Laura E. Tanner cites Kathleen Woodward's argument that 'interrogates Freud's assumption that mourning must always come to an end' (2006: 93). She writes that Woodward's 'call for the interdisciplinary study of Grief-Work … stands in opposition not only to psychoanalytic theories that mark sustained grief as illness but to cultural attempts to "comfort mourning" through attention to the consolations of memory or the reconstitution of bodily loss in spiritual terms' (2006: 105). Clewell suggests that Freud responds to Woodward's challenge in his later work; however, Tanner distinguishes a different approach to Grief-Work by addressing the 'marginalization of embodied experience' and the 'unspeakability of embodied grief' (ibid.).

4    Tanner argues that 'factoring embodiment into Freud's psychological model further disrupts what Woodward has already critiqued as Freud's "mysteriously" smooth narrative of mourning' (2006: 94).

5    Little turns his focus away from Leonard to identify how the viewer is engaged in the *fort-da* game within *Memento*. He writes that *Memento* 'invites the viewer to convert such disappointment into tolerable, even entertaining, disappointment by replaying – and playing with – its reel(s)' (2005: 71). According to Little, 'One way *Memento* wakes up the viewer, in the course of time, to absence is by functioning like a memento' (ibid.).

6    Fisher describes the Mal projection as 'a trauma that disrupts any attempt to maintain a stable sense of reality; that which the subject cannot help bringing with him no matter where he goes' (2011: 42).

7    Patrick O'Donnell writes, '*Memento* is a film about time and memory that mangles narrative temporalities in such a manner that the relation between past and future is not simply reversed but made wholly discontinuous' (2009: 122).

8    Saito 'kicks' the previous architect out of the helicopter, necessitating the replacement.

9    Fisher cites Nolan's statement 'I choose to believe that Cobb gets back to his kids' but says that this statement doesn't resolve the issue; the film's final shots complicate this reading (2011: 38).

*Bibliography*

Blouin, Michael J. (2011) 'A Western Wake: Difference and Doubt in Christopher Nolan's *Inception*', *Extrapolation* 52, 3, 318–337.

Bronfen, Elisabeth and Sarah Webster Goodwin (1993) 'Introduction', in Sarah Webster Goodwin and Elisabeth Bronfen (eds) *Death and Representation*. Baltimore, MD: Johns Hopkins University Press, 3–25.

Clewell, Tammy (2004) 'Mourning Beyond Melancholia: Freud's Psychoanalysis of Loss', *Journal of the American Psychoanalytic Association,* 52, 1, 43–67.

Fisher, Mark (2011) 'The Lost Unconscious: Delusions and Dreams in *Inception*', *Film Quarterly*, 64, 2, 37–45.

Freud, Sigmund ([1917] 1957) 'Mourning and Melancholia', trans. and ed. James Strachey. *The Standard Edition of the Complete Psychological Works of Sigmund Freud, vol. 14.* London: Hogarth, 239–58.

_____ ([1923] 1961) 'The Ego and The Id', trans. and ed. James Strachey. *The Standard Edition of the Complete Psychological Works of Sigmund Freud, vol. 19.* London: Hogarth, 1–66.

_____ ([1920] 1989) 'Beyond the Pleasure Principle', in Peter Gay (ed.) *The Freud Reader*. New York: W. W. Norton, 594–627.

Klein, Andy (2001) 'Everything You Wanted to Know about "Memento"', *Salon*, 28 June. Online. Available: http://www.salon.com/2001/06/28/memento_analysis/ (accessed 18 February 2015).

Little, William G. (2005) 'Surviving Memento', *Narrative*, 13, 1, 67–83.

O'Donnell, Patrick (2009) 'Henry James's *Memento*', *The Henry James Review*, 30, 2, 115–28.

Ramazani, Jahan (1994) *Poetry of Mourning: The Modern Elegy from Hardy to Heaney*. Chicago: University of Chicago Press.

Spargo, R. Clifton (2004) *The Ethics of Mourning: Grief and Responsibility in Elegiac Literature*. Baltimore, MD: Johns Hopkins University Press.

Tanner, Laura E. (2006) *Lost Bodies: Inhabiting the Borders of Life and Death*. Ithaca, NY: Cornell University Press.

Woodward, Kathleen (1992/93) 'Grief-Work in Contemporary American Cultural Criticism', *Discourse*, 15, 2, 94–112.

CHAPTER NINE

# Revisiting the Scene of the Crime: Insomnia and the Return of the Repressed

## Stuart Joy

'I could feel it right then, this is gonna catch up with me. I don't do things like that.'

Detective Dormer, *Insomnia*

Remarkably, despite the critical successes of both *Following* (1998) and *Memento* (2000), for several critics *Insomnia* (2002) represented a sweeping stylistic change of direction that not only undermined Christopher Nolan's creative talent, but also marked the beginning of his gradual transition towards more conventional, and thus pedestrian, mainstream filmmaking practises (see Grove 2002; Lim 2002). In general, whilst critical responses to the film were largely positive, there is a sense that *Insomnia* represented a cautious entry into the Hollywood studio system rather than a direct continuation of Nolan's innovative stylistic traits (see Kendrick 2002). Writing for the *Washington Post* Stephen Hunter noted that, 'both in his first film, the little-seen *Following*, and in his breakout hit *Memento*, Nolan showed an edgy creativity and willingness to bend the rules ... but in this film, he seems overwhelmed by the budget, the egos of the stars, the thinness of the script, and he doesn't impose much personality on the picture' (2002). For many, this kind of criticism is a by-product of the central issue that overshadows *Insomnia*, which is that the film is a Hollywood remake of a successful European film (see Dujsik 2002; Heilman 2002; Schwartz 2002).

Made in 1997, the original featured Stellan Skarsgård as Jonas Engström, a police detective who along with his partner, Erik Vik (Sverre Anker Ousdal) is sent to a small Norwegian town to investigate the murder of a teenage girl (Maria Mathiesen). Whilst in pursuit of the murder suspect, Jonas accidentally shoots his partner and attempts to cover up his death. In doing so, he begins his moral descent into uncertainly as guilt, confusion and shame are enhanced by his inability to sleep. Despite some obvious omissions in the form of an attempted rape, scenes of animal cruelty and the contrasting fate of the central characters, the subsequent remake of *Insomnia*

retains several of the key plot points from the original. In the film, detectives Will Dormer (Al Pacino) and Hap Eckhart (Martin Donovan) are similarly sent to a remote destination to assist local police with their investigation into the death of a young girl (Crystal Lowe). In a scene that parallels the original, Dormer shoots his partner but his intentions are deliberately less clear. In particular, the undercurrent of an Internal Affairs investigation alluded to prior to the death of Eckhart is allowed to permeate the narrative adding another dimension to the film previously lacking in the original.

As already noted, the reviews for the remake of *Insomnia* were mainly positive. However, there is a shared tendency in a selection of the negative reviews that is indicative of wider academic debates surrounding the division between high and popular culture. Specifically it would appear that there is an implicit cultural value associated with the original that is a consequence of the frequent debates that are often cited by those who equate European cinema with art cinema or high culture (see, for example, Wollen 1972; Eleftheriotis 2001; De Valck 2007). For critic Walter Chaw, a comparison between the two versions of *Insomnia* draws attention to the inherent division between the different modes of production in European cinema and Hollywood: 'A close comparison between [Erik] Skjoldbjærg's and Nolan's visions for the material brings to light the defective machinery of big-budget motion pictures in Hollywood' (2002). Interestingly in this critic's subsequent comment there is also an implied distinction between the freedoms of the artist working in an independent production as opposed to the apparent constraints of the Hollywood studio system: 'The sad irony of such a discussion is that Nolan's *Memento* was so remarkable because it represented nearly everything that *Insomnia* is not' (ibid.). By distinctly identifying *Insomnia* in relation to Nolan's previous film, Chaw continues the recent trend particularly evident in film journalism, of privileging the director as an identifiable commodity.

This tendency is apparent in several of the other reviews of *Insomnia* which locate the director within the dichotomy of a personal vision associated with an artist and the stigma of a commercially produced film made as part of the studio system. For instance, Andrew O'Hehir in *Salon* writes that 'in a year that so far has offered little more than dippy, die-stamped Hollywood product, here's proof that it's still possible to make pop-oriented yet personal movies with an A-list cast and a zillion bucks' (2002). Paul Tatara brands Nolan as a 'craftsman' alongside other directors such as Steven Soderbergh, David O. Russell, Curtis Hanson and M. Night Shyamalan whilst also calling him an 'individual voice working within the Hollywood system' (2002). Similarly Harry Guerin notes that *Insomnia* is 'a classic example of a director bringing his own vision to the mainstream' (2002). What is significant about both positive and negative reviews of the film is that there is a distinct emphasis on Nolan's auteur persona that supersedes any potential adverse connotations of the film being a product of the Hollywood studio system.

As his debut studio film and the only film in his body of work that Nolan has not directly written or co-written, the general emphasis in the critical discourse surrounding *Insomnia* positions him primarily as a technically gifted director emerging from independent cinema to tackle a conventional and thus uninspired Hollywood remake. Described by one critic as a 'worthy, if not particularly distinguished piece of

entertainment' (Lazere 2002), and by another as simply, 'a decent remake of a foreign film' (Turner 2002), *Insomnia* has been positioned largely as a competent achievement in direction that lacks the ingenuity of Nolan's previous efforts. As a final example, consider the following critique which aptly summarises the consensus of indifference surrounding the film. Writing in *Need Coffee*, Widgett Walls notes: 'there's nothing extremely wrong with this piece, but there's nothing terribly right about it, either' (2002). In a retrospective analysis of *Insomnia* following the film's release on Blu-ray, Brian Eggert succinctly encapsulates the key contradictions surrounding academic and critical interpretations of the film:

> At first glance, *Insomnia* seems like an undemanding choice with which director Christopher Nolan should follow his feature-length debut, 2001's *Memento*, a landmark motion picture composed of intelligent narrative and structural trickery. By contrast, what could be more straightforward than a Hollywood remake of a foreign – not to mention linear – cop thriller? And yet, as with all his films, Nolan treats his narrative with grand symbolism to reflect the layers of the story. Looking back, the picture's themes of obsession, means justifying ends, and self-deception fit nicely into the director's body of work, but here he explores them in such emotionally engrossing and suspenseful ways that it catches the audience off guard, if only because on the surface the material looks so typical. (2002)

With these comments in mind, particularly those of Eggert, I want to consider Nolan's treatment of traumatic memories by analysing *Insomnia*. In particular I want to suggest that despite the prevailing climate of academic and critical disregard *Insomnia* can be considered one of the central films in Nolan's filmography to engage with the effects of traumatic memories on consciousness.[1]

Whilst the film marks a stylistic deviation from the movies with which he made his name, *Insomnia* remains thematically similar, representing a continuing effort to explore themes that have dominated his work. For example, in the *New York Times* Elvis Mitchell writes, 'the intensely sharp-witted remake of the *noir* thriller *Insomnia* – a cat-and-mouse game in which the mouse feels its pursuer's breath on its fur and the cat is burdened with shame – matches the director Christopher Nolan's particular interests' (2002). The review in *Time Out London* continues this trend, claiming that, 'despite its linear storyline, the film is very recognisably the work of the sharp, probing intelligence that gave us *Following* and *Memento*' (Anon. 2002), while John Bleasdale remarks, 'although it feels at times like Nolan was a gun for hire ... there are definite features in *Insomnia* that are consistent with his other work' (2012). The reviews on the whole identify the style and themes that run throughout the director's existing catalogue of films in relation to *Insomnia*. In particular there is a varying focus on time, identity, guilt and self-deception (see Anderson 2002; Ebert 2002) that is implicit in these discussions of the film, but rarely addressed is the underlying theme of trauma. Although Nolan's previous representations of the mind have engaged with a general psychoanalytic framework – in terms of the depiction of repression and traumatic

memories in *Memento*, for example (see Thomas 2003; Little 2005) – *Insomnia* does so in a much more ostensibly subtle manner. These ideas, which are unique to Nolan's interpretation of the source material, are established in the film's opening sequence, principally with the first image of the film, which will for the remainder of this essay be given particular attention.

Starting with the opening sequence from *Insomnia*, this formal analysis of the film is contextualised through a discussion of psychological theories with specific reference to the assertions of Sigmund Freud in relation to trauma and time. As the opening credits start, dark blood spreads outward on a white cloth in a series of receding close-ups as the film's title emerges from the depth of the image. Subsequent aerial shots of the Alaskan landscape are interspersed with the repetition of the blood-spreading motif. As each shot of the jagged glaciers and mountains transitions into a blank screen before segueing into the image of the white fabric, there is a sense that the visual transition between the shots represents the liminal state between waking and sleep. In this way, the manner in which the images of the glacier become increasingly blurred foreshadows Dormer's (a name that is similar to the French verb 'dormir', meaning 'to sleep') subjective mental state as one that is continuously framed as trapped between the transitional states of waking and asleep. The sequence ends with an image of blood being dropped on to a white shirt cuff and an unidentified person (later revealed to be Dormer) who appears to be attempting to rub away the bloodstains. As the shots are so fleeting, the full measure of what has been shown only becomes apparent in flashbacks that occur later in the film. However, in these brief shots (and the subsequent cut to Dormer analysing several crime scene photos) there is an underlying visual association implied by the relationship between the shots. This relationship suggests a connection between the image of the unidentified person attempting to rub away the bloodstains and the criminal suspect who will become central to Dormer's subsequent investigation during the remainder of the film. Todd McGowan suggests that this common editing technique linking the crime and the investigator is employed in many detective films, citing Jonathan Demme's *The Silence of the Lambs* (1991) as a prime example (2012: 81). We subsequently learn near the film's ending that, contrary to our initial assumption, what appears to be a criminal attempting to remove evidence is in fact Dormer in the process of framing a suspect. McGowan points out that it is this type of causal linkage that is seemingly present in the opening sequence, which deceives the spectator by operating at the level of the 'deceptiveness of cinema' (2012: 82):

> The structure of the film creates a deception in which the spectator misinterprets the opening images, and this initial misinterpretation paves the way for a series of misinterpretations that end only when the film's conclusion enables the spectator to recognize them as such ... the deception marks the beginning and occurs before any truth. The spectator begins the Nolan film with a mistaken idea of what has happened and what's at stake in the events. The movement of the typical Nolan film is not, as in most films, from ignorance to knowledge. Instead, the spectator moves from mistaken knowledge to a later

knowledge that corrects mistakes. The beginning point is not a blank slate but an initial error. (2012: 2)[2]

This reversal of what we have seen, the way in which Nolan provides the images with a new and unexpected meaning as well as assigning it much more significance in the context of the film, is central to an understanding of the relationship between the spectator and screen in the director's work. However, for now I want to highlight the dual function of this sequence which reveals more than just the 'deceptiveness of cinema' but also engages with the psychoanalytic translation of trauma.

In *Beyond the Pleasure Principle*, Freud returned to the historical conception of trauma as a bodily wound in order to reflect on how the mind responds to traumatic events. Freud argued that, like other organisms, the mind develops 'a special integument or membrane that keeps off the stimuli' (1922: 30). Here Freud uses the analogy of the body, placing a particular emphasis on the skin as a point of contact between the interior and exterior layers of the mind. This anatomical framework allows Freud to consider the function of this 'protective barrier', later reframed as a 'shield', which prevents excessive stimuli from entering consciousness (1955: 27). He writes that the organism 'floats about in an outer world which is charged with the most potent energies, and it would be destroyed by the operation of the stimuli proceeding from this world if it were not furnished with a protection against stimulation' (1922: 30). For Freud, the traumatic incident represents a rupture in the protective shield that overwhelms and penetrates through the protective 'membrane' of consciousness (ibid.). In the following section he outlines the function of the protective barrier in the context of traumatic neurosis. It is worth examining the entire passage and remembering the description of the opening sequence, particularly that of the blood-spreading motif:

> Such external excitations as are strong enough to break through the barrier against stimuli we call traumatic. In my opinion the concept of trauma involves such a relationship to an otherwise efficacious barrier. An occurrence such as an external trauma will undoubtedly provoke a very extensive disturbance in the workings of the energy of the organism, and will set in motion every kind of protective measure. But the pleasure-principle is to begin with put out of action here. The flooding of the psychic apparatus with large masses of stimuli can no longer be prevented: on the contrary, another task presents itself – to bring the stimulus under control, to 'bind' in the psyche the stimulus mass that has broken its way in, so as to bring a discharge of it. (1922: 34)

In *Insomnia*, trauma is communicated both symbolically and structurally in the form of the blood-spreading motif. For instance, if we consider Freud's analogy of trauma as a bodily wound then the blood bears a direct correlation to a rupture in the protective barrier of the skin parallel to the penetration of the protective 'membrane' of consciousness. From a symbolic perspective, the intricate layering of the fabric can be understood as a representation of Freud's multi-layered structure of consciousness first introduced in *The Interpretation of Dreams* (1953 [1900]). As the blood slowly perme-

ates every thread of the fabric to the point of saturation, so too does the traumatic memory emerge from the depths of the unconscious to encroach upon the conscious region of the mind.

From a structural perspective, it is only when the relevance of the blood-spreading motif is exposed in relation to Dormer's past that the significance of the scene can be understood in terms of the narrative's connection to trauma theory. At this point, a brief overview of the concept of *Nachträglichkeit* will be useful before proceeding with a further analysis of the opening sequence. For Freud, *Nachträglichkeit* is the process of delayed action. He suggested that the subject's initial experience of trauma only acquires traumatic meaning through the introduction of a second trauma. It is the secondary event that effectively reactivates the earlier memory, revealing its traumatic origin. Jean Laplanche and Jean-Bertrand Pontalis write that 'the subject revises past events at a later date (*Nachträglichkeit*) and that it is this revision which invests them with significance and even with efficacy or pathogenic force. […] It is not lived experience in general that undergoes a deferred revision, but, specifically whatever it has been impossible on the first instance to incorporate fully into meaningful context. The traumatic event is the epitome of such unassimilated experience' (1973: 112). So what, then, in the context of *Insomnia* is the secondary trauma? One potential answer resides in the link between the death of the teenage girl and Dormer's decision to frame Wayne Dobbs, a child murderer in an event that precedes the diegesis. Whilst we are given no indication of the duration between Dormer's indiscretion and Kay Connell's death, we can assume that due to the (imagined) vision of her death and the parallels between Dobbs and the suspect Walter Finch (Robin Williams) as two child murderers, these separate events are connected in Dormer's mind. We can also assume, then, that it is the (imagined) death of Kay reconstructed from the images contained within the coroner's report shown briefly during the opening sequence, which acts as the second trauma effectively reviving the affect of the earlier memory of Dormer's actions in the previous case.

As the blood motif occurs from the outset of the film during the opening credits, there is potential to dismiss the images as a cinematic tool designed simply to mislead the spectator.[3] However, the combination of non-diegetic sounds of a plane experiencing turbulence simultaneously increasing in volume whilst included over the images of Dormer planting evidence, as well as the initial shot of Dormer opening his eyes at the climax of these sounds, suggests that the opening sequence could be considered a representation of Dormer's subjective state of mind as he drifts in and out of consciousness. This reading is further supplemented by the subsequent shots of the Alaskan landscape, which become increasingly blurred before transitioning back to the blood motif. However, this reading of the opening sequence is problematic primarily as it relies heavily on claims that are difficult to substantiate with the visual evidence of scenes from the film. For instance, Nolan conflates any sense of subjectivity by manipulating the conventional use of eye-line match cuts.[4] The second shot of Dormer in the film shows him looking screen left (figure 1). The subsequent shot of the landscape (figure 2) provides a causal link between these two shots. However, the nature of this cut on action is immediately undermined as a plane comes into view from screen

Figures 1–3: Dormer looking screen left; (implied) POV of Alaskan landscape; a plane enters screen right.

right as part of the same continuous shot (figure 3). We can assume that from the (now) diegetic sounds of the plane's engine heard during the initial shots of Dormer that he is on the plane shown in figure 3, therefore making the point-of-view shot redundant. From a technical perspective, what we are witnessing is a kind of spectatorial manipulation involving a disruption of the conventional editing techniques. As a consequence, the distinction between subjectivity and objectivity has been, perhaps deliberately, distorted.

It is ultimately unclear whether the imagery of the blood and the panoramic shots of the landscape are interlinked through Dormer's subjective perceptions or whether, like many of Nolan's films such as *Following, Memento* and *The Prestige* (2006), the opening shots merely act to foreshadow the events of the film. This is not to dismiss the interpretation of the opening sequence offered here but rather it is to say that there is perhaps another clearer explanation of the experience of *Nachträglichkeit*, one that is more easily identifiable within the confines of the film's narrative. If we assume, as McGowan does, that the opening sequence acts as a cinematic cypher leading the

spectator down a false path, then it is also possible to consider the opening as existing non-diegetically with only a tenuous link to the fictional world of the story. What this means is that if the notion of *Nachträglichkeit* is to be applied to the representation of the relationship between trauma and memory in *Insomnia*, we must look elsewhere within the diegetic realm of the film in order to locate the secondary site of trauma. It is important to keep in mind that due to the frequency of the blood-spreading motif throughout the film, this would appear to be tied to the memory of the initial traumatic event. Within the diegesis, then, the blood-spreading motif initially occurs after Detective Eckhart's death during Dormer's failed attempts to sleep; the symptom of his neurosis. Intercut with fragmentary shots of Eckhart and a few imagined images of Kay, it seems logical to suggest that Dormer's secondary trauma occurs at the time when, or sometime after, Dormer supposedly accidentally shoots and kills Eckhart whilst in pursuit of Finch.[5]

Throughout the remainder of the film Dormer's past actions, notably communicated through shots of him planting evidence, impose themselves upon his consciousness visually through the sporadic inclusion of subjective recollections borne out of the memory of the initial traumatic event. In order to apply the concept of *Nachträglichkeit* in *Insomnia*, at least two related traumatic events require consideration. Continuing McGowan's thread of analysis, and assuming that the opening sequence merely foreshadows the events of the film, when the blood spreading motif first appears as Dormer tries to sleep (discounting the earlier pre-credit sequence as a subjective experience), the subsequent images of the murder victim that appear momentarily onscreen, are part of the cinematic diversion designed to deceive the viewer into associating the imagery with the criminal under investigation. A single shot of an unknown individual attempting to remove some bloodstains, repeated from the film's opening, further enhances this conjectural reasoning. However, more tellingly, taking into account the framing device of Dormer attempting to sleep, the emphasis placed on Detective Eckhart during the remainder of this sequence is worth further analysis. In particular, three ensuing scenes which culminate in the blood-spreading motif ostensibly appear to be fragments from earlier in the film which include shots of Eckhart, but which are either fabricated or the same events seen from a slightly different angle. These scenes not only question the reliability of memory but they also establish a clear connection between the imagery of the blood and Eckhart. The final scene from this sequence seems to support this reading as the moment Dormer discovers he has shot Eckhart is repeated onscreen, suggesting that it is Dormer's role in the shooting that acts as the secondary trauma which prompts his recall of the initial traumatic event.

Dormer's situation then demonstrates the process of *Nachträglichkeit* in the sense that the original traumatic event (planting false evidence) is isolated from memory and thus resides in a region of the mind removed from his daily experience. The original traumatic event which had not been available as part of conscious recall nonetheless emerges in the second stage of the traumatic process when triggered by the experience of an ancillary trauma (Eckhart's death) causing the initial trauma to irrupt into the present moment. The original trauma then imposes itself repeatedly on Dormer's psyche in the form of the blood-spreading motif which acts as reminder of the initial

traumatic event. The structural function of trauma in this sequence is similar to the case of Emma Eckstein, noted in Freud's early work on the *Project for a Scientific Psychology* (1950 [1895]) and *The Aetiology of Hysteria* (1962 [1896]). Freud's account of Emma is predicated on an understanding of trauma that is rooted in a relationship between two traumatic events. As an adult, Emma, whose symptoms included a phobia of going into shops alone, ascribes the cause of her response to an event which took place at the age of twelve, but which in reality occurred when she was aged eight. At age twelve, Emma experienced an anxiety attack whilst in a shop where she witnessed two employees, one of whom she knew, laughing at her clothes (1950: 353). In his analysis, Freud surmises a link between this event and a previous memory, which, at aged eight, involved Emma being sexually assaulted by a shopkeeper (1950: 354). This event fails to register as meaningful to her having taken place prior to an understanding of the sexual nature of the attack (1950: 356). However, the initial trauma later emerges as an after-effect of the onset of puberty in the form of psychosomatic symptoms that enable a reinterpretation and re-evaluation of the initial traumatic event. What needs to be emphasised in the context of an analysis of *Insomnia* is the structural mechanics of trauma as opposed to, in this instance, the sexual meaning retroactively attributed to the experience of trauma. In the case of Emma and *Insomnia*, the structural similarities between the deferred nature of their experiences of trauma highlight how Nolan is able to articulate an audio-visual expression of an abstract mental process.

It is worthwhile at this stage to consider the way in which Laplanche extends Freud's notion of *Nachträglichkeit*. By doing so, I can incorporate the earlier reading of the opening sequence as a representation of Dormer's subjective state of mind, whilst maintaining McGowan's argument that the sequence operates at the level of the 'deceptiveness of cinema' (2012: 82). What distinguishes Laplanche's notion of 'afterwardsness' from *Nachträglichkeit* is an emphasis on a third factor (1999: 260). Laplanche proposes a complex notion of afterwardsness whereby the emphasis is not on the initial traumatic event or the corresponding second event but rather the relationship *between* the two events. Discussing the case of Emma, he suggests that no event in and of itself is fundamentally traumatic:

> It may be said that, in a sense, the trauma is situated entirely in the play of 'deceit' producing a kind of seesaw effect between the two events. Neither of the traumatic events in itself is traumatic; neither is a rush of excitation. The first one? It triggers nothing: neither excitation or reaction, nor symbolization or psychical elaboration. [...] If the first event is not traumatic, the second is, if possible, even less so. (1976: 41)

Simply put, for Laplanche an event only becomes traumatic through an engagement with the structures of the unconscious which retroactively make the event traumatic. This process of constructing the past out of the present reverses the cause and effect relation inherent in time's arrow, albeit temporarily.[6] Ultimately then, when applied in the context of *Insomnia* it is not the original event of planting evidence that causes Dormer's trauma, nor the death of Kay Connell, and nor is it his involvement in

the subsequent death of Detective Eckhart. Equally, whilst the repeated reminders of Eckhart's death (hallucinations, flashbacks and so on) ostensibly appear to be clear indicators of the source of his trauma, these images are also not to be considered the primary focus for his experience of trauma. Rather, the cause of his trauma is a result of the way in which all of these events are manifested by way of a pattern that shapes the unconscious motivations of Dormer's psyche. The key to understanding this pattern emerges from a broader consideration of Dormer's actions within the film and central to these is Dormer's motivation for concealing his role in Eckhart's death.

In the context of the narrative, Dormer's decision to implicate Kay's murderer in the death of Eckhart thus temporarily exonerating himself represents an extension of his desire to disavow the truth that stems from his decision to frame Dobbs in the events that precede the diegesis.[7] Discussing the nature of Dormer's decision to lie about Hap's death, McGowan points out that, 'there is no clear reason for Will to lie in this situation. The dense fog in the area hampered visibility and would fully justify the claim that the shooting had been accidental, even if Will had in fact shot Hap purposely' (2012: 74). Similarly, J. L. A. Garcia writes: 'the detective was justified in firing to hit a fleeing suspect who had just shot one of the Alaskan policemen pursuing him, and hit Hap only by mistake' (2006: 103). This course of action then is borne out of a wish to hide the truth that is manifested throughout the film suggesting that the essential element of trauma is motivated by Dormer's unconscious desire to lie. What I mean by the *unconscious desire to lie* is that without this desire, it is reasonable to suggest that a traumatic response would not have occurred. The original event of planting evidence would not have taken place, while the triggering event of either Kay's or Eckhart's death would not have acquired traumatic meaning, if unconsciously they had not been linked to his initial indiscretion.[8]

Though Nolan abandoned the overt pro-filmic manipulation of narrative time-lines associated with *Following* and *Memento*, in structural terms, *Insomnia* can still be understood in terms of how the narrative explores the mechanisms of traumatic memory. The key to understanding the film's structural relationship to trauma and memory resides in comprehending the cinematic deception that Nolan induces in the spectator from the outset of the film. According to McGowan:

> The structure of the credit sequence perpetuates a similar deception in the film's relationship to the spectator. The juxtaposition of the bloodied white fabric and the plane flying over the Alaskan wilderness leads the spectator to associate the fabric with the crime that Will is going to investigate, not with his own act of fabricating evidence. In this way, Nolan links the necessary lie of the police investigation with the deceptiveness of cinema (and specifically cinematic editing). (2012: 82)

As the meaning of the opening scene is deliberately edited in a way to render it both misleading and unclear, we misunderstand the nature of what is presented to us. In this way, the fragments of information presented can be referred to as what Maureen Turim labels as a 'lying flashback'; for her, the conventional use of the flashback acts

to 'reveal, verify, or reiterate a narrative truth' – however, the flashback may also be used to question the authenticity of what is presented by undermining the truth (1989: 168). Such is the case with the flashback in Alfred Hitchcock's *Stage Fright* (1950), she remarks: 'it presents a version of events that is later shown to be not the way these events happened' (ibid.). Similarly, in *Insomnia* the film subsequently corrects our judgement in a scene where, as already noted, the fleeting images of the bloodied white fabric are explained when Dormer confesses to planting evidence. In light of this information about the past, the audience is encouraged to retroactively question the unconscious assumptions engineered by the film's 'lying flashback'. In effect, the confession rewrites the information available to the audience and retrospectively rewrites the story. In doing so, the recurrence of the blood-spreading motif throughout the film becomes a structural signpost that frames the narrative in relation to trauma theory by communicating Freud's notion of the return of the repressed for both Dormer and the spectator.

The continued repetition of the image throughout the film aligns Dormer's unresolved experience of the triggering event with the spectator's unawareness or misplaced understanding of the trauma's source. In this way, the temporal disjunctions of deferred action are integrated into the narrative structure replicating Dormer's cognitive function, thus inviting the audience to experience *Nachträglichkeit* vicariously. The importance of this scene is underscored by Nolan as part of the director's commentary available on the film's DVD release. He remarks that the imagery of the blood

> is crucial to the understanding of the narrative and what the narrative of the film represents because to me, at this point, you realise that you're really seeing the last act of the story, not the whole story and that everything that is really going on with this guy [Dormer] relates to something that happened before the film even began. That to me was a very interesting notion narratively speaking ... beginning the film with this blood imagery and then coming back to it at this point helps get that across.

In the film the flashbacks are used to show Dormer's past but these are a mixture of subjective point-of-view shots and images presented as if an observer were looking in on the events. In this way, the spectator is positioned as both Dormer himself, in an attempt to understand his trauma, and as victims of trauma more generally. The absent, or rather, misunderstood trauma at the heart of the story distorts the rest of the narrative prompting the spectator's involvement to repeat the mechanisms of deferred action by going back to re-examine the past. The viewing experience then is therefore an opportunity to experience *Nachträglichkeit*. Even more so, as the text is fixed but the viewing of it is not, seeing the film again renders its traumatic meanings differently, therefore the experience is similar to a psychoanalytic experience.

As mentioned in the introduction to this essay, critical responses to Nolan's decision to follow up *Memento* with *Insomnia* are somewhat polarised. For many commentators, *Insomnia* represented a conscious decision to move away from the independent productions with which he made his name. For many, this movement towards more

mainstream filmmaking practises raised several questions about his artistic credibility, questions which have continued to hang over the director ever since.[9] However, for others the continuation of a recurring set of thematic concerns relating to trauma and memory, evident in the transition from *Memento* to *Insomnia*, highlighted Nolan's ability to work within the apparent confines of Hollywood while at the same time enjoying a rare level of creative and artistic freedom. In either critical context, *Insomnia* has often been overlooked or considered to be a mere stepping stone in his career in favour of an emphasis on his more 'personal' films or his more recent blockbusters such as the *Dark Knight* trilogy (2005, 2008, 2012), *Inception* (2010) and *Interstellar* (2014).[10] And yet, as demonstrated here, *Insomnia* can be considered to be one of the key films in his body of work to engage with the themes of trauma and memory, which are so central to an understanding of his entire filmography.

*Notes*

1    Notable exceptions include J. L. A. Garcia (2006) and Todd McGowan (2012).

2    The initial misinterpretation that occurs during the film's opening sequence can be related to '*proton pseudos*', a concept outlined by Freud in the *Project for a Scientific Psychology* (1950 [1895]) to refer to 'false premises and false conclusions' (1950: 352).

3    In a typical mainstream film, credits are conventionally signalled at the beginning or the end of the text. However, there is some debate as to how to establish where credits begin and end as Lesley Stern points out: 'the difficulty of locating where the film "proper" starts can be seen if you try to ascertain the differences between a pre-credit sequence, a diegetic credit sequence (where credits are superimposed over moving images, a slice of narrative action) and an autonomous non-diegetic segment (where titles are superimposed over a background that is frequently though not invariably fixed and abstract)' (1995: 128–9). Based on this distinction, *Insomnia* would appear to be a diegetic credit sequence operating as a 'slice of the narrative action'.

4    In the history of film, eyeline-match cutting conventionally uses two shots to establish spatial continuity. The first shot usually begins with a character looking off-screen followed by a second shot which indicates that which the character is looking at, or in many cases, who the character is talking to.

5    A momentary shot of Dormer attempting to scrub away Eckhart's blood from his shirt bears a significant symbolic parallel to the initial shot contained within the opening sequence of Dormer attempting to remove bloodstains accidentally dropped onto his own shirt whilst trying to plant evidence. In both instances, it is the same act that represents an attempted disavowal of the truth and it is this revelation which provides evidence of the potential essence of the trauma.

6    According to the second law of thermodynamics, time's arrow is unidirectional (see Eddington 1929; Coveney and Highfield 1990).

7    In a revealing sequence deleted from the film's theatrical release, Dormer's willingness to disavow the truth is made evident from an even earlier point within the

diegetic world. In a conversation with Rachel (Maura Tierney), Dormer says that in his job he often deals with people who have lost someone. He finds that their feelings are often ambiguous and discloses that he himself felt embarrassed as a boy over his brother's death. As a result, he would often make up stories to tell people who would ask about him to avoid feeling different.

8  Furthermore, the frequent appearance of hallucinations, flashbacks and so on, related to the traumatic incidents make little sense as traumatic events in themselves. Instead, these can be considered as being part of an unconscious wish to be punished brought about due to the interaction between the ego and the superego.

9  These questions began to increase even more so after it was announced that Nolan would attempt to resurrect one of Warner Bros'. most lucrative franchises, Batman.

10  By 'personal' here I am referring to his independent productions or those that overtly indulge in his favoured stylistic treatment of time such as *Following*, *Memento* and *The Prestige*.

*Bibliography*

Anon. (2002) '*Insomnia*', *Time Out London*, no date. Online. Available: http://www.timeout.com/london/film/insomnia-1 (accessed 10 September 2012).

Anderson, Jeffrey M. (2002) '*Insomnia*: Dead Beat', *Combustible Celluloid*, 5 March. Online. Available: http://www.combustiblecelluloid.com/2002/insomnia.shtml (accessed 12 June 2012).

Bleasdale, John (2012) 'Christopher Nolan Season: *Insomnia*', *Cine Vue*, no date. Online. Available: http://www.cine-vue.com/2012/07/christopher-nolan-season-insomnia.html (accessed 12 December 2012).

Chaw, Walter (2002) 'Review: *Insomnia*', *Film Freak Central*, 19 July. Online. Available: http://www.filmfreakcentral.net/ffc/2012/07/insomnia-2002.html (accessed 22 August 2012).

Coveney, Peter and Roger Highfield (1990) *The Arrow of Time*. New York: Ballantine Books.

De Valck, Marijke (2007) *Film Festivals: From European Geopolitics to Global Cinephilia*. Amsterdam: Amsterdam University Press.

Dujsik, Mark (2002) '*Insomnia* Review', *Mark Reviews Movies*, no date. Online. Available: http://www.markreviewsmovies.com/reviews/I/insomnia-2002.htm (accessed 24 September 2012).

Ebert, Roger (2002) '*Insomnia*', 24 May. Online. Available: http://www.rogerebert.com/reviews/insomnia-2002 (accessed 24 January 2013).

Eddington, A. (1929) *The Nature of the Physical World*. Cambridge: Cambridge University Press.

Eggert, Brian (2012) '*Insomnia* (2002)', *Deep Focus Review*, 15 July. Online. Available: http://www.deepfocusreview.com/reviews/insomnia.asp (accessed 24 January 2013).

Eleftheriotis, Dimitris (2001) *Popular Cinemas of Europe: Studies of Texts, Contexts and Frameworks*. New York: Continuum.

Freud, Sigmund (1922 [1920]) *Beyond the Pleasure Principle*, trans. by C. J. M. Hubback. London and Vienna: International Psycho-Analytical.

_____ (1950 [1895]) *Project for a Scientific Psychology*, in trans. and ed. James Strachey. *The Standard Edition of the Complete Psychological Works of Sigmund Freud, Vol. 1.* London: Hogarth, 281–397.

_____ (1953 [1900]) *The Interpretation of Dreams*, in trans. and ed. James Strachey. *The Standard Edition of the Complete Psychological Works of Sigmund Freud, Vols. 4 and 5.* London: Hogarth, ix–627.

_____ (1955 [1920]) *Beyond the Pleasure Principle*, in trans. and ed. James Strachey. *The Standard Edition of the Complete Psychological Works of Sigmund Freud, Vol. 18.* London: Hogarth, 7–64.

_____ (1962 [1896]) *The Aetiology of Hysteria*, in trans. and ed. James Strachey. *The Standard Edition of the Complete Psychological Works of Sigmund Freud, Vol. 3.* London: Hogarth, 191–221.

Garcia, J. L. A (2006) 'White Nights of the Soul: Christopher Nolan's *Insomnia* and the Renewal of Moral Reflection in Film', *Logos: A Journal of Catholic Thought and Culture*, 9, 4, 82–117.

Grove, David (2002) '*Insomnia*: Review', *Film Threat*, 23 May. Online. Available: http://www.filmthreat.com/reviews/3117/ (accessed 10 September 2012).

Guerin, Harry (2002) '*Insomnia*: review', 29 August. Online. Available: http://www.rte.ie/ten/reviews/movies/2002/0829/446247-insomnia/ (accessed 21 February 2015)

Heilman, Jeremy (2002) '*Insomnia*: Review', 26 May. Online. Available: http://www.moviemartyr.com/2002/insomnia.htm (accessed 19 April 2012).

Hunter, Stephen (2002) 'Numb, Alaska', *The Washington Post*, 24 May. Online. Available: http://www.washingtonpost.com/wp-dyn/content/article/2002/05/24/AR2005033117456.html (accessed 12 June 2012)

Kendrick, James (2002) '*Insomnia*: Review', no date. Online. Available: http://www.qnetwork.com/index.php?page=review&id=938 (accessed 11 February 2012).

Laplanche, Jean (1976) *Life and Death in Psychoanalysis*. Baltimore, MD: Johns Hopkins University Press.

_____ (1989) *New Foundations for Psychoanalysis*. Oxford: Basil Blackwell.

_____ (1999) 'Notes on afterwardsness', in *Essays on Otherness*, trans. John Fletcher. London: Routledge, 260–5.

Laplanche, Jean and Jean-Bertrand Pontalis (1973) *The Language of Psychoanalysis*, trans. Donald Nicholson-Smith. New York: Hogarth.

Lazere, Arthur (2002) '*Insomnia*', *CultureVulture*, 6 June. Online. Available: http://www.culturevulture.net/Movies/Insomnia.htm (accessed 11 February 2012).

Lim, Dennis (2002) 'Waking Life', *The Village Voice*, 28 May. Online. Available: http://www.villagevoice.com/2002–05–28/film/waking-life/2/ (accessed 09 July 2012).

Little, William G. (2005) 'Surviving *Memento*', *Narrative*, 13, 1, 67–83.

McGowan, Todd (2012) *The Fictional Christopher Nolan*. Austin, TX: University of Texas Press, 67–85.

Mitchell, Elvis (2002) 'A Cop Runs But Can't Hide', *The New York Times*, 24 May. Online. Available: http://www.nytimes.com/2002/05/24/movies/film-review-a-cop-runs-but-can-t-hide.html (accessed 9 July 2012).

O'Hehir, Andrew (2002) '*Insomnia*: review', *Salon*, 24 May. Online. Available: http://www.salon.com/2002/05/24/insomnia/ (accessed 9 July 2012).

Schwartz, Dennis (2002) '*Insomnia* Review', 28 May. Online. Available: http://home-pages.sover.net/~ozus/insomnia1.htm (accessed 14 February 2012).

Stern, Lesley (1995) *The Scorsese Connection*. London: British Film Institute.

Tatara, Paul (2002) 'Review: *Insomnia* one of year's best', 23 May. Online. Available: http://edition.cnn.com/2002/SHOWBIZ/Movies/05/23/ca.s02.review.insomnia/index.html (accessed 14 February 2012).

Thomas, Peter (2003) 'Victimage and violence: *Memento* and trauma theory', *Screen*, 44, 2, 200–7.

Turim, Maureen (1989) *Flashbacks in Film: Memory and History*. New York: Routledge.

Turner, Matthew (2002) '*Insomnia*', 30 August. Online. Available: http://www.viewlondon.co.uk/films/insomnia-film-review-3239.html (accessed 3 June 2013).

Walls, Widgett (2002) '*Insomnia*: Review', no date. Online. Available: http://www.needcoffee.com/html/reviews/insomnia.htm (accessed 9 April 2013).

Wollen, Peter (1972) 'Godard and Counter Cinema: Vent d'Est', *Afterimage*, 4, 6–17.

# 'You keep telling yourself what you know, but what do you believe?' : Cultural Spin, Puzzle Films and Mind Games in the Cinema of Christopher Nolan

## Sorcha Ní Fhlainn

'Theatricality and deception are powerful agents.'

Ra's Al Ghul, *Batman Begins*

Recent cinema is heavily preoccupied with the manipulation and alteration of subjective memory. In particular, cinematic and cultural texts of the 1990s and early 2000s were heavily laced with memories that were eradicated, questioned, fabricated and/or altered, mirroring a distinct period in popular culture that openly questioned and often rewrote shared cultural memory. This period produced texts on conflicting accounts of disasters and terrorism (9/11, for example), and a constant questioning of reality in entertainment via the puzzle film in a time described as one of cultural spin. In particular, films like *The Usual Suspects* (Bryan Singer, 1995), *The Game* (david Fincher, 1997), *The Truman Show* (Peter Weir, 1998), *The Matrix* (Andy and Lana Wachowski, 1999) and *Memento* (Christopher Nolan, 2000) all grapple with themes of reality, simulation, the erosion of certainty and trauma in late postmodernity. With these themes re-emerging in late twentieth-/early twenty-first-century film and culture, the subjective space of memory and uncertainty has become the central diegetic force for Anglo-American writer/director Christopher Nolan. Nolan's works, from his early cult film *Memento* – in which a man with no short-term memory seeks out a mysterious man who apparently murdered his wife (Jorja Fox) – to his blockbuster auteur film *Inception* (2010) – a film set in the subconscious mind of a business heir (Cillian Murphy) who is subject to psychological invasion by a team of dreamscape experts implanting an idea – repeatedly tread the difficult terrain of perceived memory

and puzzle box film form. For Nolan, the act of controlling our perception of events becomes the site of a game, as his characters deceive, betray and are driven by the trauma of a memory or deception which brings them to crisis points. With emphasis on a selection of Nolan's films to-date including *Memento*, *Insomnia* (2002), *The Prestige* (2006), the *Dark Knight* trilogy (2005, 2008, 2012), *Inception* and *Interstellar* (2014), and focusing in particular on the cultural echoes and auterist strategies of the director, this essay intends to demonstrate that Nolan's diegetic textual playground is rooted in a fear of doubting our own memories (the fiction we tell ourselves overwrites our reality) and, in his non-franchise films, we are subjected not only to playful deceit, but puzzle box structure and narrative games. In short, like Nolan's protagonists, we wish to believe the palatable lie over the unbearable truth in his films. Juxtaposing these films with recent cultural history and the rise of spin, this essay will illustrate that in our current age of virtual reality, simulation, misdirection and puzzles all inform the brand of cinema Nolan produces, and his cinema hinges upon frequently contested subjectivities. However, the *Dark Knight* trilogy wholly exploits the deceptions of spin while resisting levels of playful form and puzzle box structures, proving resistant to Nolan's more celebrated forms through Batman's established cultural endurance.

*Cultural Spin – Revisionism and Misdirection Since the 1990s*

To contextualise the signatory style of Nolan's films, it is first necessary to understand both the origins and style of his cinema in the larger context of cultural history. Making his debut in the late 1990s with *Doodlebug* (1997), *Following* (1998) and *Memento*, Nolan consciously tapped in to a very present trend that was breaking away from art house cinema and in to the multiplex arena. The 1990s was, for many, a decade of shifting representations – a decade split with doubling, excess and new historicism. History was now subject to reinterpretations, and thus the historical narrative began to spin out of control as re-imaginings dominated concepts of truth or veracity.[1] No person or narrative was truly trustworthy – and such fracturing became a recognisable feature of the period, largely evident in screen studies (television, popular visual media), and cinema in particular. There was no longer one shared version of events – a wholly linear framework for any narrative seemed strangely out of place within the decade. William J. Palmer (2009) cogently presents the 1990s as a decade fraught with endless reinterpretations of history and historical revisionism, which dominated the American cultural imagination, becoming increasingly evident after the decline of the Cold War. As this post-war period ended and nation-states were reunified, freed under the collapse of Soviet influence, or fragmented under crumbling former dictatorships, the psychological and narrative terrain of the 1990s was largely dominated by different emerging groups presenting alternate and often contested versions of historical events; ownership of one historical narrative soon produced fragmented subjective accounts which contested dominant discourse or 'accepted' histories. The 1990s was also a period of significant cultural and historical revisionism – gothic undercurrents, infamous court cases and scandalous revelations became frequent features in international media, all revealing shocking alternate narratives largely concerning known public

figures (including O. J. Simpson, Michael Jackson and President Clinton, to name the most infamous). Their established place in history and popular personas in the public sphere were unravelled by questions of doubt, tabloid scrutiny and scandal, and contested court testimonies. In short, history was no longer an agreed upon metanarrative, but rather undermined, reclaimed and rewritten in terms of subjective narrative frameworks. History, or accepted narratives as truths, became fractured, diluted, and subsequently 'spun out of control' (Palmer 2009: xi).

It is important to remember that the 1990s celebrated and incorporated many of the themes and concepts to which Nolan returns in his films. From the outset, we know not to fully trust our own viewing experience of his films, because, at any moment, a thread of certainty in the narrative will be frayed by rising doubt or visual deceit. Nolan, in particular, likes to lull the audience in with a sense of the film's world, only to reveal a vital memory, or a significant clue, has been deceitful, misread or misunderstood all along. Memory is an increasingly problematic and slippery slope in 1990s culture which becomes a site of instability and raw emotion in Nolan's films:

> Memory and nostalgia are therefore integral to the sensibility that gave rise to periodising by decades, but they also took on a special significance in the 1990s, when it was not simply that the past was rapidly disappearing but that the very modes of remembering and representing it had become problematic. Preoccupations with memory were widespread in popular film, from *Total Recall* (1990) to *Memento* (2000), or in debates over the challenges CGI posed to the film record. (Harrison 2010: 3)

The instability of history and its ongoing tensions with nostalgia and memory is extremely evident in 1990s cinema. Such revisionism of the film record (or the importance and threatened eradication of 'the original version'), was vehemently fought against in the 1980s during Ted Turner's colourisation project (by filmmakers such as George Lucas and Steven Spielberg), but since the 1990s, these revisions were now deemed permissible in a digital age of endless touch-ups and cinema re-releases.[2] Much to the ire of *Star Wars* fans in particular who struggled to get copies of the original versions of the trilogy on new formats, George Lucas has simply overwritten the film versions that these fans endlessly re-watched on VHS as children in the 1980s (another form of repetition borne uniquely of that generation). As puzzle box films in particular command a desire to be re-examined and re-watched, it is interesting to note that these types of 1990s films are largely made by filmmakers (including Nolan) who grew up with VHS, the first home viewing format which enabled repetition, compilation and re-recording.

The 1990s in particular seemed to present time as being on the brink of a historical precipice, and cinema, in the thrall of the digital in response to the limitations of the photomechanical process, followed suit. Revisionism was now not only possible but thriving, and the boundlessness of digital technology seemed to be developing at an alarming rate. Coupled with this modification of cinema and history, the fear of 'the very malfunction of time' itself at the millennial turn with the Y2K bug was notable,

and media 'spin' raged with half-truths and apocalyptic predictions of malfunctioning technology continued apace. As William J. Palmer notes:

> In the nineties, contemporary social history and the media actually collaborated to define a shared metaphor for the age. Their metaphor was the phenomenon of spin. Public intellectuals, media pundits, and cultural historians (as well as filmmakers) embodied the nineties leading up to the traumatic turn of the new century (the millennium a.k.a Y2K). [...] It all had to do with an age-old philosophical question 'what is the nature of reality?' By the nineties, reality had become such a slippery issue, such a babel of contesting narratives that the deconstructive metaphors were the only ones that made sense. (2009: xi)

Nolan arrived at the latter end of the 1990s when these shifts in filmmaking and popular culture had started to take considerable effect. His early films were largely noted for their clever construction, and his ability to present interesting narratives in intricate ways. While other directors such as David Fincher had imbued their cinema with clever ruses and dramatic cinematography, Nolan's style was quickly revealed to be more controlled in its film form, and while mooted as clever and thoughtful, his films did not rely on the mere shock revelation of a 'twist ending' made infamous by contemporaries such as M. Night Shyamalan in his supernatural film *The Sixth Sense* (1999). With Nolan's non-franchise films to date, the twists and deceptions of his stories are woven in detail throughout his films, which invites audiences to re-watch the films repeatedly, in search of further meanings and clues. The film which garnered him serious Hollywood attention was *Memento*, a cleverly structured film not only demanding meticulous attention to its detailed, complex narrative, but finely crafted so that it may be viewed as a fragmented film interspersed with forward and reverse sections within its original structure, or 'in reverse' (i.e. linear chronological order) which unravels the complex fabric of the film's central diegesis. The complexity of the film is rooted in the restructuring and visual rearrangement of its plot, using clever editing and mixing colour and black and white sequences to illustrate multiple strands of time amidst our protagonist's search to find his wife's apparent killer. That our protagonist Leonard Shelby (Guy Pearce) suffers from the memory dysfunction anterograde amnesia (in that, he cannot make new memories) is no mere affectation or quirk – at the core of this is the cultural narrative of misreading and misunderstanding information (what would come to be known as a distinctly Nolan-esque trait) and the compulsion to return to what we *believe* to be true or certain. The clues Leonard tattoos on to his body or keeps as polaroid photos are open to misinterpretation and misunderstanding, repeatedly revisited and open to exploitation by others who use his memory-lapses for their own gain. He maps the clues concerning his wife's murder onto his body but either misreads or deceives himself by revisiting the same information without gaining a known completion, a nuanced understanding or firm ending. Leonard is stuck in a liminal space of suspended memory/existence that simply cannot be resolved, and he is doomed to repeat his actions over and over, because he cannot form the new memory that permits him to stop. Time in the film is disjointed – under-

scored by the film's form and playfulness with chronology and non-linear narrative – while consistently spinning around the central problem of repeating and revising steps to achieve Leonard's central goal of revenge.

Perhaps then, this concept in itself stands in for the entire decade of the 1990s and early 2000s – in an age of revisionism, it can be read that the concept of moving forward but 'forgetting' the present proves to be dizzying, or 'spinning' as Palmer argues; in hindsight what has happened becomes all too clear. In an attempt to understand the spin of the 1990s in particular, what becomes evident is that the trauma of the 1990s is rooted in an attempt to reclaim a perfect past that does not exist. The re-arrangement of the sequencing works to enhance the complexities of 1990s spin while also conferring the idea that the perfect past is only achievable with hindsight, and that we are doomed to seek it out endlessly, as is Leonard Shelby in the search for his wife's apparent murderer. By playing cleverly with form, the film uses spin and misdirection to shift the film into a puzzle – a puzzle film that demands multiple viewings, just as the Droste Effect (of a picture within a picture within a picture that can, in theory, continue forever) that memorably features in the film's poster artwork matches this sense of endless replication, spin and an unsolvable riddle at the core of the film. The cultural fingerprint at the heart of it is that it both captures the cultural amnesia of the period as it spins into the uncertainty of the millennial turn, by losing our narrative foothold in the process; the cruelty of this lies in the film's final revelation, in its fundamental rejection of one form of narrative truth (the truth that Shelby conceals from himself, giving himself purpose and meaning by endlessly recycling an unsolvable puzzle), which leads us to relate to and experience Shelby's nightmare of endless repetition without knowing satisfaction. Being denied such satisfaction typically enjoyed by linear narratives promotes re-watching and re-evaluation, and so the cycle of repetition continues.

Puzzle films have often been thought of as those films with the 'twist' or surprise ending that 'pulls the rug' from under the spectator and calls into question the veracity of the events onscreen, turning, twisting or spinning the 'truth' of the tale so that we may read the film in two or more subjective/playful ways. As Thomas Elsaesser cogently notes, mind-game films fall broadly between two levels of cinematic games: where characters are being played with, which I claim as films predominantly concerned with what Palmer describes as 'spin'; and 'puzzle films', a term Warren Buckland uses (2009: 6), in which the audience is played with 'because certain crucial information is withheld or ambiguously presented' (Elsaessar 2009: 14). The puzzle film, as a branch of the mind-game film, transcends genre, and fundamentally takes pleasure in one binding desire: 'a delight in disorientating or misleading spectators (besides carefully or altogether withheld information, there are the frequent plot twists and trick endings)' (2009: 15). The desire to achieve such disorientation lies in the flow of information, the ability to decode a vital moment's significance or importance and to solve the mystery at the core of the film. Unlike spin, the aim of the puzzle film is to deceive its *spectators* at every turn, while also playing fair (meaning having enough clues evident throughout the film so that the solution is at least coherent, if not visually evident throughout, when re-watched). Therefore, it is important to note that not

all films borne of 1990s 'spin' are puzzle films, but the culture of 1990s spin brought forth a huge increase in puzzle films and complex narrative cinema. Puzzle films and deceptive films predicated on lies or spin exist in various styles and forms throughout cinema history, but such a condensed cycle of cinema in the 1990s proves that a fundamental distrust of the cultural narrative is at crisis point. Spin cinema affirms that there is no one version of events or core truth, but puzzle films actively deceive the audience in terms of form, narrative and complexity. *The Truman Show* is a film surrounded with spin, as reality for Truman (Jim Carrey) is fabricated and oddly perfect, but it is a multiple narrative that deals with two 'realities' – Truman's life within the show and the world outside of it. Nolan's cinema plays with the concept of spin or possible multiple-versions of narrative 'reality' to create his own style of puzzle films – films that demand we pay attention and move the necessary narrative pieces into place as viewers. *Memento* demands this type of solving when (re)viewing it, while *The Truman Show* demands no such shifting for coherency.

Nolan's neo-*noir* film *Memento* belongs alongside other 'strange' or complex 'puzzle box' or 'mind-game' films that began to garner critical and cultural attention in the late 1990s/early 2000s. The tide for spin, questioning reality, alongside puzzle films, was already set with multiple films in various genres decentring expected filmic genres and styles, innovating structure and form, and renewing cultural interest with this type of 'clever' filmmaking. Alongside *Memento*, Harold Ramis's *Groundhog Day* (1993), Bryan Singer's *The Usual Suspects*, David Fincher's *The Game* and *Fight Club* (1999), Spike Jonze's *Being John Malkovich* (1999) and Michel Gondry's *Eternal Sunshine of the Spotless Mind* (2004), to name but a few memorable titles, all played significantly with form, style and meaning within the same cinematic period which questioned not only the nature of 'reality' but the very narrative around which the film was structured. In the case of spin and puzzle cinema, what is crucially important to remember is that this cycle regains significant cultural traction in the 1990s that solidly continues today with filmmakers such as Nolan continuing to use cinema as a dream palace where reality and deception are consistently called in to question. Exploring the slippery slope of memory, misdirection and audience recall (which *world*/version are we in?) as a touchstone of each of his puzzle films (in varying degrees), Nolan's *Memento*, while complex and demanding multiple viewings, firmly belongs to this era of film styles, where the pleasure of viewing lies in the fabrication of the film world, and the visual misdirection in which we are encouraged to invest. As with all of these films, the fun lies not only in the solution of the riddle (if possible), but also in the invisibility of the riddle throughout the film itself. This is what brings about the 'surprise element' of the final revelation of the central mystery – the clues have been evident all along (if the film has played fair), but we have been encouraged, on first viewing at least, to misread or misunderstand them. Nolan's own brand of puzzle film style is largely achieved through acts of misdirection, obfuscated knowledge, or falsified histories and memories of unreliable protagonists, all of whom struggle to come to terms with their own particular form of trauma.[3] For each of Nolan's protagonists (or competing rivals and doubles), psychological explorations form a core of their central narrative; memory is a puzzle, a riddle which must be addressed, if not solved, in order to escape the trauma

of their situation or deadly struggle. His central characters frequently struggle to accurately remember what led them to their terrible fate, and who they truly are – losing their way in their temporary madness to complete their (often futile) goal. Consciousness and perception are repeatedly explored and questioned, unravelled, rearranged or polluted, drawing Nolan's film worlds and fragmented memory together as a signatory visual symbiosis.[4]

After all, so many of Nolan's central characters (protagonists and antagonists) are traumatised by the loss of a wife or partner that their demise is key to the mental unravelling of the character's notion of reality – memory becomes contaminated in some way. In *Inception*, Mal's (Marion Cotillard) suicide due to her inception by Cobb (Leonardo DiCaprio) renders him traumatised and ultimately responsible for her death, and unable to go home to their children; in *The Dark Knight*, the death of Rachel Dawes (Maggie Gyllenhaal) at the hands of the Joker (Heath Ledger) reduces Bruce Wayne/Batman (Christian Bale) to inertia as Batman ultimately abandons his post as protector of Gotham at its conclusion. At the beginning of *The Dark Knight Rises*, Wayne is surrounded by the ghosts and memories of dead women – the pearls belonging to his dead mother Martha, and Rachel Dawes's framed photograph become cues that reinforce his inability to move beyond these traumatic disruptions that even his transformation into Batman cannot assuage. Even the Joker claims his wife is horrifically mutilated in one of his 'origin' stories, which, though used as a form of psychological threat (as his stories are fictions modified for each audience) fits as a tantalising trick of traumatic spin – there is no solution to his riddle here; there is no 'truth' that demands verification or solution. Furthermore, in *The Prestige*, the drowning of Robert Angier's (Hugh Jackman) wife Julia (Piper Perabo) in an onstage accident leads to the feud with Alfred Borden (Christian Bale), who is in part responsible for her death, while Borden's own deceptive dual identity results in his wife, Sarah (Rebecca Hall), committing suicide. The core reason for Leonard Shelby's detective story is to uncover who apparently raped and murdered his unnamed wife in *Memento*, and the true source of this trauma lies in the terrible possibility that he may have killed her himself. The actions of driven, singularly focused men often result in the destruction of their core relationships, and drive so many of them to the brink of madness. In *Interstellar*, Cooper (Matthew McConaughey) is a widower whose raw emotional journey largely concerns his connection with his daughter Murph (Mackenzie Foy/Jessica Chastain), in the absence of his deceased wife.

*The Prestige* and *Insomnia* are also predicated on multiple misdirections, or questionable 'white lies' and audience deception through misreading opening scenes. However, it should be noted that both films are potentially constrained by their origins as adaptations of source materials, namely Christopher Priest's 1995 novel *The Prestige*, and the Norwegian film *Insomnia* (1997), starring Stellan Skarsgård. Nolan's adaptations, therefore, do come with certain modifications which are filtered through Hollywood storytelling, and through the desire to repackage material to fit in with his overall style of tantalising visual deceit.[5] The final moments of *The Prestige*, when Borden's and Angier's secrets are revealed to one another, brings forth the central idea of Nolan's auteurism, and reveals the central reason for his puzzles:

You never understood why we did this. The audience knows the truth. The world is simple, miserable, solid all the way through. But if you can fool them, even for a second, then you can make them wonder. Then you got to see something very special … It was the look on their faces.

Similarly, the sacrifice of 'seeing', and the cost of refusing to see, reality behind simulation and misdirection is central to this cruel battle waged between the two warring magicians Borden and Angier.[6] The desire to believe the impossible, and the wonder that magical illusion affords, fundamentally stands in for the magic of filmmaking. The conjuring of their magic lies in Borden and Angier's gothic doubleness (a metaphor for the entire 1990s in its own right with its successive unmasking and revelations of shadow selves), combined with the film's alchemy of masterful illusions (through Borden), manipulating science (though Angier, via Nikola Tesla's machine), and Nolan's celebration of misdirection and visual sleight of hand; the film is a wonder box of puzzles.[7] It is through this combination that the film celebrates cinematic art, conjured from illusion, or pretence, visual misdirection and scientific achievement. The film forewarns us of its own untrustworthy state and riddles in its opening line – 'Are you watching closely?' – and reminds us in its closing lines: 'Now you're looking for the secret but you won't find it because, of course, you're not really looking. You don't really want to work it out. You want to be fooled.' This is the wondrous pretence of magic and of cinema; we want to be dazzled and amazed, to experience the wonder of trickery. As Ann Heilmann notes, '[Nolan] can then be compared to … a conjuror: like the audience of a stage magician, we know from the start that it is all an act, but judge the quality of the performance by its ability to deceive and mystify us' (2009/10: 18–19).

While *Insomnia* (Nolan's most understated film to date) also signals a misinterpretation of evidence and lies, at its core it is a film about the flawed nature of institutions that are supposed to be honest and affirming, yet work by preserving a 'necessary' lie to uphold a societal belief in pursuing justice. While recent history has brought traditional institutions and previously held values into sharp focus, corruption in law enforcement and government in particular continues to hold traction in the public sphere. Nolan's film adaptation reveals the true nature of driven-but-flawed cop Will Dormer (Al Pacino) doing terrible things to find some sense of justice and mental peace in a corrupt world, all while doubting his own actions, conscience and 'justified' ends. The film works through a series of subverted expectations in more subtle (but nonetheless devastating) ways in revealing its inner deceptions: bathed in the relentless Alaskan midnight sun, the town of Nightmute underscores that under the harsh conditions of unending daylight, the true nature of these public institutions blinds and misdirects rather than illuminates truth and justice. Dormer, as noted by Mark Fisher (2011: 39), can be considered as the opposite of *Inception*'s Cobb – unable to sleep or dream, Dormer's restlessness signals his inability to find any form of comfort or solace within his own mind. Fisher's analysis cuts to the core of Nolan's own auteur imprint – in the end, we tell ourselves lies to sustain a version of ourselves with which we can cope; the lies that enable us to carry on living.

This is particularly prevalent in both *Inception* and *Interstellar*, whereby both Cobb and Cooper need to believe in a positive outcome for their respective missions at all costs. However, whereas *Inception* triumphs as a puzzle film and demands multiple viewings, *Interstellar*'s own 'puzzle' is comparatively flat and lacks the necessary *jouissance* of the puzzle formula: while its narrative is spectacular and performances are tinged with the necessary emotional currency to feel invested throughout, the *dénouement* is remarkably joyless and, worse still, its game/puzzle is visible from early scenes in Murph's bedroom where she and Cooper decipher messages from the 'ghost' behind her bookshelves. Of all of Nolan's puzzle films, *Interstellar*'s game unravels remarkably quickly, and its emotional journey does not compensate for its lacklustre puzzle formula.

In his study of Nolan's cinema, Todd McGowan (2012) convincingly argues that Nolan's entire film catalogue hinges upon various modes of deception, but it is unusual in the case of puzzle films to have one director become celebrated for this repeated mode overall.[8] Many of the films that came to be known as puzzle films grew in prominence during the Clinton years, and continued into the new millennium – the deceits and trickery of the 'decade of spin' made an indelible mark in popular culture. While puzzle films predate the 1990s, the extremely popular adoption of duplicity in film form in this period in particular stems from the perceived 'inauthentic' or manipulative nature of modern culture. From the Clinton era onwards, we are expecting to find a covert truth beneath the narrative lie in cinema, or, more worryingly, our entire existence (which becomes split between the virtual and the 'real' with the rise of information technology). Our world at the rise of the digital age seemed increasingly one of simulacra, computational avatars, an inter-connected virtual existence, fabricated yet vital to modern life. However, as we increasingly occupy and rely upon the virtual world, Nolan's films capitalise upon these blurred spaces, and frequently draw upon fears that we may never come to distinguish the limits between the real, the simulated/synthetic and flawed human memory.

In *The Matrix*, the world as we know it is merely a simulation, and one from which it is traumatic to awaken. An inversion of this happens to Mal in *Inception* – the real world is no match for the dreamworld which she and Cobb built in Limbo. Their dreamworld of Limbo proved to be too tantalising to resist, and Cobb's successful inception blurred Mal's grasp on reality. Confusing the dreamworld with reality led to her suicide in a failed attempt to return to her innerworld with Cobb, 'where [they] could grow old together'. It is therefore tempting to read Cobb's own existence in the narrative as one stuck in the dreamworld also. Mal's projection refers to his private 'creeping doubts' about the seemingly impossible mission he has undertaken which will enable him to return to their children; he is also reminded to 'come back to reality' by his father-in-law, Miles (Michael Caine), the only figure from his past not to feature in his dreamscapes. The terrible truth, perhaps, is that Cobb has ultimately become lost in this world himself, doomed to dream his achievement of reunification rather than genuinely experience it. Adding layers of visual clues for the audience in this puzzle film, such as Cobb's disappearing/reappearing wedding ring and his use of Mal's spinning top totem, yet playfully denying a firm conclusion in its final frame, Nolan

provokes debate by simply teasing the audience by cutting away from the riddle's perceived solution. As with puzzle films more generally, we are encouraged to revisit the arrangement of clues throughout the piece to find additional evidence to support our own conclusions. Which narrative lie can we accept? Cobb may have simply made too many memories in the dreamworld to distinguish the difference, making him an echo of *Memento*'s Leonard Shelby who cannot escape the nightmare of reliving and re-enacting his unsolvable puzzle, trapped by being unable to form new memories. If read pessimistically, the trauma of being denied this familial reunification or solution leads to Cobb's fabrication of a positive outcome; as with Leonard, it provides a reason for living/dreaming. However, *Inception* is more positive in its overall tone than *Memento*, and this leads to reading the film as more hopeful in its outcome – Cobb just may have accomplished his goal in the end; Leonard did achieve his goal but tragically cannot remember it.

When Nolan first conceived of his mind-based psychological heist thriller in 2002, his idea nestled into other films of a similar ilk whose central thrust called the veracity of the whole world in to question:

> Since the late 1990s, such a move has become a common one; after *Fight Club* (1999), *The Others* (2001), *A Beautiful Mind* (2001) and *The Matrix* (1999), it is a trusting viewer indeed who never suspects something is amiss with the 'facts' a film shows them. We have come to suspect the stories we are told, to doubt the evidence of our eyes. The great fear is manipulation – by the government, by corporations, by criminals and, finally, by film itself... In *The Matrix*, pleasure enters from rising above the ruck, and standing out as 'The One', the world around you transformed into a video game. A fear of terrible control turns into a counter-fantasy of enormous empowerment; a triumphant quasi-religious refusal to feel small. It is a dream of self-importance... Reality becomes suspect; the surface must be continually reassessed. (Newton 2014)

In *Inception*, the heist film is turned on its head – it is not what Cobb's dream team can steal but rather implant or leave behind which first signals a distinctive playful game at work (alongside Nolan's favoured use of *in medias res* in the opening frames of his films). The film's 'Russian Doll' or *mise-en-abyme* structure is also important here: layer upon layer of interlocked dreamworlds are introduced and demarcated by different weather patterns and colour palettes to easily identify each dream level, and physical and psychological disturbances bleed across each dreamworld. We have here an aesthetic construct of worlds that are continually remapped according to the team's needs via the aptly-named architect Ariadne (Ellen Page), which takes on a form of game culture, with its multiple levels, players and goals, complete with each team member contributing a particular ability or gift in the quest.[9]

What begins as an inverted heist tale of psychological espionage for corporate powers to gain competitive advantage over one another by stealing secrets and information (or planting ideas, which go against the target's self-interest), soon turns into commentary on contemporary fears of privacy and mental manipulation: the film

turns terrifying ideology concerning privacy and free will into an exercise to free oneself from guilt and traumatising memory. Invading a person's mindscape by deceptive means is fundamentally an assault but here the assault is neutralised by achieving Cobb's singular goal of returning home. The tragic figure of the film, therefore, is not Mal, but rather Robert Fischer, the team's target for inception. Fischer is betrayed at every turn in the film: by his father's lingering disappointment; by the inception team planting doubts about his one meaningful relationship with his godfather Peter (Tom Berenger); and by the implantation of a false idea, sugar-coated as a means to provide a misinterpretation of his father's dying words, despite the incepted idea ultimately contradicting Fischer's best financial interests. The dream may only be implanting an idea, but the result is one that forms a layer of tragic deceit where a person's memories and desires are subject to manipulation for private gain by invading the privacy of personal memory and core relationships. The ideological motivations evident in the film, then, transform the mind into a site of terrifying invasion and vulnerability – the dreamscape becomes a space where manipulation and deception are open to the highest corporate bidder, invaded by the most skilled deceivers in psychological manipulation; a new form of dream mercenary entrepreneurship is born. As Drew Winchur notes, 'At one level, the film works as corporate propaganda… By disguising such aggression as the benign setting of private turmoil, *Inception* coerces the viewer into legitimizing behaviour that she might otherwise find morally and politically revolting' (2012: 47). In an age of digital tracing and unending observation, recorded by national security agencies and defended by Western governments as necessary to protect the nation and its citizens in the post-9/11 age, the actions of Cobb's team in *Inception* reveals that the privacy of one's own mind is now also a legitimate target for invasion by corporations.[10] Nolan's benign repackaging of this invasion, in the guise of a resolution to Cobb's personal circumstance, mutes the potential threat and ideological terror of psychological violence by governments and corporations on the public at large; we too could be adjusted with a lie they want us to live with.

*Puzzle Resistance: 'What do you believe in?' – The Dark Knight*

In the *Dark Knight* trilogy, what at first is interpreted as a multiple-sourced re-exploration of Bob Kane's caped crusader, rescued and revised from its campy DayGlo demise in the late 1990s, soon turns into a potent political allegory for the Bush-led post-9/11 decade. While Nolan denies a conscious political positioning or commentary in his films, their place in terms of cultural materialist readings is both striking and contradictory. *Batman Begins* and *The Dark Knight* in particular articulate a host of post-9/11 anxieties and contesting ideological positions, while *The Dark Knight Rises* offers competing and potentially reactionary narratives on the 2008 economic crisis, class warfare and ousting the 'Occupy' movement. In *Batman Begins*, Batman is tasked with overcoming two extremely potent villains who embody the political tensions of the mid-decade: Ra's Al Ghul (Liam Neeson) and the League of Shadows' quasi-religious reckoning on Gotham City for its sins of hedonism and corruption; and Arkham Asylum's psychiatrist Jonathan Crane/Scarecrow's (Cillian Murphy) chemical warfare

on Gotham by spreading fear and extreme paranoia with his deadly neurological toxin. Both villains stand in for a barely veiled political narrative centred on fundamentalist zealotry and hysterical media response in the aftermath of 9/11. That Batman must become the exceptional hero in a world that has become riddled with corruption and greed is core to the Batman canon; what is new here is an adaptation rooted in 'cinematic realism', with Batman ultimately being a trained fighter of bruised flesh and broken bones, traumatised yet caped and armed, with military-styled weaponry at his disposal. Due to the 'realist' aesthetics of Nolan's rebooted trilogy, much attention has been paid critically to the political leanings of the trilogy's narrative on terror, and the desire to interpret the symbolic and ideological meanings in Ra's Al Ghul's, Bane's (Tom Hardy) and Joker's fiendish schemes to raze Gotham to the ground. The films deliberately evade any one meaning or interpretation, constructed to give the maximum amount of profit while resisting conscious critical commentary on either end of the American political spectrum. However, despite this attempt of political evasion, the *Dark Knight* trilogy is largely conservative because it must remain within the confines of a conservative genre and draw (however loosely) from its conservative narrative source. While *Batman Begins* is ultimately an origins story of Bruce Wayne's first foray into becoming Batman and protecting Gotham from destruction by the League of Shadows, Nolan succeeds here in borrowing, adapting and overwriting portions of the origins story which becomes a foundational series of events leading to Wayne's transformation into Batman. Like all successful rebooted franchises, it borrows, celebrates and inserts itself within the arc of the Batman origins myth while erasing the memory of the cinematic Batmen of before.

Yet Nolan, for all of his puzzle-box gamesmanship outside of the *Dark Knight* trilogy, does not apply much of his stylised form of trickery on the audience within these films. Arguably the most 'gritty and realistic' of Batmen (though still flirting with the spectacle of the fantastic through fetishised gadgetry and the futuristic landscape of Thomas Wayne's Gotham in *Batman Begins*), the suspense throughout the trilogy is sustained not by a distinct playfulness with film form or a core mystery to be solved, nor a clue that has been deliberately misread, despite flirtations with each of these Nolan-esque flairs; the central deceits evident in the films are rooted in a study of the societal lies that infect Gotham itself. Batman is a 'multiple' figure as Will Brooker (2012) asserts, and is culturally sustained through reimagining and reinterpreting the character for each generation through multiple platforms; Batman is a cypher which can be read as 'Dark' (gritty, realistic, straight and violent) or as 'Rainbow' (comical, colourful, camp and carnivalesque) who has been claimed by different artists and directors who tap in to various aspects of this fluidity to express particular facets of Bruce Wayne/Batman and the city of Gotham. Nolan's awareness of the canonical and branding legacy that surrounded the franchise is evident also, and as Brooker notes, his directorial branding was largely downplayed for the first instalment (2012: 11). However, despite its celebrated success, the *Dark Knight* trilogy, as a whole, feels distinctly separate to the puzzle films for which he is largely critically lauded. Nolan's more cerebral films exist outside of the Batman multi-verse, with only traces and echoes of his known styles and expected tropes shining through on occasion.

There is no doubt that the *Dark Knight* films belong to Nolan's overall aesthetic style (reaffirmed by his longstanding partnership with cinematographer Wally Pfister); however, in terms of structure and form, they are remarkably linear, commercial and traditionalist films for Nolan, and work within the confines of the superhero subgenre. They have the expected visual and dramatic flair of Nolan's known playfulness and contain multiple deceits, but these deceits neither puzzle nor twist any narrative form – instead they produce twisted traumatised characters located from within the Batman multi-verse. This puzzle resistance is partly rooted in the brand of Batman, which, when stylistically over-associated or claimed by one auteur, can implode into mere style and repetition; a fate to which both Tim Burton's and Joel Schumacher's films succumbed in their respective sequels – *Batman Returns* (1992); *Batman & Robin* (1997). Nolan's temptation to work in favoured styles is kept largely contained in *Batman Begins* and *The Dark Knight*, where the complexities of the plot are interwoven into character development and the films' diegeses. Batman's exceptionalism extends not only to the character as a protector of Gotham, but also to the franchise's directors – you can only go so far to claim Batman within a distinctive directorial style. This gives Nolan two distinct spaces as a film director – one within his puzzle film 'art-house' roots and preferred style, and one beyond it within the confines of enormous studio demands and fan power. This does not mean that Nolan can resist certain directorial embellishments, but there is a conspicuous tension evident, most explicitly at the conclusion of *The Dark Knight Rises*. Batman's world in the twenty-first century may indeed be decentred by the white noise of cultural spin, lies and manipulations, but there is no core puzzle; the audience are left dazzled, but not fooled.

The *Dark Knight* trilogy as a franchise rejects puzzle form, largely because we know that Batman will endure – he transcends his physical limitations by becoming a symbol, as stated by Bruce Wayne in *Batman Begins*. However, there is a distinct puzzle film feel inserted in to the final shots of Bruce Wayne at a café in Florence in the concluding moments of *The Dark Knight Rises*, when Wayne is glimpsed by Alfred (Michael Caine), and both exchange a knowing nod; Bruce Wayne/Nolan may be bowing out, but Batman endures. Nolan effectively inserts this self-reflexive turn as director and leads us to briefly question if this is a form of wish fulfilment on our part (as the audience who witnessed the Bat explode mid-air), via his faithful father figure and friend's self-confessed fantasy. Yet Nolan cannot carry this through to its logical end (which would form an *Inception*-style puzzle) – it is undercut in the preceding scene (if we are to believe it) when we are told that Wayne fixed the autopilot on the Bat, thus enabling his escape from the bomb blast at the film's climax. Furthermore, to underscore that this is not a dream, Wayne's mother's pearls are also missing from Gotham, presumed to be now in the possession of Selina Kyle (Anne Hathaway), who is with Wayne in the Florentine café. This inclusion of flair doesn't work to achieve its intended goal, beyond revealing Nolan's own filmic fingerprints as a visual tease; rather, it reads distinctly like a compromise. By including an increasingly familiar moment in his puzzle films where the conclusion emphasises the mastery of his puzzle films, being unsure of our footing until the final frame, Nolan includes this nod between Alfred

and Bruce Wayne to reassure, while echoing similar exchanges at the conclusion of both *The Prestige* and *Inception*.[11] The ending attempts a playful insertion of a puzzle, however minor, but this is ultimately rejected by the need for closure, and the cultural knowledge that Batman endures, before and after Nolan's trilogy. As Nolan notes, 'it's all about endings … it's about knowing where you want to go',[12] and here Nolan is explicitly trying to create a Schrödinger's Batman. While *Inception*, *The Prestige* and *Memento* form loops and create a desire to re-interrogate the films to solve the puzzle in their final scenes (enabling a desire to loop back to the beginning again), Batman simply cannot be twisted into this form – the Dark Knight's cultural cachet is beyond Nolan's own signature conclusion.

In examining the directorial style and form of Christopher Nolan's cinema to date, what has become apparent is that he explores the repeated motif of the lie (the core form of spin). Each film includes the elements of cultural spin, the deceits and multiplicities that gained heightened cultural emphasis in cinema during the 1990s. By taking spin and reforming it into puzzles, Nolan has acquired a distinctive flair that demands re-entering his puzzle films again and again to solve a mystery or to reveal a hidden truth at its heart. He provokes us, challenges us and relishes in the final moments of his films – to capture the wonder of clever cinema, and to transmit awe as Angier describes through 'the look on [the audience's] faces'. His style to-date is divided between his auteur films (which feature his signatory *in medias res* or 'inside-out' opening frames) and the *Dark Knight* trilogy which, while clever, narratively demanding and visually stunning within the cohort of twenty-first-century superhero films, and among previous Batman films in particular, are nonetheless remarkably linear. Spin films, then, ultimately provoke the question of what we digetically *believe* (lies, misdirections, lack of trust or being 'spun'), but puzzle films challenge us to ask ourselves what do we *know* from the events onscreen. Spin deceives others in the narrative, puzzles go further and aim to deceive beyond the frame by playing games with the audience. James Verini claims that Nolan is perhaps best understood, then, as a games master, in that his narratives best fit into a sense of play and overall satisfaction from participation:

> Nolan's entertainments, the best ones, anyway, are games. I don't mean that they resemble puzzles or tricks (though they do that, too), I mean that they are most satisfying when understood as games, not as novelistic narratives. They are contests with rules and phases, gambits and defenses [sic], many losers and the occasional victor, usually a Pyrrhus type. (2012)

Through this lens, the difference between puzzle and spin rests with whom the games master plays. The Batman universe is one of play, but one where the audience knows he will ultimately return. Batman may be spun out, but his continuance demands that he will win, at some personal cost. But Nolan knows that we know this, and gives clues in all of his films to remind us that we are playing a game of his design: ultimately addressing us, *Inception*'s Mal voices Nolan's alluring riddle: 'You keep telling yourself what you know, but what do you believe?' Nolan's continued successes will then ulti-

mately rest on the spin games and puzzles forms with which he tantalises his audience; he knows we want to be visually dazzled, but fundamentally, his auteur style rests on our continued cultural desire to be fooled.

## Notes

1   See William Palmer (2009) and Colin Harrison (2010) for a more detailed account of the turbulent and fragmented cinema of the 1990s.

2   As Joe Utichi writes: 'The [2008] DVD edition [of *Star Wars*], at least, featured bonus discs holding weak transfers of the original versions, even if they felt like poorly treated outcasts, added just to prolong their humiliation at their creator's increasingly malevolent hands' (2010). See http://www.savestarwars.com/news.html for a detailed chronology of the multiple versions of the original *Star Wars* trilogy across various media formats. The use of the term 'original trilogy' in this instance refers to *Star Wars* (1977), *The Empire Strikes Back* (1980) and *Return of the Jedi* (1983). Any reference to the 'original versions' denotes the theatrical unaltered versions and 1980s VHS releases.

3   Trauma in 1990s cinema is particularly evident in 'puzzle films', as many of the protagonists find that the world around them has been changed irrevocably through bloodshed and the prevalence of 'wound culture'. For more on this, see Mark Seltzer (1998) and Claire Sisco King (2012).

4   Nolan's own production company with his co-producer/wife Emma Thomas, Syncopy, is a direct play on this repeated motif. Derived from syncope, a medical term for temporarily losing consciousness, it can be attributed as Nolan's own style of 'disorientation' in his films. Another reading of it is Syn (synthetic) Copy which ties in with Baudrillard's Simulacra, and Nolan's visual style of seamlessly blending established photomechanical trickery and CGI effects.

5   J. L. A Garcia (2006) accounts for these alterations, as does Todd McGowan, by discussing the redemption of Dormer in the film's concluding shots, warning Detective Burr (Hillary Swank) not to lose her way. The Norweigan film offers no such 'moral' conclusion.

6   This playfulness in Christopher Priest's 1995 novel and Nolan's 2006 film extends to both characters' initials, which spell 'Abra' (cadabra) when combined.

7   For more on Gothic doubles in the 1990s, see Mark Edmundson (1997).

8   Indeed, to become known for this 'twist' ending or subverting the veracity of the narrative can undo a director's career, or at least become detrimental to their films, as in the case of director M. Night Shyamalan. Shyamalan's films were noted for their excellence at the beginning of the 2000s with *The Sixth Sense* (1999) and *Unbreakable* (2000), which paralleled the rise of Nolan's own directorial ascent in the Hollywood ranks. However, this success fizzled out after the release of *The Village* (2004) when the director was deemed predictable for his 'twist endings' which undermined the audience's investment in the film rather than reward them for their attentive viewing. This implosion was later affirmed with his unpopular *The Lady in the Water* (2006).

9   For more on the video game construct and aesthetics of *Inception*, see Warren Buckland's essay, '*Inception*'s Video Game Logic', in this volume.

10  In a similar vein, brain-manipulation was the Riddler's (Jim Carrey) own dastardly scheme in Joel Schumacher's *Batman Forever* (1995) when the Nygma television device brainwashed the citizens of Gotham, making them docile and compliant.

11  All three films share a version of this scene, with a knowing nod from Cutter, Miles and Alfred (all played by Michael Caine) and Cobb, Fallon (Borden's alter-ego) and Bruce Wayne. Special thanks to Dr Hannah Priest for an insightful discussion on this Nolan echo.

12  Christopher Nolan interviewed by Pete Hammond at the Santa Barbara International Film Festival, 31 January 2011. Interview available online at: https://www.youtube.com/watch?v=6MF3iPmSgGE (accessed 22 February 2015).

*Bibliography*

Brooker, Will (2012) *Hunting the Dark Knight: Twenty-First Century Batman*. London: IB Tauris.

Buckland, Warren (2009) 'Introduction: Puzzle Plots', in Warren Buckland (ed.) *Puzzle Films: Complex Storytelling in Contemporary Cinema*. Oxford: Wiley-Blackwell, 1–12.

Edmundson, Mark (1997) *Nightmare on Main Street: Angels, Sadomasochism and the Culture of the Gothic*. Cambridge, MA: Harvard University Press.

Elsaesser, Thomas (2009) 'The Mind-Game Film', in Warren Buckland (ed.) *Puzzle Films: Complex Storytelling in Contemporary Cinema*. Oxford: Wiley-Blackwell, 13–41.

Fisher, Mark (2011) 'The Lost Unconscious: Delusions and Dreams in *Inception*', *Film Quarterly*, 64, 3, 37–45.

Garcia, J. L. A. (2006) 'White Nights of the Soul: Christopher Nolan's *Insomnia* and the renewal of Moral Reflection in Film', *Logos: A Journal of Catholic Thought and Culture*, 9, 4, 82–117.

Harrison, Colin (2010) *American Culture in the 1990s*. Edinburgh: Edinburgh University Press.

Heilmann, Ann (2009/10) 'Doing it with Mirrors: Neo-Victorian Metatextual Magic in *Affinity*, *The Prestige* and *The Illusionist*', *Neo-Victorian Studies*, 2, 2, 18–42.

McGowan, Todd (2012) *The Fictional Christopher Nolan*. Austin: University of Texas Press.

Newton, Michael (2014) 'Paranoid celluloid: conspiracy on film', *The Guardian*. 7 Feb. Online. Available: http://www.theguardian.com/film/2014/feb/07/paranoid-celluloid-conspiracy-film-rosemarys-baby (accessed on 25 February 2014).

Nolan, Christopher (2011) '"Master Director": Interview with Pete Hammond', Santa Barbara International Film Festival. 31 January. Online. Available: https://www.youtube.com/watch?v=6MF3iPmSgGE (accessed 22 February 2015).

Palmer, William J. (2009) *The Films of the Ninties: The Decade of Spin*. Basingstoke: Palgrave.

Seltzer, Mark (1998) *Serial Killers: Death and Life in America's Wound Culture*. New York: Routledge.

Sisco King, Claire (2012) *Washed in Blood: Male Sacrifice, Trauma and the Cinema*. New Brunswick, NJ: Rutgers University Press.

Utichi, Joe (2010) 'Star Wars on Blu Ray: George, don't do that…', *The Guardian*, 19 August. Online. Available: http://www.theguardian.com/film/filmblog/2010/aug/19/star-wars-blu-ray-lucas. (accessed on 28 January 2015).

Verini, James (2012) 'Christopher Nolan's Games', *The New Yorker*. 19 July. Online. Available: http://www.newyorker.com/online/blogs/culture/2012/07/christopher-nolan-batman-inception-video-games.html (accessed on 9 April 2014).

Winchur, Drew (2012) 'Ideology in Christopher Nolan's *Inception*', *CineAction*, 88, 44–7.

CHAPTER ELEVEN

# Stumbling Over the Superhero:
# Christopher Nolan's Victories and Compromises

Todd McGowan

*Why Christopher Nolan is Not Wong Kar-Wai*

It is difficult for filmmakers to retain an aesthetic or political project when they move from independently financed productions to those financed by Hollywood. Hollywood's money tends almost inexorably to produce a more ideological result. Perhaps the clearest example of this infelicitous trajectory is that of Wong Kar-Wai. After creating his masterpieces *In the Mood for Love* (2000) and *2046* (2004), Wong made his first Hollywood film. The result, *My Blueberry Nights* (2007), represents a radical departure from his earlier films. While *In the Mood for Love* and *2046* both insist on the impossibility of the successful romantic union and the necessity of a sexual antagonism, *My Blueberry Nights* depicts the overcoming of this antagonism when Elizabeth (Norah Jones) finally comes back to Jeremy (Jude Law) at the end of the film. This is the kind of ending that would be unthinkable for *In the Mood for Love* or *2046* because it violates Wong's preoccupation with the obstacles to the romantic union. In Wong's earlier films, the obstacle is constitutive for the romantic union, and the films focus formally on how the impossibility of the union is simultaneously its condition of possibility. And yet, in his first Hollywood film, Wong departs openly from his insight into the constitutive function of the sexual antagonism. The effect of Hollywood on Wong Kar-Wai is deleterious but at the same time exemplary.

What stands out about Christopher Nolan is his ability to sustain his filmmaking project even when he goes to Hollywood. This project consists in showing how all understanding depends on an initial misunderstanding that results from a deception. Though Nolan's films eventually bring the spectator to a point of understanding, they begin by misleading the spectator through the film's formal structure. By forcing the spectator to follow this path through misunderstanding to understanding, Nolan reveals the impossibility of strictly separating truth from falsity.

The strict separation of truth and falsity creates a social order based on the denigration and expulsion of the false rather than the embrace of its necessity; this expulsion of the false provides the theoretical basis for all societal exclusions. Grasping the importance of the false for the emergence of the true first appears in Hegel's thought; Nolan depicts the idea that underlies Hegel's entire philosophy and that receives its most concise expression in the preface to the *Phenomenology of Spirit*. There, Hegel states, 'truth is not a minted coin that can be given and pocketed ready-made' (1977: 22). The point is not that there is no truth, that all truth is a matter of perspective, but that truth requires the false in order to emerge as such. The false establishes a terrain on which the true can constitute itself; one must accept the false as the price that one pays for subsequent access to the truth.

We need the false, Nolan shows, not just for contrasting it with the true (as we might think) but because the true does not concern an empirical object in external reality that corresponds to our idea of it. Instead, the true resides in our relation to the object and thus in what we choose to embrace and what we choose to reject. If the subject accepts the false, this tells us that the terrain of truth is not knowledge but desire. Truth is the truth of our desire, not a correspondence between our representation and an actual object.[1] Desire shapes how we see an object: if I desire to find evidence for God's creation of the world, I will find it at the exact point where the evolutionary biologist will discover evidence for a Darwinist hypothesis. My desire counts for much more than the correspondence of the object with the idea. The facts matter, but they always matter within the context of a desire that enables them to matter.

Though Nolan's films take the false as their point of departure, they do not celebrate the power of the false as Gilles Deleuze sees it operating in the cinema. For Deleuze, the power of the false, manifested most clearly in the films of Orson Welles, impels us to move beyond the question of truth altogether. As Deleuze puts it, 'narration ceases to be truthful, that is, to claim to be true, and becomes fundamentally falsifying. This is not at all a case of "each has its own truth," a variability of content. It is a power of the false which replaces and supersedes the form of the true, because it poses the simultaneity of incompossible presents, or the co-existence of not-necessarily true pasts' (1989: 131). While Deleuze conceives the false in the cinema as what eliminates the question of the truth of the image, Nolan uses the false hero in order to relocate the question of truth. It is no longer in the image but in the spectator's relation to the image. The false hero – the figure who embodies Nolan's exploration of the false – exposes where the truth of the spectator's desire resides.

Nolan's films define the false through a contrast made within the films themselves, not in reference to any external marker of the true. That is to say, the false is not false because it fails to represent adequately an object or according to any ontological criterion. Instead, the false is false insofar as the film itself reveals it as false and exposes the cause for its emergence. The true in Nolan's films is not the actual events as they happen within the diegesis but the spectator's desire that accepts a false account of these events. Nolan will sometimes leave the truth of the events within the diegesis ambiguous so that the spectator cannot know with total certainty what happened.[2] But what he never leaves ambiguous is the truth of the desire for a specific account of these events.

This is what Nolan so successfully expresses in his films, and he sustains a remarkable fidelity to the false even when he enters Hollywood, a domain that eschews completely the necessity of the false. One might say that any depiction of the necessity of the false endangers Hollywood's ideological function. If spectators grasp the necessity of the false, they will call into question every representation as a lure designed to ensnare their desire. This type of spectatorship is wholly incompatible with Hollywood cinema, which tries to convince spectators of the givenness of their social reality by constructing ideological fantasies that encourage a psychic investment in this social reality. But Nolan does not just expose the act of production in the manner of an avant-garde filmmaker. This type of filmmaking fails to account for the spectator's desire and consigns itself wholly to the plane of knowledge, which is precisely what Nolan hopes to challenge. In order to reveal how the spectator's desire constitutes the field of the visible, one must begin by creating a bond between the spectator and the hero that the film will subsequently shatter. In this way, the spectator can see why the investment in the false occurs rather than simply taking up a critical attitude toward this investment. Nolan's central filmmaking project of depicting the primacy of the false places him at odds with Hollywood, and it necessitates a false hero, one who ends up betraying the spectator's confidence.

The falsity of the hero underlies Nolan's efforts to depict the role that misunderstanding plays in all understanding. A filmmaker cannot simply depict falsity occurring within the film's diegetic reality. If one does so, this permits the spectator to relate to this falsity from a distance and to avoid recognising its necessity. A film about falsity remains invested in the primacy of the truth through its attempt to show the truth about the false. Only by deceiving the spectator and then revealing the reasons for this deception can a filmmaker make evident the primacy of the false. This deception must pass through the hero with whom the film encourages the spectator to identify. The film must establish a basic trust between the spectator and the hero, and then it must subsequently show how this trust has no solid ground.

The falsity of the hero appears in both of Nolan's early independent productions, *Following* (1998) and *Memento* (2000), as well as his later Hollywood films, like *Insomnia* (2002), *The Prestige* (2006) and *Inception* (2010). Unlike Wong Kar-Wai, Nolan doesn't abandon his fundamental project when he enters Hollywood. One might even claim that he creates the ultimate false hero in the case of *Inception*, which is not just a Hollywood film but a summer blockbuster. This fidelity to his filmmaking project amid the ideological demands of Hollywood represents Nolan's most significant achievement as a filmmaker. Challenging an ideology from the inside is always the most effective way of undermining it. Unfortunately, it is also the most difficult. But Nolan's ability to sustain his project does run aground. The problem is not that he becomes too attached to Hollywood but that he turns to a genre that neutralises his emphasis on the false.

Even though Nolan continues his insistence of the necessity of the false when he enters Hollywood, it does not survive his encounter with an even more dangerous enemy – the superhero film. Nolan's turn to the superhero film derails his filmmaking project and mutates the critical edge of his cinema. The generic demands of the superhero film prove incompatible with Nolan's emphasis on the primacy of the false, and to

the extent that Nolan succumbs to these demands, he contributes to the construction of an ideological fantasy that his other films would put into question. The superhero film derails Christopher Nolan.

## We Don't Need Another Hero

In the past few decades, the superhero film has become the contemporary version of the western, a genre that became extremely prolific in the 1940s and 1950s. Like the western, the superhero film most often focuses on an isolated hero (or heroes) who exists outside the constraints of the social order and the law. But at the same time, the western hero fights for the sake of the social order. This hero is the exception to the law that makes the law possible – often going so far as to found the social order by ridding it of violent threats.[3]

The superhero's exceptional status relative to the law encapsulates this figure's ideological function. The superheroic exception endorses an unlimited and extra-judicial power not subject to the law's restrictiveness. The problem is that the exceptional superhero becomes identified with the normal functioning of the law. The exception and the law become indistinct, so that nothing restricts the reach of the law's force. As Giorgio Agamben notes in *State of Exception*, 'when the state of exception … becomes the rule, then the juridico-political system transforms itself into a killing machine' (2005: 86). The merging of the state of exception and the rule, for Agamben, results in the absence of the limit that inheres within the law. The exception extends the law's reach even into the territory outside the law. In the same way, superheroes, unlike normal law officers, have no restriction on their activity. No one complains, including the spectator, when superheroes transgress the laws that govern the social order to stop extraordinary criminals. As the state of exception has become the rule, the rise of the superhero film plays a part in justifying this state of affairs.

But the chief damage that the superhero does to Nolan's filmmaking is not the exceptionality that the superhero embodies. This separates Nolan from other filmmakers who delve into the superhero film and succumb immediately to the lure of the celebration of the superhero's exceptionality. In fact, Nolan uses the superhero's exceptionality as a source for criticising the contemporary state of exception in *The Dark Knight* (2008). In *Batman Begins* (2005), Nolan shows how exceptionality is not limited to Batman himself but available to everyone, and in this way, he universalises exceptionality, challenging from another angle the state of exception.[4] But what trips up Nolan when it comes to his Batman films is the identification of the superhero with truth. The superhero cannot deceive the spectator or become caught up on deception and still retain the status of a superhero. The superhero cannot act as a false hero in the same way that Nolan's other heroes do. And the false hero is the requisite center of an authentic Nolan film.

Given the nature of the superhero film and the emphasis that it places on the false guise of the hero, one can see why this genre appeals to Nolan. It enables him to explore directly his fascination with the false presentation that emanates from the truth of our desire. In order to function effectively as a superhero, most of these figures must

hide their identity. Batman must pass himself off as Bruce Wayne, Superman as Clark Kent, Wonder Woman as Diana Prince, Spider Man as Peter Parker, Daredevil as Matt Murdock and so on.[5] But the superhero film functions by allowing the spectator to see behind the disguise, so that the falsity of the superhero's persona deceives other characters within the diegesis but not the spectator outside of it.

It seems as if the spectator's inside information about the superhero is not a *sine qua non* of the genre. One might imagine a superhero film in which the spectator remained in the dark about the identity of the superhero and found herself or himself in the same situation as the characters in the diegetic reality. We would wonder, 'who was that masked man?' along with the characters. But there are no superhero films that opt for this structure. Even though it is imaginable, it is not feasible on the fantasmatic level. The enjoyment that the superhero film offers is inextricable from the spectator's investment in the figure of the superhero, an investment that would be lost if the spectator did not share in the superhero's secret.

When a spectator knows the superhero's secret identity, the spectator does not gain access to the superhero's power. Knowing that Bruce Banner is the Hulk doesn't give us the Hulk's strength, but it does place us on the side of the subject who knows. The superhero film creates a sharp divide between those who know and the masses who don't, and by aligning the spectator with the few who have knowledge, this genre produces enjoyment through secret knowledge. The key to the superhero is not a super power but the secret knowledge that holds the key to this super power, and the spectator partakes fully in the enjoyment of this knowledge.[6]

Superhero films not only let spectators in on the secret of the superhero's identity, they also usually depict the myth of the superhero's origin, which further grants the spectator privileged access to knowledge. We see, for instance, Superman's voyage to Earth in *Superman* (Richard Donner, 1978) and *Man of Steel* (Zack Snyder, 2013), or we see the military experiment that creates a superior warrior in *Captain America: The First Avenger* (Joe Johnston, 2011). Revealing the origin of the superhero's powers gives the spectator an insight into the superhero that only the superhero herself or himself (and sometimes a few insiders) has.

Even though only Superman explicitly stands for 'truth, justice, and the American way', the superhero as such has an intrinsic devotion to truth. Superheroes don't deceive because they are not divided subjects. To become a superhero is to overcome the division that the signifier creates in subjectivity and to embody a fantasy of completion for the spectator. Superheroes can certainly suffer, but they do not have the limitations with which ordinary subjects must contend. They can avoid traffic jams, eliminate powerful villains and even defy the laws of physics; but most importantly, they have the capacity – unlike every divided and lacking subject – to overcome traumatic loss. Their superheroic status emerges at a moment of traumatic loss, but the loss magically produces the power of overcoming loss in the superhero.

This is probably clearest in the case of Superman. He becomes Superman only through the destruction of his parents and his entire home planet. If Krypton had not been destroyed, his parents would have never sent him to Earth where he could become Superman as a result of the difference between the Earth's sun and Krypton's.

Though Superman doesn't gain the ability to restore Krypton's existence or bring his parents back to life, he does become able to overcome all subsequent traumas. Being a superhero, for Superman, brings with it an immunity to trauma. This is apparent in Richard Donner's *Superman*, when Superman (Christopher Reeve) reverses the Earth's rotation in order to turn back time and save Lois Lane (Margot Kidder). Like other superheroes, Superman does not have to confront an irreducible trauma. Their lack of any necessary loss constitutes them as beings of truth rather than as divided subjects.

In *Batman Begins*, Nolan paints a trajectory for Batman similar to the one that Superman follows. The primary trauma that shapes Batman occurs when he is a young boy, falling into a cave filled with bats. Bats become the mark of trauma, but when Bruce Wayne becomes Batman, he overcomes this trauma and uses it as a source of power. He traumatises villains with the figure of the bat that once traumatised him; thus the trauma ceases to be traumatic at all and becomes a source of mastery. At the end of *Batman Begins*, we see Batman literally eliminating the site of traumatic loss as he boards over the hole into which he fell as a child. Even though the villain Ra's Al Ghul (Liam Neeson) has burned his home, Wayne Manor, to the ground, Bruce isn't at work reconstructing it but instead covering the hole in the yard. The hole represents the childhood trauma that the superhero (and he alone) has the capacity to repair completely. This scene metaphorically reveals the fundamental capacity of the superhero: this capacity isn't so much defying the laws of physics but those of subjectivity. Without the necessity of traumatic loss, one is not a divided subject and instead occupies a position of fantasmatic completeness.

The completeness of superheroes is the basis for their identification with truth. Only a complete being can avoid the fiction that accompanies all subjectivity. The division of the subject prevents any subject from speaking the truth directly or having a true identity. This division separates the subject from the signifier that represents it. For subjects, this signifier is always a lie relative to the speaking subject itself.

The subject can never be completely truthful because it is not identical with itself. Jacques Lacan argues that the subject cannot unify its meaning and its being, which is why it is destined to always be a split subject. In *Seminar XI*, Lacan lays out this impossible dilemma that confronts the subject and leaves it divided:

> If we choose being, the subject disappears, it eludes us, it falls into non-meaning. If we choose meaning, the meaning survives only deprived of that part of non-meaning that is, strictly speaking, that which constitutes in the realization of the subject, the unconscious. In other words, it is of the nature of this meaning, as it emerges in the field of the Other, to be in a large part of its field, eclipsed by the disappearance of being, induced by the very function of the signifier. (1978: 211)

In other words, one gains a symbolic identity only by losing the kernel of one's being, and no subject can escape this forced choice. But superheroes, because they are not ordinary subjects, do escape this choice and thereby achieve an impossible wholeness. But this is not to say that superheroes have no experience of division.

The superhero has an external rather than an internal relation to division. That is to say, the superhero represents the division of the subject but doesn't experience it. Most superheroes have a doubled identity, like Clark Kent and Superman or Bruce Wayne and Batman, and this doubling marks the division of the subject. If the subject is the division between meaning and being, Bruce Wayne is the meaning or symbolic identity, and Batman is the being. For Batman, however, this division is not a division at all. He feigns being Bruce Wayne to hide his true identity as Batman, but he always knows who he really is. The division of the subject is an act that he performs for the public that doesn't affect Batman himself, and this is the case for all superheroes who have a public alias that hides their true identity.

In fact, the term 'true identity' that we use when talking about superheroes reveals the fundamental ideological problem with the figure of the superhero that even Nolan cannot escape. Unlike other subjects, the superhero does have a true identity, even though the alias hides it. That is to say, ordinary subjects emerge as subjects through their failure to have a true identity. They are subjects because they cannot be identical with their symbolic identity. The subject identifies with a signifier that it cannot fully take up, but it nonetheless presents itself as identical with this signifier. This is the subject's fundamental lie. Falsity inheres within subjectivity, and Nolan's filmmaking project continually returns to this necessary falsity.

But the superhero cannot play the part of the false hero that Nolan's project requires and still remain a superhero. Though Batman (Christian Bale) deceives the people of Gotham about his true identity and even about his culpability for the murderous rampage of Two-Face/Harvey Dent (Aaron Eckhart), he does not deceive the spectator as Leonard Shelby (Guy Pearce) does in *Memento* or as Alfred Borden (Christian Bale) does in *The Prestige*. In Nolan's superhero films, the falsity occurs within the diegesis. Nolan's formal concern with falsity manifests itself solely in the content, and the result is that spectators see the power of this falsity rather than succumbing to it themselves.

But the turn to the superhero film doesn't indicate Nolan's complete abandonment of falsity. It is Nolan's concern for a necessary falsity that drives his choice of superheroes. While most superheroes have a super power that distinguishes them from others, all Batman has is his disguise. He is the least super of superheroes, and he relies on training and technological devices to best his opponents. But it is only the Batman uniform that constitutes him as a superhero. In this sense, Batman himself testifies to the power of falsity, and this is what Nolan focuses on in his construction of this character in *Batman Begins* and its sequels. But in order to emphasise the falsity of Batman's appearance, Nolan gives the spectator insight into how Batman constructs this appearance. The film thus does not force the spectator to experience Batman's falsity that the characters in the film confront.

Nolan not only revived the Batman franchise, but in doing so, he also transformed the superhero film. He transformed the genre of the superhero film to such an extent that one might speak with justification of superhero films before Nolan and after Nolan. Though not every subsequent superhero film has taken his lead, his *Batman Begins* announces a new epoch of the realist superhero film. The cartoonish villains

from the Batman series (the Penguin, Poison Ivy, Mr. Freeze) disappear along with the outlandish gadgets that populate Batman's utility belt. If Nolan retains a character like the Joker (Heath Ledger), he becomes maniacal and threatening rather than excessive and clownish, as he (played by Jack Nicholson) was in Tim Burton's original *Batman* (1989). When the gadgets remain in Nolan's Batman films, Nolan takes pains to show, especially in the first film, their origin in the technological research and development of Wayne Enterprises.

By exposing the realistic origin of Batman's seemingly super powers, Nolan emphasises the falsity of the superhero. This figure is just an ordinary person with sophisticated training and technological gadgets, not someone who possesses actual super powers. But because Nolan lets the spectator see behind the curtain and witness how Batman constructs his falsity, the spectator does not experience this falsity as such but is able to view it from a distance. The distance not only separates the spectator from the falsity of Batman but also separates the Batman films from the rest of Nolan's films.

Nolan's failure in the Batman films stems directly from the ideal of the superhero itself. Even though he tries to transform the genre in the direction of the false, the superhero's intrinsic link with truth proves immune to this transformation. Batman remains a beacon of truth, even when he lies within the diegesis. Batman's lack of falsity relative to the spectator renders him an ideological figure who helps to blind the spectator to the enjoyment that the false provides. This is precisely what Nolan's other films work to expose.

*Beyond the Unreliable Narrator*

Unreliable narration is a convention that has a long existence in the novel.[7] But it becomes widespread in modernity. Novels such as William Faulkner's *The Sound and the Fury* (1929), Albert Camus' *The Fall* (1956) and Vladimir Nabokov's *Lolita* (1955) all use an unreliable narrator to mislead the reader. The misleading hero is present in the cinema as well, from Francis (Friedrich Fehér) in *The Cabinet of Dr. Caligari* (Robert Wiene, 1920) to Verbal Kint (Kevin Spacey) in *The Usual Suspects* (Bryan Singer, 1995) to Tyler Durden (Edward Norton/Brad Pitt) in *Fight Club* (David Fincher, 1999). But no novelist or filmmaker makes the falsity of the hero the central focus of a series of works in the way that Nolan does. For Nolan, the false hero functions as a lure for the spectator's desire, but this lure is designed to make clear the spectator's investment in the form of the false.

Falsity provides an enjoyment for us that truth cannot. The image of the whole truth deceives us even more than falsity does, and truth always disappoints in a way that falsity does not. Falsity reenacts the division of the subject and returns the subject to the trauma of its emergence. But this trauma is at the same time the only source of enjoyment for the subject. Through the division between meaning and being, an object emerges that directs and orients the subject's desire. Without this division, the subject is left with nothing to arouse it. A subject of truth would be a subject who had no object that embodied the possibility of enjoyment. Though a subject of truth is impossible because the signifier necessarily divides the subject from itself, the fantasy of this subject

has deleterious effects. Through the fantasy of complete truthfulness, the subject avoids its constituted division, and it thereby misses its source of enjoyment.

By creating a false hero, Nolan submits the spectator to the logic of the subject's division. The spectator enjoys Nolan's films through the falsity that they employ and discovers the necessity of this falsity for any enjoyment. Each of Nolan's films handles the falsity of the hero differently. *Following* depicts an honest hero but one who doesn't himself know the trap into which he has fallen. Thus, the spectator can't help but be misled by the hero's voiceover narration, a narration that aims at exculpating him but finally condemns him (falsely) as a murderer. *Memento* takes the investment in falsity one step further by investing the spectator in a quest that has its basis, we learn at the end of the film, in a lie that the hero tells to himself. The narrator's mental condition causes him to forget this lie, but it nonetheless informs the entirety of the film's action. This dynamic continues in *Insomnia*, where the hero's fabrication of evidence gradually becomes clear to the spectator. Unlike *Memento*, here the hero is aware of his lie, but the film uses deception to implicate the spectator in the lie. The filmic deception matches the hero's deception. This focus then reaches its peak in *The Prestige*, which is Nolan's masterpiece of falsity.

Though *The Prestige* concludes by exposing the deceptions of the two primary magicians, Alfred Borden and Robert Angier (Hugh Jackman), it does not expose the fundamental trick that it plays on the spectator. The trick is not that Borden can perform 'The Transported Man' because he is a twin or that Angier can perform 'The Real Transported Man' because he has Tesla's teleportation device. Many spectators of the film proudly announce that they figured out this deception a few minutes into the film. But this is not at all Nolan's feint. Instead, the trick is our investment as spectators in the fictional story itself, the fact that we can devote ourselves to the destinies of characters who exist only in the filmic world of *The Prestige*. The film functions as a commentary on the magic act of cinema itself, which uses falsity to arouse spectators who would otherwise have nothing to enjoy. The truth of falsity is our investment in this falsity, and this is what Nolan's film enacts on the spectator. This investment is the source of any enjoyment that the subject has.

Nolan's commitment to falsity extends to *Inception*, which, as mentioned earlier, is not just a Hollywood film but a summer blockbuster. If anywhere we should see Hollywood's power to undermine Nolan's project, it would be here. And yet, the film creates a false hero the equal of Leonard Shelby in *Memento*. During *Inception*, the spectator invests in the quest by hero Cobb (Leonardo DiCaprio) to return to his children only to discover that this quest is itself deceptive. Rather than wanting to return to his children, Cobb wants to escape his own desire that manifests itself in the dreamworld. The film uses the falsity of Cobb and his quest to highlight the psychic priority of the false world of dreams for the divided subject. Dreams are not, for Nolan, respite from the trauma of social reality. As the film makes clear, it is social reality that is respite from the trauma of dreams.[8] Though Nolan returned to Batman after *Inception*, the existence of the latter demonstrates his ability to sustain a form of political filmmaking within a Hollywood system constructed to make this kind of filmmaking impossible. Because Nolan challenges ideology with the false

hero and not by positing an alternative truth, he is able to work both outside and inside Hollywood.

Christopher Nolan is unusual among directors. He is able to create the false hero both outside Hollywood in *Following* and inside Hollywood in *Inception*. Hollywood's financial and ideological imperatives did not alter Nolan's commitment to the necessity of the false, despite the fact that this commitment runs counter to Hollywood's own concern for hiding falsity rather than exposing it. This triumph over the ideological power of Hollywood distinguishes Nolan from other directors who began outside of Hollywood and subsequently turned to it. The existence of authentic Christopher Nolan films in the heart of Hollywood allows us to conclude that it is not Hollywood that impairs Nolan's filmmaking project but the figure of the superhero.

One can make a superhero film that challenges ideology, and certainly there are elements of *The Dark Knight* and even *The Dark Knight Rises* (2012) that call ideology into question. But these are fundamentally compromised films as well. Their investment in Batman as a being of truth marks their betrayal of the politics of the false hero, a politics that assaults Hollywood's propagation of the image of completion. The problem with the superhero film is that it cannot avoid this image. Batman, despite his flaws, is incapable of being false. For this reason, Batman marks the point at which Christopher Nolan ceases to be Christopher Nolan.

*Notes*

1   The first thinker to reconceive truth as the truth of desire was Hegel, but Freud developed this idea and transformed it into the fundamental idea of psychoanalysis. According to Freud, it is the distortion of our desire that provides the matrix through which our perceptions and understanding must operate. This is why Freud pays more attention to dreams than to the conscious statements of his patients; see, for instance, Freud 1953.

2   Nolan's films often produce ongoing disputes about what has actually occurred in the diegetic reality. The existence of these disputes indicates not that Nolan is attempting to be ambiguous in his films but that the diegetic reality is not at all his real concern. The ambiguity is the result of a turn away from the question of what is real and what isn't rather than a preoccupation with it.

3   The paradigmatic example is *Shane* (George Stevens, 1953), in which Shane (Alan Ladd) destroys the threats to a legal order and then rides away slumped over his horse. Whether or not Shane is literally dead, what is important here is his symbolic death. Shane's violence has no place within the social order that it founds.

4   For an explanation of the universalising of the exception in *Batman Begins* and Nolan's critique in *The Dark Knight* of George W. Bush's invocation of the state of exception, see McGowan 2012.

5   Though there are superheroes that live without disguising themselves in everyday life, this absence of a disguise either condemns them to a form of exile (like the X-Men) or constantly puts themselves and those close to them in danger (as is the

case with Iron Man). The disguise is the only thing that allows a superhero to have an ordinary life in addition to life as a superhero.

6   Even when everyone in the diegetic reality knows the identity of the superhero, as they do with Iron Man (Robert Downey Jr.) after the conclusion of the first *Iron Man* (Jon Favreau, 2008), the spectator retains a privileged knowledge of the superhero. Unlike the other characters, the spectator sees how Tony Stark constructs his uniform and how he prepares to battle in it. This is even more the case with Nolan's *Batman Begins*, where the spectator sees exactly how Batman constructs each special device.

7   The concept of the unreliable narrator has a long literary history, but Wayne Booth (1983) was the first to name it in this way.

8   *Inception* makes clear Jacques Lacan's claim that we often wake up from a dream in order to continue dreaming – that is, in order to continue avoiding the encounter with trauma; see Lacan 1978.

## Bibliography

Agamben, Giorgio (2005) *State of Exception*, trans. Kevin Attell. Chicago: University of Chicago Press.

Booth, Wayne (1983) *The Rhetoric of Fiction*, second edition. Chicago: University of Chicago Press.

Deleuze, Gilles (1989) *Cinema 2: The Time-Image*, trans. Hugh Tomilson and Robert Galeta. Minneapolis, MN: University of Minnesota Press.

Freud, Sigmund (1953 [1900]) *The Interpretation of Dreams* (I), in trans. and ed. James Strachey. *The Standard Edition of the Complete Psychological Works of Sigmund Freud, Vol. 4.* London: Hogarth.

Hegel, G. W. F. (1977 [1807]) *Phenomenology of Spirit*, trans. A. V. Miller. Oxford: Oxford University Press.

Lacan, Jacques (1978) *The Four Fundamental Concepts of Psychoanalysis*, trans. Alan Sheridan, ed. Jacques-Alain Miller. New York: W. W. Norton.

McGowan, Todd (2012) *The Fictional Christopher Nolan*. Austin, TX: University of Texas Press.

# Inception's Singular Lack of Unity Among Christopher Nolan's Puzzle Films

## Andrew Kania

### Introduction

Without endorsing an auteur theory of film in any strong sense, one can reasonably divide Christopher Nolan's extant films into two groups: the more and less personal.[1] The more personal films are those with respect to which Nolan had more control over the script from the outset. These include his first feature-length film, *Following* (1998), his breakthrough sleeper-hit *Memento* (2000), his first big-budget film that was not a remake, *The Prestige* (2006) and the sci-fi action film *Inception* (2010).[2] I thus classify as less personal *Insomnia* (2002) (a remake of the Erik Skjoldbjærg's 1997 debut of the same name) and Nolan's Batman trilogy (2005, 2008, 2012). One could quibble with the principle or its application. On the one hand, both *Memento* and *The Prestige* were based on literary works; on the other, there is a lot of flexibility within the conventions of remaking a film and the constraints of the Batman myth. But there are also broadly formal features shared by the more personal films that I believe justifies discussing them together for some purposes. In particular, in all these films, central narrative and thematic puzzles are posed not only by the *story* – what happens in the fictional world of the film – but also by the *plot* – the order in which elements of the story are presented.

In this essay, I will argue that *Inception* is a significantly less accomplished film than Nolan's other more personal films, in part because of the lack of any deep connection between its formal structure and its thematic concerns. A large part of my case is a rejection of the popular interpretation that everything we see in the film occurs within the central character's dream. While there are advantages to this interpretation, they are outweighed by costs that defenders of the interpretation have unjustifiably ignored. The upshot is that *Inception* does not meet the high artistic standards Nolan has shown himself amply capable of meeting.

*Form and Content in Nolan's Earlier Puzzle Films*

## Following

The central puzzle in *Following* is simply to figure out, from the non-linear narrative, what actually happens in the fictional world of the film – though the process of figuring this out is by no means simple. The plot is cunningly constructed to conceal certain information until well-orchestrated twists occur, but by the end of the film no ambiguity remains with respect to the basic content of the story. Notably, however, the structure of the film is thematically related to the content. The Young Man (Jeremy Theobald) gets into deep trouble – the ending implies he will be convicted of a murder he did not commit – by following, first literally and then figuratively, a beguiling stranger known as Cobb (Alex Haw), without seriously examining either his own motives for doing so or what it is about the stranger that makes him so seductive. There are some nasty surprises waiting around the corner for the protagonist, surprises that reveal to him that while he thought he was actively following, he was in fact being led; we could say much the same thing about the viewer beguiled by the narrative structure of the film.

## Memento

*Memento* raised the puzzle-solving stakes. As in *Following*, the story of *Memento* is presented in a non-linear fashion, but its structure is much more intricate and elegant. Most of the film (in terms of both screen- and story-time) is presented in colour sequences arranged in reverse chronological order, putting the viewer into (roughly) the epistemic shoes of the protagonist, Leonard Shelby (Guy Pearce), who has lost his ability to form new long-term memories after being hit on the head during a home invasion – referred to throughout the film as 'the incident'. These sequences are interleaved with chronologically-ordered black-and-white sequences that segue, during the climactic scene at end of the film, into the beginning of the colour sequences (the beginning, that is, with respect to the story). As with *Following*, the viewer has to work hard just to piece the story back together from the fragmented plot, but there is an additional puzzle that adds to the difficulty of unraveling the plot. It becomes clear that there is an ambiguity about what happened during 'the incident' and between then and the film's present, an ambiguity that threatens to systematically undermine our central judgements about the characters and their actions.

Throughout the film, Leonard explains to various characters that his wife (Jorja Fox) was killed on the night of 'the incident' and that he has been on a quest since then to avenge her death. That he has managed to make any headway at all given his psychological condition is due in part to his involvement, as an insurance investigator before the incident, with Sammy Jankis (Stephen Tobolowsky). Sammy had a condition similar to Leonard's, and Leonard has put that experience to use in part through 'conditioning' himself to tattoo important information from his investigation on his body, to leave notes to himself in his pockets, and, crucially, to instinctively look in those places when he is confused. As Leonard says, 'it was useful experience, 'cause now it's my life'.[3] However, at the climax of the film, Leonard's partner, Teddy (Joe Pantoliano), accuses him of having confabulated Sammy in order to escape his guilt

at having killed his wife himself. Teddy claims that Leonard's wife was a diabetic, and that she effectively committed suicide by asking Leonard repeatedly, within a short space of time, to give her an insulin shot. She reasoned that if Leonard was faking his condition, he would not take it so far as to kill her, and that if Leonard was not faking she could not bear to go on living. Part of the shock of this revelation (if revelation it be) is due to the fact that we have taken this story of death by insulin overdose to be an uncontroversial part of *Sammy's* story. For throughout the film, Leonard has told various characters that this is how Sammy killed *his* wife (Harriet Sansom Harris), and we accept it as fact because Leonard's memories of events from *before* the incident are supposedly unaffected by his condition.[4] In fact, if Teddy is right, Leonard's condition is quite different from its presentation throughout the film – both verbally by Leonard and in terms of the very structure of the film. Rather than simply having lost the ability to form new long-term memories, Leonard (or some sub-personal part of him) is selectively suppressing memories inconvenient to his current conception of himself, and confabulating false memories in keeping with that conception.

Which of these interpretations is correct? My view is that the film is ultimately ambiguous; Berys Gaut (2011), by contrast, has argued that *Memento* is an intricate puzzle with a single correct solution (see also Kania 2009b). For the purposes of this essay, determining the correct interpretation of *Memento* is irrelevant; the point is to show that, no matter which interpretation is correct (if any), the value of the puzzle at the heart of the film is due in large part to the connection between its solution – conceived as both process and answer – and our understanding of the film, both formally and thematically.

*The Prestige*

The fragmented narrative of *The Prestige*, though less intricately structured than that of *Memento*, is likewise connected to its two central themes. First, the film is in part about the nature of entertainment: most obviously stage magic (the profession of the protagonists) but also, by analogy, the magic of the movies. It opens with a shot slowly tracking across a wooded hollow filled beautifully with decaying leaves and, bizarrely, with black top-hats. A *sotto voce* voice-over asks: 'Are you watching closely?' and immediately the screen goes black. It is 84 minutes before we return to the hollow and realise where the hats have come from, and 39 minutes more before we understand the horrific implications of this fact. Now, what's going on with all those top hats is just one small question among a myriad the film raises in our minds as we watch. And had Nolan told the story in a more straightforward manner, we would not be in so much suspense as we watch the film. But, of course, if the film did not raise these questions, setting us a series of puzzles we're desperate to solve, the film would not be nearly as enjoyable. As Cutter (Michael Caine), *ingénieur* and mentor to magician Robert Angier (Hugh Jackman), explains to his protégé about watching a magic trick: 'You don't really want to work it out. You want to be fooled.'

The second central theme of the film is personal identity. Throughout his oeuvre, Nolan has explored how our selves are constructed, with an emphasis on the fragmented nature of the self and the extent to which we are shaped by other people.

This theme is fairly explicit in both *Following* and *Memento*, but it reaches its fullest expression (so far) in *The Prestige*. One of the main characters – Alfred Borden (Christian Bale) – turns out to have been identical twins throughout the film. The twins have concealed their duality for years in order to pull off their signature illusion, 'The Transported Man', in which a single person (Borden) appears to move across a considerable spatial distance instantaneously. Tormented by his inability to figure out the trick, Angier ends up commissioning technology from Nikola Tesla (David Bowie) that enables him finally to upstage Borden in 'The *Real* Transported Man': he uses the technology to clone himself every night (the clone's appearance supplying the illusion that Angier has moved instantaneously) and then kills the self he's just cloned to avoid any awkward consequences.

As with *Following* and *Memento*, the formal structure of the film – a disjointed narrative that cuts between the 'two' central characters' lives and jumps around in time – embodies these themes.[5] Like the audiences for Angier's and Borden's illusions, Nolan's viewers want to be fooled, we want to be puzzled, though it could be argued on the basis of these three films that Nolan considers it a moral failing not to try to understand features of our lives by which we are puzzled.[6] And the same puzzling, cross-cutting narrative that provides us with jigsaw pieces we must reassemble into a chronological story also provides us with a cinematic symbol of the way in which the magicians' very selves impinge on one another, as their rivalry consumes them and destroys their ability to participate in loving relationships with others and even themselves.

*Form and Content in Inception*

The formal structure of *Inception* falls somewhere between those of *Memento* and *The Prestige* in terms of elegance. The story driving the narrative structure of *Inception* is that of a group of outlaws, led by Dom Cobb (Leonardo DiCaprio), attempting a high-tech act of corporate espionage. They have been hired by Saito (Ken Watanabe) to 'incept' his competitor, Robert Fischer (Cillian Murphy), the heir to an energy conglomerate – that is, to plant an idea in his mind, namely the idea of breaking up his father's company. They don't do this by taking out ads in the *New York Times* or attempting to reason with Fischer, however; the technique this band is expert at makes *Inception* a science-fiction film: they invade their target's dreams. Cobb believes that the only way to achieve inception is to introduce the seed of the idea at the heart of a series of nested dreams – a dream within a dream within a dream. Because this *matryoshka* of dreams occurs simultaneously, Nolan has already set himself a difficult narrative task in keeping at least four contemporaneous narrative balls in the air; those of the three nested dreams and reality – but there is also a fourth dream-level, 'Limbo', to keep track of, and a series of flashbacks explaining Cobb's past.[7] Raising the stakes even higher, Nolan makes it a part of the nature of the nested dreams that they proceed at 'different speeds'. Beginning from the fact that you might dream of a whole week's activities in a single night, Nolan makes it part of the fictional world of *Inception* that the apparent duration of a dream is roughly twenty times the apparent duration of the

dream (or reality) within which it occurs. This means that during the ten-hour plane flight during which the inception is attempted, the team members inhabiting the first dream level will seem to spend about a week in the dream, those at the second level six months, and those at the third – where the seed of inception is to be planted – will seem to spend *ten years of their lives* in the dream. When they wake up, however, just as when you wake from an ordinary dream, only ten hours will have passed. The time spent in the dream will presumably seem like, well, a dream. The nature of this story-time structure increases the challenge Nolan faces exponentially. Usually when cutting between simultaneous story lines, filmmakers don't need to worry about one story getting ahead of another, since the two run at the same speed.[8] But now Nolan has set himself the challenge of telling several stories that occur simultaneously, yet take place across hugely different (apparent) lengths of time.

As it turns out, however, the operatives at the deepest dream level do not get ten years to complete their task. Because of problems at the highest dream level, the entire cascade of dream time is cut short: instead of ten years, they have only sixty minutes to execute their plan, which is then even further reduced. Understanding this turn of events requires following the other main narrative arc of the film.

The reason Cobb believes that inception is possible, if difficult, is that he has achieved it before – though with awful results. In a series of flashbacks distributed throughout the film, we learn that Cobb and his wife, Mal (Marion Cotillard), were experimenting with nested dreams and spent so long in some deep dream-level that Mal forgot they were dreaming. Unable to convince her of their true situation, Cobb planted the idea that they were dreaming in her subconscious, by means of inception. However, he planted the idea so deep in her mind that even when she awoke, Mal continued to suspect that reality was mere dreaming appearance, ultimately leading to her suicide. (Being killed in a dream is one method of waking up from it, in the film.) Before killing herself, however, in a noirish twist, Mal framed Cobb for her murder, in a failed attempt to coerce him into 'waking himself up' – that is, killing himself in what Mal took to be a dream. As a result he is a fugitive from the law. The only reason Cobb agrees to attempt the difficult task of inception is that Saito guarantees, if he is successful, to have his record expunged, so that he can return home to the United States and, most importantly, to his young children.

Cobb is trying to manage not only the legal consequences of Mal's suicide, of course, but also its psychological effects. In short, Cobb feels guilt over Mal's suicide, which has consequences in the shared dreamworlds in which he works. His guilt manifests itself as a projection of Mal, who often turns up at the most inconvenient times while he is conducting dream operations, and attempts to sabotage them. For instance, as the attempted inception is just beginning – at the highest dream level – Mal runs a locomotive through the middle of a road in the city that forms the dream-scape. And this is what precipitates the problems that lead to the operation's severely foreshortened schedule: Saito is mortally wounded. Because of the particularly heavy sedation the crew is using, if Saito dies in this dream, rather than waking he will end up in Limbo, an 'unconstructed dream space', his brain potentially turned to 'scrambled egg'. If this happens, Cobb will lose his last chance to return to his children.

The central puzzle of *Inception* is where exactly to draw the line between dream and reality. Several times throughout the film, the question is raised whether Mal was right that she and Cobb never actually awoke from their nested-dream experiment. If so, then by 'killing herself' she in fact woke up, and Cobb missed his real chance to return to his children.[9] It is notable that, in contrast with the films already discussed, there is little reflection of this puzzle in the formal structure of *Inception*. Of course, it is sometimes difficult to keep track of which dream we are in, especially as further levels are added, and the pace of cutting between them increases. Even Cobb's dream-architect, Ariadne (Ellen Page), says at one point 'Wait, whose subconscious are we going into, exactly?' And there is a deliberately confusing transition at the beginning of the film, when we cut from a sequence in Limbo from very late in the story to a designed dream at the beginning of the story. Because both feature the same dreamscape and central players – the Japanese castle on a cliff, Saito and Cobb – we have no hope of figuring out their relationship until late in the film. But there is not the systematic paralleling of form and theme throughout the film that we find in *Following*, *Memento* or *The Prestige*.

The puzzle of what is dream and what reality is foregrounded most notoriously in the film's final shot. One of the aspects of dream-sharing explained early in the film is the use of 'totems'. A totem is an object one carries to test whether or not one is in someone else's dream. The basic idea is that the totem behaves in some idiosyncratic way of which only its owner is aware. For instance, like Cobb's right-hand man, Arthur (Joseph Gordon-Levitt), you might carry a loaded die that, say, always turns up six. If you're unsure whether you're in someone else's dream, you just have to take out the die and roll it. If you're awake, the die will come up six. But if you're in someone else's dream, the die will act according to the rules of their dream – the ordinary rules of physics, say (after all, if you're in a dream, you're not really taking out your die – you're asleep and someone is merely dreaming that you're taking out your die). So if the die comes up three, you know you're in someone else's dream. If the die comes up six, you should probably roll it again – even if you're in someone else's dream, the chances are one in six that you'll get this ambiguous result! But even if the die keeps coming up six, this doesn't prove you're awake, according to the film's explanation of how totems work. For since you know how your totem works, *you* could be dreaming that it works as it actually does.

At the end of the film, Cobb, having successfully completed the inception, returns home to his children. Entering his house, however, he has the strange sense of *déja-vu* that dream operatives often experience when entering a place of which they've dreamed. So he takes out his totem – a small top – and sets it spinning on the dining table. The final shot of the movie shows the top spinning away. It seems to falter once or twice, about to slow and tumble, but before we can be sure, the screen cuts to black – THE END. As many commentators have pointed out, this scene seems to imply that Cobb – the best in the business – is implausibly confused about how totems work.[10] First, Cobb seems to think that if the top never falls, he can conclude he is in a dream, while if it falls he can conclude he is awake. But a totem should have a distinctive behaviour *in reality*, not in the dreamworld. Since people generally expect tops to fall, Cobb's

totem will give him a false positive if he's in almost anyone's dream. Second, Cobb has explained to Ariadne how his totem works, and that it used to be Mal's totem. So, even ignoring the first problem, he cannot rule out the possibility that he is in a dream of Ariadne's or Mal's by using his totem. Third, as with all totems, its distinctive behaviour cannot tell Cobb whether or not *he* is dreaming, and this is the epistemic question he should be most concerned about at this point in the film.

So, the question implicit in the final cut – does the top keep spinning? – is a red herring.[11] However, some commentators have marshaled other evidence suggesting that the entire film is a dream. One approach is to argue that the entire film is Cobb's dream according to the rules of shared and nested dreaming set up by the film. For instance, it's unclear how Cobb and Saito return to the real world from Limbo. Cobb finds Saito in Limbo and apparently convinces him to kill them both in order finally to wake them up. But given how things work elsewhere in the film, it seems more likely that this will result in their merely jumping up to some other dream level.[12] If this is the case, then it's unclear how *Cobb and Mal* returned from their deeply-nested shared dream in the first place, and this means that Cobb's life *since then* has all been a dream, with the implication that, far from being insane, Mal's idea that they need to wake up to return to the real world and their children is exactly right. However, this kind of evidence is too shaky a foundation for a global interpretation of the film; the internal logic of the dream-sharing technology just isn't that secure or replete. This *allows for* all sorts of possible interpretations (as discussion of the film on the Internet bears out), but it doesn't provide a strong reason for any particular global interpretation.

A more compelling argument is that there are easily overlooked cinematic details that, once noticed, constitute a compelling case that the entire film is Cobb's dream. For instance, the supporting characters have been described as one-dimensional, the editing is a little jumpier than we might expect, scene after scene is begun *in medias res*, and so on. As Mal points out, Cobb's life resembles a paranoid dream – mysterious agents chase him around the globe, yet he always manages to escape in the nick of time, often in quite unlikely ways. Jason Southworth (2012) argues that these details would count as flaws in an ordinary film, but that we should be motivated by a principle of aesthetic charity when interpreting films and other artworks, aiming to maximise their artistic value. Since there are two possible global interpretations of the film, we should favour the one that transforms these flaws into virtues. Thus Southworth argues they are best interpreted as evidence that the entire film is Cobb's dream.[13]

Even if Southworth's interpretive principle is correct, I am not sure that he applies it correctly in this case. For one thing, he seems to assume that the best interpretation will always be a definitive, as opposed to ambiguous, interpretation. But there is a long tradition of valuing artworks that admit of multiple, even conflicting, interpretations. Even if you think that we can give reasons in favour of one interpretation over another, you can still allow that in some cases the reasons support a kind of disjunctive interpretation, according to which the work is simply ambiguous (or polysemous) between a number of different, even incompatible, interpretations.[14] And it is by no means a stretch to imagine that *Inception* might be one of those works. In fact, one reason to favour this interpretation would be to consider the film's place in Nolan's puzzle-film

oeuvre. Arguably, *Memento* and *The Prestige* are both films displaying deep ambiguities, both narrative and moral.

Be that as it may, there is a more troublesome problem for Southworth's argument. He seems to be suggesting that an *internal explanation* (that is, an explanation within the fictional world) of a *prima facie* artistic flaw automatically transforms it into an artistic virtue. But this is not obviously the case. It may be that the *internal explanation* is an artistic virtue, adding coherence to the work, but it does not follow that the *original feature* now explained is thereby transformed into an artistic virtue. That the virtue of coherence has been added does not imply that the original flaw has been removed. Nor does it necessarily follow that the added virtue of coherence outweighs the original flaw. For example, because of the problems generated by Mal's meddling at the highest dream-level, the entire cascade of dream-time is cut short. One result is that, instead of a ten-year process of psychological manipulation at the deepest dream-level, we get an hour-long snowmobile chase right out of a 1970s Bond flick. (Admittedly, this sequence sometimes feels like it's taking ten years.) Southworth does not address this sequence in particular, but it's plausible, on his interpretation, that the reason this sequence employs hackneyed action-flick tropes is that Cobb (whose dream the entire movie is, according to Southworth) has watched too many James Bond movies. As a result, his 'projections' act like the stooges in the ski-chase scene from *The Spy Who Loved Me* (1977) and, in general, the episode unfolds like a chase scene from such a film.[15] If plausible, this explanation adds some coherence to the film – there's an internal explanation of why this sequence unfolds as it does. But it doesn't thereby eliminate the artistically bad features of the sequence. This is known to high-school English teachers everywhere. You can append 'And then she woke up, and realised it was all a dream' to the end of any incoherent or unresolved story, and thereby improve it – there is now an internal explanation of the incoherence or unresolved nature of the story. But it doesn't transform the story's incoherence or loose ends into artistic virtues.

Finally, even if an internal explanation of a *prima facie* artistic flaw *did*, despite that just argued, automatically transform it into an artistic virtue, it would not follow that an interpretation that effects such a transformation is to be preferred overall to one that does not. For the transformation may affect other properties of the work, thereby reducing its overall artistic value. Consider the charming short sequence when Arthur urges Ariadne to kiss him. He claims that this might lead Fischer's projections to ignore him (the dreamer of this dream level), but when it doesn't work, he simply shrugs and says 'yeah, it was worth a shot'. Ariadne's incredulous yet flattered response tells us all we need to know: Arthur simply grabbed an opportunity to steal a kiss. Now, Southworth embraces the criticism some made of the film that the secondary characters (that is, everyone but Cobb) are one-dimensional. Like the other artistic flaws Southworth considers, this fact is supposedly transformed into a virtue by the interpretation that the movie in its entirety is Cobb's dream. What we took to be real people are really just projections of various aspects of Cobb's psyche. But though this hypothesis might explain some of the characterisation in the film, it will have the opposite effect on the short sequence just mentioned, for this sequence *humanises* these two characters – Arthur in particular, who has been presented for the most part as the emotionally

restrained counterpart to Cobb, valuing efficiency over everything else. If Arthur and Ariadne are mere projections of Cobb's, this sequence simply doesn't make any sense.

For all that, Southworth might maintain that the increased overall coherence of the film outweighs the few artistic flaws that are introduced by the interpretation that everything we see in *Inception* is part of an overarching dream of Cobb's. But, as detailed below, there is a major cost to this interpretation that Southworth ignores, and this cost is enough to show that the interpretation according to which the entire film takes place in a dream of Cobb's, far from maximising the artistic value of the film, severely reduces that value, and thus that we should prefer either an interpretation according to which what we initially take to be reality in the film world is in fact so, or an ambiguous interpretation. Nonetheless, though these interpretations are to be preferred, they still leave *Inception* significantly behind *Following*, *Memento* and *The Prestige* in terms of Nolan's artistic achievements.

## 'Inception isn't easy' – But Who Cares?

When the film was first released, some critics noted that the corporate-espionage narrative was not well chosen to enlist our sympathies for the characters' efforts. More emotionally engaging are Cobb's attempts to deal with his loss of Mal and the guilt he feels over her death. I have already mentioned the way this guilt erupts into the dream-worlds in which Cobb's crew works. The problem is exacerbated by Cobb's practice of keeping his memory of Mal alive by going into a dream state alone and re-experiencing key moments in their relationship. In all these dreams – professional and personal – Mal tries to convince Cobb to join her, though sometimes she seems to mean that he should kill himself in his apparent waking life, which she takes to be a dream, some-times that he should remain in what they both know to be a dream state. Either way, to the extent that Cobb is tempted by these suggestions, he is himself suicidal.

Mal thus joins a line of *femmes fatales* in Nolan's work who are twisted – not psychologically, but with respect to viewers' expectations. Consider Natalie (Carrie-Anne Moss) in *Memento*. The way the film is structured, we come to believe on first viewing that Natalie is an evil person, using Leonard's condition to manipulate him in order to escape the consequences of her lover Jimmy's drug deal gone bad. On closer inspection, however, it becomes apparent that the only reason the drug deal went bad is that it was a set-up, orchestrated by Teddy. Moreover, by the time Natalie meets Leonard, she is aware of this fact, and fairly certain that Jimmy is dead. In light of these facts, Natalie should be considered at the very least cool-headed and pragmatic, but more plausibly extremely empathetic and generous in her treatment of Leonard. She gives him a place to stay, and helps him in his quest, even though she could easily refrain from doing so and still get what she wants from Leonard. It is true that she uses him to her advantage, but in the circumstances that hardly seems blameworthy – after all, she knows that the person she's using has just played a central role in the murder of her lover. The unnamed blonde in *Following* (Lucy Russell) undergoes two twists. She is first presented as a victim of her gangster ex-boyfriend's blackmail. Then the protagonist discovers that on the contrary she has been working with the protagonist's

false friend, Cobb (no relation!). In a final twist, however, it turns out that Cobb is in league with the gangster and they have been setting up both the blonde (to be murdered) and the protagonist (as the murderer).[16]

We get a similarly bad feeling about Mal throughout *Inception*, beginning with the opening scenes (not to mention her name). But it's very easy to forget that we almost never actually see Mal in the film; rather, we see Cobb's projection of her.[17] This fact is foregrounded during the scene near the end of the film, the climax of this emotionally engaging narrative strand, when Cobb realises that his guilt-based attempts to keep Mal alive in his memory are futile. To Ariadne (though while looking Mal in the eye) he says 'I can't stay with her anymore because she doesn't exist. He then admits – to Mal, which is of course really a deep part of himself: 'I can't imagine you with all your complexity, all your perfection, all your imperfection. Look at you. You're just a shade … of my real wife. You were the best that I could do, but, I'm sorry, you're just not good enough. … I miss you more than I can bear, but we had our time together, and I have to let you go'. This is clearly the emotional *dénouement* of the movie.

Now consider what is going on here if the entire film is a dream of Cobb's. First, this makes it difficult to know what has really happened, since according to this inter-pretation nothing we see or are told throughout the film is transparent to the film's fictional world in the manner of classical cinematic narration.[18] But let's assume for the sake of argument that the most highly-foregrounded alternative interpretation is correct – that Mal was right. If so, she has only committed suicide in a dream, thereby effecting her awakening in the real world, while Cobb is ironically stuck in a dream-world he mistakenly takes to be reality, resisting Mal's hints at the truth of his situ-ation.[19] If this is so, then his guilt over Mal's suicide is misplaced, to say the least.[20] Rather than feeling guilty over Mal's 'death', he ought to be paying attention to her arguments that he's quite literally living a dream. But recall that *Mal* isn't actually making any of these arguments, for even according to this interpretation, Mal isn't sharing a dream with Cobb – she's woken up. So it's rather Cobb's projection of Mal that is making these suggestions.

This isn't exactly incoherent: Cobb believes his inception of Mal has led to her tragic suicide by making her unable to trust her judgement of what's real; he thus projects or remembers a version of Mal who tries to convince him that he's similarly making faulty judgements of what's real; and it turns out these projections or memo-ries are expressing the truth of his situation, even though he can't know that. But though it's not incoherent, it makes a mockery of the emotional climax of the film. For a start, in this scene, Cobb's projection of Mal gets his situation *wrong*, since she encourages him to stay in Limbo, rather than to kill himself in order to wake up. More importantly, in letting go of Mal, on this interpretation, Cobb is not moving on emotionally, but rather letting go of his last hope of reconnecting with reality. So if this interpretation is correct, there is a major artistic flaw in the film. Not only does the apparent emotional resolution at the core of the story turn out to be merely illusory, at the point at which almost all the other narrative strands are simultaneously resolved (Fischer's inception and the 'kicks' that collapse the lower dream-levels, returning all the operatives but Saito and Cobb to the top dream-level), but it also turns out that

what was apparently the film's emotional core was really just one more red herring.[21] Cobb's guilt over Mal's suicide is misplaced, so the question of whether he will overcome it is irrelevant. This question is replaced by that of whether Cobb will realise that he is living a dream. And the answer is that he is left in a slightly worse position than at the beginning of the film, since he's abandoned his projection of Mal – the one thing that might have convinced him of his true situation. This, in essence, is the major cost that the all-dream interpretation incurs. What looked like the film's main hope for emotionally engaging the audience evaporates if the apparent emotional core of the film is not what it seems.[22]

In sum, even if Southworth is correct that the best interpretation of an artwork is that which maximises the work's artistic value, and that the all-dream interpretation of *Inception* turns some artistic flaws into artistic virtues (and adds one or two artistic virtues all its own), it does not follow that the all-dream interpretation is the best one. For other interpretations, notably that according to which the film is ambiguous and that according to which what is presented *prima facie* as reality in the film is in fact reality, have artistic virtues that far outweigh the virtues gained by the all-dream interpretation. In particular, the former retain the emotional tension and resolution at the heart of the film, namely Cobb's guilt over his role in Mal's suicide.

## Conclusion

I began with a discussion of how the complex narrative structures of Nolan's earlier puzzle films are related to their thematic concerns – these films are classic marriages of form and content. I then argued that there are strong reasons to reject one solution to the central puzzle of *Inception*: if the entire film is a dream of Cobb's, it loses its main source of emotional significance. But I have said little about the relationship between *Inception*'s form and content in the way I did with respect to the earlier films. The simple reason for this is that there is not much to say. The structure of the film is virtuosic, and related in obvious ways to the nature of the nested dreams central to the corporate-espionage storyline. But that structure is not related to the puzzle of how to distinguish dream from reality in the film world. Moreover, there is no close connection between that puzzle and the emotional core of the film – Cobb's attempt to deal with the loss of his wife and the guilt he feels over that loss – the way there is between the narrative and thematic puzzles of *Following, Memento* and *The Prestige*. On the contrary, one tempting solution to the puzzle would undermine that emotional core. For this reason, we should rate *Inception* a lesser achievement among Nolan's more personal films. It is, for the most part, a gripping science-fiction action flick, but it fails to live up to the fusion of popular genre, complex form and philosophical content exhibited by his best work.

## Notes

1    For a rewarding discussion of auteur theory and other issues of film authorship, see chapter three of Gaut (2010).

2    When completing this essay, *Interstellar* (2014) had not been released, so it is not discussed here.

3    'Roughly' because, unlike Leonard, as the film runs we continue to amass memories of what has happened in the film – albeit memories of things that have not yet happened in the film world, due to the reversed chronology. For more on the form of *Memento*, see Kania (2009a).

4    In fact, I think part of the shock of this twist (if twist it be!) is that the story of Sammy Jankis can seem a clunky part of the script. What are the chances, we ask ourselves rhetorically, that Leonard, in his pre-incident life as an insurance investigator, would have professionally interacted at length with someone with virtually the same incredibly rare memory-condition? Surely, we might think to ourselves, this is just a convenient way for the director to expound the nature of Leonard's memory condition. If Teddy is right, however, the all-too-convenient nature of this parallel is in fact a sign that something fishy is going on in the fictional world. (And even if Teddy isn't right, the convenience can be artistically justified in terms of contributing to the central ambiguity of the film.)

5    The peculiar situation of these characters with respect to personal identity makes the use of number in reference to them rather awkward.

6    Just as Cutter claims the audience wants to be fooled, Teddy accuses Leonard of wanting to create a puzzle he could never solve (1:43).

7    The difficulty of presenting several narratives simultaneously is well illustrated at either end of the history of film by D. W. Griffith's *Intolerance* (1916) and the Wachowski siblings' adaptation (2012) of David Mitchell's matryoshkan novel, *Cloud Atlas* (2004). In their defence, both films contain narratives that are much more loosely connected than those of *Inception*. (Thanks to Patrick Keating for pointing out to me the connection between *Inception* and *Intolerance*.)

8    Of course, two simultaneous stories that take the same length of time to play out may have different internal structures, which presents a challenge to the filmmaker in terms of unfolding them in parallel. But *Inception* is no different in this regard.

9    Things are never this simple, however. How could Mal know when she reached reality, and thus should stop killing herself?

10   See, for example, many of the essays in Johnson (2012).

11   Of course, if the top *did* keep spinning, we'd know *something* was up, but there is little if any reason to think it should do so. The point is that if it did fall, the ambiguity would remain. One might argue that though whether the top keeps spinning is a red herring, Cobb's confusion about how totems work is a vital clue. For such confused reasoning about relatively simple things is a hallmark of our dream lives. I discuss such evidence below (though note that if professional dreamers get confused about totems in dream, they're not much use). However, it's not as clear as some suggest that the distinctive behaviour of this totem *for Cobb* is whether or not it falls. We are led to believe its continuous spinning in dreams is its totemic behaviour because that's what Mal (who invented totems) designed it to do and because this behaviour was central to Cobb's inception of Mal. But the *particular*

*way* it falls, for instance, might be its totemic behaviour for Cobb. (For a discussion of red-herring shots in *Memento*, see Kania 2009b.)

12    In fact, it's quite unclear how the rest of the gang wake up from the top dream level they return to at the climax of the film. Perhaps, having achieved their goal, they simply wait for the time to run out on the machine that keeps them in the dream state. But why have Fischer's projections stopped hunting them at this level?

13    For considerations of space, I ignore many of the particular features Southworth claims (dubiously, in my view) would count as flaws in an ordinary film.

14    For an introduction to the huge literature on this topic, see Currie (2003); for an overview of theories of interpretation as applied to film, see Gaut (2011).

15    In fact, since projections are generated not by the dreamer but the subject – i.e. the person whose mind is being infiltrated – it's even unclear whose projections these would be. Perhaps they're not even true projections, but merely projected projections! Again, trying to work out the implications of the film's logic is an exercise in rapidly diminishing returns.

16    I develop the ideas in this paragraph in Kania (2014). Ariadne is an interesting case among Nolan's women characters. She is certainly Cobb's help-meet, guiding him through the process of psychological healing he requires, but she is not a love interest (apart from the brief scene with Arthur, discussed above). In fact, one might argue that one reason Nolan cast the girlish Ellen Page was to reduce the audience's expectation that she would become the emotional replacement for Mal in Cobb's life. (This might also explain the need for the short scene with Arthur discussed above.)

17    When Ariadne asks Arthur what Mal was like 'in real life,' he says simply: 'She was lovely' (0:41).

18    On such transparency, see Wilson (1986).

19    To make sense of this interpretation, we must again ignore the complications mentioned in note 10, above.

20    For an argument that Cobb's guilt is misplaced either way, see Blessing (2012).

21    Andrew Terjesen (2012) argues that it doesn't make any difference to our emotional engagement with the film if the whole thing is (fictionally) a dream, since it's fiction either way; fictional characters don't exist, and thus they can be no *less* real for being figments of Cobb's (fictional) imagination. But this relies on too simplistic a view of our engagement with fictions. Our emotional reactions to fictions depend on their contents. We rightly sympathise with a character who is being tortured because we infer that he is (fictionally) feeling pain. We do not have the same emotional response to a character who is *dreaming* or *imagining* he is being tortured, because we infer that he is *not* (fictionally) feeling pain.

22    When Mal finally presses Cobb to ignore what he *believes* and tell her what he *feels* is real, he replies simply, 'Guilt. I feel guilt, Mal' (2:01). That this sets the emotional *dénouement* in motion is a clue that Nolan himself takes the issue of Cobb's guilt to be more important than that of what is dream or reality.

# Bibliography

Blessing, Kimberly (2012) 'Mal-Placed Regret', in David Kyle Johnson (ed.) *Inception and Philosophy: Because it's Never Just a Dream*. Malden, MA: Blackwell, 295–309.

Currie, Gregory (2003) 'Interpretation in Art', in Jerrold Levinson (ed.) *The Oxford Handbook of Aesthetics*. Oxford: Oxford University Press, 291–306.

Gaut, Berys (2011) 'Telling Stories: Narration, Emotion, and Insight in *Memento*', in Noel Carroll and John Gibson (eds) *Narrative, Emotion, and Insight*. University Park, PA: Pennsylvania State University Press, 23–44.

____ (2010) *A Philosophy of Cinematic Art*. Cambridge: Cambridge University Press.

Johnson, David Kyle (ed.) (2012) *Inception and Philosophy: Because it's Never Just a Dream*. Malden, MA: Blackwell.

Kania, Andrew (2014) 'The Twisted *Femmes Fatales* of Christopher Nolan', *Aesthetics for Birds*, 1 June. Online. Available: http://www.aestheticsforbirds.com/2014/06/the-twisted-femmes-fatales-of.html (accessed 10 July 2014).

____ (2009a) 'Introduction', in Andrew Kania (ed.) *Memento*. New York: Routledge, 1–22.

____ (2009b) 'What is *Memento*?: Ontology and Interpretation in Mainstream Film', in Andrew Kania (ed.) *Memento*. New York: Routledge, 167–88.

Southworth, Jason (2012) 'Let Me Put My Thoughts in You', in David Kyle Johnson (ed.) *Inception and Philosophy: Because it's Never Just a Dream*. Malden, MA: Blackwell, 31–45.

Terjesen, Andrew (2012) 'Even if it is a Dream, We Should Still Care', in David Kyle Johnson (ed.) *Inception and Philosophy: Because it's Never Just a Dream*. Malden, MA: Blackwell, 46–61.

Wilson, George (1986) *Narration in Light*. Baltimore, MD: Johns Hopkins University Press.

CHAPTER THIRTEEN

# Inception's Video Game Logic

## Warren Buckland

Is there anything new to say about Christopher Nolan's *Inception* (2010), after the publication of two edited volumes (both called *Inception and Philosophy*) and numerous papers and blog posts devoted to the film? (see Botz-Bornstein 2011; Johnson 2012).[1] Several reviewers (but few academics) have remarked in passing on the overlap between *Inception* and video games.[2] Vanessa Thorpe has stated: 'The thriller [*Inception*], which is largely set inside the heads of its protagonists during a drug-induced sleep, closely resembles the structure of a video game. It sets up a world where narrative is reversible [sic] and several things can go on at the same time, at different speeds' (2010). For James Meek: 'The story, about a team of dream designers trying to secretly alter a dreamer's ideas, is a model of video game society. Substitute "video game" for "dream" and the film still makes sense' (2010: 28). While Patrick Goldstein noted: 'I was dazzled by the movie's originality, but also so confused by its dense, video-game narrative style that, by the last forty minutes of the film, I'd pretty much lost track of the story' (2010: 12). These reviewers base their video game–*Inception* comparisons primarily on the film's dream levels, a dream's different time frame to everyday perception, but also on the violent combat that takes place on all levels between the main characters and numerous 'security projections', which have a status similar to figures in video games. Moreover, under normal conditions, characters in the film resemble avatars in video games in that they simply exit the game (the dream state) or move up/down one level when 'killed'. In this essay I go beyond the reviewers' brief comparisons between *Inception* and video games and investigate in more detail the video game rules that structure the film's logic. In previous studies I have carried out similar analyses of *The Fifth Element* (Luc Besson, 1997) (Buckland 2002) and *Source Code* (Duncan Jones, 2011) (Buckland 2014b).

The study of video game rules, and their influence on a film's logical structure, should be placed within the broader context of what Lev Manovich (2001, 2013) and Matthew Fuller (2003, 2008), amongst others, call 'software studies'. In *Software Takes*

*Command* (2013), Manovich identifies a shift in the computer age from fixed, static physical media tools (e.g. paper pages, cardboard folders, steel filing cabinets, typewriters) to dynamic virtual tools that simulate these physical objects on a computer screen via algorithms. However, he points out that these algorithms do not simply reproduce or remediate the physical objects; instead, the objects are represented as discrete digital bits of information that can be extended – amplified, manipulated and transformed – at will. Software studies does not simply focus on the content (information) that is stored in computers; rather, it examines the software's new structures and techniques that dynamically manipulate the content (sometimes in ways unique to a digital environment). Analysing video game rules within the context of software studies focuses attention on general game structures and techniques that have been remediated and transformed in video games. In turn, we can use this framework to analyse the way video game rules are remediated in certain films.

By analysing *Inception* in terms of video game rules, I am not proposing that the film simply simulates a video game. Classical narrative structures (setup, complicating action, development, climax, exposition, deadlines) and film aesthetics (or, at least, intensified continuity) still dominate (see Bordwell 2013). The premise of this essay is that, formally, *Inception* is in part structured around a number of video game rules. The purpose of my investigation is not to offer a general discussion of the film or repeat what others have said about it, but to present a narrowly focused study that identifies and establishes what role video game rules play in structuring the film's logic, for it is evident that *Inception* and films like it combine various media rules. This combining of media results in hybridisation, or a mixing of different media. Manovich uses the more specific term, 'deep remixability':

> *Today designers remix not only content from different media but also their fundamental techniques, working methods, and ways of representation and expression.* United within the common software environment the languages of cinematography, animation, computer animation, special effects, graphic design, typography, drawing, and painting have come to form a new *metalanguage*. A work produced in this new metalanguage can use all the techniques, or any subset of these techniques, that were previously unique to these different media. (2013: 268–9; emphasis in original)

Films such as *The Fifth Element*, *Source Code* and *Inception* are hybrids or deep remixes, in Manovich's sense of these terms within a software environment, that combine the rules, techniques and modes of representation from both narrative cinema and video games.

*Video Game Rules*

Before analysing the video game rules that partly structure *Inception*, I will examine a number of key rules that constitute video games. These rules are not contingent to (video) games, but constitute their very core and their source of pleasure, for ludolo-

gists generally agree that 'every game *is* its rules' (Parlett 2005). For Jesper Juul, game rules function as instructions, which define some actions in a game as meaningful and others as meaningless (2005: 57–8). In other words, rules set the limits or boundary of meaningful gameplay.[3]

Video games possess 'an excess of visual and aural stimuli' but also 'the promise of reliable rules' (Gottschalk 1995: 13).[4] These rules, which are reliable in that they are systematic and unambiguous (for they are unencumbered by morality or compassion), constitute the video game's environment, or location, which is not restrained by the laws of the physical world. The game user can experience video pleasure primarily by attempting to master these rules; that is, decipher the game's logic. Moreover, the desire to attain mastery makes video games addictive, which at times can lead to the user's total absorption into the game's rules and environment. This absorption in turn may alter the user's state of consciousness and lead to a momentary loss of self (see Fiske 1989, chapter 2). Some of the most common video game rules are listed below:

Table 1: Video Game Rules

- In-game tutorial level
- Serialized repetition of actions (to accumulate points and master the rules)
- Multiple levels of adventure
- Space-time warps
- Magical transformations and disguises
- Immediate rewards and punishment (which act as feedback loops)
- Pace
- Interactivity
- The game's environment can be open or closed, linear or nonlinear
- The game needs to remain balanced
- Some games consist of a foldback story structure
- In role-playing games, players can usually choose or customize their avatar
- The avatar possesses a series of resources and entities
- Typical gaming skills a player needs are strategy and tactics
- Most games (unintentionally) have an exploit
- Many games include a sandbox mode

An in-game tutorial level offers players a quick, partial, introductory experience of a game's design and, more generally, of gameplay (informing the player of the skills necessary to take on the game's challenges, how to use the controls and navigate the space, and so on). A number of films combining narrative logic and video game logic also include a tutorial level. *The Matrix* (Andy & Lana Wachowski, 1999), for example, explicitly consists of tutorial levels, as Neo (Keanu Reeves) is trained to learn (and bend) the rules in the matrix, the film's game world.

Video games are organised around the serialised repetition of actions for several reasons, including the accumulation of points and the opportunity to master the rules

of the game. 'Once players have learned a set of skills,' writes Nicholas Luppa, 'they want to apply them in new situations. Elevating a game to other levels has long been a secret of good game design' (1998: 32). In other words, users are keen to refine their newly acquired competence in gameplay by applying and testing it in similar but more difficult environments (which keeps the game in balance, as described below).

Space-time warps represent an alternative way to reach another level. They are the video game's equivalent of the hypertext link, for they enable the player to be immediately transported to an alternative space (and time), leading to a sense of multiple fragmented spaces, with immediate transportation between them. Space-time warps are common in science fiction and in video games, including early video games such as *Spacewar* (1962) and *Asteroids* (1979), in which the player could escape danger by pressing a button that took them to hyperspace – essentially, a random place on a new screen. Many of the *Sonic the Hedgehog* games produced by Sega (1991 onwards) used Chaos Emeralds to warp time and space.

The user's accumulation of points acts as a feedback loop in the process of mastering the rules, since it represents a reward for good gameplay, and confers upon the user the sense that his competence is improving and the game is progressing. In a similar fashion, the loss of points or a life acts as an immediate punishment for failing to master the rules. A repetition of this punishment leads to the user's premature death and an early end to the game, or a return to its beginning. Serialised repetition therefore involves repeating the same stages of the game – usually at a faster pace, or moving up to another similar (but more difficult) level. According to Luppa, pace is one of the most important features of video games: '[video games] require pacing and the beats that are being counted in that pacing are the beats between interactions' (1998: 34). The important point here is that the player controls the beats via interaction, which confers upon the player the feeling of control – the manipulation of a character in a usually hostile digital environment. Moreover, the interactions need to be immersive – that is, must focus the user's concentration, and must be multiple and varied. Interaction is also dependent on the interface design, which must be detailed, but also easy to use.

In *Fundamentals of Game Design* (2007), game developers Ernest Adams and Andrew Rollings map out the various environments or layouts a game designer can adopt, from open layouts that allow for a player's unconstrained movement within a game, to closed layouts (usually a set of interior spaces) (2007: 405–10). The open layout has little linear structure, while closed spaces have single or multiple paths the player needs to follow.

One of the key concepts in game design for Adams and Rollings is balance (2007, chapter 11). As the game progresses, the player feels it is becoming easier, because he/she gains game experience. If the game becomes too easy, the player becomes bored. To keep the game in balance and to avoid boredom, tasks and challenges must progressively become more difficult.

In the foldback story structure, 'the plot branches a number of times but eventually *folds back* to a single, inevitable event' (Adams and Rollings 2007: 200) – in other words, several ways exist for reaching the same unavoidable endpoint. This story

structure is usually combined with serialised repetition of actions, for a player within each repetition takes a different path to reach the same endpoint. The foldback story structure can also be defined in terms of game design. Games of emergence offer the player huge variations, improvisation and open play in order to reach the endpoint, whereas games of progression are more linear and closed, thereby limiting the player's ability to stray from the predetermined path. Games of emergence therefore have a stronger foldback structure than games of progression.[5] Game designers enable players to construct or modify their avatar, and also confer on it a series of resources, 'objects or materials the player can move or exchange, which the game handles as numeric quantities' (Adams and Rollings 2007: 323). Whereas a resource is a *type* of object or material (for example, energy), an entity names an avatar's possession of an actual amount of that resource at any given time in the game (for example, five units of energy).

The distinction between strategy and tactics derives from military theory, although Michel de Certeau (1984) also developed it to analyse the routines and habits of everyday life, including resistance to everyday forms of control. In studying video games, the terms can be used to cover both sets of meanings. A strategy involves constructing a game plan on the available knowledge of the rules and the opponents in the game. Because information is usually concealed in a game, the player relies on probability and skill in succeeding (see Adams and Rollings 2007: 298). A strategy is implemented through tactics, the carrying out of a strategy through a variety of actions. Both strategy and tactics need a clear, measurable outcome, although tactics can try to subvert and find short cuts to the strategy, ultimately leading to exploits (and here we switch to de Certeau's meaning of tactics as a form or resistance to the established rules embedded in the strategy).

An exploit is an unexpected action the player uses to gain advantage within a game. The player usually exploits a weakness, glitch or bug in the game's design. Adams and Rollings give an example: 'in an old side-scrolling space-shooter game on the Super Nintendo Entertainment System ... the player could, after upgrading her weapons to a certain level, make her way through the rest of the game without ever losing a life by traveling as low on the screen as possible and keeping her finger on the fire button. Although clearly unintended, this position made her invulnerable to enemy attacks' (2007: 366).

Finally, the sandbox mode allows free play, or the player to explore the game without constraints. The player can experiment with using the game without devising a strategy or achieving a goal. In this mode, emergence is predominant while progression is negligible. Some games (most famously, *Grand Theft Auto*) are based almost exclusively on the sandbox mode. Kurt Squire calls these sandbox games open-ended simulation games – 'games that have open-ended worlds, through which there is no one single, correct pathway. Sandbox games are known for their status as contexts for creative player expression, with multiple solution paths (their quality is judged according to their ability to deliver such an experience) as opposed to their ability to create a more-or-less common experience' (2008: 170–1).

Video pleasure, created by a user's addiction to and immersion in a game, is therefore not simply a matter of a heightened stimulation generated by high quality

graphics, audio and animation, but is also – and, I would argue, primarily – a function of these rules, of the user's success at mastering these rules. Of course, in discussing the popularity and pleasure of video games, we should not leave out their content and themes, which can in fact be summarised in one word – violence: 'The central organizing assumption of videology is unarguably that of violence. ... The only relevant question posed by videology is not whether a particular situation calls for negotiation or violence but how efficiently can violence be administered' (Gottschalk 1995: 7).

*Video Game Rules in Inception*

The film begins with a prologue, showing Saito (Ken Watanabe) and Dom Cobb (Leonardo DiCaprio) in 'Limbo' dream space (infinite raw sub-consciousness), an event that takes place towards the end of the film's action. The following scenes move back in time and involve an unsuccessful attempt to steal secrets from Saito's mind. In narrative terms, these scenes serve to introduce film spectators to one of the film's main themes, the invasion of a character's dream space to extract information. These scenes therefore present the characters performing a 'dry run' before the more complicated invasion of dream space later in the film – to perform inception on Robert Fischer (Cillian Murphy). But, in terms of video games, the opening scenes of Cobb's team attempting to steal secrets from Saito's mind resemble an in-game tutorial level, introducing the game rules to film spectators by showing them how the game is played. In this exposition-heavy film, the tutorial is repeated, this time when Ariadne (Ellen Page) enters a dream space (Paris) with Cobb, where he spells out the game rules to her while she learns to manipulate the environment. However, Ariadne is punished when she attracts the attention of Cobb's projections, including his wife Mal (Marion Cotillard), who kills her in the dream space, forcing her to wake up and exit the game.[6]

The film's main gameplay, the invasion and inception of Fischer's mind (to encourage him to break up his father's company), is carried out via a serialised repetition of action. This is implemented via a nested or embedded structure. In other words, to ensure the inception takes hold, the idea must be implanted deep in Fischer's mind, within three embedded levels of dream space – a dream within a dream within a dream. The inception begins with all the characters occupying the first class compartment of a flight from Sydney to Los Angeles. From there they are transported to the first level of dream space, a rainy cityscape, where Fischer is kidnapped and interrogated. However, the characters come under sustained attack from Fischer's projections, forcing them to move more quickly down to the next dream level, a hotel. In each level, an action is repeated: characters need to be put to sleep in order to be transported to the dream level (or to the next dream within a dream). Transfer to the (next) dream level is effortless: the characters are connected to the PASIV (Portable Automated Somnacin IntraVenous) Device via IV tubes, which administers the sleep potion Somnacin. *Inception* therefore resembles an online multi-player game, in which several characters meet up in the same dream, or imaginary space (see Brophy 2011). Once they are hooked up and the potion is administered, the characters automatically undergo a space warp that involves their consciousness moving to a new imaginary dreamworld

populated with avatars identical to themselves. Presumably, the potion enables characters to experience lucid dreaming (in which the dreamer can manipulate the dream). This dreamworld, designed by architects, also has a different time frame than the real world: in each new level time is stretched by a factor of twenty. (In other words, three minutes of a dreamer asleep in the real world is stretched out into – or experienced by the dreamer as – one hour within the dream.) The Somnacin is a game resource that enables the avatars to sleep and, therefore, empowers them to enter the next level. Characters return to the previous level either when the dream ends, or in more violent ways – via death within the dream or via a 'kick' administered by a character outside it. The death of a character within a dream acts as a feedback loop: it signals to them that they have failed, and that they will be punished by being forced to exit the level and wake up. However, performing inception on Fischer necessitates the use of a stronger than normal potion, one consequence of which is that characters do not wake up if killed one level down; instead, their punishment is more severe – they end up trapped in Limbo. The rules therefore change in the main game (performing inception on Fischer on the flight to Los Angeles) – it becomes more challenging because the risks are greater: that is, performing inception is more hazardous than performing extraction. If the main game simply involved performing extraction, it would be no different to the attempted extraction performed on Saito earlier in the film; subsequently, the game would appear easier and less challenging. Performing inception on Fischer raises the stakes, making the game harder, thereby keeping it in balance.

The design of the environment (the game levels) is a significant action in the film. The designer (Ariadne) is depicted as a character in the film (compare with *Source Code*, where the designer of the source code technology, Dr. Rutledge, is also in the film). The game's environment can be open or closed, linear or nonlinear. Ariadne designs all three levels as labyrinths (in order to slow down the dreamer's projections from attacking the intruders into the dream), with an open space (a cityscape, level one) and two closed spaces: the interior of the hotel (level two), and the Mountain Fortress in the snowscape (level three). This Fortress also contains an exploit, a shortcut through its labyrinth via an air duct. The final level, Limbo, is not designed, but is a raw dream state or an open space with few rules, thereby conforming to the freeplay of the sandbox mode (although the film confers upon this space a negative connotation, whereas in video games it has a more positive connotation). Cobb and Mal occupied this level in the distant past, and built their own city together, due to the long stretch of time they lived there (usually considered to be fifty years, which equals about three hours of dreaming in the real world).

Strategy, which involves constructing a game plan on the available knowledge of the rules and the opponents in the game, is a key part of the film. The team's original strategy, to successfully perform inception on Fischer, is severely compromised when Saito is shot and injured by one of Fischer's projections on the first dream level. Such projections were not expected; furthermore, it is at this moment that the team discovers from Cobb the change of rules in the main game – when they realise the higher stakes. Although the goal remains the same and the tactics are similar, the new knowledge (Fischer's projections, new rules) compromises the initial strategy; it

is quickly modified as the team improvises a new strategy to address or circumvent the additional dangers. The same tactics are used: Eames (Tom Hardy) still disguises himself as Fischer's godfather, Browning (Tom Berenger), in order to make suggestions to Fischer in the interrogation. However, the interrogation of Fischer is reduced from several hours to one hour. (On level two, in the hotel, Eames also adopts the identity of a blonde woman to entrap Fischer. But on the whole, characters remain the same whatever level they are on.) After the short interrogation, the characters get into a white van and are chased along the city streets. In this chase, several team members and Fischer are sedated and move down to the next dream level. Cobb has to improvise on this level, and uses a risky strategy – he introduces the 'Mr Charles' gambit, in which he tells Fischer that he is dreaming and is under threat (which was not part of the initial strategy). This risky strategy works, since Fischer is convinced that the inception team is protecting him. He then volunteers to join the team at level three, the Fortress in the snowy landscape.

Arthur (Joseph Gordon-Levitt) also has to improvise on level two, in the hotel. He is unable to implement the 'kick' on the characters (to wake them up) because of the zero gravity caused by the van falling on level one. He therefore comes up with a new strategy to wake up the team members (by using explosives to force an elevator up the elevator shaft). At level three, Fischer is shot and 'killed' by Mal, an action that halts the strategy and prevents inception from taking place; it also sends Fischer into the game's Limbo level. Saito 'dies' soon afterwards on level three (from the gunshot he received on level one), and also enters Limbo (the two main business rivals therefore suffer the same fate). It is here that the most radical strategy is implemented. The characters have been attempting to avoid Limbo throughout the whole mission. It is Ariadne's counter-intuitive suggestion to voluntarily enter Limbo (with Cobb) as a way of saving the mission, of getting the strategy back on track – by finding and then 'killing' Fischer in Limbo, thereby returning him to level three. Once this is achieved, Cobb goes looking for Saito. However, Cobb's agenda is more complex.

Most characters in *Inception*, like video game players, simply aim to carry out the mission successfully and to survive in the dream spaces (by mastering the rules of the game), whereas Cobb also has a distinct narrative motivation – to clear his name (against the charge that he killed Mal) and to see his children again. In narrative terms, Mal is the main obstacle to Cobb achieving his goal, in two senses: as a projection in his mind, she tries to prevent Cobb from carrying out his missions (and almost succeeds, when she shoots Fischer); and secondly, Cobb feels guilt and regret about her death, in which she jumped from a hotel window under the illusion she was in an imaginary world and would simply wake up. While in Limbo, Cobb implanted into her via inception the idea that her world in Limbo is not real, so that she would wake up from it. The inception succeeded. But that feeling of unreality carried over into her real existence, which eventually led to her suicide and to Cobb's feelings of guilt and regret.[7] When Cobb voluntarily enters Limbo with Ariadne, he confronts (his own projection of) Mal – or, more specifically, confronts his guilt, finally achieving catharsis. He then tries to find Saito who can (in a *Deus ex machina* way) simply have his murder charges dropped with one phone call. It is this action, of Cobb finding

Saito in Limbo, that opens the film (the prologue), and which is partly repeated. Through its repetition, the actions now make sense.

The film can be said to have a weak foldback structure – the main part of the film has one goal, one outcome (the successful inception of Fischer), but the characters have to change their strategy (which takes them on different paths, including a journey to Limbo) in order to reach that goal. In other words, the film primarily follows a game of progression rather than a game of emergence.

*Conclusion*

Reviewers were right to identify the dream levels, temporality and violence as a link between *Inception* and video games. In this essay I have identified several other video game structures evident in *Inception*, which, of necessity, go beyond but complement the canonical narrative structure predominant in the film's Hollywood storytelling techniques. Key to *Inception*'s video game logic, in addition to levels of play and violence, we discovered: two in-game tutorials; the serialised repetition of action (especially in the way characters move to different dream levels, which constitute a space warp); immediate punishment for not mastering the rules of the game during gameplay (in which players either wake up or enter Limbo); an emphasis on strategy and tactics (and the need to change strategy quickly); a successful balancing of the game and an increase in its pace, in which the tasks become harder and the risks higher as the game progresses; an emphasis on constructing the game's environment (designed by Ariadne as labyrinths, with a mix of open and closed spaces); plus great significance conferred upon the Limbo level, the equivalent of the video game's sandbox mode. In addition, there is a game resource (Somnacin), a small use of disguises and one use of an exploit.

*Inception* is not simply the result or an aggregate of narrative and video game structures; collectively, these structures combine to create a distinctive hybrid that cannot be reduced to its simple components. This hybrid (based on 'deep remixability') results in a non-structural complexity, a value that cannot be located in the structure's components (in the same way that the 'mind' cannot be reduced to physical, neural properties of the brain, even though the mind is composed of neural properties). One component missing, of course, from *Inception* is interactivity between audience and film (although there is interaction depicted *within* the film, between its different levels of reality – between, that is, waking and dreaming characters, and between the dream levels: the characters become avatars on the next level down, and the avatars are controlled by their dreaming 'players' one level up).[8] However, the audience for *Inception* was not entirely inactive. Video game structures make *Inception* complex and unpredictable – that is, innovative, a commodity prized in Hollywood (within limits, of course). Complexity and unpredictability encourage a cult following and repeat viewing in order to master the complexity (just as games are played multiple times in order to master their rules). The video game structures create an active fan (and academic) base that replays *Inception* over and over in order to interpret it in all its minutiae, unpacking its ambiguities, improbabilities and plot inconsistencies on

blogs, dedicated web pages and in academic volumes. Nolan achieved this active fan and academic base with the art-house hit *Memento* (2000). He then achieved the same response in the multiplexes with *Inception*.

*Notes*

1    See also David Bordwell (2013, chapter 3); Miklós Kiss (2012); Jane Lugea (2013); Annie van den Oever (2012). My own edited volume, *Hollywood Puzzle Films* (2014a), contains five chapters devoted to *Inception*. From the myriad websites devoted to the film, the Pinterest page called 'Inception Explained' is invaluable: http://www.pinterest.com/explore/inception-explained/ (accessed 10 January 2014).

2    The two exceptions I have encountered are Matthew Brophy (2011) and Jasmina Kallay (2013). Brophy explores the parallels between *Inception* and online multi-player games, while Kallay analyses *Inception* as a psychological puzzle film, built around a multi-level labyrinth: 'The labyrinth in *Inception* is … represented as structuring the overall narrative, as well as shaping the internal design of the dream levels' (2013: 52). She argues that such a 'super-maze … owes its origins to the dynamic properties of the computer' (ibid.).

3    Juul defines gameplay as 'the way the game is actually played when the player tries to overcome its challenges. [...] The gameplay is an interaction between the rules and the player's attempt at playing the game as well as possible' (2005: 56). In other words, the rules are part of the game's underlying system, while gameplay is their enactment or use within a particular game.

4    Some of these rules and structures were first outlined in Buckland (2002) and later expanded and developed in Buckland (2014b).

5    For an outline of games of emergence and of progression, see Juul (2005: 67–83).

6    This also occurs in *Source Code*. The whole film is based on the serialised repetition of action, in which Colter Stevens (Jake Gyllenhaal) is sent back several times to a train with a bomb on it. He (or his avatar, Sean Fentriss) has eight minutes to find and defuse the bomb before it explodes. Every time he fails, the bomb goes off and kills him, which throws him out of the game. He is then sent back in to the beginning to try again. By contrast, in *The Matrix*, the death of a character/avatar in the game will also kill the player outside the game.

7    Guilt and regret over the death of someone close are dominant themes in Nolan's films: in *Memento*, does Leonard Shelby feel guilty about inadvertently killing his wife? In *Insomnia*, is detective Will Dormer (Al Pacino) wracked with guilt because he intentionally shot his partner Hap (Martin Donovan) while chasing a criminal through the fog? Alfred Borden (Christian Bale) is responsible for the death/drowning of Julia McCullough (Piper Perado) in *The Prestige*, after tying a difficult knot she cannot undo under water; Batman's guilt and regret concerning his parents' death are legendary.

8    James Cameron's film *Avatar* (2009) and Jones' *Source Code* are based on the same principle: both depict a character in a pod or capsule manipulating an avatar in a different location.

# Bibliography

Adams, Ernest and Andrew Rollings (2007) *Fundamentals of Game Design*. Upper Saddle River, NJ: Pearson.

Bordwell, David with Kristin Thompson (2013) *Christopher Nolan: A Labyrinth of Linkages*. Madison, WS: Irvington Way Institute Press.

Botz-Bornstein, Thorsten (ed.) (2011) *Inception and Philosophy: Ideas to Die For*. Chicago: Open Court.

Brophy, Matthew (2011) 'Shared Dreams in Virtual Worlds', in Thorsten Botz-Bornstein (ed.) *Inception and Philosophy: Ideas to Die For*. Chicago: Open Court, 189–202.

Buckland, Warren (2002) 'S/Z, the "Readerly" Film, and Video Game Logic (*The Fifth Element*)', in Thomas Elsaesser and Warren Buckland (eds) *Studying Contemporary American Film: A Guide to Movie Analysis*. London: Arnold, 146–67.

\_\_\_\_ (ed.) (2014a) *Hollywood Puzzle Films*. New York: Routledge.

\_\_\_\_ (2014b) '*Source Code*'s Video Game Logic', in Warren Buckland (ed.) *Hollywood Puzzle Films*. New York: Routledge, 185–97.

De Certeau, Michel (1984) *The Practices of Everyday Life*, trans. Steven Rendall. Berkeley, CA: University of California Press.

Fiske, John (1989) *Reading the Popular*. London: Routledge.

Fuller, Matthew (2003) *Behind the Blip: Essays on the Culture of Software*. London: Autonomedia.

\_\_\_\_ (2008) *Software Studies: A Lexicon*. Cambridge, MA: MIT Press.

Goldstein, Patrick (2010) 'The Older You Get. The Age of Inception: Gamers Generation Get It, Geezers Don't', *The Hamilton Spectator*, 4, 12.

Gottschalk, Simon (1995) 'Videology: Video-Games as Postmodern Sites/Sights of Ideological Reproduction', *Symbolic Interaction*, 18, 1, 1–18.

Johnson, David Kyle (ed.) (2012) *Inception and Philosophy: Because It's Never Just a Dream*. Hoboken, NJ: John Wiley.

Juul, Jesper (2005) *Half-Real: Video Games Between Real Rules and Fictional Worlds*. Cambridge, MA: MIT Press.

Kallay, Jasmina (2013) *Gaming Film: How Games are Reshaping Contemporary Cinema*. Basingstoke: Palgrave Macmillan.

Kiss, Miklós (2012) 'Narrative Metalepsis as Diegetic Concept in Christopher Nolan's *Inception* (2010)', *Acta Univ. Sapientiae, Film And Media Studies*, 5, 35–54.

Lugea, Jane (2013) 'Embedded Dialogue and Dreams: The Worlds and Accessibility Relations of *Inception*', *Language and Literature*, 22, 2, 133–53.

Luppa, Nicholas V. (1998) *Designing Interactive Digital Media*. Boston: Focal Press.

Manovich, Lev (2001) *The Language of New Media*. Cambridge, MA: MIT Press.

\_\_\_\_ (2013) *Software Takes Command*. London: Bloomsbury Academic.

Meek, James (2010) 'Calling on the Audience to Live the Dream: The Zeitgeist is All About Joining In – In Video Games, Theatre, TV. But Are We Losing the Ability to Sit Still?', *The Guardian*, 21 August, 28.

Parlett, David (2005) 'Rules OK, *or* Hoyle on Troubled Waters', *The Incompleat Gamester*. Online. Available: http://www.davpar.com/gamester/rulesOK.html (accessed 1 October, 2013).

Squire, Kurt (2008) 'Open-Ended Video Games: A Model for Developing Learning for the Interactive Age', in Katie Salen (ed.) *The Ecology of Games: Connecting Youth, Games, and Learning*. Cambridge, MA: MIT Press, 167–98.

Thorpe, Vanessa (2010) 'How *Inception* Proves that the Art of Baffling Films Does Actually Make Sense: Christopher Nolan's Complicated Blockbuster has Left Audiences Baffled and Sparked Heated Debate Across Twitter and Online Forums. But Complex Films are Part of Cinema's Rich History', *The Observer*, 25 July, 23.

Van den Oever, Annie (2012) 'Mainstream Complexity: Nolan's *Inception* as a Case for (Amateur) Narratologists', *Cinéma & Cie*, 18, 33–43.

CHAPTER FOURTEEN

# On the Work of the Double in Christopher Nolan's The Prestige

## Kwasu David Tembo

The troubling of identity is a theme that can be traced throughout Christopher Nolan's oeuvre (see, for example, Elsaesser 2009; McGowan 2012: 103–23; Pisters 2012: 37–98; Bordwell and Thompson 2013). In each case, Nolan presents the audience with a protagonist whose perception is in some way distressed by psychological and physical trauma such that it ruptures their sense or perception of self and their reality. The disruptive affect of seemingly unameliorable trauma in Nolan's protagonists ultimately presents them to the viewer as unreliable mediators of aesthetically and narratalogically complex sequences of events: Leonard Shelby's (Guy Pearce) anterograde amnesia in *Memento* (2000); the disorienting pathetic fallacy of the combination of guilt-driven insomnia and perpetual daylight experienced by Will Dormer (Al Pacino) in *Insomnia* (2002); Dom Cobb's (Leonardo DiCaprio) inability to definitively distinguish between shared dreams and conscious and subconscious realities in *Inception* (2010); and Cooper's (Mathew McConaughey) vertigo of spacio-temporal quantum confusion after crossing an event horizon in *Interstellar* (2014). In each instance, Nolan's narratives and innovative aesthetics centralise the psycho-emotional dissonance, multiplicity, non-linearity, paradox and overarching fracture in a way that reflects the hypostatic themes of guilt and psycho-physical trauma experienced by all of his protagonists. In this sense, Nolan employs multifaceted narratives that unfold, refold, double or echo themselves, and are presented to the viewer concurrently, in reverse and/or repeatedly in the form of flashbacks. This authorial tendency consistently takes the concepts of unitary identity, self, memory and subjectivity as objects of deconstruction and play. While insightful contributions and emergent scholarly attention has been directed towards Nolan's films as 'mind game' narratives (see Kooijman *et al.* 2008; Elsaesser 2009; Buckland 2014), the innovative narratalogical and aesthetic techniques evidenced in *Memento* (see Clarke 2002; Gargett 2002; Bodnar 2003; Shiloh 2007; Botez 2015), *Inception* (see Greenberg 2009; Botz-Bornstein 2011) and the psychoanalytical aspects of trauma in *Insomnia* and *The Prestige* (see Joy

2013, 2014), this essay will examine Nolan's use of the double in *The Prestige* (2006) to explore the concepts of identity, subjectivity and the performative nature of both. To begin with I will explore the twin/clone argument surrounding the character(s) Borden/Fallon (Christian Bale), which is concerned with whether the characters are artificially created doubles of one another or monozygotic twins[1] in order to address the relationship between the double, dissimulation[2] and dedication to the craft of an illusion. I will also examine the existential anguish experienced by Robert Angier (Hugh Jackman) as a means of investigating the relationship between identity, presence and the existential troubling of both through the device of the double, and lastly I will explore the existential and ontological consequences of the mechanical work of the reproduction of self (see Benjamin 2010).

## On the Concept of the Double

Inherent in the concept of the double is the phenomena of reflection (see Lacan 2010). The concept of the double also evokes more ethereal, supernatural and folkloric concepts (for further work on the phenomena of reflection and/or the double in philosophical terms by philosophers and critical theorists, see Baudrillard 2010; Davies 1998; Pyysiäinen 2009; Freud 2010). For example, the *Doppelgänger*,[3] the mystical phenomena of *bilocation*,[4] the precession of the double as is the case with the Norse *Vardøger*[5] and the Finnish *Etiäinen*.[6] The double is also connoted with various processes and their end result. For example; duplication, re-duplication, reproduction, abstraction, printing, copying – either through the time-consuming process of manual reproduction, or through a process of technological reproduction that troubles the distinction between an 'authentic original' and a 'derivative copy' – the facsimile, dissimulation, supplementation and illusion. So, how does the concept of the double relate to the twins Alfred Borden and Bernard Fallon or Angier's alter ego Lord Caldlow and look-a-like Roote?

## On the Logic of Illusion

We are first introduced to Borden through his daughter Jess (Samantha Mahurin) who watches Cutter (Michael Caine) perform a magic trick that demonstrates the logic of illusion.[7] He shows the girl a canary. This canary is identical to the other canaries shown in a row of cages in the cluttered workshop they are in. He places the canary in an ornate cage and rests it on top of a prop table. He covers this caged canary with a shawl, and seemingly smashes the cage into non-existence with his hands. He removes the shawl to reveal that the cage and the canary therein have seemingly vanished. He covers his closed fist with the same shawl, then swiftly removes it to reveal *a* canary, unharmed, in his hand. Jess's child-like wonder and joy at having witnessed what appears to be magic is a reflection of the sense of wonder, anticipation and mystification inherent in any process, device or object that is claimed to be magical or claims magical properties for itself. This is set against the rational and empiricist impulse to demystify the illusion, its mechanism or secret, its apparatuses, as well as the magi-

cian or illusionist performing them. This scene is counterpoised by a later scene in which *a* Borden meets Sarah (Rebecca Hall) for the first time. In the scene we are shown *a* Borden employed as an assistant to a magician named Virgil (J. Paul Moore). The illusion Virgil performs is exactly the same as the one Cutter performs. What is different, however, is the reaction of the child watching it, who in this instance is Sarah's unnamed nephew. Upon seeing Virgil smash the cage, the boy is horrified and begins crying. When the final canary is revealed, the child is not convinced that it is the *same* one employed at the start of the illusion later asking 'but where's his brother?' After Virgil's performance, the canary employed at the beginning of the trick is revealed to have actually been destroyed. Borden cleans out the trick cage by unceremoniously discarding the dead canary's carcass into a wastebasket. Sarah's nephew does not witness this part of the trick. However, his distress suggests that he had imagined the canary's fate. The two reactions of the children reflect the feelings of an audience witnessing what is claimed to be magic namely, a mixture of wonder and terror.[8]

The canary is a symbol of a particular type of magician, one who is caged within his absolute dedication to the craft and performance of an illusion. This can be noted in Borden's ability to immediately detect the method of Chung Ling Soo's (Chao Li Chi) fishbowl trick in which a seemingly feeble, elderly magician conjures a fishbowl filled with water from thin air. The method that Borden immediately and correctly deduces is concerned with Soo's dedication to the illusion of *appearing* decrepit. The *method* of the illusion inheres in Soo's ability to dissimulate his own strength in order to feign the frailty of old age. Borden is able to detect Soo's method because he is performing an *identical* illusion. By doubling himself or by always-already being a double of himself, and by protecting the truth of his plurality by totally dedicating and sacrificing himself to the performance of an identity, Borden is, at once, able to escape himself, to empirically and metaphysically transport himself and yet never escape himself at all. According to *a* Borden, the 'true' nature of magic and the logic of a great illusion is to utterly lose oneself in the performance of the illusion to a degree that the differentiation between 'illusion' and 'life' can no longer be made. The magician has to eschew all organic expressions of a singular self by diligently and consistently obscuring his past and as such, becoming the illusion by living it. As such, the canary is also a symbol of the double in that the canary is identical but distinct, uncanny to the other canaries the viewer is shown. The paradox here is that each canary the viewer sees, caged or uncaged, looks indistinguishable from the next. The viewer assumes that logically, all the canaries are also unique, individual and therefore discrete from one another. While being a symbol of the double, the canary is also a symbol of expendability. In the performance of the birdcage illusion, a canary is paired with a double of itself. One dies and the other lives through the illusion of its disappearance. In this way, an illusion involving the use of doubles functions through the dissimulation of the plurality of an object whereby the pledged object *does* disappear or even die, but it is immediately *replaced* by something else which looks exactly the same as the thing which was made to disappear. The double's function in an illusion therefore is to simultaneously hold and misdirect the viewer's gaze in order to maintain the illusion of the magical object's singularity by deferring or delaying the fact of its plurality.

## On the Fraternal and Simulacral Readings

*The Prestige* presents two ways of reading Borden. The first is what I call the Fraternal reading. The Fraternal reading suggests that Borden and his enigmatic *ingénieur*[9] Fallon are identical twins, and that these twins lead a compound life in which they each supplement or *stand-in-the-place-of* one another. However, Nolan's treatment of Borden's simultaneous interchangeability and distinctness is always evasive, displaced and inconclusive. The viewer never knows with absolute certainty *which* Borden s/he is seeing at any given time. Even with *a* Borden's confession at the end of the film that each of the Bordens had half of a full life, the viewer does not conclusively know which Borden is Jess's father, Sarah's husband, Julia's (Piper Perabo) killer, Olivia's (Scarlett Johansson) lover or Angier's murderer.[10] What he does admit to is that both Bordens were both 'Borden' and 'Fallon'. Therefore, all the viewer can refer to with any reasonable degree of accuracy is the performance of the illusion, and yet the illusion is itself consciously unreliable in terms of furnishing the viewer with a complete, singular identity.

The second reading of Borden is what I call the Simulacral reading (see Baudrillard 2010: 6). This reading is based on the enigmatic engineering pioneer Nikola Tesla (David Bowie) and the machines we are told he builds for Angier and an unnamed 'colleague' who may or may not be *a* Borden. Discovering the identity of this colleague is problematised because the viewer's experience of Tesla is mediated entirely through Angier during his quest to discover the secret of Borden's greatest trick, 'The Transported Man'. When Angier is speaking with Tesla in his private workshop in Colorado Springs, Tesla says to him that 'exact science is not an exact science', which is the same as saying that the mechanism of Tesla's machines is inconclusive. We do not know the nature of the machines, nor how or for whom they were made, or why, and as such, cannot discern it in their mechanism in this way. All the viewer knows is that Cutter considers Tesla to be a 'wizard', to be able to do what magicians pretend to do, namely 'real magic'.

In this sense, the secret of the machine is deferred in its use, namely as an apparatus of doubling. We are then left with the question of the relationship, if any, between Tesla and Borden. It is possible that Borden has no relation with Tesla and that the brothers' suggested association with Tesla is yet another one of many multi-layered misdirections used to mislead their rival Angier in an obsessive and ultimately meaningless quest to discover the method of 'The Transported Man'. But the quest is shown not to be entirely fruitless. Angier's resources and dedication result in him finding Tesla and the creation of a machine that allows him to perform what is considered to be the best version of the illusion. In a later scene in which *a* Borden confronts Angier at Highgate Cemetery where Fallon is buried alive, Angier forces Borden to write down and describe his method for 'The Transported Man' in full. That Borden reveals that the key to the cypher in *their* journal is the word 'TESLA'. Therefore, one possible reason that the Bordens chose the word 'TESLA' as the key to the cypher of their journal is because, at some undisclosed point, they interacted with Tesla. I am willing to concede that Tesla's association with the Bordens is more suggestive

than it is factual. However, the circumstantial evidence of the relationship between Tesla and the Bordens is made concrete during their confrontation with Angier at the cemetery because *a* Borden states that the keyword to the cypher of their notebook *is* the method, namely 'TESLA'.

The possibility that the Bordens are doubles is further compounded by the strange phrasing their wife uses in a later scene when, during an argument, she yells 'I know *what* you *really* are, Alfred!' Why would Sarah use the word 'what' instead of 'who'? Does Sarah later hang herself because she discovers that the man she thought to be her husband is in fact a double of himself? Does she hang herself because she can no longer suffer the torment of experiencing half a life, half a lover and half a marriage with two identical yet distinct men *sharing* her, her life, her trust, that take turns loving her – and being innately able to tell the difference in what should be the intimate declarations of love that *both* men present to her, whose veracity varies from day to day?

The most extreme suggestion of the Simulacral reading is that Tesla built a machine for some now inaccessible 'original' Borden similar to the one he built for Angier, whereby Borden doubled himself a non-disclosed number of times, after which the Bordens committed themselves to the maintenance of the illusion of the separate identities of 'Borden' and 'Fallon'. This reading is not without its problems. For example, while the keyword to the Bordens' cypher proves to be genuine in that it allows Angier to decipher their journal, it is revealed that the journal Angier comes to acquire has been written with the intention of being deciphered and read by Angier himself. This raises the problem of whether the journal Angier deciphers is the Bordens' 'real' journal at all, or whether there are numerous journals in which the secret of 'The Transported Man' is potentially hidden, diffused in multiple volumes or described in full in a single notebook. Nor can the Simulacral reading account for the fact that Borden and Angier come from polarised socio-economic backgrounds. While Angier, an aristocratic magician, has the capital to not only finance his quest for the Bordens' secret, but also to act as sole financier to Tesla *and* pay for the construction of a machine, the Bordens are shown to be working-class magicians up until the success of their version of 'The Transported Man'. How, then, could the Bordens afford a machine from Tesla at all? Furthermore, upon witnessing one of *an* Angier's limited performances of 'The Real Transported Man', *a* Borden and *a* Fallon frustratedly attempt to detect Angier's method.[11] Their frustration at the mystery of that Angier's method begs the question that if the Bordens are in fact acquainted with Tesla and the types of machines he is able to make, why would they be unable to detect the method of a machine Tesla himself had built?

With identity and method problematised in this way, it is easy to see the Fraternal reading's appeal to a viewer seeking an underlying rational explanation for the secret of 'The Transported Man'. The Fraternal reading leads the viewer to believe that they are always witnessing the *same* Borden/Fallon *duo* and that they have *always* been a duo in this way. However, this reading overlooks just how much we don't know about Borden in the first instance and, as such, seeks out a reconciliation that concludes that the magical phenomena doesn't have a fundamentally gentico-graphical,[12] but instead a logocentric[13] explanation that the viewer can rely on and return to. A reading

of this kind eschews the film's inexplicable and subtle moments, those moments that cannot be neatly untangled by 'watching closely' as we are constantly reminded to do. It disregards Cutter's warning to Angier not to believe the Bordens as they are natural magicians. When confronted by the film's aporias, the Fraternal reading becomes paranoiac precisely because it projects a coherence on to those events that may or may not be there. While the logic of the Fraternal reading seeks to neatly resolve the complex play of identities, methods and secrets, the problems of the Simulacral reading extend well beyond the limits of a stage, illusion or performance. For example, we are shown at the beginning of the film that *a* Borden is on trial for the murder of an Angier. But if the Bordens are part of an undisclosed cohort of doubles, then we are invited to conclude that 'Alfred Borden' does not refer to a singular subject. Who, which or at least *what*, then, is on trial? The Simulacral reading suggests that the answer to this question is that the reproduction of oneself diffuses the authority of the law. The law can exercise its authority on the body of the condemned. It can discipline and punish that body upon whose space its authority is localised and reified. But if the subjecthood of the condemned is diffused through a network or series of two or more bodies, if the subject is always-already more accurately *subjects*, in multiple places, at multiple times, the superfluity of self keeps the law from exercising its authority in any kind of *total* way. Like the canary, one may be killed, and yet – that which was killed or made to disappear persists.

Regardless of whether the viewer chooses to subscribe to the Fraternal reading, the Simulacral reading or neither, it is clear that Nolan uses the device of the double to problematise a definitive explanation of the method of 'The Transported Man' by *simultaneously* endorsing and discrediting both the Fraternal and Simulacral readings of the illusion. This is evident in *both* readings' ability to explain other mysteries presented in the film, chiefly the mystery of which knot Borden tied around the wrists of Angier's wife – a simple slipknot or a Langford Double – that led to her death. Despite the fact that the viewer is shown *a* Borden *switching* the knot and tying what is presumably a Langford Double moments before Julia is hoisted above the water tank that kills her, the viewer cannot be sure *which* Borden it is. Nor can the viewer be sure which Borden attends Julia's funeral, nor can the viewer in fact know conclusively which Borden wrote about the ordeal in their journal. In each instance of a mystery or secret, identity is shown to be an illusion predicated on the necessity of a double. In this sense, it does not matter whether one is 'watching closely' or not because Nolan problematises the logical association between identity and perception and that identity is predicated on the perception of something the perceiver believes to be singular and unitary.

The play of mystery in *The Prestige* troubles this notion that the viewer is ever looking at an object in its *totality*, or that the viewer is ever perceiving the *same* object – be it a cat, a hat or a man. Regardless of the method through which the doubling of self is achieved, both readings are predicated on the diffusion of self through either a single double as is it is suggested with the case of the Bordens, or with an undisclosed series of doubles as is the case with the Angiers. In the last instance, neither 'The Transported Man', 'The New Transported Man', 'The Original Transported Man' nor

'The Real Transported Man', which are also uncanny doubles of themselves, can function without the sacrifice, diffusion, deferral, loss or death of the illusionist as a single, unitary subject. In other words, through the doubling of self, and using doubles to maintain the illusion of a single identity, to always-already be elsewhere, one is able not only to attain a measure of omnipresence, but also immortality. In this way, the film suggests that it is only the magician who can dissimulate his own death by turning his life into an illusion.

## On the Agony of Drowning

After we are shown Angier making what we are led to believe is his first double, he immediately destroys it by shooting it in the chest. In effect, Angier doubles himself, then kills himself. In that instant, 'Robert Angier' no longer exists as a single, indisputably authentic subject.[14] He becomes hyperreal.[15] We are never privy to what this supposedly first double would have said were it allowed to speak. It could have yelled out 'No! I am the original!' or 'No! I'm the real Angier!' As such, the mechanical process of the reproduction of self suggests that the distinction between inner and outer, original and copy, can no longer be relied upon as the demarcation of any sort of definitive difference. The machine perfectly duplicates the same content over and over again. There is nothing about that which is reproduced that resists reproduction. In other words, there is no transcendent 'essence' that somehow defers the process of its unfolding and reproduction. In this sense, the work of the machine shows us that there is *only* either inside or outside, self or other, originals or copies. All we are presented with in the film is the immanence of reproduction, which in turn is used as a means of obscuring the fact there is no dialectic of inside or outside. It is on the axiom of this tension that the illusion functions, namely, the products of the machine that demystifies 'the soul' through reproduction are simultaneously used to mystify the onlooker. The goal is to make one believe that the world is not simple, not 'miserable' or 'solid all the way through', but unpredictable, mysterious and magical in some way. In this sense, the machine is an apparatus that simultaneously demystifies and mystifies the self. It writes and it erases the self at once. It reproduces and destroys the self simultaneously.

What the supposedly first double would have said, again, is a mystery. What is not a mystery, however, is the Angiers' treatment of the superfluity of self that Tesla's machine allows. From the supposed first instance, we are shown that the Angiers treat their doubles as expendable, as if they hold themselves in contempt; a contempt that, through the means of the double, can be *acted* out and *re-enacted* in a way that allows the Angiers to literally punish themselves in their iterations. In essence, this recurrent and reproducible self-contempt is predicated on the death of a deferred Angier's wife. As such, illusion represents a way for all the Angiers to perform numerous real acts of ritual suicide disguised as the performance of an illusion which, in turn, transform his run of 'The Real Transported Man' into a series of acts of penance for their wife. There is nothing illusory about their suicide(s), which we are told will occur at least one hundred times.[16] Despite the possibility of the infinite reproducibility of

self through the work of the machine, we are shown that the machine, and the illusion it sustains, cannot offer the Angiers any solace from their pain. We see that every iteration of Angier 'senses an inexplicable void, stemming from the fact that he has been volitized, stripped of his reality, his life, his voice' (Benjamin 2010: 1060). The machine, and the doubles it produces and reproduces, alienates that which is being reproduced from itself. Angier is shown to lose his sense of self. He does not know whether he is to be the drowned man in the box, or the man on stage. The illusion and the apparatus needed to execute it defer a moment of contact, an encounter with himself while simultaneously proliferating himself, surrounding himself with himself, diffusing himself through various iterations of his self. He becomes lost to himself. What is not lost, however, the remainder that is carried over *through* and *throughout* an undisclosed number of repetitions of himselves, is the memory of the face of his drowned wife, swaying silently in a tank of water. As such, the mechanical work of self-reproduction does not erase memory, pain or anguish. It does the opposite: it reproduces these traumas.

The double is a device that intimates the possibility of some kind of existential cleansing through the reproduction of self, with the tacit suggestion that the double(s) of oneself can potentially be or become better than that from which they were copied. The possibility of self-completion or self-perfection intimated by the work of the machine is always-already deferred by the fact that the mechanical process of self-reproduction allows for any object, including a man, to be reproduced seemingly *ad infinitum*. We must keep in mind that the machine and its work does not produce heterogeneous abstractions, but rather reproduces concrete homologues. The mechanical process of reproduction of self does not produce anything new. As such, the machine is not a hermeneutical or exegetical apparatus that interprets that which is placed within it and subsequently creates something other than what it scans. The machine manufactures or creates, but is not inventive or creative. The machine's logic of reproduction is inextricable from the content of object of reproduction, namely, the self. Just before that Angier is shot and killed by *a* Borden at the end of the film, Cutter asks that Angier to consider his achievement. However, in terms of creating something new that is no longer bound to the history of that from which it was doubled, the machine achieves nothing. As such, whatever victory the Angiers can claim over the Bordens, that victory is shown to be Pyrrhic.[17]

An Angier's final monologue puts forward what would appear to be their views on the 'true' nature of magic. This Angier suggests that an illusion offers whoever so believes or allows themselves to believe in it the ability to escape themselves and the conditions of existence imposed on them as a singular subject. When this Angier confronts and is shot by *a* Borden in the basement of their abandoned theatre, he states:

> You never understood, did you? Why we did this? The audience knows the truth – that the world is simple. Miserable. Solid all the way through. But if you could fool them, even for a second, you could make them wonder. Then you got to see something very special … It was the look on their faces.

While *a* Borden states that the true nature of magic is the illusionist's total dedication to the craft at the beginning of the film, this Angier's dying statement would suggest that he views magic and illusion as a means of existential escapology. But, however noble and selfless this sentiment may appear, it is not coextensive with the views and actions of 'Robert Angier' throughout the film. Not only do the Angiers use an illusion to condemn an innocent man (innocent of the charge of murdering an Angier, at least) to the noose and orphaning an innocent child in the process, the Angiers are shown to care about little but the illusion itself. This can be noted in Angier's ruthless use of Olivia, his lover, as an agent of infiltration and subterfuge against the Bordens, disregarding the authenticity of her feelings for both himself and the Bordens in the process. But most antithetical to the selfless sentiment of that Angier's final monologue is his declaration that he does not care about his wife and that he cares only for the discovery of Borden's method for 'The Transported Man'.

It is not enough for Angier to have achieved a performance of 'The Transported Man' that outshines the Bordens' original. It is not enough for him to have the love of a woman and success as the best stage act of any kind in London. It is not enough for Angier to take his bows below stage. In this way we see that that Angier's view of the 'true' nature of magic is more accurately that everything and everyone is expendable in the pursuit not only of the best illusion, but the *prestige* of that illusion; that 'no one cares about the man who disappears, the man who goes into the box; they care about the man who comes out the other side'. In this sense, the film suggests that the machine's work cannot diffuse either memory or desire and that the agony of both are recurrent in any and all iterations of oneself, no matter the number.

That said, however, the diction of *that* Angier's final monologue suggests that magic is potentially utopian. The idea that through illusion, one can make people believe that an emptying not only of the rigours and oppressions of identity and the socio-economic and existential conditions of that identity is possible, but that this also allows one to be able to perform feats that people take to be supernatural, that rupture the privileging of logocentric approaches to experienced phenomena; stealing, tricking, re-introducing, re-directing the gaze away from the empirical and toward the mysterious, is a utopian idea. The dialetheism[18] of being myriad suggests that in being many, one is and one is not one's self, that one can and cannot be other to one's self.

The most far-reaching consequences of the mechanical work are spatial and temporal in nature. The consequences are spatial in the sense that being is no longer limited to a singular space or a singular route through space; temporal, in the sense that to be myriad is to be in multiple times. The mechanical work allows for multiple paths, however complex, to be walked by multiple selves at the same time. In other words, the doubles of some diffused original Angiers are superficially identical to him, but they are, temporally speaking, younger than he is. In this sense, the Angiers exist at once at the same and different times. Their appearance would suggest that they have been all subject to the same amount of time. But *technically*, they are, regardless of how close together the moment of their reproduction, from *different* times. The utopian potential for an individual to renegotiate the dynamics of power between them and the conditions of their existence through the mechanical reproduction of self are far

reaching. For example, one's doubles can decide to eschew an ideal self, forget the concept of an original, or choose to function as a cabal of selves, diffused throughout society tactically and carefully collecting and collating data. They could steal, serve, sabotage, assassinate, teach, proselytise, invent, build or conquer. They could distribute themselves throughout as many social strata and apparatuses as possible, to be agents of affect and observation of various socio-economic and political relations in a way that would make one of them appear omniscient or precognitive. But this particular use of the mechanical work does not necessarily have to be reduced to capital. Regardless of how it is used, the mechanical work facilitates a new kind of being, one that is no longer limited to a single self.

*On the Metaphysics of the Mechanical Work of Self Reproduction*

By its very definition, the metaphysics of the double sketched out below 'is not an exact science' (see Nolan and Nolan 2006: 89). In the film, Tesla is shown to build a machine for 'Robert Angier'. Tesla had, at some undisclosed point, built a similar machine for another magician, but the machine Tesla builds for Angier is the only example of a mechanical apparatus built by Tesla used specifically for illusions that the audience is shown. The audience is shown this machine, with its spectacular sparks, currents and sheer voltage and the wonder and terror it evokes. This machine, however, is essentially a machine that reproduces matter. We are shown that the machine is not ontologically or empirically biased in that it does not discriminate or privilege any matter placed therein – be it a hat, a cat or a man. The machine reproduces what appears to be a perfect copy that is totally indistinguishable, doubles of that matter placed therein. As such, everything – thoughts, feelings, memories and desire – becomes subject to the mechanical process of reproduction in the machine. While the machine creates a potentially endless chain of doubles, which it makes appear one after the other, it simultaneously undoes the concept of a source. As such, the machine functions through the manipulation of presence and representation. The doubles produced by the machine are instruments in an illusion that troubles the distinction between representation and presence because they facilitate a fundamentally paradoxical process: a *present* double stands for something singular and unified while simultaneously being a *representation* of that thing while also *being* that thing it represents. As such, the double is also a kind of *supplement* in the same way that in French, *supplément* means both 'addition' as well as 'substitute'; the double 'intervenes or insinuates itself *in-the-place-of* and if it fills, it is as if the continual reproduction of self, while resulting in more selves, voids the sense of uniqueness of that which is reproduced (Derrida 1997: 146). The machine therefore does not allow any sense of relief whereby the object that it reduplicates is taken over or replaced by its double because the double, though spacio-temporally distinct from that which it was doubled from, carries the same content as that from which it was doubled. In this sense, this voiding of the concept of a singular self is 'filled up *of itself* and can accomplish itself, only by allowing itself to be filled through [its doubles]' (ibid.). The double is the sign of its own supplementation: it both is and is not the self.

We should be careful of thinking of the double as a sign of the thing itself, namely a unified and singular subject. The double is a supplement of the absence of a subject that can no longer be encountered in any singular way, a subject that is delayed and deferred through the mechanical process of its doubling. The doubles are thus self-sufficient, as well as self-supplementary. As such, after the work of the machine is initiated, identity, personhood, life and love are all splintered. The only thing that can be encountered is the trace of diffused essence through the *performance* of a self.

*Conclusion*

Both the Fraternal and Simulacral readings, as well as the importance of the mechanical work of the machine, suggests that the perfect trick can only be achieved through both the figurative and literal sacrifice of the self through the mechanical process of self-reproduction (see also McGowan 2012). The mechanical process of self-reproduction is to take something ordinary and make it do something extraordinary by doubling it. In being doubles, as is the case of the hat and the cat, or doubling itself, as is the case with the Bordens and the Angiers, the double violates both the laws of space and time. However, the mechanical work of self-reproduction is also a process wherein the extraordinary is reversed back into the ordinary. What is actually occurring in the movement between the antipodes of extraordinary and ordinary is subtle. On the one hand, nothing has happened. There are many moments throughout the film where the viewer is led to believe that nothing at all has occurred. No matter how many times the machine works on the matter placed therein, the cat doesn't move, the hat doesn't move. On the other hand, something remarkable has occurred. The machine has redefined identity in that *identity*[19] can be turned into identities, an infinite amount of them. In this way the idea of the remarkable and the unremarkable are mediated and troubled by a truly remarkable device. It's the device that is remarkable, one that produces something simultaneously ordinary and extraordinary.

While the film posits that the work of mechanical reproduction of self can allow for one to transcend him or herself not just as a subject but also as a singular entity, the viewer's attempt to decipher the enigma, to demystify the illusion is a will to discover or encounter the subject delayed by the illusion being performed. However, Nolan's use of the double suggests that the subject construed in any unitary, authentic or essential way is infinitely delayed or displaced. The double upsets the expectation of encountering the secret whereby the work of the double is to evaporate it. In this way, *The Prestige* defers a definition, a taxonomy and the authority of an agreed upon identity within a series of an undisclosed number of doubles that are produced and reproduced by what appears to be magic. What is the effect? The effect is to trouble expectation and make the audience wonder; an audience whose daily experience reiterates that 'the world is simple. Miserable. Solid all the way through.'

1   Monozygotic twins or 'identical twins' refers to two offspring produced in the same pregnancy that develop from a single fertilised oocyte, which subsequently divides into two separate embryos.

2   In the subsection titled 'The Divine Irreference of Images' in *Simulacra and Simulation*, Jean Baudrillard states that 'to dissimulate is to feign not to have what one has. To simulate is to feign to have what one hasn't. One implies a presence, the other an absence [...] feigning or dissimulating leaves the reality principle intact: the difference is always clear, it is only masked; whereas simulation threatens the difference between "true" and "false". Between "real" and "imaginary"' (2010: 1558). I draw attention to this definition of dissimulation and simulation because it foregrounds the analysis of Nolan's use of the double, both as a device of dissimulation and simulation, in a way that ruptures the presence/absence dyad. When Borden and Fallon are on screen at the same time for instance, the fact that they are doubles of each other feigning to be distinct individuals troubles a definitive distinction regarding their presence or absence. In a direct sense, they are both present and absent from one another by way of being doubles of one another that are simultaneously feigning to be distinct from one another in their simulation of the lives of Borden and Fallon. The fact that they are doubles of one another, who use the multiplicity and confusion of the double to propel and sustain an illusion, obfuscates any principle of reality that can be definitively referred to distinguish which of them is the 'real' Borden, or the 'real' Fallon, or their lives/performances as 'real' or 'imaginary'.

3   *Doppelgänger* – whose literal translation from the German is 'double-goer' – refers to the supernatural or paranormal double of a living human being (see Miller 1985: 21).

4   Bilocation refers to the psychic or miraculous ability of a person or object to exist, or appear to exist, in two discrete locations at once. Bilocation is often associated with witchcraft, shamanism, paganism, folklore, the paranormal, Theosophy and secular and religious mysticism. My use of the term gestures to the magical (that is in the performance of magic) efficacy of showing an audience one's ability to be bilocated and, further, that the ability to bilocate forms the hypostatic theme of the film: from the Angiers' and the Bordens' rivalry regarding the best execution and version of 'The Transported Man', to the complex psycho-emotional dealings between their wives, friends, mistresses, all of which they share with themselves and each other. The seemingly miraculous phenomena of bilocation also reflects the idea of what I call the mechanical simultaneity of self, which describes not only the logic and telos of the Angiers' and the Bordens' versions of 'The Transported Man', but also describes the function of Tesla's machine upon them (see Alverado 2005; and Bozzano 1911, 1937 for detailed discussion of bilocation).

5   *Vardøger* refers to a spirit ancestor of Scandinavian folklore whereby a double of a subject precedes said subject, taking on either a specific aspect – be it the manner or voice of the subject – in either a specific location or activity (see Leiter

2002). I use the term to refer to the idea of a simulation of reality that precedes the reality it simulates. In a real sense, the work of the double in *The Prestige*, the being of Angier's and Borden's doubles comes to precede whatever reality from which they were originally copied, which is itself made inaccessible by the being of the doubles themselves. Notice how, in the Angiers' case, their being, after the constant mechanical reproduction of self, is completely different from their being after it is copied. They start a completely new life as Lord Caldlow; one without Cutter or Olivia or even 'Angier'. As such, the constant reproduction of self retains only the physical form, impression, or edifice of the self, and evacuates, supplements, replaces, usurps, and/or precedes the body of its original reality. This is equally true of the Bordens', though it manifests in a more radical manner. While the Angiers' illustrate the paradoxical process of self-erasure through the reproduction of self, the audience has no reliable reference of the Bordens' pre-history or life before they join Cutter's company. Cutter makes a note of this at the beginning of the film when Angier asks Cutter where Borden is from, a question Cutter either can't answer or chooses not to. This sense of pervasive uncertainty suggests that the entire reference of the Bordens' pre-history is erased, evacuated, replaced, usurped and supplemented by their dedication to illusion which, taken to the extreme as it is in their case, manifests as the necessary simulation of a real life they no longer have; a life trapped in the atmosphere of illusion that is at once free from any and all referential links to a life outside of illusion. As such, the paradoxical logic of the *Vardøger* is comparable to the paradoxical logic of simulation as described by Baudrillard in 'Precession of Simulacra' in *Simulation and Simulacra* (2010: 1556–8).

6    *Etiäinen* refers to a spirit sent into the world, typically by a shaman, to receive certain information. I use the term to evoke the sense that the Angiers' can be thought of as *Etiäinen* of themselves, sending themselves out into the world to discover the Bordens' secret of 'The Transported Man' at the cost of their lives – their relationships, their memories, their wealth, their bodies and their peace of mind – and any chance of a life outside that illusion (see Eliade 1963).

7    Cutter describes the logic of illusion as follows: 'Every great magic trick consists of three parts or acts. The first part is called 'The Pledge'. The magician shows you something ordinary: a deck of cards, a bird or a man. He shows you this object. Perhaps he asks you to inspect it to see if it is indeed real, unaltered, normal. But of course … it probably isn't. The second act is called 'The Turn'. The magician takes the ordinary something and makes it do something extraordinary. Now you're looking for the secret … but you won't find it, because of course you're not really looking. You don't really want to know. You want to be fooled. But you wouldn't clap yet. Because making something disappear isn't enough; you have to bring it back. That's why every magic trick has a third act, the hardest part, the part we call 'The Prestige'.

8    Ann Heilmann and Rachel Joseph discuss the relationship between pleasure and terror (see Heilmann 2009/10; Joseph 2011).

9   In the film, an *ingénieur* is described as an individual who designs illusions and constructs the apparatus necessary for performing them.

10  The troubling of identity in *The Prestige* is resolutely maintained in that the Borden seen at the conclusion of the film neither confirms nor denies that Angier's assumption that the Bordens were in fact twins is accurate.

11  That is, how Angier is able to disappear beneath a trap door and emerge fifty yards away from the stage in the space of a second.

12  Genetico-graphical refers to Jacques Derrida's discussion of Sigmund Freud's analysis of the 'Mystic Writing-Pad'. For Freud, the Mystical Writing-Pad is used as a metaphor that describes the perceptual and recollective apparatus of the human mind as a type of palimpsest that is affected by two hands, where one uses a stylus to make impressions upon a transparent sheet fixed on top of another sheet of wax paper which in turn sits on top of a wax slab. The impressions appear as dark writing on the wax or celluloid slab. These impressions are both imperfect and impermanent in the sense that the other hand may simply raise the double covering-sheet from the wax slab with a pull and, once returned to a resting position on the wax slab, erases any former impressions made. This processes of impermanent impression, erasure and non-recollection can be repeated *ad infinitum*. As such, Freud uses the Mystic Writing-Pad as a metaphor that describes the human mind's processes of recollection. He imagines that 'one hand' imperfectly inscribes or scratches various experienced phenomena upon the mind while the 'other hand' erases or obfuscates the perception and recollection (memory) of said phenomena (see Freud 2008). In this sense, the perceptional apparatus of the mind as a Mystic Writing-Pad is a metaphor that describes the mind as a device or apparatus of imperfect creation, copy, erasure/destruction and illusion/misperception/distortion in a similar way that I describe the functioning of Tesla's machine. It is important to emphasise that Derrida's discussion of Freud's metaphor of the Mystic Writing-Pad stresses the point that the mind's perceptual process of writing with two hands – the one inscribing, the other erasing – gestures to, directly and indirectly, the concepts of the plurality, doubling and mechanical reproduction of self. My use of the term refers to Tesla's machine and its products as repetitive impressions, with a particular emphasis on Derrida's description of the machine of human perception as one governed by a dual process that proceeds from a movement of multiplicity, inscription, copy and erasure. As such, the term 'genetico-graphical' expands the perceptual process described by the Freudian metaphor of the Mystic Writing-Pad to include the human body as the support or surface upon which it acts (see Derrida 2005).

13  Logocentrism here refers to a tendency in some methods of literary analysis to privilege words and language itself as a fundamental expression of external reality (see Derrida 1997 for an in-depth discussion).

14  For further discussions of the concept of the self, see Deleuze and Guattari (1972, 1983). They radically reassess the idea of self through post-indentarian concepts such as the Rhizome, Difference and the BwO ('Body Without Organs'). Baudrillard (2010) discusses reality, symbols, imitation, copies and originals in *Simulacra*

*and Simulation* and offers insightful ways of interrogating the complexities of the relationship(s) between the Bordens and the Angiers. Bruce Hood (2013) offers a contemporary psychological way of examining the relationship between cognition and society in the creation, maintenance and reproduction of what he states is the illusion of the self and selfhood.

15 Hyperreal refers to Baudrillard's description of the state of consciousness in technologically advanced postmodern society whereby consciousness is unable to distinguish reality from a simulation of reality, making the demarcation of 'real' and 'fictive' complex, if not impossible. Unlike the Bordens, whose number remains indistinct, I describe the Angiers' as hypperreal because the viewer is told that based on their hundred-show run, there could have been at least one hundred Angier duplicates made. One of the underlying principles of hyperreality is a hyper-saturation of images, copies of images, or signs that seemingly obfuscate the link between signifiers and referents. This means that hyppereality can be described as an irreferential play of hyper-saturated signs, or a simulation of a reality that can't refer to anything outside itself. I argue that this perfectly describes not only the Angiers, but the underlying theoretical foundations of Tesla's machine. The more copies the Angiers' make of themselves, the more the reality of whatever life they once had is paradoxically and simultaneously repeated and erased in the Angiers' hyperreality of self. The more copies they make, the less real they become. This can be noted when the viewer sees an Angier being declared dead in a plot to frame *a* Borden of murder that leads to the real death of *a* Borden, as a result. Further-more, an Angier begins living as one Lord Cadlow, a completely different identity, self, environment, accent and manner that suggests that the hyperreality of self, (re)produced by the mechanical process of doubling by Tesla's machine, makes all realities preceding the reality of the double inaccessible (or only accessible through the trauma of memory). In this sense, Tesla's machine, as a device of the hyper-sat-uration of self, brings the Angiers' into the order of the hyperreal and simulation. This hyperreality is instrumental in Angier's execution of 'The Transported Man' because in becoming hyperreal through hyper-saturation of self, it is no longer a matter of showing their audience a false representation of reality, as is the typical logic of illusion or stage magic. It is rather a question of showing the audience the amazing truth that through the mechanical reproduction of self, 'man's reach has exceeded his imagination'. The irony of 'The *Real* Transported Man' inheres in the fact that the man being transported is neither real nor being transported at all. Through the sparks and wires of 'The Real Transported Man', the Angiers' literally show the audience a suicide, a concurrent reproduction of both life and death, or in other words, immortality (see Baudrillard (2010: 1564–6).

16 While the film deftly employs misdirection and revelations to problematise the viewer's expectations, it is important to keep in mind, however, that the Angiers' doubles actually drown. In this way, 'The Real Transported Man' involves *real* death.

17  Pyrrhic or 'Pyrrhic victory' here refers to the attainment of a goal or result at the expense of devastating costs that negates any sense of gain or achievement, making said victory equatable with defeat.

18  Dialetheism refers to the view that certain statements may be simultaneously true and false in the sense that the negation of a true statement, if it is dialetheic, will also be true. My use of the term bares no relation to formal logic in any sense, but rather in reference to the multiplicity, true copy and simultaneity of being in relation to the concept of truth and illusion in the film (see Sainsbury 2009: 150).

19  Here, I capitalise the letter 'I' in 'identity' to draw attention to the idea of an original 'Identity' and its derivative 'identities.'

*Bibliography*

Alvarado, Carlos S. (2005) 'Ernesto Bozzano on the Phenomena of Bilocation', *Journal of Near-Death Studies*, 23, 207–38.

Baudrillard, Jean (2010 [1981]) *Simulacra and Simulation*, trans. Shelia Faria Glaser. Ann Arbor, MI: University of Michigan Press.

Benjamin, Walter (2010 [1936]) 'The Work of Art in the Age of Its Technological Reproducibility', in Vincent B. Leitch (ed.) *The Norton Anthology of Theory and Criticism: 2nd Edition*. New York: W. W. Norton, 1051–72.

Bodnar, Christopher (2003) 'The Database, Logic, and Suffering: *Memento* and Random-Access Information Aesthetics', *Film-Philosophy*, 7, 10. Online. Available: http://www.film-philosophy.com/vol7–2003/n10bodnar (accessed 26 February 2015).

Bordwell David with Kristin Thompson (2013) *Christopher Nolan: A Labyrinth of Linkages*. Madison, WS: Irvington Way Institute Press.

Botez, Catalina (2015) 'Skin-Deep Memos as Prosthetic Memory in Christopher Nolan's *Memento* (2000)' in Caroline Rosenthal and Dirk Vanderbeke (ed.) *Probing the Skin: Cultural Representation of Our Contact Zone*. Newcastle: Cambridge Scholars Publishing, 312–34.

Botz-Bornstein, Thorsten (ed.) (2011) *Inception and Philosophy: Ideas to Die For*. Chicago: Open Court.

Bozzano, E (1911) 'Considerations et hypothéses sur les phénomènes de "bilocation"' ['Considerations and hypotheses about the phenomena of "bilocation"'], *Annales des Sciences Psychiques*, 21, 65–72, 109–16, 143–52 and 166–72.

_____ (1937 [1934]) *Les phénomènes de bilocation* [The phenomenon of Bilocation], trans. G Gobron. Paris: Jean Meyer.

Buckland, Warren (2014) *Hollywood Puzzle Films*. New York: Routledge.

Clarke, Melissa (2002) 'The Space-Time Image: the Case of Bergson, Deleuze, and Memento', *The Journal of Speculative Philosophy*, 16, 3, 167–81.

Davies, Rodney (1998) *Doubles: The Enigma of the Second Self*. London: Robert Hale.

Deleuze, Gilles and Félix Guattari (1983) *Anti-Oedipus: Capitalism and Schizophrenia*, trans. Robert Hurley, Mark Seem and Helen R. Lane. Minneapolis, MN: University of Minnesota Press.

Derrida, Jacques (1997 [1967]) *Of Grammatology*, trans. Gayatri Chakravorty Spivak. Baltimore, MD: Johns Hopkins University Press.

___ (2005 [2001]) *Paper Machine*, trans. Rachel Bowlby. Stanford, CA: Stanford University Press.

Eliade, Mircea (1963) *Myth and Reality*, trans. W. Trask. New York: Harper and Row.

Elsaesser, Thomas (2009) 'The Mind-Game Film', in Warren Buckland (ed.) *Puzzle Films: Complex Storytelling in Contemporary Cinema*. Oxford: Wiley-Blackwell, 13–41.

Freud, Sigmund (2008 [1925]) 'A Note Upon the "Mystic Writing-Pad"', in *General Psychological Theory: Papers on Metapsychology-The Collected Papers of Sigmund Freud*. New York: Simon & Shuster, 211–17.

___ (2010 [1919]) 'The "Uncanny"', in Vincent B. Leitch (ed.) *The Norton Anthology of Theory and Criticism: 2nd Edition*. United States: W. W. Norton & Company, Inc.), 824–841.

Gargett, Adrian (2002) 'Nolan's *Memento*, Memory, and Recognition', *CLCWeb: Comparative Literature and Culture*, 4, 3. Online. Available: http://dx.doi.org/10.7771/1481–4374.1163 (accessed 26 February 2015).

Greenberg, Harvey (2009) '*Inception* and the Cinematic Depiction of Dreams', *PSYART:A Hyperlink Journal for the Psychological Study of the Arts*. Online. Available: http://www.psyartjournal.com/article/show/greenberg-inception_and_the_cinematic_depiction_of (accessed 24 February 2015).

Heilmann, Ann (2009/10) 'Doing It With Mirrors: Neo-Victorian Metatextual Magic in *Affinity*, *The Prestige* and *The Illusionist*', *Neo-Victorian Studies*, 2, 2, 18–42.

Hood, Bruce (2013) *The Self Illusion: Why There Is No 'You' Inside Your Head*. London: Constable.

Joseph, Rachel (2011) 'Disappearing in Plain Sight: The Magic Trick and the Missed Event', *Octopus: A Visual Studies Journal*, 5, 1–14.

Joy, Stuart (2013) 'Revisiting the Scene of the Crime: *Insomnia* and the Return of the Repressed', *Kaleidoscope*, 5, 2, 61–78.

___ (2014) 'Looking for the Secret: Death and Desire in *The Prestige*', *PSYART: A Hyperlink Journal for the Psychological Study of the Arts*. Online. Available: http://www.psyartjournal.com/article/show/joy-looking_for_the_secret_death_and_desire (accessed 23 February 2015).

Kooijman, Jaap, Patricia Pisters and Wanda Strauven (eds) (2008) *Mind the Screen: Media Concepts According to Thomas Elsaesser*. Amsterdam: Amsterdam University Press.

Lacan, Jacques (2010) 'The Mirror Stage as Formative of the Function of the I as Revealed in Psychanalytic Experience', in Vincent B. Leitch (ed.) *The Norton Anthology of Theory and Criticism*, second edition. New York: W. W. Norton, 1163–9).

Leiter, L. David (2002) 'The Vardøgr, Perhaps Another Indicator of the Non-Locality of Consciousness', *Journal of Scientific Exploration*, 16, 4, 621–34.

McGowen, Todd (2007) 'The Violence of Creation in The Prestige', *Žižek and Cinema: International Journal of Žižek Studies*, 1, 3. Online. Available: http://www.

zizekstudies.org/index.php/ijzs/article/viewFile/58/120  (accessed 19 February 2015)

____ (2012) *The Fictional Christopher Nolan*. Austin, TX: University of Texas Press.

Miller, Karl (1985) *Doubles: Studies in Literary History*. Oxford: Oxford University Press.

Nolan, Christopher and Jonathan Nolan (2006) *The Presige: Screenplay*. London: Faber & Faber.

Pisters, Patricia (2012) *The Neuro-Image: A Deleuzian Film-Philosophy of Digital Screen Culture*. Stanford, CA: Stanford University Press.

Pyysiäinen, Ikka (2009) *Supernatural Agents: Why We Believe in Souls, Gods, & Buddhas*. Oxford: Oxford University Press.

Sainsbury, R. M. (2009) *Paradoxes*. Cambridge: Cambridge University Press.

Shiloh, Ilana (2007) 'Adaptation, Intertextuality, and the Endless Deferral of Meaning: *Memento*', *M/C Journal*, 10, 2. Online. Available: http://journal.media-culture.org.au/0705/08-shiloh.php (accessed 26 February 2015).

CHAPTER FIFTEEN

# No End in Sight: The Existential Temporality of Following

## Erin Kealey

In Christopher Nolan's first feature film, *Following* (1998), a Young Man (Jeremy Theobald) tells a police detective (John Nolan) about his habit of following others. All that remains by the end of his account of recent events is a shoebox full of evidence to implicate him in crimes that culminate in murder and the ghostly disappearance of the dark-suited man who framed him into the hustling crowd from which he first emerged. The Young Man (hereafter, 'YM') forsakes his own identity for the anonymity of a mere shadow.[1] YM relinquishes his life to the suggestions and expectations of others, and this situation opens the possibility for him to be manipulated and shaped into someone else. Nolan provides a cinematic vision of inauthenticity in the story and narrative structure of *Following*. YM's anonymous existence is not grounded in his own identity, and his ensuing superficial understanding stifles his capacity to see how his story ends. Ultimately, because of his choice to follow others, YM condemns himself to an ending that belongs to the life he leads, even though it is fabricated by others and unforeseeable to him as he steps into a preconceived role in someone else's devious plan.

YM's circumstances in *Following* can be elucidated by a temporal theory of existence put forth by Martin Heidegger as he explores the human condition, expressed as *Dasein* (literally 'there-being'), a fundamentally situated existence (thus the 'there') usually concerned with environmental things and people but often overlooking itself. In *Being and Time* (originally published in 1927), Heidegger examines various elements of human concern, and the second division hones in on the temporal nature of existence and self-identity, along with the peculiarly indeterminate certainty of death, which intrudes on everyday life (1962: 52, 302/H258). An authentic temporal existence accepts death as each individual's 'ownmost potential', since it cannot be separated from the ongoing experiences that lead to it and it is essentially distinct from external influences and social expectations. Death is not merely the end of mortal life, but a singular, non-relational, yet indeterminate event toward which each individual

is thrown. Death is significant throughout life because it is the anticipated end toward which choices become meaningful through the urgency of finitude. Similarly, specific scenes in a film are more meaningful when viewers anticipate where the story is going, and watching a movie again allows the recognition of details and interrelations that initially may have been overlooked. Moreover, a good ending in film need not be 'happy' or what was expected, but should be fitting to each of the characters and the scenes to which they contribute.

The anticipation of death as one's ultimate possibility provides the most concrete means to recognise individuality. However, most people avoid their own potential self-hood for the security offered by a more impersonal identity, such as the indistinct roles set forth for members of society or family which abide by conventional routines and behaviour. Although it is easy to fall into the guise of such a disburdened existence, it merely fabricates a barrier to escape the 'sober anxiety' of individuality.[2] YM shows the extreme consequences of this condition as he reaches the limit of the existence established by following others: instead of charting his own course, YM gives himself over to become the kind of criminal that matches a series of burglaries and murders for which he can be framed. Heidegger proposes that some overlapping foundation of the past toward a culmination in the future is required for the possibility of an authentic selfhood, all of which form a temporal horizon. But YM has no view of his story as a whole, so his temporal existence is inauthentic (or not his own). Further, Nolan's narrative structure in *Following* indicates his protagonist's inauthenticity as he develops three distinct timelines and cuts through them in their respective orders as they each progress forward, bookended by YM's account of events. Nolan shuffles through the three timelines to portray segments of YM's recent activities, and they are distinguishable by YM's appearances: first unshaven with long greasy hair, then clean-shaven with short hair, and finally with a bruised face. The timelines build into YM's self-disclosure of his inauthentic situation toward a future state of demise that he cannot foresee; as such, the climax of the film provides an ending for the audience, but not one that YM understands until it is too late. YM attaches himself to a dark-suited man called Cobb (Alex Haw) and an unnamed blonde woman (Lucy Russell) and takes up their suggestions and coercions as his own ideas. Even before his police confession, the boredom and loneliness that lead him to follow other people establish his doom. Heidegger might say that YM is a paradigm of everyday human existence: an essentially outstanding individual with the potential to live his own life, but who instead flees from the opportunity to take up that singular responsibility. Instead, YM gets wrapped up in the immediacy of superficial interests and external forces while he remains blind to his own individual existence.

Nolan provides an important temporal summary in YM's initial description of following: the compulsion to follow people feeds his curiosity to find out 'what they do, where they come from, where they go to'. He basically wonders about their present, past and future involvements; and this same temporal structure can serve as a guide through a Heideggerian interpretation of *Following*. YM's inauthentic existence manifests in different ways for each of the aspects of temporality: he has no concrete identity of his own in the present, he conceals meaningful connections to things and

people from his past and he awaits some actual outcome to be given to him instead of choosing and anticipating his own possible future. As for the important concept of death, a story can end in many possible ways, but the ending that belongs to the character has to do with individual ownership and responsibility. Nolan's staggered timelines establish three mini-endings for each physical appearance of YM, but his ultimate end is determined by the choices he makes and who he allows to guide his decisions. So, where should an analysis of YM's ending begin? No time to start like the present.

*No Context for the Present, No Concrete Identity*

A vision of the whole story exposes the relationship between all the interconnected elements within it, and this enlivens the sequence of present moments into meaningful parts. In conventional storytelling, the ending often brings to light all the subtle twists and turns that the audience has seen and provides the context that makes each scene significant to the story as a unified totality, but this is not merely a causal chain of events. Heidegger thinks that it takes more than a mere sequence of experiential 'nows' to establish a meaningful identity (1962: 81, esp. 477/H425). Similarly, Nolan structures *Following* in a way that is 'anecdotal' rather than 'chronological' (2001b: 97). Each scene becomes more like a piece of a jigsaw puzzle connected to various other pieces: remove any one and the surrounding others lose their context. Each scene, then, serves to connect the chronological scenes in the story, but also has an anecdotal relation to juxtaposed scenes from the intercut timelines. At any moment, the anticipated ending unifies the scenes and gives meaning to the whole story. Yet, while each part of the intercut account provides forward- and backward-looking context for the whole, YM has no sight of its significance for his identity even as he tells the entire story as a flashback.[3]

YM hesitates when he delivers his explanation at the police station, as if he is unsure of where he stands in the story. He attempts to report Cobb's influential force on him, but he does not seem to have a concrete sense of selfhood distinct from Cobb or 'the Blonde'. When he meets Cobb, he says that his name is Bill, but he introduces himself to the Blonde by the name on a stolen credit card (Nolan 2001a: 18).[4] He is not employed, but acquiesces to the role of writer. His anonymity is even indicated by the screenplay: other than when he introduces himself to Cobb, the name Bill is in quotation marks in the scripted dialogue, while all of his lines are attributed to Young Man. For Heidegger, self-identity is wrapped up in the unification process of concerned temporality, but this is exactly what YM lacks as he continually tries to contextualise his present situation.

Conventional and routine behaviour is an aspect of inauthenticity and contributes to Cobb's ability to manipulate the predictable YM. However, according to José Ortega y Gasset, human beings have no given nature because there is no 'static form of being' that would suffice for a general definition (1975: 156). Unlike the stability of a stone in the field, which 'is given its existence', humans must devise a 'definite program or project of existence' to earn selfhood (1975: 153). The responsibility to determine an individual vocation can be so daunting that someone like YM allows

others to structure his life for him. Cobb does not see YM as anything more than a stone to be shaped and moved, and he indicates this in his description of YM to the Blonde. When she reports her surprise that YM broke his promise not to look in the envelope he steals for her, Cobb says: 'Nothing personal, he couldn't help it … he's a born peeper' (Nolan 2001a: 84). Cobb overlooks YM's humanity and sees him as a mere thing with a given nature that makes him predictable in a way that would be defied by authentic existence. Cobb also begins his statement with the idea that YM's actions are not personal, and this is a central trait of inauthentic existence. Nolan depicts numerous impersonal relationships in *Following*: above, as Cobb asserts YM's essential state, and also conveyed in the previous scene by the Blonde to YM as she reveals her conspiracy with Cobb.[5] Finally, while the Blonde believes her relationship with Cobb is special due to their shared manipulation of YM, Cobb intends to follow his orders to kill her and interrupts their casual conversation with the disinterested segue: 'Anyway, down to business' (ibid.). Nolan thus attributes an impersonal trait to all the major relationships in the film; and this may be acceptable for mere acquaintances, but authentic involvements should transcend such casual detachment.

Stylistically, Nolan guides the viewer through YM's story but does not provide a glimpse at any wider surroundings in which to understand him. While it may have stemmed from an economic limitation for the low-budget production, Nolan does not present any establishing shots in *Following*. Beyond production restrictions, their absence indicates that YM has no view of who he is at any given moment or how he fits in with his surroundings.[6] Traditionally, establishing shots situate the viewer in a common space of action for the characters and prompt reflective viewers to derive an idea of perspective and identity that comes from the environment. The closest Nolan comes to such an environmental view remains tied to YM: when Cobb brings YM to his hideout to discuss how to fence their stolen property, the camera shows the face of a building and then sweeps down to street level where Cobb and YM walk into the frame. A few cuts later, they enter the hideout and the camera tilts upward to show the height of the building. Even this view does not escape the confines of YM's existence because it only presents the exterior shell of what lies inside. Basically, it is the familiar glance of any random pedestrian who looks down the street before crossing and then up at the building about to be entered, so it adds nothing to a deeper understanding of the environment's contribution to YM's present situation. YM seems to know where he is going as he looks up at the building, but the content of the view is akin to stock-footage so it suggests that YM remains unaware of what this particular space reveals about his empty identity. The camera is bound to YM's perspective, so even the occasional shot that looks around merely captures YM's wandering circumspective involvement. In this way, the audience can witness the visual limits imposed on YM as he follows Cobb.

Nolan provides additional insight into YM's inauthenticity through subtle associations with other famous instances of public personas that diverge from the individuals who embody them. On the front door of his flat, YM has a sticker of the classic Batman insignia. During Nolan's later reinvention of the origin story in *Batman Begins* (2005), Bruce Wayne (Christian Bale) discloses his idea to develop a secret identity to

fight crime in Gotham. He seeks an example that will shake citizens from everyday apathy and yet will escape the frailness of being one privileged man in society. He wants to be a symbol, and so he creates the identity of an anonymous persona that can slip into the shadows of the city. YM, too, is an anonymous person, but he is not a symbolic hero who cannot be ignored or destroyed; rather, he remains an unidentifiable pawn available for sacrifice in Cobb's game.

YM also has a variety of media posted on his wall near the typewriter including a classic Marilyn Monroe head shot in which she gazes directly into the camera as if seducing every onlooker. As a cultural icon, she gave up her own private identity of Norma Jeane for the sex symbol persona of Marilyn. Also on the wall is a line of repetitive frames of Jack Nicholson from Stanley Kubrick's *The Shining* (1980) as he breaks through the door and announces his arrival with the familiar tag-line, 'Here's Johnny!' In that film, Jack Torrance (Nicholson) applies for a caretaker job and asserts, 'I'm your man' in his interview. In so doing, Jack hands himself over to the haunted persuasion of the Overlook Hotel and subsequently loses his sanity along with his identity. During a discussion of the set-up in *Following*, Cobb echoes such a transfer of identity possession as he assures the Blonde that YM has allowed himself to be 'our man' (2001a: 77).[7] The association of these images with YM suggests his lack of true identity, and further supports YM's blindness to his own situation as they are probably not intentionally exhibited. Indeed, this may be the closest YM comes to a display of his own 'unconscious collection' to illustrate his personality (Nolan 2001a: 24). Most people, though, have hidden boxes for that.

*No Significant Past, No Meaningful Attachments*

Unlike the impersonal identity in YM's inauthentic present, Cobb exposes a distinctly human trait of collecting various items throughout life which are 'more personal' than other valuables (2001a: 23). Cobb notes in passing that for men they usually are gathered in a shoebox, foreshadowing how he will plant evidence to frame YM (2001: 23, 87). The typical contents that Cobb describes are not valuables but little trinkets hidden away to provide nostalgic memories of special moments from the individual's past. In other words, the contents of the boxes represent the past that people carry along with them, and their secretive concealment implies their intimate nature. Consciously or not, an individual carries along the past so that it colours the vision of present involvements and future possibilities.[8] YM does not have any significant attachment to nostalgic items of his own past, so his ongoing present is uncoloured (a handy justification for the black and white production), and his unforeseeable future becomes available for others.

Without a contextual back-story, the viewers of *Following* remain unaware of YM's past and the extent of the isolation that led him to follow people. However, in an analysis of Nolan's first feature-length film, the audience can see glimpses of what inspired him to develop this particular character with such interesting narrative techniques. Like all filmmakers, Nolan's vision has been coloured by the past, and one influential film seems to be related to *Following* in both subject and style. In the 1966 classic,

*Seconds*, John Frankenheimer tells the story of Arthur Hamilton (John Randolph), an older man who has become bored with his daily life. The opening credits of the film roll on a sequence of extreme close-ups and hallucinogenic views of facial parts. An eye, a mouth, an ear and a nose all stretch and contort with intercuts to fearful glances. Much like Nolan's technique of introducing films with teasers for the plot, the story takes these body parts and shapes them into something different, something twisted.[9] The context of the body parts is eventually revealed: the company's clients undergo plastic surgery to create younger identities. A surgeon provides new beginnings for their second chances just as Cobb influences the physical transformations that distinguish YM in each of Nolan's timelines.[10]

*Seconds* presents the strange account of a corporation devoted to giving recommended customers a second chance at living out youthful aspirations. After the credit sequence, the story opens with the camera following Hamilton through Grand Central Station. Filmed in black and white, even though colour was a production option, it is 'photographed in a stark, distorted and mobile style' (Pratley 1998: 56). In this opening scene, the angle seems to be on the visual line of a briefcase, low in motion through the crowded concourse of Grand Central. This embedded perspective of the travels through the hustle of routine business life is similar to Nolan's hand-held documentation. The scene lacks a smooth trajectory and so disrupts the complacent ease that usually accompanies the view of steady tracking shots. In *Seconds*, Hamilton becomes Tony Wilson (Rock Hudson), and he gets company support in his new life, as long as the bills are paid and rules are followed. Wilson is told to forget his old life, but he cannot make his second chance work because he contacts his former wife to figure out why he was (and continues to be) unsatisfied. The Hamilton-past is something Wilson cannot escape as it shapes the way he sees the world and people in it.[11] However, while Frankenheimer's protagonist cannot escape his past, it seems that YM conceals his past as he sheds one identity for another with no personal loss. Without a significant impression of past identity, YM has no foundation for his present or future condition.

In another inauthentic orientation of a concealed past, Nolan explores the unique condition of Leonard Shelby (Guy Pearce) in *Memento* (2000). The film starts at a backward-running event, from and toward which the rest of the story divides into two timelines that circle toward each other, and various temporal leaps represent the situational limits of Leonard's perspective.[12] Leonard does not sink into an inescapable past like Wilson, but rather lacks awareness of his recent past and must rely on potentially faulty or misleading physical remnants such as notes, tattoos and photographs. Nolan's narrative explores Leonard's blindness to the past as *Memento* unfurls in reverse-chronology, and this creates a loop into a revealing backward-view. YM remains blind to the direction of his life, the fact that he is being used by Cobb, and the ulterior motives of the Blonde; but viewers witness the growing conspiracy as *Following* unfolds. In *Memento*, the audience experiences past events which Leonard will never remember since he has no access to the origins of his information. The dichotomy between the unknown past and an uncertain present in *Memento* falls more in line with Ortega's emphasis on history as the fixed line that grounds identity: past-lacking Leonard can

be manipulated easily, even by his own ultimate yet forgotten decision to take advantage of his condition and commit a vengeful murder.[13]

The spiraling dual-linear structure of *Memento* demonstrates the existential relevance of an individual's past to inform present choices and future possibilities; but it also enlivens Cobb's idea of concealment and display as 'flip sides of the same coin' (Nolan 2001a: 24).[14] Cobb proposes an 'early supper', and when YM begins to say that he cannot afford to go out to eat, Cobb slyly notes, 'It's covered' (2001a: 50). After their shared meal thus associated with concealment, Cobb then displays his intentions as he hands the stolen credit card to YM and announces, 'I'm not going to get caught' (2001a: 57). YM accepts this statement as confidence without considering how Cobb has already revealed his intention to evade capture and implied YM's role as the one who will be caught. Heidegger's analysis emphasises the equally fundamental importance of all three temporal positions; but true personal insight stems from understanding the futural aspect of the horizon for individual existence, and particularly one's own death. YM has no such insight into how he exists toward the ending: he does not realise that his new activities with Cobb further add to the way in which he takes his concrete existence for granted. This provides more depth to Cobb's assertion that breaking and entering shows victims 'what they usually take for granted' and forces them to remember 'what they had' (2001a: 24). Cobb breaks into YM's everyday life and steals it, taking advantage of the fact that YM does not question who he is or where he has been. YM notices only too late that he has falsely assumed his actions resulted from his own free choices. Rather than revealing his own identity, YM conceals Cobb's existence by becoming more and more like his advisor in crimes and appearance. YM hands himself over to Cobb and becomes the decoy necessary for Cobb to be able to disappear without getting caught.

### No Vision of the Future, No Anticipation of the Ending

YM's demise is firmly wrapped up in a lack of future-orientation through the three distinct timelines. When the end of each timeline is reached, it merely cycles back to the beginning of the next segment. As touchstone moments that mark transitions within the chronology of YM's account, the mini-endings do not represent meaningful disclosures. This inauthentic temporality stifles YM's ability to foresee his fate as he goes to the police and implicates himself in Cobb's crimes. Heidegger does not suggest that inauthentic existence leads to no future, rather the view of future possibilities is limited by concealment and forgetting; such is an existence that values only one side of Cobb's coin. YM's account begins at the ending manoeuvred by Cobb; so, as he tells his story, YM finds himself at various moments within a flashback that lacks a future beyond the police station since Cobb's existence is already covered.

Nolan provides viewers a glimpse of one of the mini-futures for YM during the opening teaser sequence. As YM voices his fascination for following others, he wonders 'what people do, where they come from, where they go to'. This brief litany addresses all three aspects of temporality, but at the moment of the future reference of where they are going, Nolan cuts to the beginning of timeline three as freshly-bruised YM coughs

up latex gloves. The juxtaposition of the voiceover and the image in this moment discloses YM's future of choking his way to consciousness, but it seems that he is not aware of the relation even as he gives his account. The audience thus glimpses the underlying connections that YM cannot see in his own situation. An authentic view of the future would anticipate such relations and see how apparently distinct events inform each other, but YM's inauthentic view waits for others to reveal the hidden order of things. Nolan demonstrates this temporal aspect of YM's life in the beginning of the film when clean-cut YM from the second timeline enters the opening sequence: he looks at the photos of the Blonde while awaiting her arrival. Waiting for or expecting some actual outcome is an inauthentic view of the future.[15]

Inauthentic temporality is usually characterised in a negative way: whatever choices were made in the past are no longer available as possibilities, and future possibilities appear as fixed states of being or events that are not-yet actualised facts. This is also the way viewers initially encounter Nolan's non-linear presentation: whenever a segment of the first timeline of greasy YM gets interrupted by the second, and with each cut from the second timeline of clean-cut YM to the third, viewers can fall into the habit of accepting the various timelines as actualities that can be expected to make sense once their remaining content is revealed. Such expectation of an ending that makes sense demonstrates the inauthentic view of death as 'something "actual"' (Heidegger 1962: 51, 297/H253). As in life, waiting for some expected ending of a film conceals the true character of unforeseen possibilities and cloaks the future in ambiguity; and this is how audiences can succumb to tricks within the narrative. Similarly, an anonymous YM can lose himself to the subtle machinations of someone like Cobb. YM characterises his possibilities in terms of not-yet actualities, and in fact secretly invites Cobb to fill his empty identity when he brings Cobb to his own flat under the semblance of breaking in to someone else's apartment. He wants Cobb to classify his existence based on his property and the actual conditions of the environment. When Cobb notices the ancient typewriter, YM asks: 'Do you think *he's* a writer?' to which Cobb scoffs: 'If he wanted to write he'd have a word processor. He doesn't want to write, he wants to be a writer – and that's two … completely different things' (Nolan 2001a: 38).[16] YM manifests the superficial involvement that Heidegger attributes to curiosity as inauthentic concern for the future.[17] While YM could write a story, he would rather identify himself in terms of the not-yet actual state of being a writer.

In a more environmental identification of YM's inauthenticity, Nolan extends the scene in Cobb's hideout to disclose a hidden detail of the scheme. When YM asks about the building, Cobb replies that it is one of many 'dead spaces' scattered around London. By breaking in and changing the locks, Cobb acquires a space to use for his temporary needs. YM emerges as a similar 'dead space', empty and available, just waiting to be given a purpose by someone. The Blonde sarcastically reports this to YM, who 'set [himself] up' to be framed by Cobb: days before the café meeting, Cobb noticed YM following him and recognised that YM was 'waiting to be drawn into it, used' (Nolan 2001a: 81). YM might consider his ending a not-yet actualised fact, but this is an inauthentic view of the end of life as the last of a chronological chain of events. Such a perspective keeps one's own end at a distance, as if it is some given event

detached from present concern because it is not yet an important actuality.[18] The end as the 'toward-which' in a life or a film grounds the significance of all the elements of the story; but as YM gives his account, he has no idea who he has become in the eyes of others or where his explanation leads him. An authentic existence would allow YM to be available for relationships and commitments based on his own individuality rather than falling into someone else's control. However, YM exists toward the end Cobb envisions for him. Ultimately, YM's inauthenticity does not mitigate his responsibility for the crimes he has committed, or even those for which he has been framed.

*No Authentic Temporal Horizon, No Excuse for Being Manipulated*

Heidegger confesses that his early investigation of *Dasein* in *Being and Time* is limited by an analysis that takes the form of a fixed-frame method: capture a moment of human existence and expose its significance to the investigation ... capture another moment, label, repeat. In *Memento* terminology, the investigation leads to a stack of Polaroids with brief notes on them but no crinkled map to arrange them in a totality to see how they fit together for a unified vision. An existence toward one's own ending shapes authentic selfhood before a chronological end is reached. But YM cannot anticipate his own possibilities because he is stuck waiting for actual answers to be revealed by others. An affirmation of death as one's own ultimate potential is not concerned with the factual details of some future physical demise (see Alweiss 2002: 126).[19] Rather, as that toward which an individual is moving, the certainty of the end intrudes on concerned temporality and gives meaningful context to each moment.[20] Basically, an authentic orientation in the present is like a big 'you are here' sign that maps the surrounding environment, exposes where an individual has been, and indicates the direction that individual is going toward a personally ultimate destination. This issue of establishing one's own situated place stems from the structural totality of concern, a structure that turns out to be 'ecstatic temporality' (Heidegger 1962: 65). Heidegger develops the Greek concept of *ecstasis* to capture the human condition of transcending (literally 'standing outside') familiar yet impersonal chronological accounts of existence (1962: 65, esp. 377/H329, n. 2). Like Nolan's narrative structure, the existential condition of human life is not merely sequential, but rather dynamic and fluid with an overlapping temporality that has profound and complex meaning.

So, Heidegger recognises that his analysis thus far has ignored this 'ongoingness' of human temporality. As he questions the status of his investigation, Heidegger asks: 'Have we not hitherto been constantly immobilizing *Dasein* in certain situations, while ... disregarding the fact that in living unto its days *Dasein stretches* itself *along* "temporally" in the sequence of those days?' (1962: 71, 423/H371). The unified meaning for any individual's life turns out to be stretched out on a horizon of possibilities, and each of the temporal ecstases (present, past and future orientations of existence) can affect each other as directions of concerned involvement which stand out from any one concrete experience. Every present moment is informed by past events and actions while also fused with future possibilities as the events toward which the present exists, just as Nolan weaves together distinct timelines to provide each moment with past and future

significance. Such an overlapping temporal existence is how outstanding human beings can transcend a merely chronological understanding of their own lives. Heidegger has thus worked through snapshots of inauthentic life, especially the deficient view established by an inauthentic temporal horizon, comparable to Leonard's limited Polaroid-documentation style of understanding in *Memento*. Similarly, the detached segmented timelines in *Following* allow YM to be framed in someone else's horizon: he does not see how the mini-climaxes in his story establish the ending toward which he lives. YM reveals his status as a follower, but he cannot see the relevance of his confession. He has lost himself even before entering the police station.

Authentic selfhood has a concerned involvement in the present, an acceptance of the limitations of the given past, and an understanding of the possibilities of the finite future. Further, an authentic awareness of his own possible end would release YM from his 'clinging engagement in' the activity of following and would reveal such an inauthentic project as 'illusory and destined to fail in the end' (Curtin 1976: 263, 264). However, YM does not establish an authentic vantage point on his own individual ground. Without an authentic temporal horizon to shape his experiences and unify a concrete selfhood, YM has no context to understand the whole of his identity, no meaningful attachments to things or people around him, and no foresight to guide his choices toward an ending appropriate to him alone. Ultimately, YM can be manipulated into changing his appearance and behaviour, and even implicating himself in a brutal murder, because he has no sight of his temporal horizon. His inauthentic view blinds him to the possible resolute existence available to the self-directed individual who understands the entailments of his actions and how he accounts for his life. Rather than making himself available for his own authentic selfhood, YM becomes an object of manipulation; but this does not strip YM of his responsibility. YM bears the burden of any consequences related to his inauthentic existence: as he mentions in the opening sequence, he was supposed to follow random subjects, but then he began to select whom to follow. He is aware that he has abandoned his own rules in favour of the guidance supplied by Cobb and the Blonde.

YM's opening voiceover also discloses how someone emerges as worthy of following: 'Your eyes pass over the crowd … and if you let them settle on a person, then that person becomes an individual… just… like… THAT' (Nolan 2001a: 4). Nolan cuts away from the crowd of people to bruised YM as he snaps his fingers. Here, a shock cut suggests that YM is the individual who emerges around whom the story revolves but, between the shots of the crowd and YM, Nolan inserts a medium shot of Cobb who looks directly at the camera for a split second as the 'that' and the sound of the snap take viewers to YM's confession. This links Cobb to YM's apparent individuality and reveals that they are inexorably connected in the story. The return to the confession segment at the end of the film also unites Cobb to YM as the detective claims no knowledge of 'this… "Cobb" of yours' (2001a: 84).[21] By the end of the account, Cobb and his crimes belong to YM; yet even when confronted with the shoebox full of evidence reportedly found in his flat, YM continues to assert Cobb's authority in their shared illegal activities. Finally, the detective presents the credit card, which YM pleads that Cobb stole; but when asked if it is his signature on the back, he has no

recourse. He 'looks at the card in despair' and quietly responds, 'Yes' (2001a: 89). In his commentary, Nolan notes the gravity of this moment: 'I just wanted to use the credit card, really the final nail in the coffin, it being his own handwriting. He signed it, so when he sees this he knows there's no getting out of it.' Indeed, so focused on how he arrived at this situation where he is framed for murder, there is no escape that YM can see. While he followed others with no view of where he was being led, YM became responsible for his role in the circumstances constructed by Cobb and the Blonde (who turns out to be nothing more than another tool used by Cobb). YM finally sees his ending but is left with no way to pry open the coffin nailed shut by his own 'account of… well, what happened' to him (Nolan 2001: 3).

## Following the Ending, Back to the Beginning

*Following* establishes a foundation for Nolan's narrative techniques, and his complex temporal presentations continue to challenge viewers to think about the generally accepted but derivative chronology of events in standard plots. Just as Nolan's non-linear narratives require analysis, so do the initial teaser moments which, as he states in his commentary, offer 'hints of things to come'. In the opening sequence of *Following*, the quick shot of Cobb looking directly at the camera identifies him as the key to understanding YM whose voiceover snaps away the audience's attention. This series of cuts is softened by the end of the film after the whole context of Cobb's deception is finally revealed: Nolan dissolves from a close-up of YM's wide-eyed face to Cobb's slow-motion disappearance into a crowd of pedestrians. While the opening link between YM and Cobb is established by fast cuts, the conclusion of their connection is soft and slow as if their identities merge together. Shot at waist-height, the final moments of Cobb's existence are reminiscent of the disturbing quality of the Grand Central scene in *Seconds*. Cobb looks back briefly (just as all the mini-endings ease viewers back to their timelines' beginnings) and then disappears so the world can return to how it was before his intrusion.

If YM is to understand his own ending, he must recognise how he has allowed himself to be influenced to change his appearance and methods of transgression by both Cobb and the Blonde. The subtle transformation YM undergoes during his encounters with these external influences brings him to a final place that he would not have chosen for himself. The physical evidence presented after his confession compels a moment of reflection and reveals his need to reconsider all the elements of his story in a new light. Understanding Nolan's films also requires reconsideration of the teaser after the ending, but Cutter's (Michael Caine) reiterated exposition in *The Prestige* (2006) portrays the true nature of filmgoers: you pay attention to the initial teaser to see its hidden revelation in the same way that you closely watch a magic trick unfold to find the secret, but 'you won't find it because, of course, you're not really looking. You don't really want to work it out. You want to be fooled'. Even with a vision of how all the scenes relate in the story, the filmmaker's audience mirrors the magician's audience. We watch films like *Following* repeatedly to further appreciate Nolan's intricate moves through the beautiful labyrinths he creates… but mostly we follow along as he works his magic.[22]

## Notes

1 I usually would not change a character's name in an analysis for the sake of brevity, but this particular Young Man is empty and waiting, so... well, he sets himself up for it.

2 Heidegger contrasts the kinds of selfhood generated by inauthentic and authentic views of death as a covered-over possibility and anticipatory resoluteness, respectively. The familiarity of an impersonal identity (such as acting the way a teacher or daughter should, rather than how I determine my own path in this particular situation) provides a mask which disguises individuality since it fails to stand out as a unique concrete existence. However, anticipatory resoluteness disperses all illusions and brings forth an 'unshakable joy' in the possibility of living life toward one's own most end. Heidegger (1962: 27 (esp. 165–7/H127–29) and 62 (esp. 357–8/H309–10)); hereafter, *BT*. By the end of his confession, YM has presented himself as a kind of criminal to be investigated for related types of illegal activities rather than the lesser offenses for which he feels responsible.

3 Even in the chronological cut of *Following* (available on the Criterion DVD), the bookend confession sequences remain intact (including the opening sequence's initial sightings of YM's three distinct guises); so YM's appearances change in order during the main story, but they are introduced and remain intertwined with his bruised-face flashback.

4 Because of the complexity of the narrative, citation to the script will be provided whenever possible; but when the film deviates from it, no citation will be given and the film is the primary reference source. In the script, YM introduces himself to the Blonde at the bar as 'Timothy Kerr – Tim to my friends', but in the film the identity linked to the stolen credit card becomes 'D. Lloyd' for production reasons explained by Nolan in the commentary track (available on the Criterion DVD).

5 When YM angrily asks how the Blonde could take part in framing him, she replies: '(unimpressed) It's not personal' (2001a: 82).

6 Heidegger contends that human spatiality is coupled with temporality (see *BT*: 70, 420/H368).

7 Nolan provides another subtle hint of YM's inauthenticity as the Blonde uses some simple reverse-psychology to convince YM to break into the safe: 'Nobody in *their* right mind would steal from him' (2001a: 65; emphasis added). YM then takes on the heist while he is not in his own mind, but instead falling into Cobb's grasp as YM plays the predictable rescuer to the Blonde's predetermined role of damsel in distress.

8 Nolan develops an interesting extension of the idea of concealed items that shape the vision of present circumstances and future possibilities through the totems used in *Inception* (2010): something small and personal that keeps track of one's own view of reality; no one else can touch it so that the owner remains assured that he or she is not in someone else's dream.

9 Mentioned in 'Following On', 99; for more detailed analysis of the influence of *Seconds* on Nolan, see Horne (2006).

10  At the end of *Seconds*, the surgeon reintroduces himself to Wilson, sadly saying: 'You were my best work.' Both Wilson and YM have their identities (including their physical appearances) crafted by others, but both find their new lives to be problematic and somehow lack solid grounding.

11  On a tangential note regarding another inescapable past, Nolan provides a different view of inauthenticity that stems from overreliance on family history with his *Dark Knight* trilogy (2005, 2008, 2012). In *The Dark Knight Rises*, Alfred (Michael Caine) confronts an older and ailing Bruce Wayne about his dream to run into Bruce while on vacation: they would share an unspoken moment, both knowing that he made it to a place where he could have a meaningful relationship, maybe even a family. Alfred thinks that there is no good end for Bruce as long as he is defined by his inherited family name or the anonymity required for the symbolic superhero. Only 'pain and tragedy' anchor and await Bruce in Gotham, so Alfred's charge has no chance at his own future until he can escape the grasp of the past.

12  In his commentary for *Memento* (available on the 2002 limited edition release), during the first scene that introduces Natalie (Carrie-Anne Moss) at the diner, Nolan suggests that the progression (or regression) of the wounds, tattoos and series of notes indicates the temporality of the story in the way hairstyles and wounds alert viewers to different timelines in *Following*. Nolan further discusses his fascination with how different Natalie's dialogue and intentions seem in this introductory scene during subsequent viewings as an example of 'how the chronology could affect the narrative', an idea he explores through many of his films and protagonists. Perhaps best stated in Leonard's later/earlier monologue while he thinks Natalie is asleep, Leonard questions his emotional state: 'How am I supposed to heal if I can't feel time?'

13  For Ortega, 'there stands out only one fixed, pre-established, and given line by which [a man] may chart his course, only one limit: the past' (1989: 157).

14  Concealment as an aspect of human existence emerges as a major concept in most of Heidegger's work, and as he makes this statement during the robbery, Cobb might have an idea of Heidegger's explication of truth as 'unconcealment' (*BT*: 44).

15  Similarly, toward the end of *Seconds*, Wilson is sent to a corporate waiting room where he and many others expect another identity to be given to them like soft drink refills at a restaurant.

16  When they first meet in the café, it is Cobb who seems to convince YM that he is a writer who is interested in people (2001a: 13–14); and this is part of the identity that YM internalises as he attempts to define himself to the detective in the opening scene in a similarly qualified way: 'I'm a writer – I want to be a writer', yet he does not claim that he wants to write (2001a: 5).

17  Heidegger writes: 'Curiosity is futural in a way which is altogether inauthentic, and in such a manner, moreover, that it does not await a *possibility*, but, in its craving, just desires such a possibility as something that is actual' (*BT*: 68[c], 397/ H347).

18  By and large, individual selfhood is forgotten in favour of the tranquility provided by everyday life. Heidegger explains: 'A specific kind of *forgetting* is essential for the temporality that is constitutive for letting something be involved. The Self must forget itself if, lost in the world of equipment, it is to be able "actually" to go to work and manipulate something' (*BT*: 69[a], 405/H354).

19  Moreover, Lilian Alweiss continues that death is 'not something that will happen some time in the future, but it is "now"' (2002: 126).

20  Anticipation of death as an ongoing possibility that must be endured through everyday life infuses an individual's present, past and future with wholeness even before reaching the physiological end of life (see *BT*: 53, esp. 305–7/H261–3).

21  Throughout the final scene, the script identifies Cobb in quotation marks when the detective says the name (2001a: 84, 88) but not when YM says it (2001a: 87–9). While Cobb remains an influence on YM, the detective seems to think he is some kind of ploy for YM to avert responsibility.

22  On a personal note, I have listened to dozens of commentary tracks; but Nolan's contain the most insightful explorations of narrative and production notes (along with the occasional funny-thing-that-happened story) that I have had the pleasure to hear. If you enjoy Nolan's films enough to read all this fine print, then you certainly should seek out his commentaries.

*Bibliography*

Alweiss, Lilian (2002) 'Heidegger and "The Concept of Time"', *History of Human Sciences* 15, 3, 117–32.

Curtin, John Claude (1976) 'Death and Presence: Martin Heidegger', *Philosophy Today*, 20, 4, 262–6.

Heidegger, Martin (1962 [1927]) *Being and Time*, trans. John Macquarrie and Edward Robinson. New York: Harper & Row.

Horne, Philip (2006) 'Film-Makers of Film: Christopher Nolan', *The Telegraph*, 11 November. Online. Available: http://www.telegraph.co.uk/culture/film/starsandstories/3656469/Film-makers-of-film-Christopher-Nolan.html (accessed 21 February 2015)

Macquarrie, John (1968) *Martin Heidegger*. London: Lutterworth Publishing.

Marías, Julián (1967) *History of Philosophy*, trans. Stanley Appelbaum and Clarence C. Strowbridge. New York: Dover Publications, Inc.

Nolan, Christopher (2001a) *Following* (script), in *Memento and Following*. New York: Faber and Faber.

_____ (2001b) 'Following On: Christopher Nolan and Jeremy Theobald Interviewed by James Mottram', in *Memento and Following*. New York: Faber and Faber, 93–102.

Ortega y Gasset, José (1989) 'Man Has No Nature', in Walter Kaufmann (ed.) *Existentialism: From Dostoevsky to Sartre*. New York: Penguin, 152–7.

Pratley, Gerald (1998) *The Films of John Frankenheimer: Forty Years in Film*. Cranbury, NJ: Lehigh University Press.

CHAPTER SIXTEEN

# Hearing Music in Dreams: Towards the Semiotic Role of Music in Nolan's Inception

Felix Engel and Janina Wildfeuer

*Introduction*

The music in Christopher Nolan's film *Inception* (2010) has often been described as powerful and meaning-making for the interpretation of the film. In particular, its function for the understanding of the various levels of dream and reality and the transition between these levels has been underlined in cinematic reviews and theoretical approaches to this film (see Eisenberg 2011; Schmid 2012). Interestingly, and besides all scientific discussion, Nolan has made some statements on the film's music which we want to take into consideration in this essay and for which we provide the following quotation as a starting point: 'Before I'd finished the script I warned Hans [Zimmer] about the demands *Inception* would put on its score – the music as a guide for the audience, pulling them through a potentially confusing tale by orienting them emotionally, geographically, temporally' (Nolan quoted in Zimmer 2010).

We want to particularly focus on the different functions Nolan describes in this comment as requirements for the film music composed by Hans Zimmer. In general, film music has often been defined as functional music, i.e., music which is produced or reproduced for certain ends in the reception of the film (see Kloppenburg 2012: 141). These functions are then defined in terms of their use for narrative purposes (see Wingstedt *et al.* 2010) and listed in classification schemes or according to their specific characteristics (see Gorbman 1987; Carroll 1988; Smith 1999, 2009; Cohen 2001; Wingstedt 2005). In these contexts, it becomes evident that music is mostly seen as a single resource, often separated from other patterns of the auditory level and that a scientific discussion should particularly focus on questions of the music's relation to the visual level, for example.

In our approach, therefore, we want to combine the perspective of the detailed description of the music's characteristics with the analysis of how meaning in general is constructed by the various semiotic resources in Nolan's film. We still want to ask which function the music plays in various scenes, but we will thereby focus on the

intersemiosis, i.e., the concrete interplay of the modalities in the filmic text (see Wild-feuer 2014). We take as our basis a multimodal and semiotic perspective of analysing how the recipient constructs meaning out of the combinations of various resources such as sound, images, gesture, camera movement, etc. Our analysis will be examined with the help of a recently developed tool for the linguistic and formal analysis of filmic text, the *logic of film discourse interpretation*, which helps to outline how filmic meaning can be interpreted on the basis of the recipient's inference processes in terms of abduction and active semiosis (see Peirce 1979).[1]

We think that the semiotic role of the music for inferring the film's meaning can be described as different tasks which are, on the one hand, already claimed in the quotation by Nolan above and, on the other, are mentioned again in Zimmer's response to this quotation and its accompanying requirements in several interviews and comments on the music (see Itzkoff 2010; Martens 2010). We summarise these tasks as follows: Firstly, Zimmer describes his music as a leading path through the complicated narrative structure of various dream levels. Therefore, he focuses particu-larly on the Édith Piaf song 'Non, je ne regrette rien', which is used both as a diegetic source and an important key element in the storyline as well as non-diegetically in the film's score:[2] 'The musical cue, Mr. Zimmer said, "was our big signpost" in the film of its characters' moving from one level of dreaming (or reality) into another. "It was like a drawing of a huge finger", he said, "saying, OK, different time"' (quoted in Itzkoff 2010).

According to the requirements given by Nolan, we call this task of the music and particularly the use of the song, the *temporal and geographical, or spatial, orientation* for the recipient during his/her interpretation process. In our following analysis, we will therefore examine how this function can be manifested within the intersemiotic interplay of the various resources and how it can be worked out as a significant textual cue (see Bordwell 1985, 1989) that helps to guide the recipient through the narrative. We will ask whether the music fulfils this function and clarifies the meaning of certain sequences of the film in terms of their discursive level of the storyline, i.e., the question whether they are representing a dreaming or wakening state.

Secondly, Zimmer describes his music as elucidating the emotional states of char-acters, especially that of the main protagonist, Cobb (Leonardo DiCaprio). He identi-fies the emotional core of the film as 'romance', referring to the film's second plotline (or B-plot), which shows the relationship between Cobb and his wife Mal, who appar-ently committed suicide: 'What I was writing was nostalgia and sadness. This character carries this sadness all the time that he cannot express. He's been telling us about it all along, but no one knows how to listen. I think the job that Johnny and I had to do was write *the heart* of this thing' (Martens 2010; emphasis in original).[3] We describe this function of the music as the *emotional orientation* for the recipient and we will ask for its concrete potential of transmitting emotional states of the protagonists or high-lighting the emotional significance of the narrative events we can infer from the film. Our examination will firstly be based on the analysis of the intersemiotic meaning construction and a particular view on the music in this interplay. In a second step, we will then combine this analysis with an interpretive perspective on the music in

particular, which will help us to gain more information about its involvement with the mediation of emotions. Our aim here is to question the music's ability to influence the cognitive processes of understanding Nolan's film in general and, more specifically, the interpretation of the protagonist's mental states.

Our examination will combine both bottom-up as well as top-down approaches to the analysis of the music in *Inception* in order to provide a comprehensive account for the understanding of how music works as a guiding path through the film, orienting the audience spatio-temporally as well as emotionally. In the following, we will there-fore give a few more comments on our theoretical background, the tools we apply for our analysis, and the use of the Piaf song in this film (see section two). In section three, we will then analyse in detail two different scenes from the film with regard to their meaning-making strategies and the patterns of music that have been used. Section four, finally, will especially be concerned with the emotional dimension attributed to the song's central motive. This will go beyond the textual analysis in section three and will refer to what David Bordwell and Kristin Thompson call 'implicit meaning' (2008: 61), the proper object of interpretation.

*Theoretical Background*

> The ability to perform a coherent story depends upon the viewer's under-standing of crossmodal structural congruence that affects our perceptual group-ings in visual and auditory domains in short-term memory. That is, film music works through the viewer's cognitive processing of perceived correspondences between musical and visual information. (Smith 2009: 192)

For the analysis of how the viewer operates the above-mentioned cognitive processing of a film, we work with the framework that has been developed for the systematic examination of film interpretation from a linguistic perspective (see Wildfeuer 2014). On the basis of recent advances in discourse semantics and text linguistics, this frame-work aims at a detailed description of the textual qualities of coherence and structure in film and how they guide the recipient's meaning-making process during reception. The framework allows a redrawing of the recipient's active process of relational mean-ing-making and inferring the film's propositional content in terms of assumptions and hypotheses, which the recipient makes according to concrete cues within the text. The analysis is essentially defeasible and hypothetical and goes back to the notion of abduction introduced by Peirce as a basic logical form that seeks for a possible cause of an assumption that still remains questionable (see Peirce 1979). However, because of world and context knowledge and the knowledge about how films are constructed, it is in most cases possible to ask for the discourse's plausibility, its property of making sense. This then bridges a first gap between the still-missing description of how tech-nical devices of the filmic text, which can be determined very easily, and their interpre-tation, which cannot be entirely controlled, interact.

The framework operates on two levels of filmic comprehension that have also been described for a theory of multimodal comprehension by Hans-Jürgen Bucher

(2011), for example. The first level of identification and arrangement of the meaning-making entities helps to construct so-called logical forms of the discourse in order to describe the semantic content of the modalities' intersemiosis. These logical forms display the events of the film's diegesis in terms of discourse representation structures. The second level of coherence and structure combines the logical forms into narrative discourse structures by interpreting discourse relations between the events. For the following analysis, we mainly focus on the first level of examination, the description of the intersemiotic interplay and its meaning construction.[4] According to Smith (1999: 159–60), a specific view of the music then allows a reconstruction of how it 'encourages spectators to make inferences about a film's events, characters, and setting to facilitate the ongoing comprehension of the narrative'. Consequently, in the following, we will particularly consider the music in *Inception* with regard to its respective meaning-making facilities and in terms of its contribution to the recipient's inference process.

For this, we will focus on the specific use of a key musical element in the film, which we have already mentioned above. The song 'Non, je ne regrette rien' is, on the one hand, taken as a diegetic song within the storyline that lets the protagonists know that they will soon wake up from a dream level. It is both explicitly shown as a direct cue for waking up the protagonists (as for example in one of the first scenes in which the transition between various dream levels is shown and explained (see figure 1)), as well as discussed by the characters as a specifically chosen element to be recognised by them during their dreaming (00:51:01).[5]

Figure 1: Shots from the first scene in *Inception* (2010) in which Édith Piaf's 'Non, je ne regrette rien' is used for waking up the dreaming characters.

On the other hand, parts of this song have been transferred by Zimmer into a modified version which is used both as a diegetic and non-diegetic element in the film. This modification has been recognised by spectators who discuss the creative use as a 'slowed down version' of the chanson intensively in online forums like YouTube.[6] Furthermore, the modification has been analysed from a musicological perspective and described as an abstract and extremely slow version (Schmid 2012: 68; see figure 2, opposite). Hans Zimmer himself finally comments on these discoveries as 'not only intentional but also the one element of an enigmatic film that wasn't supposed to be a secret' and sets right that it is a musical construction from a single manipulated beat (see Itzkoff 2010).[7]

In our analysis, we focus particularly on the use of this song both as a diegetic as well as a non-diegetic source. Both versions clearly work as textual cues for the film, which not only influence the understanding process of the protagonists within the

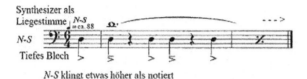

Figure 2: Musical analysis of the modified version of 'Non, je ne regrette rien' in *Inception*.

film, but also guide the recipient's interpretation and reception of the various levels of diegesis. We work out and illustrate this use in further detail in the analytical part in section three. Our analysis will show that various instances work differently in various sequences.

This then corresponds to the general assumption that music in film fulfils various functions and has to be interpreted according to the specific context. In particular, there is a specific focus in the already mentioned context of film music analysis on the potential of music not only to intensify, but also to influence the emotional content of a film. These functions can be realised by various musical techniques, e.g. 'Mood-technique' or 'leitmotif technique' (see Kloppenburg 2012: 202–38). In our interpretational work in section four, we will come back to these descriptions in further detail.

*Analysis*

In the following, we analyse two sequences from the film in order to demonstrate the use of the Piaf song as a textual cue for the recipient's inference process. We undertake this analysis by, firstly, examining the logical forms of the filmic discourse in terms of the filmic events. Within the description of these logical forms, we will take a closer look at the music and its role for the interpretation of the events and their semantic content.

As a first example, we take a short sequence from the film's beginning (starting in minute eleven), in which both elements, the original song and the modified version, are used for the first time. Two shots of this scene have already been depicted (see figure 1, opposite); a further sequence of three shots is given in figure 3, overleaf. The scene is situated in a dream level where the main protagonists are trying to get information from the Japanese businessman, Saito (Ken Watanabe). He, however, recognises the projection as a dream, which then is being dissolved by the waking up process shown in figure 2. A further character (Tai-Li Lee) on the level beyond is using a music player and headset to signal the coming end of the dream. The headset plays the song 'Non, je ne regrette rien', which can be perceived by the recipient as a diegetic source in its original version. The shot of the protagonist who is first shown sleeping is then cut to another shot of the same protagonist back at the second setting, which has already been shown before. The protagonist on this level is looking up and listening to noises and sounds in the background, and is thus in a wakening state. The sounds from a brass section can be recognised as the modified version of the song or parts of the song in a very slow replay. We illustrate this transition from one level of diegesis to the other level in figure 3.

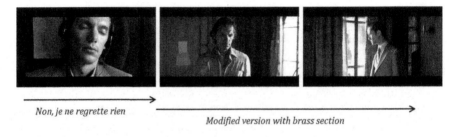

*Non, je ne regrette rien* →

*Modified version with brass section* →

Figure 3: Transition between two levels of diegesis and change of music in *Inception*.

| $e_{\pi_1} = sleep$ | $e_{\pi_2} = listen$ |
|---|---|
| $[v]$ male character, eyes closed (m) | $[v]$ male character, eyes open (p) |
| $[v]$ setting: train (n) | $[v]$ setting: house (q) |
| $[a]$ "Non, je ne regrette rien" (o) | $[a]$ slowed down version (r) |
| $m \mathbin{\vdash\!\!\!\sim} sleep\ (e_{\pi_7})$ | $p, r \mathbin{\vdash\!\!\!\sim} listen\ (e_{\pi_2})$ |

Figure 4: Logical forms of the two shots of Nash (Lukas Haas) used in figure 3.

For this scene, we can infer the two logical forms given in figure 4, which represent the semantic content of the events given in this short part of the story and which make visible the contrast between the two levels of diegesis.

The event in the first logical form on the left enlists as a discourse referent the protagonists with closed eyes and can therefore be interpreted as the eventuality 'sleep', thus as an event that would normally be inferred by the recipient because of the narrative processes shown in the image (see Wildfeuer 2014: 53–9). The second logical form, in contrast, describes a completely different setting in a house with the protagonists being awake and listening to the sounds in the background. The inference process, which is marked in the last line of the boxes with the logical operator $\mathbin{\vdash\!\!\!\sim}$ indicating a defeasible consequence relation, then leads to the interpretation of the semantic content of 'listen'. Although the song is used as a diegetic source in the first event, it is not explicitly shown that the protagonist on this level of the diegesis actually listens to the song. The discourse referent (o) and the referent (n) in the first logical form are therefore not a decisive part of the inference process depicted in the last line of the box (as is the case for the discourse referent (m)). The eventuality 'sleep' is here the preferred interpretation of the semantic content of this event, because it cannot be interpreted that the protagonist is hearing the music. In the second event, in contrast, it is shown by the movements of his eyes and head that he is directly reacting to the music in the background; he is, consequently, listening to it. This then leads to the fact that (r) as the label for the discourse referent of the music is part of the inference process, which then leads to the eventuality 'listen'. Interpreting a discourse relation between these two events as the second step of the examination with our analytical tool would then allow the inference of a typical *Contrast*-relation which, according to the framework (see Wildfeuer 2014: 59–75), can be inferred when there is semantic dissimilarity between two events. Although the film creates a temporal sequence of the two narrative proc-

esses of sleeping and listening, the meaning postulates for the inference of a simple *Narration*-relation are not fulfilled in this context. Especially, spatial coherence is not given by the two levels of diegesis that are situated at two different settings. It is the specific arrangement of the various levels that leads to the inference of a text-structuring relation such as *Contrast* in order to display these various discourse levels.

Consequently, this clear contrast cannot only be manifested by the different narrative processes that are visible in the images and that can be described on the basis of the various discourse referents listed in the logical forms, but also in terms of the two different versions of the music. Both of them are diegetically-used elements, which, in the first instance, signal the forthcoming waking up and, second, orientate the recipient in interpreting the various levels of narration. However, it is mainly the combination of both versions and their interplay with other semiotic resources that fulfil the function of contrasting the two settings and time levels and orienting the recipient both geographically as well as temporally. Nevertheless, the music operates as a textual cue for the construction of coherence between the originally divergent events.

With regard to the further unfolding of the filmic discourse structure, this is at least the case in a few other sequences in the first half of the film in which the song is used similarly. But throughout the rest of the film, especially in its second half, other parts of the soundtrack become more dominant and apparently more important for the construction of the narrative.

For our second analysis, we therefore take a scene from the end of the film, in particular from the final episode of the so-called 'kick' which is supposed to awaken the team members from various levels of dreaming that have been constructed to follow the inception idea of planting thoughts into Robert Fischer's (Cillian Murphy) subconscious. This 'kick' scene ends with the image of the transporter diving into the water after having fallen from the bridge, which is the last process of awakening the protagonists sitting in the back of the transporter. We illustrate the scene by focusing on the various shots of Ariadne (Ellen Page), the female protagonist, and her awakening (see figure 5, overleaf). Similar shots are given for the other members of the team and their awakening by the various dimensions of the 'kick'.

In contrast to the sequence we analysed before, the characters in this scene are not in the same way confronted with the specific key element used in the first half of the film. The logical forms of the events of sleeping or waking up are thus different to those we analysed before, in particular with regard to the role of the music for the inference process. We give two examples of these logical forms in figure 6, representing shot 1 and 3 in figure 5.

In both logical forms, the music influences the interpretation of the event, but is not part of the concrete inference process of inferring the eventualities, depicted again in the last line of the boxes. This is the case for all logical forms within this scene. In one of the last shots, which shows Ariadne finally waking up in the second dream level (shot 4 in figure 5), however, a very slow version of 'Non, je ne regrette rien' as well as some single parts of the slowed down version can be heard. But it's not clear whether they are diegetically used and can thus be recognised by the protagonists as signals for the awakening or whether they are further elements of the already very complex musical

Figure 5: Shots of Ariadne (Ellen Page) on various dream levels in the final 'Kick' scene, *Inception*.

| $e_{\pi_3} = hold\ on$ | $e_{\pi_4} = awake$ |
|---|---|
| [v] female character, eyes open (s) | [v] female character, eyes open (w) |
| [v] beam (t) | [v] setting: fortress (x) |
| [v] setting: Limbo (u) | |
| [a] musical context (v) | [a] musical context (y) |
| $s, t \mathrel{\vdash\!\sim} hold\ on\ (e_{\pi_3})$ | $w \mathrel{\vdash\!\sim} awake\ (e_{\pi_4})$ |

Figure 6: Logical forms of shot 1 and 3 in figure 5.

context. Since they are combined with other non-diegetic musical elements, which seem to be more dominant here, the use of these elements is ambiguous. However, the logical form in figure 6 makes clear that they are by no means a distinctive part of the inference process and, rather, accompany the unfolding of the narrative.

Whereas the different usages of the song and its modified version in the first part of the film explicitly help to guide the recipient in his/her understanding of the various levels, the music in the second part and in particular in the final 'kick' sequence cannot be described similarly. It is no longer possible to work out concrete textual cues on the level of the music that still indicate the specific contrast between the dream levels and thereby orientate the recipient temporally or spatially. Instead, it is mainly the visual level of the logical forms that maintain this contrast. Inferring discourse relations

between the events we have analysed above would again lead to the interpretation of a number of *Contrast*-relations whose semantic dissimilarities now refer completely to visible differences in the character's activity (sleeping vs. awaking). The music, on the other hand, creates a coherent and dynamic sequence of these events, without making the visible contrast further explicit, as it is the case in the first scene analysed above.

*Interpretations*

So far, we have undertaken a bottom-up analysis of the textual qualities of the two film sequences. In the following, we will combine this approach with further top-down perspectives concerning interpretational questions raised within discussions on Nolan's film. In particular, we want to focus more on the emotional function of the instances we have analysed.

As said above, the first analysed instance of 'Non, je ne regrette rien' functions as a textual cue for the interpretation of the sequence. It indicates a transition from one level to the other both for the recipient as well as for the characters within the diegesis. However, only the slowed down version orientates the audience in the ontological realm(s) of *Inception* more specifically. Moreover, the use of the deceleration technique by Zimmer seems to be diegetically motivated. One of *Inception*'s premises about time implies that it is experienced more slowly in dreams than in wakening states.[8] This means that if someone hears a melody in a dream, it is not heard at the same pace as in the wakening state. In this way, the slowed down version orientates the audience temporally and contributes to the meaning of the sequence by signalling that the characters are in a dream (and, respectively, are sleeping on the level beyond the dream).

While this is true to the fictional world of *Inception*, the converse statement is still in question: hearing a slowed down version does not necessarily mean that the characters are dreaming. Furthermore, the musical theme doesn't provide a clear indication for the pressing interpretive problem of the ontological status of the first level, i.e., the question whether is it a dream or not. Zimmer's 'huge finger' (see the discussion in section one) points to dreams, but not to reality. If we ask for an emotive function of the first instance, it is clearly not dominant. We hypothesise therefore that even if the motive in our first instance intensifies or modifies the emotional content in a direct manner, it will presumably be unacknowledged by the recipient. However, there is another dimension of emotional meaning that comes into focus when the motive is considered as a musical quotation. If we take Zimmer's suggestion that the film's emotional core is Cobb's sadness, partially aroused by his sense of guilt, a possible interpretation might be that the *chanson* echoes this core by pointing to the inner conflict of the protagonist. Piaf's song is about someone who doesn't regret what she did (or what was done to her). Putting the first instance of the song in context to the main character and referring to the contextual knowledge about the *chanson*, we draw the following assumptions. Firstly, the song can be seen as expressing the needs of the character, anticipating the resolution of his inner conflict, i.e., the wish of forgiving himself for what he feels responsible for. Secondly, it can be seen as an ironic comment in terms of the fact that a character full of regret uses a song that states that there is

no reason for being regretful. We could argue here that the use of 'Non, je ne regrette rien' is emotionally clarifying or, dependent on the particularly preferred interpretation, even evaluative.

The second analysed instance of the song does not function in the same way. As our analysis of the intersemiosis of the auditory and visual level works out, it is not indicated that the characters recognise the slowed down version as they do in the first scene we analysed. Here the motive is combined with other non-diegetic musical elements and it is therefore not clearly identifiable as a diegetic source. Nevertheless, it is recognisable as a further modified version of the song 'Non, je ne regrette rien'. Hence, with regard to its established function in the first half of the film, its use in the second instance is somehow ambiguous. As a result, it doesn't actually contribute to clarifying the question of dream or reality, since it doesn't orientate the audience, neither locally nor temporally.

Before examining the question of the second instance's emotive function, we need to consider the film's score as a whole. Notably the score does not have a motive (leitmotif) for the protagonist, which means that there is no specific musical sign that characterises the protagonist and his emotional stance in a stable and direct manner throughout the whole film. It is rather the main themes of the score that are linked to events or sequences of events (e.g. the breakdown of dreams), settings (in dreams) or other characters (Mal [Marion Cotillard]). On the other hand, the score is composed of rather simple melodic and rhythmic material that is varied throughout the film. One of the basic parts among others is the slowed down version, which, consequently, occurs at least partly in other musical contexts of the film (not only as the original song). One of these musical contexts underlines the scenes that display Cobb's desire to go back to those whom he had lost (his children and Mal) and what Zimmer called the 'sadness' and 'nostalgia' of the character. The flashback framed by Cobb's confession that he had manipulated Mal (01:58:12) is one example. Here, the first note of the slowed down version is played (and indeed identifiable as such) in the context of Mal's theme. That is, if Mal's theme represents the emotional stance of the character, then the slowed down version is presumably associated with this stance.[9]

According to Claudia Gorbman (1987), who contrasts themes that are motives from themes that are not, it is now possible to describe the emotional significance of the second example we analysed above. For Gorbman, a theme is simply music that occurs more than once in a filmic discourse. After its representational content is determined by and within a specific audio-visual context, this content can be re-found in other contexts. If this music 'remain[s] specifically directed and unchanged in [its] diegetic associations' (1987: 27), it is a motive. In this sense, the original song 'Non, je ne regrette rien' is certainly a motive. It is established as a sign for 'waking up soon' and it generally keeps this meaning, even if it is heard in other situations of the film. However, the diegetic associations of the slowed down version are changing according to their respective contexts. Hence, when it comes to our second example, the music is enriched with different contextually determined associations and therefore is a theme, but not a motive. Consequently, it can function as a sign for 'waking up soon' as well as a sign for the emotional core of the character.

## Conclusion

In scrutinising two instances of using 'Non, je ne regrette rien' in *Inception*, we have found that they function differently due to their visual, auditory and, in particular, musical contexts. Unsurprisingly, the dominant function of the first instance is *orienting* the audience *geographically* and *temporally*, to put it in Nolan's terms. However, the second instance is much more ambiguous, since we cannot specify eventualities such as 'listen'. Considering that a recipient already knows *Inception*'s narrative architecture when it comes to our second example and, moreover, considering the presence of other visual cues for grasping spatio-temporal relations in the 'kick' sequence, we have argued that the *emotional orientation* becomes the dominant function of the second instance. This shift of dominance becomes possible, since the slowed down theme of the song is heard in other, emotional significant contexts throughout the film. However, even if one is not willing to assert that the recipient will presumably infer the non-diegetic status of the slowed down version, the difference between our first and our second example still remains.

Since there is no activity of the characters that can unequivocally be identified as 'listen', the narrative status of the theme can be questioned. Reliant on the particularly preferred interpretation, it is diegetic or, as part of the musical context, non-diegetic. If it is interpreted as non-diegetic, it can fulfil only the emotional function. Yet if it is interpreted as diegetic, it can fulfil both the spatio-temporal function as well as the emotional function described above. This status of not being ascribed to the diegetic or the non-diegetic realm, the 'in between' (Kassabian 2001: 42), is neither inevitably noticed by recipients familiar with the conventions of Hollywood cinema nor disturbing the ongoing comprehension of *Inception*. On the one hand, it is a common feature of film music in the tradition of Classical Hollywood cinema to mediate between the diegetic and non-diegetic level of narration (see Gorbman 1987: 30). On the other, the conditions for the understanding of *Inception*'s ongoing story are already fulfilled by other functions (as it is, for example, the case with the first occurrence of the theme analysed above). Furthermore, the theme is part of the musical context in the background, which helps in creating the mood of the 'kick' sequence. Conventionally, such background music is 'inaudible', i.e., it avoids conscious attention, at least in Hollywood's mainstream films (see, again, Gorbman 1987). Consequently, it seems more likely that this music remains unnoticed during film reception.

Zimmer thus followed Nolan's demands not only by using 'Non, je ne regrette rien' as the original song and by combining it with the slowed down version, but also by employing the latter for other musical themes. This allows him to develop a relatively high complexity of the interplay between the visual and the auditory level from a rather simple melodic and rhythmical basement. By doing this, he seems to follow another of *Inception*'s premises: an idea must be simple to be effective.

*Notes*

1    According to Peirce, 'abduction is the process of forming an explanatory hypothesis. It is the only logical operation which introduces any new idea' (1979: 5.171). Active semiosis, the process of interpreting signs or semiotic resources and understanding their interplay, always involves (besides the simple decoding of the signs) inferences about the most plausible interpretation, which are essentially defeasible. Interpretation is thus always an abductive, hypothetical meaning construction followed by certain basic, logical principles which do not only aim at formulating new hypotheses, but at the same time also prove and verify those hypotheses (see Wildfeuer 2014: chap. 1.4 for further information).

2    We will give a more detailed explanation of the use of this song and its modifications in section two of this essay.

3    The quotation is, unfortunately, somehow ambiguous. On the one hand, Zimmer states that the character cannot express his sadness; on the other, 'he's been telling us about it all along'. Consequently, It remains unclear whether the music is able to express this sadness which otherwise cannot be expressed.

4    Due to space constraints, we cannot describe the theoretical framework in further detail. A comprehensive overview of the tool is given in Wildfeuer (2014); further analyses are examined in Wildfeuer (2012a, 2012b). The detailed analysis in section three will give more illustrative examples of how the framework operates.

5    Following Levinson (1996: 403), we differentiate between composed and appropriated score. Composed score is film music which is composed for the film in question, appropriated score is, by contrast, music which has already existed before writing the soundtrack of the film and which has been chosen by the filmmaker or composer. Hence, we see the song 'Non, je ne regrette rien' as an appropriated score; other musical elements in this film are then the composed score. The timecode refers to the DVD *Inception* (Nolan 2010), Region 2, Warner Bros.

6    A direct comparison of the two versions is, for example, given at http://www.youtube.com/watch?v=UVkQ0C4qDvM (see also Whitehouse 2010).

7    Actually, the film itself also works out the relationship between the *chanson* and its modifications by giving only the modified version in the very beginning of the film as a kind of introduction and both versions and their recognisable interconnections in succession at the very end of the film, subsequent to the closing credits.

8    This is a rewording of *Inception*'s premise about the experience of time stated by the characters and summarised by Michael J. Sirgist as follows: 'Because your mind functions more quickly in dreams, time feels slower' (2011: 199).

9    This passage is based on the detailed analysis by Schmid 2012.

*Bibliography*

Bucher, Hans-Jürgen (2011) 'Multimodales Verstehen oder Rezeption als Interaktion. Theoretische und empirische Grundlagen einer systematischen Analyse der

Multimodalität', in Hans-Joachim Dieksmannshenke and Michael Klemm and Hartmut Stöckl (eds) *Bildlinguistik. Theorien – Methoden – Fallbeispiele.* Berlin: Erich Schmidt Verlag, 123–56.

Bordwell, David (1985) *Narration in the Fiction Film.* Madison, WS: University of Wisconsin Press.

_____ (1989) *Making Meaning: Inference and Rhetoric in the Interpretation of Cinema.* Cambridge, MA: Harvard University Press.

Bordwell, David and Kristin Thompson (2008) *Film Art: An Introduction.* Eighth Edition. Boston, MA: McGraw Hill.

Carroll, Noël (1988) *Mystifying Movies: Fades and Fallacies in Contemporary Film Theory.* New York: Columbia University Press.

Cohen, Anabel J. (2001) 'Music as a Source of Emotion in Film', in Patrik N. Juslin and John Sloboda (eds) *Music and Emotion: Theory and Research.* Oxford: Oxford University Press, 249–72.

Eisenberg, Marc (2011) 'Hans Zimmer's *Inception* Score Will Release on July 13th', *Screen Rant.* Online. Available: http://screenrant.com/inception-score-hans-zimmers-mikee-65200/ (accessed 18 February 2015).

Gorbman, Claudia (1987) *Unheard Melodies: Narrative Film Music.* Bloomington, IN: Indiana University Press.

Itzkoff, Dave (2010) 'Hans Zimmer Extracts the Secrets of the "Inception" Score'. *The New York Times,* 28 July. Online. Available: http://artsbeat.blogs.nytimes.com/2010/07/28/hans-zimmer-extracts-the-secrets-of-the-inception-score/?_r=0 (accessed 18 February 2015).

Kassabian, Anahid (2001) *Hearing Film: Tracking Identifications in Contemporary Hollywood Film Music.* London and New York: Routledge.

Kloppenburg, Josef (2012) 'Musik im Tonfilm', in Josef Kloppenburg (ed.) *Das Handbuch der Filmmusik. Geschichte – Ästhetik – Funktionalität.* Laaber: Laaber Verlag, 87–337.

Levinson, Jerrold (2009 [1996]) 'Film Music and Narrative Agency', in Leo Braudy and Marshall Cohen (eds) *Film Theory and Criticism. Introductory Readings.* New York/Oxford: Oxford University Press, 402–417.

Martens, Todd (2010) 'Hans Zimmer and Johnny Marr talk about the sad romance of *Inception*', *Hero Complex, Los Angeles Times,* 20 July. Online. Available: http://herocomplex.latimes.com/movies/inception-christopher-nolan-the-smiths-johnny-marr-hans-zimmer-and-johnny-marr-on-the-sound-of-inception-its-about-sadness/ (accessed 20 January 2015).

Peirce, C. S. (1979) *Collected Papers of Charles Sanders Peirce, Vols. 1–6.* Charles Hartshorne and Paul Weiss (eds) Harvard: Belknap Press of Harvard University Press.

Schmid, Martin Anton (2012) *Filmmusik als Bedeutungsträger. Musik im Film – analysiert an Hans Zimmers Score zu "Inception".* Saarbrücken: AV Akademikerverlag.

Sirgist, Michael J. (2012) 'Dream Time: *Inception* and the Philosophy of Time', in David Kyle Johnson (ed.) *Inception and Philosophy: Because it's Never Just a Dream.* Hoboken, NJ: John Wiley, 199–214.

Smith, Jeff (1999) 'Movie Music as Moving Music: Emotion, Cognition, and the Film Score', in Carl Plantinga and Greg M. Smith (eds) *Passionate Views: Film, Cognition, and Emotion*. Baltimore, MD: Johns Hopkins University Press, 146–67.

_____ (2009) 'Music', in Paisley Livingston and Carl Plantinga (eds) *The Routledge Companion to Philosophy and Film*. London: Routledge, 184–95.

Whitehouse, Cameron (2010) *Inception Music Comparison*. Online. Available: http://www.youtube.com/watch?v=UVkQ0C4qDvM (accessed 20 January 2015).

Wildfeuer, Janina (2012a) 'Intersemiosis in Film: Towards a New Organization of Semiotic Resources in Multimodal Filmic Text', *Multimodal Communication*, 1, 3, 276–304.

_____ (2012b) 'More than WORDS: Semantic Continuity in Moving Images', *Image and Narrative: Online Magazine of the Visual Narrative*, 13, 4, 181–203.

_____ (2014) *Film Discourse Interpretation: Towards a New Paradigm for Multimodal Film Analysis*. London and New York: Routledge.

Wingstedt, Johnny (2005) 'Narrative Music. Towards an Understanding of Musical Narrative Functions in Multimedia (Licentiate thesis)', Lulea University of Technology, Sweden.

Wingstedt, Johnny, Sture Brandstrom and Jan Berg (2010) 'Narrative Music, Visuals and Meaning in Film', *Visual Communication* 9, 2, 193–210.

Zimmer, Hans (2010) *Inception. Music From the Motion Picture*. CD-Booklet. Warner Bros. Records.

# *About Time Too: From Interstellar to Following, Christopher Nolan's Continuing Preoccupation With Time-Travel*

## Jacqueline Furby

'I've always been fascinated by time, by the subjectivity of time, and *Interstellar* is the first film where I've been able to explore that as a literal part of the story. I think that kind of idea is fascinating. ... If there is an antagonist in *Interstellar*, it is time itself.'

Christopher Nolan (*Interstellar: Nolan's Odyssey*, 2014)

Although Christopher Nolan's film *Interstellar* (2014) is the first of his films to be overtly concerned with the increasingly popular science-fiction and fantasy trope of time travel, it is obviously not the first of his films to play around with temporality and linear chronology. For example, his first feature-length film, *Following* (1998), used a shuffled chronology as a distinctive plot device. Indeed, Nolan's interest in pushing against the conventions of traditional narrative storytelling through the idiosyncratic use of chronological time was especially noted with his second full-length feature, *Memento* (2000), which employed two narrative streams, one that reversed the chronology of story events, and another that presented episodic flashbacks running in chronological order, in order to offer the spectator an insight into the subjective temporal experience of the protagonist who had lost the ability to create new memories. Nolan's project to experiment with narrative time has continued and developed throughout the remainder of his directing career to date, and this essay discusses ways in which Nolan can be understood as a filmmaker who is obsessed by time and time travel. It therefore explores the different kinds of time(s) and modes of time (travel) that operate in Nolan's films and considers why it should come as no surprise that his most recent film is a (long anticipated) full-blown time travel story.

Time, and the idea of time travel, has long fascinated filmmakers. Indeed, the beginnings of cinema in the 1890s coincided with many new ways of thinking about time that ultimately heralded the early-twentieth-century Machine Age, including seeing modern temporality as a site and symptom of a dystopian movement towards a more fast-paced way of life and work. This idea is exemplified by capitalism's imposition of time-pressure on factory workers, promoted by Frederick W. Taylor in *The Principles of Scientific Management* (1911), and critiqued by many films including, *Metropolis* (Fritz Lang, 1927), *Modern Times* (Charles Chaplin, 1936), *Playtime* (Jacques Tati, 1967) and Terry Gilliam's *Brazil* (1985) (see Telotte 2001; Doane 2002; McCann 2008: McAuley 2014). During the years around the turn of the twentieth century, a period when time came to be seen as a valued commodity and a way to further exploit workers, authors and filmmakers recognised time's potential for fantasy narratives, in particular the possibilities for imagining a freedom of movement in time that offered an alternative to modernity's emphasis on an entrapment in acceleration and speed. For example, filmmaker Robert Paul approached visionary writer H. G. Wells in 1895, shortly after Wells published his story *The Time Machine,* in an attempt to involve him in a collaborative effort to produce a type of cinematic time machine. There is no evidence to suggest that Wells was interested in Paul's proposal, but Ian Christie reports that in October 1895 (four months after the publication of *The Time Machine*), Paul filed a preliminary Patent application for

> a novel form of exhibition whereby the spectators have presented to their view scenes which are supposed to occur in the future or past, while they are given the sensation of voyaging upon a machine through time. [...] The mechanism consists of platforms for the spectators, with an opening which is directed towards a screen upon which the views are presented. (1994: 28–9)

The event would be stage-managed by a 'Conductor', and Christie says that the 'illusion of travelling in time would be enhanced by a pretence that the spectators had "overshot" into the past, before the Conductor would return them to the present to end the show' (1994: 31). Paul's cinematic time machine was never realised in this form, although its DNA can be detected in its descendants as it's possible to view cinema itself as a kind of time machine; and time travel, in its many forms and variations, has become a common staple of screenwriters and filmmakers.

Mary Ann Doane points to one of the reasons for film's preoccupation with time in her discussion of early film. She writes that 'what the new technologies of vision [allowed] one to see is a record of time' (2002: 3). Todd McGowan agrees, and explains film's continuing fascination with time:

> From its inception, cinema has privileged time. The essence and the appeal of the cinematic art are inextricable from the experience of temporality that it offers spectators. Whatever else films explore, they inherently take tempo-

rality as their subject due to the nature of the medium. Whatever occurs in the film's images – or between film's images – occurs within the temporality of the film's projection. Every film orders time in some fashion or other, and the privileged role that time plays in cinematic art distinguished film from all other arts. That is, the way that a film orders time shapes its status as a work of art. (2011: 4)

Certainly time has featured as a central conceit, as playground, as setting, or as a malleable substance, throughout film history, fuelling the work of filmmakers, film theorists and philosophers.[1] Cinematic temporality, however, differs radically from time in the real world, and in Nolan's hands it is often tortured into new shapes that bear little resemblance to real world time. The latter appears to us to pass at a uniform rate of one second per second in only one direction and is the same as clock time. This real/clock time differs manifestly from our subjective experience of time, which is more malleable. Our thoughts can move easily and quickly from an appreciation of the present moment to a memory of the distant past or an anticipated point in the future. There is no limit to where (or when) we might travel to in time in our thoughts and dreams, or by harnessing cinematic time. Nearly all film narratives involve a kind of time travel as they reshuffle and reorder time, stretch and shrink duration, and alter the frequency of events, but in *Out of Time: Desire in Atemporal Cinema* (2011), McGowan identifies a trend, post-1990, of films that focus on a more explicit and complex relationship with narrative time, including achronological narrative structures, parallel ontological worlds and maze-like, layered and multilinear plots (see also Buckland 2009). In addition to this idea of time travel *of* narrative, in which we can clearly include all of Nolan's films so far, there is the idea of time travel *in* narrative: films such as *Interstellar*, whose *stories* involve temporal manipulation. These films deal explicitly with issues of time and fantasies of time travel, the implications that these issues have for the protagonist(s), and implicitly with the relationship between the spectator and films that play with the fantasy of not being anchored to the on-going present, and of being able to move around in time. Of Nolan and *Interstellar*, Vivian Sobchack states:

> fully aware that cinema is, itself, a time machine, [Nolan] has expanded – and compounded – the relativity of space-time and its effects by layering them in the multiple dimensions not only of *Interstellar*'s narrative but also of the film's overall structure and its immersive *mise-en-scène*. (2014)

In other words, *Interstellar* combines both types of film time, the manipulation of narrative time and the freedom within story time, and this results in a total time experience that reveals that Nolan is fully conscious of film's temporal potential. Nolan also sets the idea of the possibility of temporal freedom against the tricky complications of time travel within real science, which stretches and shrinks time all right, but according to its own unbreakable rules and not at the behest of any time traveling protagonists battling against a number of life's vicissitudes.

*Interstellar*

In *Interstellar,* in the near future a new global dust bowl condition forces a humanity on the brink of starvation to seek a new home in space. Previously a NASA-trained pilot and engineer, the film's protagonist, Cooper (Matthew McConaughey), now farms corn on his land alongside his father-in-law, Donald (John Lithgow), his fifteen-year-old son, Tom (Timothée Chalamet), and his ten-year-old daughter, Murph (Mackenzie Foy). Murph comments that her room is haunted by a ghost who repeatedly sends her messages, one of which results in Cooper and Murph locating a highly secret NASA base and meeting Professor Brand (Michael Caine) who is tasked with finding an extra-terrestrial solution to Earth's failing ecosystem. Cooper is recruited and with three others eagerly launches into space, and through a convenient wormhole, to assess three potential new home planets identified by three pioneers, Miller, Mann and Edmunds, after whom the planets have been named. Murph feels abandoned by her father despite his promise that he will return to her. In making this journey into space Cooper's timeline is thrown out of synch with Murph's as a result of time dilation, so that, for example, whilst the astronauts are on planet Miller, for each hour that passes seven years pass for the people on Earth. After two fruitless journeys to Miller and Mann, Cooper and TARS, a robot sidekick, journey into the mouth of a black hole, Gargantua, where Cooper enters a tesseract (see figure 1), an extra-dimensional space-time constructed apparently to enable him to successfully send vital messages back in time and across vast space to Murph that enable her to help humanity to launch themselves into a new age in space. When he ultimately returns

Figure 1: Cooper in the tesseract, *Interstellar* (2014)

in search of his daughter, Cooper finds that the ten-year-old Murph he left behind is now over a hundred years old, whilst he has aged only a few years. Nevertheless, he is able to fulfil his promise to return and an emotional scene towards the film's end sees him at his aged daughter's bedside.

There is an irony here to do with time. Most conventional time travel fantasies imagine at least one character having control over time and to where and when they travel. This is likely because in everyday life we are unable to move about in time in the way that we can move about in space. Space, for us, has three dimensions, and we are generally able to move about at will in these spatial dimensions, if we are fortunate enough to have the necessary physical strength and mobility; the physical laws of the universe do not prevent us from having freedom of motion in space. We do not have a comparable mobility in time and are only permitted to occupy our own version of the present moment as it changes our position in time at the rate of one second per second. In our everyday life we cannot change the speed or direction of our motion in clock time in the way that we can change our position in space. A key element of many time travel stories is that they address the fantasy of being able to exert control over time and to choose when to be in time in a similar way we are able to control our position in space.[2] Often this power is employed in the service of a redemptive rescue attempt. For example, time travel into the past may be motivated by a desire to change an event for personal reasons, as in *Timescape/Grand Tour: Disaster in Time* (David Twohy, 1992), where the protagonist Ben Wilson (Jeff Daniels) is able to bring back to life his dead daughter and his dead wife by using time travel technology brought to his era from the future by visiting temporal tourists. In other past-directed time travel films such as *La Jetée* (Chris Marker, 1962), *The Terminator* (James Cameron, 1984) and *Terminator 2: Judgment Day* (James Cameron, 1991) the stakes are raised, as the whole of humanity is the object of rescue. Backwards-directed time travel stories may also involve a quest for knowledge, as in *Twelve Monkeys* (Terry Gilliam, 1995), where James Cole (Bruce Willis) is 'volunteered', by a panel of scientists, to go back in time to locate a virus that devastated the global population so that the future population might find a cure.

The irony of *Interstellar* is, then, that whereas the idea of time travel often encourages narratives about travelling freely around performing heroic and epic rescues, space-time roaming Cooper is actually just as trapped in time as everyone else is in the extra-diegetic world. Kip Thorne, a real-world physicist involved with the film, relates that one of the rules that Nolan set for how the science in *Interstellar*'s universe should work is that 'physical objects ... such as people ... cannot travel backward in time. ... So, in particular, Cooper can never travel to his own past' (2014: 263).[3] Cooper, then, has to deal with a complication of relativistic time (dilation), with none of the travelling-backwards-in-time fun. Time is indeed an antagonist in *Interstellar* because it is relativistic time that Cooper has to do battle with and overcome, not least the extreme slowing of time that he encounters in the vicinity of planet Miller because it is in orbit around the black hole Gargantua. According to Thorne 'time flows sixty-thousand times more slowly' on Miller 'than on Earth' (2014: 163), and this time dilation introduces a race-against-time element to the film that is fully realised once Cooper returns

from the planet to the Endurance spacecraft to find that in the few hours that he spent on the expedition to Miller, his co-astronaut Romilly (David Gyasi) has aged over 23 years. This time dilation has serious implications for his ability to keep his promise to return to Murph, who is by now a grown woman in her thirties (and now played by Jessica Chastain).

The next temporal obstacle dealt with is after Cooper decides to eject his Ranger vehicle from the Endurance and jettison himself down through Gargantua's event horizon in a bid to acquire vital information about quantum gravity that will help humanity's quest to escape Earth. He becomes sandwiched between two singularities (see Thorne 2014: 248–9), and escaping from the Ranger encounters the tesseract, presumably placed there by some advanced five-dimensional beings (who may or may not be Murph's or Cooper's descendants). The tesseract is a 'hypercube' that has four spatial dimensions (instead of the three we would recognise), and 'looks like two cubes, inside each other' (Thorne 2014: 253). Thorne tells us that Cooper is 'confined to reside in one of the tesseract's three-space-dimensional faces (cubes)', because being a creature of three-dimensions he 'can't experience the tesseract's fourth spatial dimension' (2014: 254). The distance from Gargantua to Earth is approximately ten billion light-years, which means it would take light, which travels around a hundred trillion kilometres a year, ten billion years to travel between the black hole and Earth. Any vehicle available to Cooper (or any vehicle imaginable using the laws of science as they are currently understood) would not be able to reach speeds anywhere near light speed, but Thorne speculates that because the tesseract is a thing of five dimensions (four spatial and one temporal) the way it occupies space-time means that it is able to quickly carry Cooper home across the universe (2014: 252–61). The tesseract is positioned alongside Murph's bedroom. Luckily Nolan's second rule about the way science behaves in the universe of *Interstellar* is that 'gravitational forces can carry messages' into the past (2014: 263), and so, docked next to Murph's bookcase Cooper is able to harness the necessary gravitational forces to attempt to signal her via her (symbolically rich) books, and then through the watch he gave her before leaving.

The tesseract is not positioned just alongside Murph's bedroom at one specific time, but has potentially infinite facets, each one docked alongside the bookcase at a particular moment, and the whole representing Murph's bedroom at every possible moment. Nolan's interpretation of the tesseract seems to be that it apparently makes available a space-time continuum where all possible moments in time for this very specific space co-exist, and it is in this way that Cooper is able to reach out and message Murph in the past. TARS comments to Cooper that 'You've seen that time is represented here as a physical dimension', which means that space and time have somehow changed places so that whilst in the tesseract Cooper is free to move about in time, he is limited in terms of spatial movement, and, as Thorne confirms 'he can travel through the tesseract complex to most any bedroom time that he wishes' (2014: 260). He selects the bedroom time when Murph is ten years old and, communicating backwards in time, sends her the NASA coordinates and also the vital quantum data from TARS, that forty-year-old Murph finds thirty years later, that enables humanity to escape Earth's atmosphere and launch into space and into a new future.

In imagining the universe of *Interstellar*, Nolan as far as possible sought scientific accuracy, along with some educated guesses and outright speculation when the current understanding of science had been exhausted, and has therefore touched on some very complex theories of space-time, five-dimensional artefacts, gravity, relativity and time-travel. Despite this, and quite possibly because of it, the film may actually have a less complicated relationship with the past than other Nolan films. Whereas the past often contains an irreconcilable traumatic loss for many of Nolan's protagonists, Cooper's past is not finished, not closed off from the present, and he is able to communicate with his daughter in the past, and visit her in the future (or rather *her* future) at which time he receives forgiveness and is able to move on with his life. Protagonists of other Nolan films are not so fortunate, and they remain stuck in a series of temporal waiting rooms.

It is significant that *Interstellar* is the only Nolan film to deal with outer space, whereas the other films largely concern themselves with inner, psychological terrains of emotional torture, loss, grief, guilt and revenge, and yet it is arguably the only Nolan film that offers the protagonist absolution and redemption. This is a fitting outcome for a science-fiction story that plays with time. In general, past-directed time travel narratives re-open the past in order to effect change, for instance, by making something that didn't happen, happen – as in *The Butterfly Effect* (Bress and Mackye Gruber, 2004) – or something that did happen, not to have happened – as in *Source Code* (Duncan Jones, 2011). *Interstellar* simply allows something that always had taken place (Murph's ghost sending her messages) to occur, creating the conditions for it to happen.[4]

The film is about negotiating loss on a number of levels to do with parental failure and the collapse or failure of responsibility. The Earth has failed to sustain human life; Cooper abandons Murph and may not be able to keep his promise to return; Professor Brand lies about the fine detail of his plans to relocate humanity and as a result sends his daughter Amelia (Anne Hathaway) into space on false pretences; Mann (Matt Damon) lies about conditions on his planet so that he will be rescued, and then tries to murder his saviours. Even the poem 'Do not go gentle into that good night' by Dylan Thomas, quoted periodically throughout the film, is concerned with negotiating loss, and asks the individual about to launch into an uncertain future and, ultimately, death, to continue to bargain with the idea of destiny. The poem reminds us that Cooper and the other astronauts have journeyed into the unknown with no guarantee of return, and that the Earth is teetering on the edge of ecological disaster, and that all are tasked to 'Rage, rage against the dying of the light'.

*Inception*

Loss, then, infects each relationship that plays out in *Interstellar* and, in fact, in every Nolan film. *Inception*'s protagonist, Dom Cobb (Leonardo DiCaprio) negotiates the loss of his wife, Mal (Marion Cotillard) and the separation from his children, Phillipa (Claire Geare/Taylor Geare), and James (Magnus Nolan/Jonathan Geare). Cobb is the leader of a group of criminals engaged in corporate espionage where they collectively enter into a subject's subconscious via their dreams to either steal an idea or

secret (extraction), or plant an idea in the hope that it will shape the subject's future behaviour (inception). The film releases its own secrets slowly and we do not know Cobb's full history until very near the end, but relatively near the start we do know that although his wife Mal is dead, a subconscious projection of her infiltrates the landscape of Cobb's dreams both private and collective and threatens both his sanity and the success of the group's operations.

Whereas much of the action in *Interstellar* occurs in outer space, *Inception*'s narrative largely takes place in what can be thought of as inner space, in the subconscious landscapes of dreams, the central inception occurring in a dream within a dream within another dream in which the team attempt to insert an idea into the mind of Robert Fischer (Cillian Murphy). This is not the first act of inception that Cobb has performed, as prior to her death Cobb had seeded the idea in Mal's subconscious that the real world was not real. This thought led directly to her suicide in the mistaken belief that she needed to die in order to wake from a dream, because in *Inception*'s universe death is one of the methods of escape from the dreamworld, the others being a 'kick' or the effects of a sedative drug wearing off. Indeed in general the boundary between reality and dream feels increasingly uncertain throughout the film: the first images we see are of Cobb in Limbo, the lowest dream level, and an enduring question is whether or not he has successfully escaped from the dream at the film's end.[5] Between these two points most of the action takes place in one dreamscape or another, or in Cobb's memories of his life with Mal, both in dreamscape and, albeit briefly, in the real world.

The reward for a successful inception of Fischer's subconscious is to be an answer to one of Cobb's chief problems. Before Mal died she set things in place that would implicate her husband in her death and this means that he cannot return to the US and to his children because he is wanted for her murder. Cobb's client, powerful businessman, Saito (Ken Watanabe), guarantees to arrange for Cobb to be able to return home in payment for Fischer's inception. The film defines an idea implanted through inception as a 'virus, resilient, highly contagious', and even the 'smallest seed of an idea can grow; it can grow to define or destroy you'. Cobb is well placed to appreciate this as he has come to be defined and almost destroyed by the idea that he is responsible for Mal's death. The idea of his guilt invades his subconscious in the form of Mal's malicious presence, which is his own mind turned against himself. Guilt and traumatic loss, then, drive the narrative of *Inception* in the search for redemption and catharsis for Cobb who despairs of ever again seeing the faces of his children. There is a subplot to do with Fischer's relationship with his own father, Maurice (Pete Postlethwaite), and it is his need to not feel that he disappointed his emotionally undemonstrative and remote father that makes him vulnerable to inception. It's as if the dysfunctional relationship between Fisher and his father is there to remind us of the high stakes for Cobb of not being there physically for his children, and both cases prefigure the unhappy situation of physical and emotional detachment from his children that *Interstellar*'s Cooper also finds himself in.

Guilt, trauma and loss, as previously mentioned, shape the emotional lives and narrative thrust of all of Nolan's protagonists, with the possible exception of the Young

Man (Jeremy Theobald), protagonist of his first feature film *Following*, and guilt is Cobb's primary emotion in *Inception*. The symbolic manifestation of Cobb's guilt and sense of loss is his subconscious projection of Mal. He repeatedly sees her die in front of him. The repetition of her death in this way is an example of the kind of response to trauma Cathy Caruth identifies in her study of how survivors continue the 'unwitting re-enactment of an event that one cannot simply leave behind' because the 'experience of a trauma repeats itself, exactly and unremittingly' (1996: 2). Although dead, Mal is the film's main antagonist who consistently blocks Cobb, constantly sabotages his team's operations, and exerts her generally malevolent presence, until he finally decides to let go of her, and allows her to 'die' from her wounds after being shot by Ariadne (Ellen Page), and to remain dead. As McGowan points out, names are clearly important in Nolan's films (2012: 158), and it is therefore significant that Ariadne, who shares her name with the character of Greek mythology who leads the hero Theseus out of the labyrinth after he has slain the Minotaur, is the one to help Cobb to escape his own emotional maze. Mal is also well named of course, the word having clear associations with the French word for evil, badness, harm or illness.

Like the idea that Cobb describes as a resilient virus his guilt has overwhelmed him, preventing him from moving on. This is recognised by Ariadne, who tells him that 'Mal is bursting through your subconscious. ... Your guilt ... powers her. ... You have to forgive yourself and you're going to have to confront her.' In common with other Nolan protagonists, who deal, either successfully, or more usually, unsuccessfully, with traumatic loss, Cobb's story appears to orbit around a moment of trauma that causes time to take on a thickness and become untraversible. He explains to Ariadne how he's stuck in time after she's infiltrated his private dream and has found him talking to Mal in their house. They take the elevator to a floor that features a beach scene with Mal and their children playing. Ariadne recognises the scenes she sees as memories and asks him why he keeps returning to them. He says that they are moments that he regrets, and he has turned them into dreams so that he could change them, but he's unable to, so he's stuck. He is drawn back time and time again to the moment he left his children, regretting that he didn't wait to see their faces turn towards him. Each new dream of them ends the same way. This is one of the moments in time that he repeats. Whereas in the tesseract in *Interstellar* Cooper returns to one space as it existed in a multiplicity of moments in order to communicate with Murph, Cobb returns neurotically to a few moments out of a lifetime of moments because they are attached to guilt and regret. In this he is like the protagonist in *La Jetée*, who repeatedly time-travels back to a traumatic moment simply because it is traumatic. Marker's narrator tellingly explains that 'nothing tells memories from ordinary moments. Only afterwards do they claim remembrance on account of their scars'. The 'ordinary moments' that 'claim remembrance' do so because we attribute special meaning to them, for instance because they are the first or last times we experience something, or because we regret something done or not done. These memories do not grow old, as Sigmund Freud declares the unconscious an atemporal zone. He writes that 'the processes of the system *Ucs.* are *timeless;* i.e. they are not ordered temporally, are not altered by the passage of time; they have no reference to time at all' (1991: 160; emphasis in original) We are all familiar,

post-Freud, with the idea of the dangers of traumatic residues from the past irrupting into and threatening the emotional stability of the present, and that 'no amount of time allows us to escape the hold that loss has over us' (McGowan 2011: 14).

Present time, for Cobb, does not advance, but repeatedly spirals back to his significant moments, fuelled by guilt, traumatic loss and regret. Other ways of thinking about time in *Inception* include the kind of relativistic time encountered in *Interstellar* because of the manner in which time is dilated in the various dream levels. Because dreamers are heavily sedated, and because according to Cobb 'when you dream, your mind functions more quickly, so time seems to pass more slowly', each level of the Fischer inception dreamtime runs at a different speed, increasing exponentially by a factor of twenty. So there are five distinct temporal levels: Time in the real world; time in dream level one (warehouse and van) where ten hours of real-world time would seem like a week; time in dream level two (hotel) where ten hours of real-world time would seem like six months; time in dream level three (snow) where ten hours of real-world time would seem like ten years, and time in Limbo where ten hours of real-world time would seem like anything from two hundred years to eternity. Limbo seems an appropriate place for Cobb to 'spend time'. The term 'Limbo' has religious connotations, being part of Dante's landscape of hell, or a place of souls, but it has also come to mean a liminal space where time stands still and where the subject is caught waiting, suspended between states. Cobb lingers here because for him, without his wife and children, and with his burden of guilt, he cannot move forward. The totem that he carries, the spinning top which was once Mal's, is symbolic of his marginal atemporal existence. In dreamtime the totem will, once set in motion, spin without stopping. This is because where time does not exist, or where it passes according to the realm's own physical laws, there is no guaranteed change between one state (the spinning top) and another (the stopped top). Similarly there is no healing to be gained for Cobb from his encounters with Mal. It is only when the totem is spun in the real, waking world that it is able to stop. Of course we don't actually see the totem stop, so the question of whether Cobb actually makes it out of his dreamworld remains. But the matter in a real sense is irrelevant, because he does get to see his children's faces, and that was the desire driving him, so Cobb does achieve some measure of redemption and catharsis.

## The Dark Knight Trilogy

In a sense both *Interstellar* and *Inception* follow events as aftermath to a personal or collective disaster, and trace a journey through emotional pain and anguish. In his discussion of similar examples of atemporal cinema Todd McGowan argues that it is a 'cinema of the drive' and that the narratives are 'oriented around a foundational moment of traumatic loss' (2011: 10). Nolan's *Dark Knight* trilogy also charts a number of flights from trauma and the navigation of feelings of guilt and loss. Sometimes the trauma, like the implanted idea Cobb describes in *Inception*, comes to define the character. *Batman Begins* (2005), for instance, is a story of the origin and evolution of Batman, a coming of age, individuation narrative, which is very explicitly founded on

a moment of traumatic experience of fear, and then traumatic loss, as a direct result. The young Bruce Wayne (Gus Lewis) is frightened when he accidentally falls down a well shaft into a cave and is startled by a cloud of bats. Bruce subsequently has nightmares about bats and we understand the strength of his fear when he again encounters them, this time as actors dressed as monstrous bats, during a performance of the opera *Mefistofele* by Boito. His fear causes him and his parents to leave the theatre early and it is then that his parents are killed by a thief. Fear and guilt combine with traumatic loss to drive Wayne's journey and define his selfhood as Batman in that he takes on the identity of the thing he most fears.

The shape of time in the *Dark Knight* trilogy is in some ways cyclical, as Wayne's entire adult life remains tied to the defining moment of the bat cloud he was frightened by as a young boy. In the final third of *The Dark Knight Rises* (2012), for example, Wayne attempts to climb out of the underground prison (the pit) without a safety rope, having previously failed to climb out successfully with one. He is told by a fellow prisoner (Tom Conti) that success depends on having an appropriate degree of fear, because fear fuels the extra physical effort and extension needed to make the leap across a twelve-foot gap between one narrow ledge and another. As Wayne is poised on the first ledge a cloud of bats bursts from the cliff face beside him. Whether the bats are real, or symbolic of the primal nature of his fear at this moment is unclear, but his leap is successful. He reaches across the abyss, and climbs from the pit. So, there is a sense throughout all three films that, like Cooper and Cobb, Wayne is caught in that eternal moment of the flight of bats that has shaped his destiny but prevented him from moving forwards with his own life, as Alfred reminds him at one point, when he says 'You hung up the cape and cowl, but never move on. You won't get out there and find a life.'

If time is stuck in these films, there is yet a freedom of movement in space. In *The Dark Knight* (2008), for example, the camera often crosscuts between parallel action, or between a scene of action where the outcome is hanging in the balance, and another scene of action, so that the spectator remains unaware of the outcome of the first scene until afterwards. In this way a movement across space extends the suspense, excises time, and is in service of effective storytelling. For example, when the Joker (Heath Ledger) visits Harvey Dent (Aaron Eckhart) in hospital Dent holds a gun to the Joker's head and proposes that he tosses a coin to decide whether or not to pull the trigger. At this point the camera cuts to an exterior location leaving us in ignorance of the Joker's fate. The film plays with travelling through space, by means, for example, of a swooping, restless, mobile camera (and IMAX), to allow the spectator to see things, places, people, metaphysical domains (dreams, memories, interiority) and also manipulates the camera's movement through space to provide spectacle. The use of crosscutting between scenes of parallel action is an important aid to the atmosphere of suspense and expectancy in films, such as *Interstellar*, *Inception* and the *Dark Knight* trilogy, that use deadlines as a motivational dynamic device. In *Interstellar* the camera often alternates between action taking place in space and on Earth, so although the two locations are separated in both space and time, they are brought together through the juxtaposition of scenes. In this

way, for example, the full importance of what's happening in space is made clear when we witness the people on Earth struggling to breathe.

As these two or more lines of action, separated in space but possessing temporal simultaneity, are woven together by Nolan, the viewer is able to see simultaneous events, or even those occurring along disparate time-strings, as if they occurred consecutively. From the viewing position space-time is eviscerated: space behaves in a temporal manner, and time in a spatial one; events in space are seen in temporal sequence, and events in time are brought together spatially. The shape of space-time in these scenes is not unlike the tesseract flipped around, and instead of seeing many moments in time existing in one space we are able to see action occurring simultaneously in separate spaces brought together in consecutive moments of time. Crosscutting is also an aid to durational economy. Temporal ellipses are hidden in the transition from one spatial location to another. Cross-cutting in this way enables narrational, and spectatorial omniscience, and in the construction of the inverse tesseract produces a kind of space-time with both simultaneous and consecutive characteristics, possessing an internal rhythm as scenes move between and across space and time-strings, and therefore perhaps suggests both relativistic and internal subjective time in its idiosyncratic pulse.

*Narrative Time in The Prestige, Insomnia, Memento and Following*

Another kind of idiosyncratic pulse is found in Nolan's other four feature films, *The Prestige* (2006), *Insomnia* (2002), *Memento* and *Following*, although arguably less marked in *Insomnia*. Andrew Kania comments, in this volume, that in those Nolan films that he classes as 'personal' (he excludes *Insomnia* from this), 'the central narrative and thematic puzzles are posed not only by the *story* – what happens in the fictional world of the film – but also by the *plot* – the order in which elements of the story are presented'.

In *The Prestige*, two turn-of-the-twentieth-century stage magicians, previously friends, Alfred Borden (Christian Bale) and Robert Angier (Hugh Jackman), are pitted against one another both professionally and personally, when Angier's wife Julia McCullough (Piper Perabo) accidentally drowns on stage during an underwater escape trick. Borden is blamed for tying the wrong knot, which Julia is unable to untie, leaving her trapped in the tank of water. Borden and Angier become bitter enemies, rivals who take pleasure in sabotaging one another's performances and intent on finding the secrets of their most famous tricks, to the point where they are ready to commit murder. Both men suffer traumatic loss, and grieve for the death of a woman: Angier's dead wife, Julia, and Borden's wife Sarah (Rebecca Hall), who commits suicide as a direct result of the life Borden needs to live in order to perform his stage magic. Borden believes that sacrifice is a fundamental part of the successful magician's art, and one expression of his sacrifice is that he and his twin brother share a single life, each living a half-life as Borden and his *ingénieur* Fallon. The film tells the story through the conceit of Borden and Angier reading each others' journals, which contain details of their magic tricks and their personal lives; so, for example, Borden

reads Angier's diary in which we find Angier reading Borden's diary where Borden recounts their early career together. Diaries are a symbol of a complex, layered temporality, as they record the thickened present moment of reflecting on and processing the past (the day's events, for example), whilst anticipating the future moment when the diary will be called on by the diarist to refresh a memory, or by another to gain insight into the hidden thoughts of the writer. The narrative structure of the film is therefore complex, containing many repetitions, flashbacks and flash-forwards. Such a self-conscious narrative form, clearly acknowledges the audience who will invest energy in unpicking the story as they are offered few clear time markers to help them to orientate themselves in time.[6]

The shape of time in such a narrative within a narrative *within* a narrative can be thought of as like a *matryoshka*, or a Russian nested doll, which is a term that Andrew Kania (elsewhere in this volume) uses to describe the narrative shape of *Inception*'s dream within a dream *within* a dream, *within a dream*. At the heart of *The Prestige*'s *matryoshka* narrative is Julia's death by drowning. Everything that follows arguably happens because of Julia's death. A grieving Angier perpetrates multiple acts of revenge on Borden, finally framing him for his own death. Angier's thoughts return repeatedly to her death scene, whilst images of Julia drowning flash on screen. It can be no accident, either, that when Angier performs the 'The Real Transported Man', the version of him to be sacrificed dies by drowning in a water tank set beneath the stage. The film's final image is of a long line of identical water tanks, each containing a drowned Angier. Such a pathologically obsessive re-enactment reveals yet another of Nolan's protagonists who is temporally stuck, unable to move past the traumatic loss of a beloved woman (see Joy 2014). This confirms that Julia's death might be represented, narratively and temporally, by the tiniest, innermost Russian doll, being the event around which all other action nests. Indeed, McGowan remarks, extrapolating outwards from *The Prestige* to the generalised human subject, that 'time is not moving toward a different future that might free us from loss but returning us back to the experience of loss. Rather than being a movement forward it is a movement of return' (2012: 115).

The anxious return to and repetition of the past is also evident in three other Nolan films that play around, to varying extents, with linear temporal order in the narrative: *Insomnia*, *Memento* and *Following*. In the study of film, the story is the underlying layer of events, occurring sequentially, which take place in linear chronological time. The events in story-time may occur in a natural series (a-b-c-d), although the filmmaker will be selective about which events and parts of events to refer to, and will also select the order, duration and frequency with which these fragments are narrated. The narrative is to be understood as the period of the events depicted in the film, and is the arrangement of the story material presented on screen. The viewer reassembles the story from the information given by the narrative and reorders the story into a chronological sequence according to normal experience of the laws of cause and effect and linear temporal progression. Narrative events may follow the same order as in the story, in which case they conform to a natural chronology, or they may be presented out of story order, in which case they are anachronous. Anachronous narratives enter the story *in medias res*

and deviate from the natural chronology through flashback, or flashforward. The terms 'flashforward' and 'flashback' suggest that the scenes are presented entirely as if they are happening 'now', i.e., that the narrative unfolds in the ongoing present, and the audience sees events that have happened, or will happen, as if they were currently taking place. This time travel of the narrative is used extensively by Nolan.

*Insomnia*'s disruption of chronological order is subtle. The film is a remake of Norwegian director Erik Skjoldbjaerg's 1997 film of the same name. McGowan remarks that 'Nolan transforms the unrelenting pessimism of Skjoldbjaerg's film into what resembles a standard moralistic thriller' (2012: 68). Both films follow the story of a police detective, who, in the process of investigating the murder of a teenage girl, accidentally shoots and kills his partner and covers up the crime resorting to more and more elaborate subterfuge. In Nolan's version we learn that the protagonist, Will Dormer (Al Pacino), previously provided false forensic evidence in order to convict Dodd, the perpetrator of a murder, because of a lack of real conclusive evidence. Dormer is currently under investigation by Internal Affairs, and his partner Hap Eckhart (Martin Donovan) was planning to give evidence in return for immunity. Dormer, ironically given the connotations his name has for sleep (*dormir*), suffers from insomnia, perhaps as a result of being in a northern territory that experiences 24-hour daylight, or perhaps from intrusive feelings of guilt.

Nolan's version encourages the interpretation that Dormer responds to his own actions, both present and past, with psychological trauma that disrupts linear chronological order. Stuart Joy argues elsewhere in this volume that the opening scene is central to the film's temporal structure. In this scene, dark red blood seeps into and spreads through the threads of white fabric, and this is followed by the image of an unknown person (later understood to be Dormer) trying to remove the resulting stain. Joy's reading is that the bloodstained fabric represents the traumatic memory that refuses to be permanently repressed into the subconscious mind but which repeatedly returns to exert pressure, and unpleasure, on the subject's conscious mind (see Freud 1955). The gesture of the blood seeping upwards into the otherwise pure whiteness of the material is a structural conceit, repeated throughout the film, metaphorical of Dormer's irrepressible guilt.

The shape of time in this film, then, is comparable to the way time behaves in human subjectivity. Although we are unable to move about in time in the everyday world, in our minds we continually move between past, present and future as we remember past events, apprehend the present and anticipate the future. The repetition of the blood-spreading motif that haunts the narrative suggests that Dormer is fated to repeat mistakes of the past, and he's fated to die like the protagonists of a Shakespearian tragedy, the story driven forward by the mechanism of the character's fatal flaw. This is confirmed as he implicates himself more and more by escalating his manipulation of evidence in covering up the shooting of his partner, and in pursuit of the murderer, Walter Finch (Robin Williams). The past is not past, but present, and applying pressure, preventing him from resting, precluding him from doing anything but run headlong into his rendezvous with destiny at the film's end, where he dies, and finally, symbolically, sleeps.[7]

The idea that the protagonist's journey is fated, and the future already predestined, is strongly in evidence in *Memento,* a *noir* thriller dealing with the subjectivity of time of the protagonist, suffering from chronic severe memory loss, through backwards storytelling while he attempts to come to terms with the traumatic loss of his wife and redeem his part in it by punishing others. *Memento*'s story events are revealed in isolated, closed-off moments of stunted plot time experienced by the protagonist Leonard Shelby (Guy Pearce). The film has two narrative strands. One strand is in colour, and runs chronologically backwards in segments equivalent to a few minutes of time in the real world, comparable to the length of time Shelby can retain a thought or remain focused on a task. The other narrative strand is in black and white, and runs chronologically forwards until shortly before the start of the colour strand (at the beginning of the story, but at end of the narrative). The black and white strand reveals a sub-plot where Shelby relates the story of Sammy Jenkis, a case that Shelby dealt with as an insurance investigator, who suffered from the same condition of anterograde amnesia. The two separate time strands are plaited together for the viewer who receives a fragmented, confusing experience of time rushing headlong into the past from an uncertain present.

Shelby's anterograde amnesia is apparently connected with the murder of his wife. As he is unable to make new memories his experience of life and time is as a series of unconnected moments reduced to the baffling present. Having no intersubjective store of recent memories, which lack he equates with an inability to feel time, Shelby relies on external and somatic devices: he records important images on Polaroid, and tattoos important messages on his body. He can only retain a sense of the continuity of temporal passage for as long as he can hold on to one thought and the instant that he is distracted from that one thought, the continuity of that particular time-strand is cut and is lost, together with the memory contained within that moment. He therefore has an incomplete grasp of the direction in which time passes, cause and effect relations, and no stable position in time. The instant Polaroid photographs that he uses to record the events contained within the fleeting, separate, discontinuous instants of his life are a metaphor for his experience of time. Each image is only a highly selective, non-contextualised, worldview with a very restricted internal narrative. For Shelby, 'history has become reduced to the evidence of the photograph' (Harvey 1990: 313). He uses film as a portable memory, but in addition to being a memory substitute he uses the photographic image as a way of lying to himself about his past.[8] Shelby annotates each photograph in an attempt at contextualisation, but as his grasp of situations is flawed (by his restricted view and by his unconscious secret agenda), his narrative accompaniment is highly unreliable.

*Memento* is an extreme example of how the filmmaker can interfere with narrative time, and fit narrative form to storytelling function. The film is constructed to present the spectator with a confusing and fragmented viewing experience that echoes Shelby's life experience. The story unfolds in reverse chronology because, in a sense, so does Shelby's life; one character comments: 'It's all backwards. You might get an idea about what you're going to do next, but you don't know what you just did.' Each scene is a partial view that only makes sense when seen in context with the subsequent scene and,

as the film withholds vital information until the final scene (which occurs chronologically at the beginning of the story), the entire film is a collection of incomplete and unreliable fragments that the spectator has to knit together, but only makes sense of as a whole when being reviewed (remembered) after it has finished. With only fractured glimpses of the passing moment, and brief snatches of incomplete story information, Shelby is unable to adequately narrate his own life.

Philosopher of science Karl Popper suggests that a sense of time is one of the defining features of human beingness. It is necessary to know not only that we exist in the present moment but that we also extend in time, into both the past and the future, in order to be aware of ourselves as individuals, and to possess a unity of selfhood. This unity requires, Popper comments, 'an almost explicit *theory* of time ... to look upon oneself as possessing a past, a present and a future: as having a personal history; and as being aware of one's personal identity (linked to the identity of one's body) throughout this history' (1974: 277). Shelby's theory of time involves actively disavowing the past. His only anchor to a sense of self is based on his memory of his life before his wife died. This memory turns out to be incomplete, heavily self-censored and quite possibly false. Despite his insistence on the importance of facts, and his stated belief that 'we all need memories to remind ourselves who we are', Shelby refuses to remember. His is another exemplary Nolan case study of a traumatised character negotiating the traumatic residues from the past irrupting into and threatening the emotional stability of the present. He actively lies to himself, suppresses the past, and denies memory a foothold, preferring to remain eternally isolated on the tiny island of the present rather than confront the horrors lurking in the past. Shelby's time can be described as discontinuous uncontextualised durational snapshots.

This is the shape of time also offered to the viewer of Nolan's first feature-length film, *Following,* which is a thriller that uses fragmented and shuffled story order for extra intrigue, and therefore form can be said to follow function. To some extent the experience of the viewer of *Following,* like the viewer of *Memento,* is to echo the experience of the protagonist. In *Following* the protagonist (sometimes referred to as Bill, Ted, D. Lloyd or the Young Man, but equally often going unnamed; I shall refer to him as the Young Man) is an aspiring writer who follows people at random, curious to know things about them and their lives. This is another way that the film aligns the audience with the protagonist; they are also here to watch and follow other people in order to assuage a voyeuristic curiosity. The Young Man follows a man, called Cobb, and becomes involved in his seedy world of breaking into homes and stealing items, in particular personal belongings and intimate mementos. It becomes clear eventually that Cobb has set the Young Man up to be the fall guy for the murder of a woman whose death has become necessary to Cobb's criminal boss. This brief plot summary does nothing to transmit the film's key feature, which is that the story is told through short, apparently randomly ordered narrative segments. Andrew Kania comments, elsewhere in this volume, that the film's central puzzle is 'simply to figure out, from the non-linear narrative, what actually happens in the fictional world of the film – though the process of figuring this out is by no means simple'. Nolan himself states:

In a compelling story of this genre we are continually being asked to rethink our assessment of the relationship between the various characters, and I decided to structure my story in such a way as to emphasise the audience's incomplete understanding of each new scene as it is first presented. (Williams 2012)

In the course of viewing, then, the audience reconstructs the story from the information presented in the plot using a number of assumptions. David Bordwell says these assumptions are that 'a story is composed of discriminable events performed by certain agents and linked by particular principles' (1985: 33). When information is lacking about any of these components (events, agents, principles), 'perceivers infer it or make guesses about it' (1985: 34). The audience will also attempt to reorder events presented out of sequence, and 'seek causal connections among events, both in anticipation and in retrospect' in the quest towards unified coherence (ibid.). The story re-assemblage is carried out by a process based upon certain assumptions and ideas grounded in 'sets of schemata derived from context and prior experience' (ibid.). In other words, the viewer needs to piece together what happens, when it happens and why it happens. Interpretation involves identifying links between cause and effect and is assisted or blocked, accelerated or retarded, by gaps and omissions in the presentation of information. Manipulations of story order offer obvious narrational possibilities. Adhering closely to story order focuses the viewer's attention on events as they happen and encourages suspense. This natural chronological presentation of cause and effect enables the viewer to form clear-cut hypotheses about future events. Conversely, shuffling story order can force the viewer to re-evaluate early material in the light of new information about prior events. It can also create narrational gaps that can be temporary or permanent. If we have been given the effect of an action before the cause, either because we have entered *in medias res,* or because some time has been elided, a flashback may effect to fill the gap. Normally, 'the traditional function of a flashback [is] to reveal, verify, or reiterate a narrative truth' (Turim 1989: 167). But the flashback may also be used to produce further gaps.

As the narrative of *Following* is shuffled, one of the markers by which we can locate the story fragment in the overall story assemblage is that of the Young Man's appearance: for example, whether his hair is long and lank or short, whether his face is bruised or unmarked, or whether he wears casual or smart clothes. In other words, these markers tell us what position he is occupying along the line of destiny between the story's start and the story's end. Although the film starts *in medias res* with what appears to be the Young Man's narration of past events, the non-chronological order gives equal weight to all time segments in terms of 'presentness', so that regardless of whether an event has already occurred (to make sense of the cause and effect relationship), it *feels* as if it is unfolding in the present. Anna Powell states:

The temporal process, unseen in ordinary perception, is expressed when cinema self-reflexively foregrounds its own mechanisms, such as the synthesis of shots by editing and the rhythms set in motion by the resulting sequence.

Cinema does, of course, *depict* time in one sense: the fictionalised 'present' of its diegesis. (2007: 140–1)

The 'fictionalised "present" of its diegesis' gives the story an immediacy that suggests that the future (the Young Man's fate) is open, and that it can yet go in any direction. However, because scenes from the future of the story time-line the Young Man presently occupies have already happened in the narrative (as they have already been shown), there is also a sense that his destiny is sealed, in common with other Nolan protagonists who are unable to break free from their temporal prisons, whether due to time dilation in outer space, or due to equally complex and equally difficult to negotiate, conscious or unconscious thoughts in inner space.

*About Time Too*

Nolan's cinema is a cinema of time. His films play with narrative time, shifting time segments from one place to another to enhance the audience's understanding both of the experience of the protagonists, and the conventions of the genres. The shape of time in *Following* is like one of those sliding puzzles where there is one less little tile than there are spaces, and you have to gradually reorganise the tiles in order to resolve the pattern and solve the puzzle. The pleasure is in seeking the solution. The shape of time in *Memento* is that of a plaited rope with both ends extending into both the past and the future. It is possible to unravel the rope's threads, but it is more rewarding to admire its complexity as a complete thing. *Insomnia* unfolds mostly in chronological order in the ongoing present, with some brief reminders, in the images of blood-soaked cloth, that the unconscious is an atemporal realm and some events will not be ignored, and cannot be undone. *The Prestige*'s narrative is stacked inside a *matryoshka*, or a Russian nested doll, where the desire to avenge the pain contained in the innermost doll motivates actions, which lead to other actions, which lead to yet further actions, and where one of the final images is evidence that the repressed thought that repeatedly returns is of the central tragedy of the drowned woman. The *Dark Knight* trilogy has several temporal schemes. For example, one is the spiralling back of time to the traumatic image of the cloud of bats that came to define Bruce Wayne, and another is the inverted tesseract that allows the omniscient cinema audience to be in many places, and to see otherwise impossible to witness events. *Inception* also draws the audience into hidden, secret, layered realms of dream landscapes, where dreamtime is relative, where symbols of trauma, loss and grief still walk, and where thoughts reside so potent that they are able to seek and destroy the dreamer. Finally, *Interstellar*'s time, based on real science, educated guesses and speculation, is no stranger than time found elsewhere in Nolan's universe. Time is the antagonist in *Interstellar*, and the intrigue of what Nolan had finally made of a real time travel story was the film's unique selling point. This is fitting, because, as Nolan himself says, 'we are all engaged in the biggest mystery of all, which is just living through time' (Shone 2014).

*Notes*

1   Time in film is such a broad subject that it's almost impossible to single out individual films, and to recommend any specific critical or philosophical works, but anyone keen to understand the topics could do worse than to start by seeking out a sample from the following lists in addition to the films and other material mentioned in the body of the essay: Films by James Cameron (*The Terminator*, 1984; *Terminator 2: Judgment Day*, 1991), Terry Gilliam (*Time Bandits*, 1981; *The Fisher King*, 1991; *Twelve Monkeys*, 1995), Duncan Jones (*Moon*, 2009; *Source Code*, 2011), Chris Marker (*La Jetée*, 1962), Harold Ramis (*Groundhog Day*, 1993), Alain Resnais (*Last Year at Marienbad*, 1961), Andrei Tarkovsky (*Solaris*, 1972; *The Mirror*, 1975; *Stalker*, 1979), Robert Zemekis (*Back to the Future* trilogy, 1985–1990; *Contact*, 1997; *Cast Away*, 2000). Critical or philosophical writing by Robert Bird (2008), Gilles Deleuze (1986, 1989), Sorcha Ní Fhlainn (2010), Ursula Heise (1997), David Lewis (2010), Anna Powell (2007), David Rodowick (1997), Andrei Tarkovsky (1998).

2   Some examples of time travel films that allow the protagonist(s) to journey around space-time with relative freedom are *The Time Machine* (George Pal, 1960; Simon Wells, 2002), *Time Bandits*, *Back to the Future* trilogy, *Bill and Ted's Excellent Adventure* (Stephen Herek, 1988), *Timescape/Grand Tour: Disaster in Time* (David Twohy, 1991), *Timecop* (Peter Hyams, 1994), *The Butterfly Effect* (Eric Bress and Mackye Gruber, 2004), *About Time* (Richard Curtis, 2013).

3   Kip Thorne was an executive producer for the film in addition to being the scientific advisor and problem solver.

4   *Interstellar* is not unique in this. Examples of other films that involve creating conditions for events that have already happened to occur include *Back to the Future*, *The Terminator*, *Premonition* (Mennan Yapo, 2007) and *Timecrimes* (Nacho Vigalondo, 2007).

5   See Johnson (2012), and Botz-Bornstein (2013), two volumes of philosophical essays on *Inception*, for discussions of whether or not Cobb finds his way back to the real world at the film's end.

6   McGowan's interpretation of *The Prestige* is that it is a self-referential contemplation of the phenomenon of cinema as a sacrificial work of creation, an illusion that requires the work of the audience to complete.

7   This ending is another departure from the original film, where the protagonist Jonas Engström (Stellan Skarsgård) does not die.

8   The theme of deceit common in Nolan's films is particularly noted and discussed by McGowan (2012).

*Bibliography*

Bird, Robert (2008) 'Time', in *Andrei Tarkovsky: Elements of Cinema*. London: Reaktion Books, 111–88.
Bordwell, David (1985) *Narration in the Fiction Film*. London: Routledge.

n, Thorsten (ed.) (2013) *Inception and Philosophy: Ideas to Die For.*
Open Court.

rren (ed.) (2009) *Puzzle Films: Complex Storytelling in Contemporary*
Oxford: Blackwell.

eph (1993 [1949]) *The Hero with a Thousand Faces.* London: Fontana
Press.

Caruth, Cathy (1996) *Unclaimed Experience: Trauma, Narrative, History.* Baltimore,
MD: Johns Hopkins University Press.

Christie, Ian (1994) *The Last Machine: Early Cinema and the Birth of the Modern World.*
London: British Film Institute.

Deleuze, Gilles (1986 [1983]) *Cinema 1: The Movement-Image,* trans. Hugh Tomlinson
and Barbara Habberjam. London: Athlone Press.

_____ (1989 [1985]) *Cinema 2: The Time-Image,* trans. Hugh Tomlinson and Robert
Galeta. London: Athlone Press.

Doane, Mary Ann (2002) *The Emergence of Cinematic Time: Modernity, Contingency,
the Archive.* Cambridge, MA: Harvard University Press.

Fhlainn, Sorcha Ni (ed.) (2010) *The Worlds of Back to the Future: Critical Essays on the
Films.* Jefferson, NC: McFarland.

Foundas, Scott (2006) 'That Old Black Magic', Online. Available: http://www.
villagevoice.com/2006-10-10/film/that-old-black-magic/ (Accessed 28 February
2015)

Freud, Sigmund (1955 [1920]) *Beyond the Pleasure Principle. Standard Edition. Vol.
18.* Trans. James Strachey. London: Hogarth, 7–64.

_____ (1991 [1915]) 'The Unconscious', in *The Essentials of Psycho-Analysis.* trans.
James Strachey. Harmondsworth: Penguin.

Harvey, David (1990) *The Condition of Postmodernity.* Oxford: Blackwell.

Heise, Ursula K. (1997) *Chronoschisms: Time, Narrative, and Postmodernism.*
Cambridge: Cambridge University Press.

*Interstellar: Nolan's Odyssey* (2014) Directed by Dan Storey. UK. Sky Movie
Production.

Johnson, David Kyle (ed.) (2012) *Inception and Philosophy: Because It's Never Just a
Dream.* Hoboken, NJ: John Wiley.

Joy, Stuart (2014) 'Looking for the Secret: Death and Desire in *The Prestige*', *PsyArt:
Online Journal for the Psychological Study of the Arts.* June 14. Online. Available at:
http://www.psyartjournal.com/article/show/joy-looking_for_the_secret_death_
and_desire_ (accessed 28 February 2015).

Lewis, David (2010) 'The Paradoxes of Time Travel', in Richard Fumerton and Diane
Jeske (eds) *Introduction to Philosophy of Time: Introducing Philosophy Through Film,
Key Texts, Discussion, and Film Selections.* Oxford: Wiley Blackwell, 492–501.

McAuley, Paul (2014) *Brazil.* London: British Film Institute.

McCann, Ben (2008) '"De verre, rien que du verre": Negotiating Utopia in *Playtime*'
in John West-Sooby (ed.) *Nowhere is Perfect: French and Francophone Utopias/
Dystopias.* Newark, NJ: University of Delaware Press, 195–210.

McGowan, Todd (2011) *Out of Time: Desire in Atemporal Cinema*. Minneapolis, MN: University of Minnesota Press.

_____ (2012) *The Fictional Christopher Nolan*. Austin, TX: University of Texas Press.

Popper, Karl (1974) 'Scientific Reduction and the Essential Incompleteness of All Science', in *Studies in the Philosophy of Biology: Reduction and Related Problems*, ed. by Francisco Jose Ayala and Theodosius Dobzhansky. London: Macmillan.

Powell, Anna (2007) *Deleuze: Altered States and Film*. Edinburgh. Edinburgh University Press.

Plutarch (75 ACE) *Theseus*. Available at: http://classics.mit.edu/Plutarch/theseus.html (accessed 22 February 2015)

Rodowick, D. N. (1997) *Gilles Deleuze's Time Machine*. Durham, NC: Duke University Press.

Shone, Tom (2014) 'Christopher Nolan: The Man Who Rebooted the Blockbuster'. *The Guardian*. 4 November. Available at: http://www.theguardian.com/film/2014/nov/04/-sp-christopher-nolan-interstellar-rebooted-blockbuster (Accessed: 28 February 2015)

Sobchack, Vivian (2014) 'Time Passages: Space-Time is all Relative in Christopher Nolan's *Interstellar*', *Film Comment*. November/December. Available at: http://www.filmcomment.com/article/time-passages (accessed 22 February 2015).

Tarkovsky, Andrei (1998 [1986]) *Sculpting in Time: Reflections on the Cinema*, trans. Kitty Hunter-Blair. Austin, TX: University of Texas Press.

Telotte, J. P. (2001) *Science Fiction Film*. Cambridge: Cambridge University Press.

Thorne, Kip (2014) *The Science of Interstellar*. New York: W. W. Norton.

Turim, Maureen (1989) *Flashbacks in Film*. London and New York: Routledge.

Williams, Brad (2012) 'Chris Nolan's *Following*: Fascinating Neo-Noir That Plants Seed For Later Masterpieces'. Online. Available at: http://whatculture.com/film/chris-nolans-following-fascinating-neo-noir-that-plants-seed-for-later-masterpieces.php (accessed 2 March 2015).

# INDEX

3D technology  5, 44–5, 58n.3
35mm  5, 13n.8, 31–8, 41n.6, 45–6
70mm  5, 31, 33, 45–6; *see also* IMAX
Abbott, Megan  75
Adams, Ernest  191–2
aesthetic  7, 18, 31, 33, 38, 40, 45, 67,
    96n.1, 156, 158, 161n.9, 163, 201; of
    celluloid  5; film  31, 190; principle of
    181; realist  157; *see also film noir*
*Aetiology of Hysteria, The* (book)  140
*American Psycho*  90
analogue  7, 31, 38, 47
Anderson, Paul Thomas  31, 87
art-house  75, 159, 198
*Asteroids* (video game)  192
audience  1, 3–5, 7–8, 11, 17, 21, 23,
    27n.3, 33–4, 37–40, 41n.n.6,8, 42n.18,
    44–57, 58n.4, 63–4, 77–8, 82, 86, 90,
    95, 101, 116, 128, 134, 142, 149–55,
    158–60, 161n.8, 178, 185, 186n.6,
    187n.16, 197, 201, 203, 208, 210–11,
    212n.4, 213–13n.5, 215n.15, 220–6,
    229–30, 233, 235, 241–3, 259–64,
    265n.6; cinematic  19; cinephile  32;
    diegetic  56; experience  3, 7, 44, 46,
    113; male  63; mass  1, 7; reception
    7, 19
*Austin Chronicle* (newspaper)  20, 24, 27n.6
auteur/auteurism  2, 6, 12n.4, 17–27, 63,
    70–2, 101, 143, 153–4, 158, 160,
    175; of a blockbuster  5, 17, 24, 26,
    147; criticism  18; ideology  17, 27;

language  27, 17; persona  17, 19,
    21–7, 133; theory  12n.4, 18–9, 175
authentic cinema  5, 7, 31

*Back to the Future*  264n.n.n.1,2,4
Bale, Christian  3, 6, 9, 35, 46, 52, 57, 62,
    89–91, 100, 113, 153, 161n.11, 170,
    178, 202, 222, 258
Bane  35, 66, 68–71, 94–5, 114–15, 157
Batman  4, 10, 26, 35–9, 62–71, 72n.3,
    89–96, 112–15, 148, 153, 157–60,
    167–70, 171–3, 174n.6, 175, 198n.7,
    222, 256, 257
*Batman*  170
*Batman & Robin*  159
*Batman Begins*  4, 26, 46, 52, 54, 63, 66,
    68–9, 89–92 , 96, 103, 112, 115, 120,
    147, 157–9, 167, 169–70, 174n.6, 222,
    256
*Batman Forever*  161n.10
*Batman Returns*  158
*Batman v Superman: Dawn of Justice*  13n.10
Baudrillard, Jean  161n.4, 202, 204, 212n.2,
    213, 214n.15
Baumann, Shyon  20–1
*Being and Time* (book)  219, 227
*Being John Malkovich*  152
Benjamin, Walter  11, 202, 208
Benshoff, Harry  101
*Beyond the Pleasure Principle* (book)  122, 136
*bilocation*  202, 212n.4
*Blade Runner*  2

Dyer, Richard  18, 66
dystopia  248

Eckhart, Aaron  36, 63, 115, 170, 257
Elsaesser, Thomas  32, 40, 100, 110, 151, 201
*Empire* (magazine)  20, 22, 33
*Entertainment Weekly* (magazine)  20, 24, 50
*Eternal Sunshine of the Spotless Mind*  152
*Etiäinen*  202, 213n.6

falsity  164–8, 170–73
Faludi, Susan  9, 87
female/femininity  8–9, 63–8, 71, 79–80–1, 85–7, 90–1, 94, 96–97n.5, 95, 97n.8, 239; female malignity  94; feminine role  8, 62; feminine virtue  63
*femme fatale*  8, 9, 65–70, 75–6, 79–80, 86, 88, 94
*Fifth Element, The*  188–9
*Fight Club*  82, 87, 88, 96n.5, 152, 156, 171
film-as-film  5, 13n.8, 31
*Film Comment* (magazine)  62
film culture  17, 19, 26, 32
film form  5, 10, 17, 22, 26, 31, 58n.4, 147, 150, 155, 158
film history  20, 21, 249
*film noir*  2, 7–9, 13n.11, 21, 49, 65, 66, 74–80, 82, 85, 86, 99, 106, 179; male 74; modernist 83n.1; neo- 75–7, 81, 152; non-linear 83n.3; postmodern 8, 79; thriller 25, 134, 261; *see also* female characters and *femme fatale*
Fincher, David  49, 82, 87, 96n.5, 150, 152, 171
*Fisher King, The*  264n.1
Fisher, Mark  123, 126–7, 129, 130n.n.n.2,6,9, 154
flashback  51–2, 78–9, 81, 83n.5, 99–100, 102–3, 105–15, 135, 141–2, 144n.8, 178–9, 201, 221, 225, 230n.3, 242, 247, 259–60, 263
foldback  191–3, 197
*Following*  1, 3–5, 7–8, 10–12, 17, 21–6, 27n.5, 46, 49–50, 52, 86–8, 96, 96n.2, 123, 132, 134, 138, 141, 144n.10, 148, 166, 172–3, 175–6, 178, 180, 183–5, 219–29, 230n.3, 231n.12, 247, 255, 258–9, 262–4

*fort-da game*  122–4, 129, 130n.5
Foundas, Scott  39, 62, 89
Franklin, Paul  6
fraternal reading  204–6, 211
Freud, Sigmund  9, 110, 120–6, 129, 130n.n.3,4, 135–7, 140, 142, 144n.2, 173n.1, 202, 214n.12, 255–6, 260
Fuller, Matthew  189

*Game, The*  49, 147, 152
Gargantua  250–2
Generation X  87
gender  85, 95, 97n.8; -based anxieties  9; discourses of 8; fantasy 75, 81; identity 2, 8, 68, 74–82; politics 8; power 69–70; script 71; *see also film noir*
genre  4, 9, 17, 20, 22, 26, 33, 47, 48, 50, 53, 62–4, 80, 99, 102, 115–16, 151–2, 158, 166–8, 170–1, 186, 263–4; history 21; non-fiction 46, 49; western 166; *see also* con-artist and heist and *noir*
Gilliam, Terry  248, 251, 265n.1
Google  5
Gordon-Levitt, Joseph  35, 50, 51, 93, 123, 180, 196
Gotham  8, 35, 37, 58n.4, 62–71, 89, 92–5, 114–15, 153, 157–9, 161n.10, 170, 223, 231n.11
Goyer, David S.  46, 90
Griffin, Sean  101
*Groundhog Day*  152, 265n.1
Guantánamo  101, 114–16
*Guardian, The* (newspaper)  20, 22–3
guilt  9, 89, 94, 99–100, 104–9, 112–13, 116, 121, 132, 134, 156, 177, 179, 183-5, 188, 196, 198n.7, 201, 241, 253–7, 260

Hammett, Dashiell  75
Hardy, Tom  35, 50, 66, 93–4, 114, 126, 157, 196
Hathaway, Anne  6, 35, 47, 63, 94, 159, 253
Hegel, Georg Wilhelm Friedrich  165, 173n.1
Heidegger, Martin  11, 219–21, 225–8, 230n.n.2,6, 231n.n.14,17, 213n.18
*Heist*  48

CPSIA information can be obtained
at www.ICGtesting.com
Printed in the USA
LVOW04s0055111215

466234LV00002B/6/P

9 780231 173971